Canon® EOS
70D
Digital **Field Guide**

Canon® EOS
70D
Digital Field Guide

Charlotte K. Lowrie

WILEY

Canon® EOS 70D Digital Field Guide

Published by
John Wiley & Sons, Inc.
10475 Crosspoint Boulevard
Indianapolis, IN 46256

www.wiley.com

Copyright © 2014 by John Wiley & Sons, Inc., Indianapolis, Indiana

Unless credited otherwise, all photographs Copyright © Charlotte K. Lowrie.

Published simultaneously in Canada

ISBN: 978-1-118-16912-4

Manufactured in the United States of America

10 9 8 7 6 5 4 3 2 1

26
14
―――
40
====
$28.42

H 1920
W 1280
48 mHZ (sound)

Credits

Acquisitions Editor
Courtney Allen

Project Editor
Amanda Gambill

Technical Editor
George Maginnis

Senior Copy Editor
Kim Heusel

Editorial Director
Robyn Siesky

Business Manager
Amy Knies

Senior Marketing Manager
Sandy Smith

Vice President and Executive Group Publisher
Richard Swadley

Vice President and Executive Publisher
Barry Pruett

Project Coordinator
Patrick Redmond

Graphics and Production Specialists
Ronda David-Burroughs
Andrea Hornberger

Proofreading and Indexing
Evelyn Wellborn
BIM Indexing & Proofreading Services

About the Author

Charlotte K. Lowrie is a professional photographer and award-winning writer based in Seattle, Washington. She has more than 25 years of photography experience ranging from photojournalism and editorial photography to nature and food photography. Her images have appeared in national magazines and newspapers, and on a variety of websites, including MSN.com, www.takegreatpictures.com, and the Canon Digital Learning Center, http://learn.usa.canon.com/.

Charlotte divides her time among maintaining an active photography business, teaching photography, and writing books and articles. Charlotte is the author of 16 books including the best-selling *Canon 5D Mark III Digital Field Guide*. She is the coauthor of *Exposure and Lighting for Digital Photographers Only*. In addition, she teaches monthly online photography courses at www.betterphoto.com. Visit her website at http://words andphotos.org/.

This book is dedicated to my wonderful family, whose unfailing support means so much to me, and to God, my source of inspiration and insight.

Acknowledgments

I am most grateful to the top-notch team at Wiley Publishing for their excellent work on this book. I've had the privilege of working with Courtney Allen for many years, and I was fortunate to work with her on this book as well. She is one of the best acquisitions editors in the industry and is great to work with. Amanda Gambill is a fine project editor, and she helped keep everything on track for the short deadlines throughout this project. Thanks also for the great technical editing by George Maginnis and the eagle-eyed copyediting from Kim Heusel. Without question, it takes a village, or at least a well-oiled team, to make a book.

Thanks, also, to my clients, who graciously allow me to use their images in my books.

Contents

CHAPTER 3
Working with Exposure 79

CHAPTER 4
Getting Sharp Focus and
Setting Drive Modes 135

CHAPTER 5
Working with Color and
Creative Effects 155

CHAPTER 6
Customizing the Canon EOS 70D 187

CHAPTER 10
Choosing Lenses and Accessories 273

APPENDIX A
Shooting Checklist 295

APPENDIX B
How to Use the Color Checker
Gray Scale Card 299

GLOSSARY 303

INDEX 315

Introduction

Over the years, I've written many books about Canon cameras, and every time I do, I'm excited about the camera and the new features it offers photographers. This is very much the case with the Canon EOS 70D. On the surface, the 70D may not look like a huge upgrade to its predecessor, the EOS 60D, but looks are deceiving. The 70D holds the potential to revolutionize autofocus (AF) technology with Canon's new Dual Pixel CMOS AF system. With this technology, approximately two-thirds of the image sensor surface is capable of providing autofocus — not just the group of autofocus points clustered in the center of the viewfinder. Thus, in the Live View and Movie modes, where the new technology is used, you get quick, accurate focusing just about anywhere over two-thirds of the sensor area. That means that the smaller array of 19 AF points is no longer a restriction for still shooting provided that you use Live View mode. The new focus system is also fast and accurate.

Even when shooting still images using the viewfinder, the focus is improved over the 60D. The 70D inherits the high-performance autofocus system from the popular EOS 7D with a 19-point AF array (and again, the autofocus performance is excellent). The 70D also got a modest increase in resolution to 20.2 megapixels versus 18 megapixels in the 60D, and a big jump to 7 frames per second with continuous shooting (Large/ JPEG quality). The fast DIGIC 5+ image processor delivers speedy camera performance with sterling image quality. If you are upgrading from the 60D, you'll appreciate the improved noise performance, along with an increase in the ISO sensitivity range from 100 to 12800, and in the absolute lowest of light, you have the option of expanding the range up to 25600.

Now, you can use the new touchscreen to set focus, as well as to change camera settings and play back images using the same gestures that you use on your smartphone and tablet. Built-in Wi-Fi connectivity means easy and wireless transfer of images, and a built-in stereo microphone is a definite step up over previous models with mono microphones. Movie mode also offers new options that make it easier to synchronize video and audio. Altogether, the new technology and upgrades put the 70D on the leading edge of technology while providing a friendly and comfortable tool for photographers of all skill levels.

That last sentence is important. This camera is approachable and easy to use for everyone — photographers who are just learning the craft or professionals. So, whether you use the automatic, semiautomatic, or manual modes, the 70D is a capable story-telling tool that delivers top-quality images and movies.

Clearly, I'm excited about the 70D, but I'm also excited about this book. I've tried to pack in as much information about the 70D as possible. There will be instances in which this book intersects with the camera instruction manual — it's simply inevitable. However, with this book you get practical information and suggestions for using the 70D in your day-to-day shooting, as well as background explanations to help you understand features and options. Depending on your photography, you may need all the information, or you may need only part of it for now. Regardless, I hope the book will have staying power as a continuing source of information as you continue shooting.

If you are new to photography or returning after a long absence, I recommend reading the article on my website, *How Photo Savvy Are You?* (http://wordsandphotos.org/ WordsandPhotosB/Articles/HowPhotoSavvyAreYou.html). It provides a quick refresher on the fundamentals of photography.

You may be wondering if this is the type of book where you can skip around reading chapters in random order. Reading at random is fine, but I recommend that you go through Chapters 1 through 3 to get a good foundation for using the 70D. Also, be sure to check out the chapters on the Live View and Movie modes to learn more about Canon's new autofocus technology.

I've told students for years that the best way to learn photography and their camera is to just shoot pictures — *a lot* of pictures. Evaluate those, and then shoot some more. Rinse and repeat. Before long, using the 70D will become second nature to you.

Be curious. Be fearless. Be passionate — and always look for the light.

Exploring the Canon EOS 70D

If you've used the Canon 70D for any length of time, you already know that it delivers beautiful high-resolution images and snappy performance. Equally important are the creative controls, including a full range of exposure modes, shooting controls, and an extensive camera menu system. Externally, the controls on the back of the camera are streamlined, clearly labeled, and within easy reach during shooting. The touch LCD screen is a bonus, particularly when shooting in Live View () and Movie () modes.

However, the streamlined exterior belies the power under the hood with Canon's latest autofocus technology, which promises to change the industry as a whole. Couple that with a sophisticated metering system and the very fast DIGIC

The Canon EOS 70D offers a wealth of features to help you get the best images, even in bright lighting like this. Exposure: ISO 100, f/5.0, 1/3200 second.

5+ image processor, and you have everything you need to create stunning images. In this chapter, I cover the various controls and menus on the 70D.

The Camera Controls

There are several primary controls that, when used together or separately, control many functions on the 70D. Once you learn these controls, you can make camera adjustments more efficiently. Here is a summary of the controls:

▶ **The Main (⚙) and Quick Control (◯) dials.** Use these controls to make changes to the four buttons located on top of the camera above the LCD panel, such as the AF button (Autofocus mode). You can

1.1 The Main dial.

press the button, and then turn the Main dial (⚙) or the Quick Control dial (◯) to change the Autofocus mode. This holds true for the Drive, ISO, and Metering mode buttons above the LCD panel as well. Some camera menu screens, such as Image Quality, use both the Main (⚙) and Quick Control (◯) dials for selecting different settings.

▶ **Setting button (⑯).** You use this button to confirm changes you make to many menu items and open submenus. On the Quick Control screen, accessed by pressing the Quick Control button (Q), you can select a setting using the Multi-controller (⊕), and then press the Setting button (⑯) to display all the options for the setting.

▶ **Multi-controller (⊕).** This eight-way control functions as a joystick when it is pressed in any of the eight directions marked on the dial. The Multi-controller (⊕) is the primary control on the Quick Control screen to choose different functions. You can also use the Multi-controller (⊕) to manually select the AF point or zone, move through an image in magnified view during playback, and move the autofocus point in Live View mode (📷). It also works to navigate through the camera menus and options.

Quick Control dial

Multi-controller

Setting button

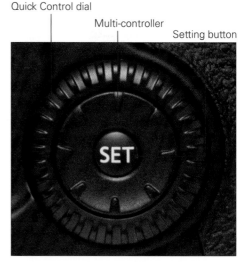

1.2 The Quick Control dial, the Multi-controller, and the Setting button.

NOTE To prevent unintentional setting changes, you can lock the Main (⚙) and Quick Control (○) dials, and the Multi-controller (✴) by using the Custom Function, C.Fn III-2: Multi-function Lock, and then by setting the Lock switch to the up position.

The front of the camera

The front of the camera has very few (but still important) controls, including the self-timer lamp, the Depth-of-Field Preview button (🔘), the lens mount, and the lens release button. The front of the camera is also where you find the comfort grip, which provides good control and balance while using the camera.

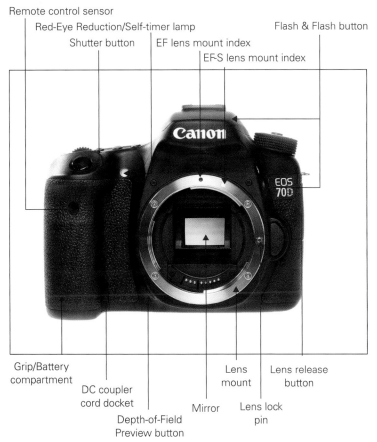

Remote control sensor
Red-Eye Reduction/Self-timer lamp
Shutter button
EF lens mount index
EF-S lens mount index
Flash & Flash button

Grip/Battery compartment
DC coupler cord docket
Depth-of-Field Preview button
Mirror
Lens lock pin
Lens mount
Lens release button

1.3 The front of the Canon EOS 70D.

3

Here is a summary of the controls on the front of the camera:

► **Remote control sensor.** This sensor works with the accessory Remote Controller RC-6 for remote release of the shutter up to 16.4 feet (5 meters) from the camera. Alternately, you can use RC-1 and RC-5. With the Remote Controller, you can either shoot immediately or after a 2-second delay. To use the remote controller, set up the camera for the exposure and focus on the subject, and then point the remote control at the sensor and press the transmit button. You can also set the Drive mode to Self-timer 10-second (⁞ⓞ) or 2-second (ⓞ2) delay.

► **Red-eye reduction/Self-timer lamp.** When using the built-in flash, this light helps reduce the appearance of red in the pupils of the subject's eyes if you've enabled Red-eye reduction on Shooting menu 2 (◯) menu. In the two Self-timer modes (ⓞ), this lamp flashes to count down the seconds (either 10 or 2) to shutter release. Self-timer drive modes (ⓞ) enable you to avoid blur from your finger pressing the shutter button at the beginning of long exposures, and the 10-second mode gives you time to get into the picture yourself.

► **EF and EF-S lens mount index markers, lens mount, and contacts.** The lens mount is compatible with Canon EF lenses and EF-S lenses. The lens mount has a red index and a white index mark. Use the red mark to line up EF-mount lenses. Use the white index mark to mount EF-S lenses. Always keep the rear lens cap handy to protect the lens contacts when the lens is off the camera. If there isn't a lens on the camera, use the camera body cap to protect the contacts and internal components of the camera.

► **Flash and Flash button.** Press this button to pop up and use the built-in flash in all exposure modes, except Flash Off (⚡), Landscape (🏔), Sports (🏃), and HDR Backlight Control (▦). In the automatic, or Basic Zone exposure modes except the ones mentioned previously, the flash pops up and fires automatically when the camera detects either low light or backlight (bright light behind the subject). To turn off the flash, press the flash head down.

CROSS REF How to use the built-in flash and Speedlites is covered in Chapter 9.

► **Lens release button and Lens lock pin.** Pressing this button releases the lens from the lens mount. To disengage the lens, hold down the lens release button as you turn the lens so that the red or white index mark moves toward the top of the camera. The lens lock pin does what its name says: it engages and locks the lens in position.

▶ **Reflex mirror.** When you use the viewfinder for shooting, the reflex mirror is in a down position so that it reflects light from the lens to the pentaprism enabling you to see the scene in the viewfinder. Through the viewfinder, you see 98 percent of what will be captured by the imaging sensor. In the Movie ('🎥) and Live View (📷) shooting modes, the mirror is flipped up to allow a current view of the scene on the LCD screen. If you are using Quick mode focusing in Live View, the mirror must flip down to focus, thereby suspending Live View momentarily. For some exposures (especially with a telephoto lens), you may want to lock up the mirror to prevent any vibration from it flipping up to make the exposure. Just enable Mirror lockup on Shooting menu 2 (📷).

▶ **Depth-of-Field Preview button (🔆).** Press this button to stop down the lens diaphragm to the current aperture so that you can preview the depth of field. As you look through the viewfinder, the larger the area of darkness, the more extensive the depth of field will be. The button can also be used during Live View shooting (📷) when the depth-of-field preview is displayed on the LCD screen. If the lens is set to the maximum aperture, the depth-of-field view does not change because the diaphragm is already fully open. You can also reassign the function of this and other camera controls using Custom Function, C.Fn III-4, Custom Controls, on the Custom Functions menu (📷).

▶ **DC coupler cord hole.** With the accessory AC Adapter Kit ACK-E6, you can power the camera with household electricity. Your movement range is limited, of course, by the length of the 7.5-foot cord.

▶ **Grip/Battery compartment.** The molded handgrip doubles as the housing for the Canon LP-E6 rechargeable lithium ion 7.2V DC battery. This battery is a workhorse with excellent performance. Be sure to use the battery until it is exhausted before recharging for the best and longest battery performance. If you are not using the camera for an extended period, take the battery out of the camera and put the cover on the battery. Then store it in a clean, dark area with moderate temperatures. Heat, humidity, cold temperatures, and exposure to direct sunlight can damage the battery.

The top of the camera

Dials and controls on the top of the camera provide access to frequently used shooting functions. The top of the camera is also home to the hot shoe and diopter control.

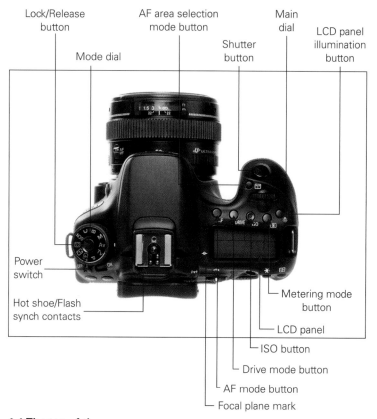

1.4 The top of the camera.

Here is a look at the controls on top of the camera:

▶ **Mode dial and Lock/Release button.** Select an exposure mode by pressing the Mode dial lock release button, and then turning the Mode dial to the mode that you want to use. Exposure modes are grouped as follows:

- **Basic Zone modes.** These modes include Scene Intelligent Auto (🅰️), Flash off (🚫), Creative Auto (CA), and Special Scene mode (SCN). The Special Scene mode (SCN) gives you access to these scene modes: Portrait (👤), Landscape (🏔️), Close-up (🌷), Sports (🏃), Night Portrait (🌃), Handheld Night Scene (🌆), and HDR Backlight Control (🖼️).

CROSS REF Exposure modes are detailed in Chapter 3.

• **Creative Zone exposure modes.** Program AE (**P**), Shutter-priority AE (**Tv**), Aperture-priority AE (**Av**), Manual (**M**), and Bulb (**B**).

• **Custom exposure mode (☉).** One custom exposure mode (☉) enables you to program it with your favorite camera settings. This great mode enables you to preset virtually all the camera settings for a specific scene or subject.

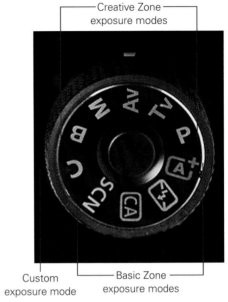

Creative Zone exposure modes

Custom exposure mode

Basic Zone exposure modes

1.5 The mode dial.

CROSS REF Chapter 6 explains how to set up the Custom mode (☉).

▶ **Power switch.** The power switch turns the camera off and on. The camera automatically goes to sleep after 1 minute if it's not being used. You can set the power off interval on Setup menu 2 (♈). The choices are 1, 2, 4, 8, 15, or 30 minutes, and Disable.

▶ **Hot shoe and flash sync contacts.** The hot shoe is where you mount an accessory flash unit or a transmitter such as the ST-E2 or ST-E3-RT. The mounting plate has flash sync contacts to communicate with the camera. The 70D is a Type A camera that is compatible with E-TTL II auto flash with accessory Canon EX-series Speedlites. When using a compatible EX-series Speedlite, the 70D offers flash configuration and control options on Shooting menu 2 (🗖).

▶ **AF mode button (AF).** Pressing this button enables you to change the Autofocus mode using the Main (𝄜) or Quick Control (◎) dials. The options you can choose are One-shot AF (**ONE SHOT**), AI Focus AF (**AI FOCUS**), and AI Servo AF (**AI SERVO**) for still shooting. In Live View (liveviewshoot) and Movie ('🎥) modes, the AF options appear on the LCD.

▶ **Drive mode button (DRIVE).** Pressing this button enables you to change the drive mode using the Main (🎯) or Quick Control (◌) dials. The drive modes from which you can choose are Single (□), High-speed continuous (🔁H) 7 frames per second (fps), Low-speed continuous (🔁) 3 fps, Silent single (□ˢ), Silent continuous (🔁ˢ) 3 fps, 10-second Self-timer/Remote control (⌚ঔ) and 2-second Self-timer/Remote control (⌚ঔ2).

▶ **ISO speed button (ISO).** Press this button to change the ISO sensitivity setting using the Main (🎯) or Quick Control (◌) dials. In Basic Zone modes, the ISO is set automatically. In Creative Zone modes, you can set the ISO to Auto (A) to have the camera determine the sensitivity setting to use, or you can set the ISO yourself.

CROSS REF ISO settings, ranges, and minimum and maximum settings are detailed in Chapter 3.

▶ **Metering mode button (⊡).** Press this button and then turn the Main (🎯) or Quick Control (◌) dial to change the Metering mode. The options are Evaluative (⊡) 63-zone TTL metering, Partial (◖) 7.7 percent at center frame, Spot (⊡) 3 percent at center frame, and Center-weighted Average (⊡).

▶ **LCD panel.** This panel gives you a quick snapshot of the important camera set-tings. It displays the autofocus and drive modes, ISO speed setting, Highlight Tone Priority (if set), remaining shots on card, Self-timer countdown, Bulb expo-sure time, Error numbers and codes, metering mode, Wi-Fi status, battery sta-tus, Auto Exposure Bracketing (AEB) if set, exposure compensation amount, aperture, AF point selection method, shutter speed, use of Multiple-exposure or HDR shooting, and Multi-shot Noise Reduction.

▶ **Focal plane mark (⊖).** The Focal plane mark (⊖) indicates the location of the image sensor. Knowing the exact distance from the focal plane to the subject enables you to set focus manually and precisely, which is useful for movie or macro shooting when you need to know the exact distance from the front of the image sensor plane to the subject.

▶ **AF area selection mode button (⊞).** Press the AF area selection mode button (⊞) one or more times to switch among the AF area modes: Single-point AF Manual selection (◙), Zone AF (⊞, Manual zone selection), or 19-point automatic selection AF (▣).

CROSS REF AF area selection modes are covered in Chapter 4.

▶ **Shutter button.** When you press the shutter button halfway, the 70D automatically meters the light in the scene and focuses on the subject. Completely pressing the shutter button opens the shutter and makes the picture. In Continuous shooting drive mode (➲), you can press and hold the shutter button to shoot at 7 frames per second (fps) in High-speed continuous mode (➲H), and at 3 fps in the Low-speed continuous (➲) and Silent continuous drive (➲s) modes. In the Self-timer modes, pressing the shutter button completely initiates the 10- or 2-second timer, and after the timer delay, the shutter fires to make the picture.

▶ **Main dial (🜊).** The Main dial (🜊) selects a variety of options. You can use the Main dial (🜊) to change settings for the buttons above the LCD panel, to cycle through camera menus, to move horizontally through the autofocus points when selecting an AF point manually, to set the aperture in Aperture-priority AE mode (**Av**), set the shutter speed in Shutter-priority AE (**Tv**) or Manual (**M**) modes, and shift the exposure in Program AE mode (**P**).

▶ **LCD panel illumination button (🔆).** Pressing this button turns on an amber light to illuminate the LCD panel for approximately 6 seconds. This is a handy option when it is too dark to see the LCD panel so that you can make adjustments to the buttons above the LCD panel or see the camera settings. If you're using the LCD panel light to set up the camera for a bulb exposure, you don't have to wait the 6 seconds for the light to go out. The light goes out when you press the shutter button.

The back of the camera

Many of the adjustments you'll make during shooting use the controls on the back of the camera. The controls are kept to a minimum for ease of use, and are within easy reach of the left and right thumbs during shooting and image playback.

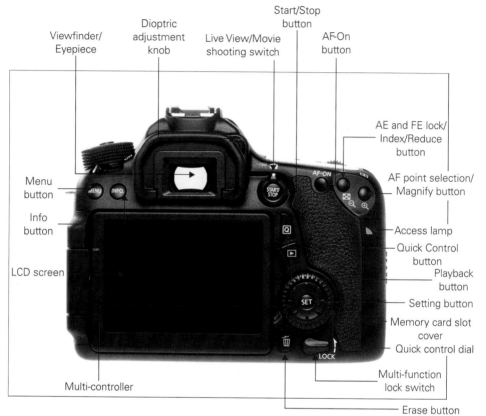

1.6 The back of the Canon EOS 70D.

Here is a look at the back of the 70D:

▶ **Menu button (MENU).** Pressing the Menu button (**MENU**) displays the most recently accessed camera menu. To move among the menus, turn the Main dial (⌒), or press the direction keys on the Multi-controller (⋮).

▶ **Info button (INFO.).** During shooting, you can press the Info. button (**INFO.**) to cycle through different displays: the Shooting information screen that details the current camera settings, the Electronic Level, and the Quick Control screen, or no information. When playing back images, pressing the Info button (**INFO.**) one or more times cycles through four playback display modes.

▶ **Viewfinder/Eyepiece.** The 70D viewfinder is an eye-level pentaprism with approximately 98 percent vertical and horizontal coverage. The focusing screen cannot be changed.

▶ **Dioptric adjustment knob.** Turn this control forward or backward to adjust the sharpness in the viewfinder for your vision. The adjustment ranges from -3 to +1 diopters. If you wear eyeglasses or contact lenses for shooting, be sure to wear them as you turn the dioptric adjustment control. To make the adjustment, point the lens to a light-colored surface such as a piece of white paper or a white wall, and then turn the control until the AF points are perfectly sharp.

▶ **Live View (🎥)/Movie shooting switch ('🎥) and Start/Stop button (START/STOP).** Setting this switch to the Live View shooting (🎥) position and pressing the Start/Stop button (START/STOP) initiates Live View shooting. The reflex mirror flips up to display a current view of the scene on the LCD monitor so that you can compose the image using the view on the LCD. Alternatively, set the switch to Movie shooting ('🎥), and then press the Start/Stop button (START/STOP) to begin shooting movies. Press the Start/Stop button (START/STOP) again to stop shooting in Live View (🎥) or Movie ('🎥) mode.

▶ **Quick Control button (Q).** Pressing this button displays the Quick Control screen on the LCD, where you can make changes to the most commonly used camera settings. To make changes on the Quick Control screen, touch the option on the screen or press the direction keys on the Multi-controller (⁖) to select an option. Then turn the Quick Control (○) or Main (⌖) dial to change the setting.

▶ **AF-On button (AF-ON).** Pressing this button initiates autofocus in the Program AE (**P**), Shutter-priority AE (**Tv**), Aperture-priority AE (**Av**), Manual (**M**), Bulb (**B**), Custom (**C**), Live View (🎥) and Movie ('🎥) modes.

▶ **AE and FE lock (✻)/Index/Reduce (▦·⚲) button.** During shooting, pressing this button enables you to set and lock the exposure at a different point from where you set the focus. When using the flash, pressing this button locks the flash exposure at a specific place in the scene. When playing back images, pressing this button one or more times switches to index views of the images on the media card. If an image is magnified during playback, you can press this button one or more times to reduce the magnification.

▶ **AF-point selection/Magnify button (⊞).** During shooting, press this button, and then press the direction keys on the Multi-controller (⁖) to manually choose an AF point. When you're playing back images, press this button to magnify the image to check the focus or other details.

▶ **Access lamp.** This lamp lights or blinks red when any action related to taking, recording, reading, erasing, or transferring images is in progress. Whenever the light is lit or blinking, do not open the memory card slot door, turn off the camera, remove the battery, or jostle the camera.

▶ **Playback button (▶).** Press this button to display the last captured or viewed image. To cycle through images on the card, turn the Quick Control dial (◯) counterclockwise to view images from last taken to first, or turn the dial clockwise to view images from first taken to last. To change the information displayed with the image during playback, press the Info. button (**INFO.**) one or more times.

▶ **LCD screen.** The 3-inch LCD screen dominates the back of the 70D. The 1.04-million-dot TFT liquid-crystal display (LCD) monitor offers a bright, detailed preview of images and movies. The LCD screen is touch sensitive so you can change settings and focus with the touch of your finger. The screen is also articulated so that you can move it around. When you're not using the camera, close the LCD with the screen turned in toward the camera to protect it.

▶ **Erase button (🗑).** Pressing this button during image playback displays options to erase the currently displayed image as long as it does not have protection applied to it. Batches of images can be erased together by selecting and check marking images.

▶ **Multi-controller (⬩).** The eight-way Multi-controller (⬩) offers direction keys for selecting options on the camera menus, and you can press the keys in any of the eight directions to choose an AF point and other options. During shooting, use it to select an AF point after pressing the AF point selection button (⊞), to move the AF point in Live View shooting mode (📷), or to select camera menu options. On the Quick Control screen, press the direction keys on the Multi-controller (⬩) to move among and select options you want to change. The Multi-controller (⬩) is also used for setting white balance shift.

▶ **Quick Control dial (◯).** Turn the Quick Control dial (◯) to change settings for the buttons above the LCD panel, to choose options on the camera menus, or to move vertically through the AF points after pressing the AF Point Selection button (⊞). On the Quick Control screen, select a setting, and then turn the Quick Control dial (◯) to change to, or scroll through, different settings.

▶ **Setting button (SET).** Pressing this button confirms menu selections, opens submenu screens and, on the Quick Control screen, opens screens from which you

can change settings, such as the ISO, exposure compensation, and exposure bracketing.

▶ **Multi-function lock switch (LOCK▶).** You can program this switch to prevent accidental changes to camera settings with the Main dial (🖐️), the Quick Control dial (◯), and/or the Multi-controller (⬦). To set up the use of the switch, go to the Custom Function menu (.🗭.) and choose C.Fn III-2 Multi-function lock. You can then choose which of (or all of) the three controls to lock when the switch is in the up position. When the Multi-function lock switch (LOCK▶) is in the up position, it limits use of the selected controls, thereby preventing accidental changes to camera settings. When the switch is in the down position, you have full use of the Quick Control dial (◯), the Main dial (🖐️), and the Multi-controller (⬦) for selecting camera options and settings.

External microphone IN terminal

Remote control terminal

HDMI mini OUT terminal

Audio/Video OUT digital terminal

1.7 The Canon EOS 70D terminals.

The side of the camera

On one side of the 70D is the door for the Secure Digital (SD) memory card. The opposite side of the camera houses two sets of camera terminals under individual rubber covers. The rubber covers are embossed with descriptive icons and text to identify the terminals.

Here is an overview of each camera terminal by row:

▶ **External microphone IN terminal (MIC).** This is a 3.5mm external microphone terminal for an accessory stereo microphone equipped with a miniature stereo plug. When you use an accessory microphone for recording audio during movie shooting, the camera automatically switches audio recording to the external microphone. Audio is recorded at 48 k/Hz with a16-bit sampling rate.

▶ **Remote control terminal (⏚).** This terminal connects with the accessory Remote Switch RS-60E3.

▶ **HDMI mini OUT terminal (HDMI OUT).** This terminal, coupled with the accessory HDMI Cable HTC-100, enables you to connect the camera to an HDTV. You cannot use the HDMI mini OUT terminal (**HDMI OUT**) simultaneously with the Audio/video OUT/Digital terminal (**A/V OUT/DIGITAL**).

▶ **Audio/Video OUT/Digital terminal (A/V OUT/DIGITAL).** Use this terminal when you want to connect the camera to a non-HDTV to view images and movies stored on the media card. You need an accessory Stereo AV cable AVC-DC400ST to make the connection.

▶ **Microphone (not shown).** The built-in stereo microphone, located above the terminal covers, can be used for recording stereo audio when you're shooting a movie. On Movie menu 2 (📹), you can adjust the recording level and use a built-in wind-cut filter to reduce noise from the wind when necessary. Alternatively, you can disable sound recording or use an accessory stereo microphone.

An Overview of Lens Controls

Using the controls on lenses, you can control whether to use automatic or manual focusing, Image Stabilization, as well as other functions depending on the lens you're using. If you want to switch from autofocusing to manual focusing, you can position the switch on the side of the lens to Manual Focus (**MF**) on lenses that offer it.

Manual focusing includes focus assist. As you adjust the focusing ring on the lens, the focus confirmation light in the lower-right side of the viewfinder lights steadily, and the camera sounds a focus confirmation beep (if you've enabled it) when sharp focus is achieved. While lenses are covered in Chapter 10, navigating the camera includes being familiar with lens controls, so I include them here.

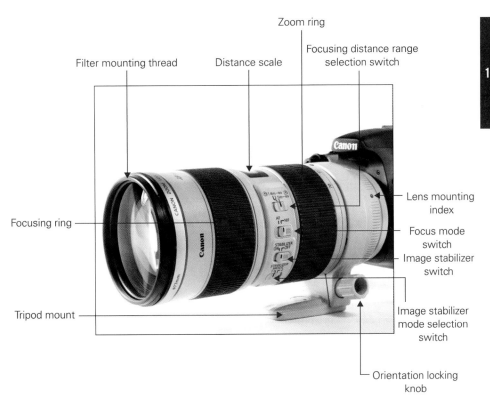

Zoom ring

Focusing distance range
selection switch

Filter mounting thread · · · · · · · · Distance scale

Lens mounting
index

Focusing ring ────

Focus mode
switch

Image stabilizer
switch

Tripod mount ────

Image stabilizer
mode selection
switch

Orientation locking
knob

1.8 The lens controls on the Canon EF 70-200mm f/2.8L IS USM.

Depending on the lens, additional lens controls may include the following:

▶ **Lens mounting index.** For Canon EF lenses, the index mark on the lens is red. For EF-S lenses, the index mark is white. Just match it up with the mark on the 70D's lens mount to attach the lens to the camera. All lenses have a lens mounting index mark.

▶ **Zoom ring.** Turning this ring zooms the lens to the focal length marked on the ring. On some older lenses, such as the EF 100-400mm f/4.5-5.6L IS USM lens, zooming is accomplished by first releasing a zoom ring, and then pushing or pulling the lens to zoom out or in.

▶ **Focusing distance range selection switch.** This switch is offered on some lenses, and it limits the range that the lens uses when seeking focus. For example, if you choose the 2.5m-to-infinity focusing distance option on the EF 70-200mm

f/2.8L IS USM lens, then the lens does not seek focus at 2.5m and closer, and this speeds up autofocus. The focusing distance range options vary by lens.

▶ **Distance scale.** The distance scale shows the lens's minimum focusing distance through infinity. The scale includes an infinity compensation mark that can be used to compensate for shifting the infinity focus point that results from temperature changes.

▶ **Focusing ring.** Turning the focusing ring enables you to bring the subject into sharp focus when the lens is set to Manual focus (**MF**). Or in Autofocus mode (**AF**), you can turn the focusing ring to tweak the focus. Not all lenses offer manual focusing.

▶ **Focus mode switch.** Choose Manual focus (**MF**) or Autofocus (**AF**).

▶ **Image stabilizer switch.** This switch turns on or off optical Image Stabilization. Optical Image Stabilization (IS) corrects vibrations from handholding the camera. Corrections are made at any angle or at only right angles.

▶ **Image stabilizer mode selection switch.** On some telephoto lenses, this switch enables Image Stabilization for standard shooting and stabilization when you are panning with the subject movement at right angles to the camera.

Camera Menus and Displays

Many of the settings you use often are on the camera body, but the camera menus and displays also offer a wealth of additional controls and adjustments. The 70D offers 17 menus when the Mode dial is set to one of the Creative Zone exposure modes, such as the Program (**P**), Shutter-priority AE (**Tv**), or Aperture-priority AE (**Av**) modes.

In Basic Zone modes, such as Scene Intelligent Auto (▣) and Creative Auto (CA), fewer menus are available. Also, the two Movie menus are available only when you switch to Movie mode ('🎥). In addition, you can quickly verify camera settings using several displays, whether you're shooting with the viewfinder or with the LCD in Live View mode (📷).

The viewfinder display

Along with a 98 percent view of the scene, the eye-level pentaprism viewfinder also displays the 19 AF points for viewfinder shooting and the Quick focus (AFQuick) method in Live View mode (📷), as well as the current exposure and camera settings.

Looking through the viewfinder during shooting allows you to verify whether camera settings are as you want or if they need to be changed. In addition, you are alerted when any exposure element you have chosen is beyond the exposure capability of the light in the scene. The diagram in Figure 1.9 shows the viewfinder information.

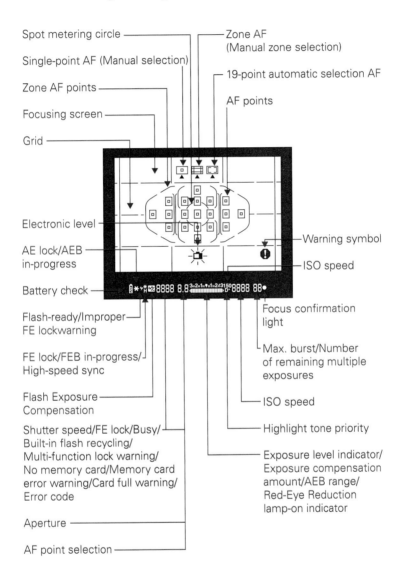

1.9 The viewfinder display.

The Quick Control screen

The Quick Control screen is one of the handiest ways to quickly see and change camera and exposure settings with minimum effort. You can use this screen to bypass the camera menus in many cases to adjust key camera settings.

To access the Quick Control screen, just press the Quick Control button (Q). Then, press a direction key on the Multi-controller (⬡) to select a setting you want to change. Turn the Quick Control dial (○) to make the change, or press the Setting button (SET) to display the settings screen, in which you can choose the setting you want.

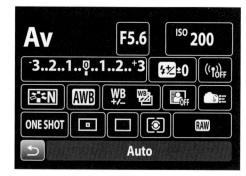

1.10 The Quick Control screen.

The camera menus

The 70D offers 17 menus categorized as Shooting (📷), Live View (📹), Playback (▶), Setup (🔧), Custom Functions (⚙), My Menu (★), and Movie (🎬). Just press the Menu button (**MENU**) to open the camera menus. The menus and options change, based on the shooting mode you select. In the automatic Basic Zone modes, the menus are abbreviated, and you can make only limited changes to the exposure and camera settings.

However, in the Creative Zone modes, such as Program AE (**P**) and Shutter-priority AE (**Tv**), all the menus are available. Tables 1.1 through 1.17 show the camera menus and options displayed in the Creative Zone exposure modes.

Table 1.1 Shooting Menu 1

Commands	Options
Image quality	**RAW**, M **RAW**, S **RAW**, ▲L, ▲L, ▲M, ▲M, ▲S1, ▲S1, S2, S3 .
VF grid display	Disable, Enable (unavailable when shooting movies).
Viewfinder level	Hide, Show (unavailable in when shooting movies).
Beep	Enable, Touch to (◪), Disable.
Release shutter without a card	Enable, Disable.
Image review	Off, 2 sec., 4 sec., 8 sec., Hold.

Table 1.2 Shooting Menu 2

Commands	Options
Lens aberration correction	Peripheral illumination: Enable, Disable. Chromatic aberration: Enable, Disable.
Flash control	Flash firing, E-TTL II metering, Flash sync. speed in Av mode, Built-in flash settings, External flash function settings, External flash C.Fn setting, Clear settings. (unavailable in Movie mode)
Red-eye reduction	Disable, Enable. (unavailable in Movie mode)
Mirror lockup	Disable, Enable.

Table 1.3 Shooting Menu 3

Commands	Options
Expo. comp./AEB (changes to Exposure comp. during movie recording)	1/3-stop increments, up to +/- 5 stops of exposure compensation and up to +/- 3 stops of AEB.
ISO speed settings	ISO speed, ISO speed range, Auto ISO range, Min. shutter spd.
Auto Lighting Optimizer	Disable, Low, Standard, High. OFF with **M** or **B**.
White Balance	**AWB**, ☀, ☎, ☁, ☀, ☀, ⚡, ◣, **K** (Color Temperature 2500 to 10000 K).
Custom White Balance	Set a manual White Balance.
WB Shift/Bkt.	White Balance correction using Blue/Amber (B/A) or Magenta/Green (M/G) color bias of +/- 9 levels; White Balance Bracketing using B/A and M/G bias of +/- 3 levels.
Color space	sRGB, Adobe RGB.

Table 1.4 Shooting Menu 4

Commands	Options
Picture Style	Auto (⬛A), Standard (⬛S), Portrait (⬛P), Landscape (⬛L), Neutral (⬛N), Faithful (⬛F), Monochrome (⬛M), User Def. 1-3 (⬛1), (⬛2), (⬛3).
Long exp. noise reduction	Disable, Auto, Enable.
High ISO speed NR (Noise Reduction)	Disable, Low, Standard, High, Multi Shot Noise Reduction.
Highlight tone priority	Disable, Enable (**D+**).
Dust Delete Data	Locates and records dust on the image sensor so you can use the data in the Canon Digital Photo Professional program to erase dust spots on images.
Multiple exposure	Multiple exposure, Multi-expos control, No. of exposures, Continue Multiple exposure (unavailable when shooting movies).
HDR Mode	Adjust dynamic range, Continuous HDR, Auto Image Align (unavailable when shooting movies).

Table 1.5 Live View Shooting Menu 1

Commands	Options
Live View shooting	Enable, Disable.
AF method	Face + Tracking (⬛), FlexiZone - Multi (⬛), FlexiZone - Single (⬛), Quick mode.
Continuous AF	Enable, Disable.
Touch Shutter	Enable, Disable.
Grid display	Off, 3×3, 6×4, 3×3+diag (diagonal X-shaped lines).
Aspect ratio	3:2, 4:3, 16:9, 1:1.
Expo. simulation	Enable, During ⬛, Disable.

Table 1.6 Live View Shooting Menu 2

Commands	Options
Silent LV shooting	Mode 1, Mode 2, Disable.
Metering timer	4 sec., 16 sec., 30 sec., 1 min., 10 min., 30 min.

Table 1.7 Playback Menu 1

Commands	Options
Protect images	Select images, All images in folder, Unprotect all images in folder, All images on card, Unprotect all images on card.
Rotate image	Rotate the selected vertical image.
Erase images	Select and erase images, All images in folder, or All images on card.
Print order	Select images to be printed (Digital Print Order Format, or DPOF).
Photobook set-up	Specify images for a photobook. Select images, All images in folder, Clear all in folder, All images on card, Clear all on card.
Creative filters	Grainy B/W (▣), Soft focus (▣), Fish-eye effect (▣), Art bold effect (▣), Water painting effect (▣), Toy camera effect (▣), Miniature effect (▣).
RAW image processing	Select and process RAW images.

Table 1.8 Playback Menu 2

Commands	Options
Resize	Select image and downsize it to one of the next smaller sizes.
Rating	OFF, choose a one- to five-star rating.
Slide show	Set up: Display time, Repeat Transition effect, Background music.
Image jump w/☼	Move through images by: 1, 10, 100 (images at a time), Date, Folder, Movies, Stills, Rating.

Table 1.9 Playback Menu 3

Commands	Options
Highlight alert	Disable, Enable.
AF point display	Disable, Enable.
Playback grid	Off, 3×3, 6×4, 3×3+diag (diagonal X-shaped lines).
Histogram disp.	Brightness, RGB.
Movie play count	Rec time, Time code.
Ctrl over HDMI	Disable, Enable.

Table 1.10 Setup Menu 1

Commands	Options
Select folder	Create a new or select an existing folder.
File numbering	Continuous, Auto reset, Manual reset.
Auto rotate	On camera and computer, On computer, Off.
Format card	Initializes the SD card and erases all data.
Eye-Fi settings	Option available when an Eye-Fi card is in the SD card slot. Displays options to set up file transmission.

Table 1.11 Setup Menu 2

Commands	Options
Auto power off	1, 2, 4, 8, 15, 30 min., Disable.
LCD brightness	Seven adjustable levels of brightness.
LCD off/on btn (unavailable in Movie mode).	Remains on, Shutter btn.
Date/Time/Zone	Set the date (year/month/day) and time (hour/minute/second).
Language	Select the language for the camera user interface.
GPS device settings	Select settings if and when an accessory GPS Receiver GP-E2 is attached to the camera.

Table 1.12 Setup Menu 3

Commands	Options
Video system	NTSC, PAL.
Feature guide	Enable, Disable.
Touch control	Standard, Sensitive, Disable.
INFO. button display options	Displays camera settings, Electronic level, Displays shooting functions. (Choose one, two, or all options.)
Wi-Fi	Disable, Enable.
Wi-Fi function	Transfer imgs between cameras, Connect to smartphone, Remote control (EOS Utility), Print from Wi-Fi printer, Upload to Web service, View images on DLNA devices.

Table 1.13 Setup Menu 4

Commands	Options
Sensor cleaning	Auto cleaning (Enable, Disable), Clean now, Clean manually.
Battery info.	Shows: Remaining cap, Shutter count, Recharge performance, Press the Info. button (**INFO.**) to access Battery registration or Delete info.
Certification Logo Display	Displays some of the logos of the camera's certifications.
Custom shooting mode	Register the camera settings as the settings to use for the Custom shooting mode (**C**), Clear settings, Auto update set.
Clear all camera settings	Press the Setting button, and then choose OK to restore the manufacturer's default settings, or choose Cancel.
Copyright information	Display copyright info, Enter author's name, Enter copyright details, Delete copyright information.
Firmware ver. (Firmware version number)	Select when you want to update the camera's firmware after you've copied the firmware to the media card.

Table 1.14 Custom Functions Menu

Commands	Options
C.Fn I: Exposure	Exposure level increments, ISO speed setting increments, Bracketing auto cancel, Bracketing sequence, Number of bracketed shots, Safety shift.
C.Fn II: Autofocus	Tracking sensitivity, Accel./decel. tracking, AI Servo 1st image priority, AI Servo 2nd image priority, AF-assist beam firing, Lens drive when AF impossible, Select AF area selec. mode, AF area selection method, Orientation linked AF point, Manual AF pt. selec. pattern, AF point display during focus, VF (Viewfinder) display illumination, AF Microadjustment.
C.Fn III: Operation/ Others	Dial direction during Tv/Av, Multi function lock, Warnings in viewfinder, Custom Controls.
Clear all Custom Func. (C. Fn)	Restores all Custom Function options to the factory default settings.

Table 1.15 My Menu

Opening My Menu	Options
Choose My Menu settings, and then press ⊛ to display the options.	Register to My Menu, Sort, Delete item/items, Delete all items, Display from My Menu.

Table 1.16 Movie Shooting Menu 1

Commands	Options
AF method	Face+Tracking (⬛), FlexiZone-Multi (⬛), Flexi-Zone-Single AF (⬛).
Movie Servo AF	Enable, Disable.
Silent LV shoot.	Mode 1, Mode 2, Disable.
Metering timer	4, 16, 30 sec., 1, 10, 30 min.

Table 1.17 Movie Shooting Menu 2

Commands	Options
Grid display	Off, 3 × 3, 6 × 4, 3 × 3 + diag (diagonal, X-shaped lines).
Movie rec. size	1920 × 1080 with options for 30, 25, or 24 fps, using either All-I or IPB compression; 1280 × 720 with the option for 60 or 50 fps using either All-I or IPB compression; 640 × 480 at 30 or 25 fps using IPB compression.
Digital zoom	Disable, Zoom to approximately 3 to 10x.
Sound recording	Basic Zone modes: On. Off. Sound recording: Auto, Manual, Disable. Recording level: Wind filter (Disable, Enable), Attenuator (Disable, Enable).
Time code	Count up (Rec run or Free run), Start time setting (Manual input setting, Reset, Set to camera time), Movie rec count (Rec time or Time code), Movie play count (Rec time or Time code), Drop frame (Enable, Disable).
Video snapshot	Video snapshot: Enable, Disable. Album settings: Create new album, Add to existing album.

My Favorite Menu Features

The camera menus are rich with features that you may overlook initially. Here are a few features that are very helpful for everyday shooting:

▶ **VF grid display (Shooting menu 1 ○).** If you turn on the grid display, a tick-tack-toe-like grid is overlaid on the viewfinder. You can use the grid to square up vertical and horizontal lines in the scene. It's also a nice guide if you often use the Rule of Thirds for composing images.

▶ **Highlight tone priority (Shooting menu 4 ○).** This feature helps maintain highlight details. I leave it enabled for 95 percent of my shooting.

▶ **Highlight alert (Playback menu 3 ▶).** Turning on this option shows blown highlights as blinking areas. If you see the blinking areas, you can apply some exposure compensation or otherwise reduce the exposure to preserve highlight detail in critical areas of the scene. There are, of course, times when it's better to use HDR mode (**HDR**) to capture the full dynamic range in the scene.

▶ **AF point display (Playback menu 3 ▶).** I like this feature because it shows me at a glance where the sharp focus was set in the image. Then, I can magnify the image on the LCD screen and verify that the focus is tack sharp.

Camera Setup and Image Playback

Among the first things I do when I get a new camera is go through the menus, and set up the camera for shooting. Setup takes only a few minutes, and it saves a lot of time during shooting to have the settings the way you like them. This chapter explains setup options ranging from setting the image quality and customizing file numbering, to transmitting images wirelessly. In this chapter, I also cover how to add your copyright to image data, register the camera battery, and different ways to play back images.

Also, be sure to read Chapter 6 for additional ways to customize the camera using Custom Functions. Setting up for Live View (◻) and Movie ('🎥) modes are detailed in Chapters 7 and 8, respectively.

A bee takes advantage of late summer flowers. Exposure: ISO 200, f/5.0, 1/800 second.

SD Cards

The 70D is compatible with all types of Secure Digital (SD) memory cards. Also, the camera complies with the Ultra-High Speed-I (UHS) standard, so you can use new UHS SDHC/SDXC cards for fast performance and high capacity. There are many different types of cards, and the type you choose may depend in part on whether you shoot movies or still images. This section helps you decide on the type of SD card to buy.

The names of SD cards indicate their maximum capacity. For example, an SD card has up to a 2GB capacity, although lower capacities are also available. An SD High Capacity (HC) card ranges from 4 to 32GB, and an SD Extended Capacity (SDXC) card ranges from 32GB to a whopping 2 terabytes (TB). If you shoot primarily still images with the 70D, then an SDHC or SDXC card up to 32GB is sufficient for most shooting. I use a midrange-capacity card to keep from putting too many images on a single card — going back to the wise adage of not keeping all your eggs in one basket.

NOTE In this book, *SD card* is used as a general term to refer to all types of SD cards.

In addition to capacity, you have also have to consider the card speed. If you use the 70D primarily for still-image recording, then with the 70D's high 20-megapixel resolution, a faster card will not slow you down especially when shooting a large burst of images.

If you're using the 70D to record movies, then card speed is a compelling consideration because it helps ensure a constant minimum write speed for video so that the movies play back smoothly. The card speed depends on the movie compression method you choose. Compression methods are covered in Chapter 8, but in short, the IPB method offers higher compression, and thus, a smaller file size. If

Lock switch

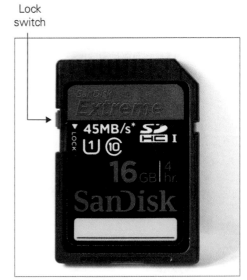

2.1 Be sure the lock switch on the memory card is set to the up position so that images can be written to and erased from it.

you shoot movies with the IPB method, then a 6 MB/second or faster card will ensure that they are recorded properly. If you choose the ALL-I lower-compression method, then you need a 20 MB/second or faster card.

As you shop for SD cards, it pays to know that the card speeds vary by manufacturer, so check reviews for real-life data on a specific card and its advertised speed. Currently, the SDXC UHS-I and SDHC UHS-I are at the top end of the scale.

NOTE Be sure to go to Shooting menu 1 (**⌖**), highlight Release shutter without card, and then select Disable. This prevents you from taking pictures with no SD card in the camera.

Selecting Image Quality and Processing In-Camera

Many considerations factor into the image type and quality settings you choose. If you like to have ready-to-print images straight out of the camera, and if you want to maximize the number of images you can get on the SD card, then shooting JPEG images will meet your needs. However, if you want control over the image appearance and you want to get the maximum image quality, then shooting RAW images is the best option.

Of course, there are times when you need to switch between file types and image resolution. For example, when I shoot weddings, I choose full-resolution RAW format for the portraits and the images during the ceremony. However, for the reception, I change the image quality to medium JPEG because these images are seldom printed larger than 5 × 7 inches. Your needs may be different, so consider how you can use the options to suit your workflow and give you the best quality prints at the size you need. The next sections detail the advantages and disadvantages of each option to help you decide what works best for you.

JPEGs

JPEG is the default file format on the 70D, and it is a commonly used format for images on the web and some commercial printing services. JPEG offers efficient, high-quality file compression that saves space on an SD card. It also offers quick

display of image files on the camera's LCD monitor and on the computer. Unlike RAW files, JPEG files can be displayed without special viewing programs or preprocessing, making image files compatible across computer platforms for easy viewing.

JPEG is the image-quality option to choose when you want to get the maximum burst rate from the camera for sports and action shooting. For example, when you shoot the highest-quality JPEG images, the burst rate is 65 shots at 7 frames per second (fps) with a UHS-I card. With non-UHS-I cards, the maximum burst is 40. By comparison, the maximum burst rate with full-resolution RAW files is approximately 16 shots with a UHS-I card. (If you're shooting RAW+JPEG, the burst rate is 8 shots.)

The 70D offers three JPEG compression levels: Large, Medium, and Small each with a compression level of fine or normal. The image recording size changes accordingly with three image-recording sizes: 20, 8.9, or 5.0 megapixels. There are also Small 2 (**S2**, 2.5 megapixels) and Small 3 (⬛, 0.3 megapixels) sizes intended for use in digital photo frames, web display, and e-mail messages. Of course, the higher the compression and the smaller the image size, the more images that can be captured in a continuous shooting burst, and the more images will fit on a SD card. The trade-off with high compression and low image size is that image quality suffers proportionally and noticeably.

Despite the small size and portability of JPEG files, there are disadvantages. JPEG is known as a *lossy* file format because it discards some image data to reduce the file size. The higher the compression level, the more image data is discarded, and the smaller the image file size. Conversely, the lower the compression level, the less data discarded and the larger the file size. While data loss isn't ideal, the amount of data lost at a low compression level is typically not noticeable in prints.

> **TIP** If you edit JPEG images on the computer and continue to save them as JPEGs, data loss continues to occur. To preserve image data during editing, be sure to save JPEG images as TIFFs or in another lossless file format before you begin editing.

Also, when you shoot JPEG images, the 70D processes or edits the images in the camera before storing them on the media card. This image processing determines the color rendering, contrast, and sharpness, and it applies any automatic exposure adjustments you've chosen, so you get a finished, printable file. You can then use the image as is, or you can edit it on the computer. While you can't control the in-camera image

processing, you have some control by choosing one of the seven Picture Styles. Each style has unique settings for sharpness, contrast, saturation, and color tone, and you can modify those settings.

CROSS REF Picture Styles and color spaces are described in Chapter 5.

Another aspect to consider with JPEG capture is the data lost when the camera converts the image bit depth. Every 70D image is captured as a 14-bit file that delivers 16,384 colors in each of the three color channels: Red, Green, and Blue. However, the JPEG file format doesn't support 14-bit files, so the 70D automatically converts JPEG images to 8-bit files with only 256 colors per channel. While the conversion from 14- to 8-bit is done judiciously using internal camera algorithms, the fact remains that much of the image color information is discarded in the process.

Combine this data loss with the automatic in-camera processing and JPEG compression, and you get a file that has one-third or more of the image data discarded before it's written to the media card. Certainly, the JPEG image files are smaller, but with the data loss, the files are not as rich as RAW files, and they offer less latitude and stability when you edit them on the computer. Depending on the output, the data loss may not be problematic. However, for files destined for maximum printing size, RAW offers a much richer file.

NOTE The Small 2 (**S2**) and Small 3 (**S3**) JPEG options produce images at a diminutive 3.5 × 5.1 inches, a size that fits a digital photo frame. If you shoot only JPEGs, I don't recommend choosing these small sizes. However, if you shoot RAW, adding a small JPEG file is a convenient way to have a file small enough to e-mail, post online, or use in a digital photo frame right out of the camera.

RAW files

When you want to get the highest image quality that the 70D can deliver, then your best option is to set the image quality to RAW (**RAW**). RAW files are captured and stored on the media card with little in-camera processing and images suffer no loss of data from compression. Unlike JPEG files, RAW files are not converted in the camera to 8-bit, but rather they are captured and stored as 14-bit images. The only settings the camera applies to RAW images are the aperture, ISO, and shutter speed. Other settings

such as Picture Style and white balance are noted in the file, but they are not applied unless you process the images in Canon Digital Photo Professional (DPP), a program included on the CD that comes with the camera.

In Figure 2.2, the inset histograms show the image as an 8-bit JPEG file in the sRGB color space on the left. The histogram shows that there is clipping in the highlights. The histogram on the right is a 14-bit file in the Adobe RGB color space. The clipping doesn't occur with the greater bit depth and larger color space.

The big advantage of shooting RAW is that you can adjust key image settings such as white balance, brightness, contrast, and saturation after the image is captured. These adjustments are made during RAW image conversion.

2.2 A comparison of the image histogram with the image in the sRGB color space on the left and the Adobe RGB color space on the right. Exposure: ISO 400, f/5.0, 1/4000 second.

You convert RAW images using Canon Digital Photo Professional (DPP), Adobe Camera Raw (a plug-in for Adobe Photoshop), Adobe Lightroom, or Apple Aperture. During conversion, you can adjust the image color, brightness, tonal range, contrast, and color saturation to your liking. If you use Digital Photo Professional, you can also apply a Picture Style, Auto Lighting Optimizer (icon), lens correction settings, and other options with the same effect as applying them in the camera.

In addition, if images have blown highlights — areas where the highlights went to solid white with no image detail — you can often recover some or all of the detail in the blown highlights during conversion. If an image is underexposed, you can brighten it during conversion. All the adjustments made during RAW-image conversion are non-destructive, as if you made the adjustments in the camera.

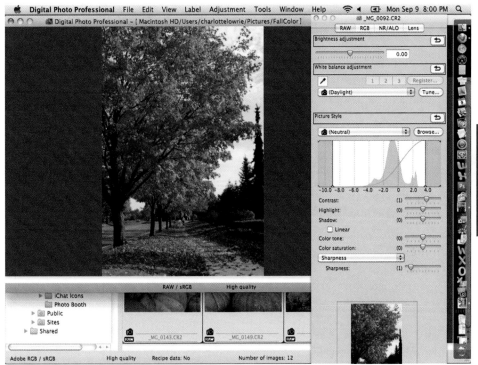

2.3 The Digital Photo Professional RAW editing window with the tool palette on the right.

With RAW files, you begin with a rich 14-bit file that you can save as a 16-bit file in a RAW conversion program. A 16-bit file can withstand image editing much better than an 8-bit JPEG file. Less-robust JPEG files can suffer *posterization,* or the loss of smooth gradation among tonal levels, including stretching tonal ranges and the loss of image detail from compressing tonal ranges during image editing.

Some people complain that the full-resolution RAW file at 24-plus MB takes up too much space on the memory card and on the computer. When compared to the Large/Fine JPEG that weighs in at approximately 6.6 MB, RAW files *are* hefty. If file size is a concern, but you still want the option to make key changes to images after shooting, then you can opt to use Canon's Medium (**M RAW**) or Small RAW (**S RAW**) image-recording

options, both of which offer the same advantages as full-size RAW files, but at a smaller image size. The 70D offers Medium RAW (**M RAW**) at 11 megapixels (19.3MB file), or Small RAW (**S RAW**) at 5.0 megapixels (13.31MB file).

RAW capture has drawbacks, however. RAW files lack the portability of JPEG files. You cannot edit RAW files unless you've installed Digital Photo Professional or another RAW conversion program, such as Adobe Lightroom or Photoshop's Camera Raw plugin. RAW files also add steps to the workflow because they must be converted and saved in another format, such as TIFF, PSD, DNG, or even JPEG. Finally, as previously noted, RAW image file sizes are considerably larger than JPEG images.

When you know the advantages and disadvantages of JPEG and RAW capture, you are in a better position to choose when and whether you want to shoot JPEG or RAW images for various shooting scenarios. Table 2.1 later in this chapter details the options that you can select on the 70D and their effect on the burst rate during continuous shooting.

RAW+JPEG

Another image quality option is to shoot both RAW and JPEG files. The advantage of RAW+JPEG capture is having a pre-edited JPEG file that you can print directly from the SD card or quickly post online for client viewing. You also have a RAW file, either full size or smaller, that you can later convert and edit.

Of course, RAW+JPEG fills up media cards much faster. For example, on an 8GB card, you can store approximately 200 full-size RAW and Large Fine JPEG (**◢L**) images; whereas if you shoot only Large Fine JPEGs (**◢L**), you can store approximately 1,000 images on the card.

When you capture both JPEG and RAW, the images are saved with the same file number in the same folder. They are distinguished by the file extensions of .jpg for the JPEG image and .CR2 for RAW (**RAW**), Medium RAW (**M RAW**), or Small RAW (**S RAW**).

RAW+JPEG capture also slows down the continuous high-speed shooting burst rate, as shown in Table 2.1. Estimates in Table 2.1 are approximate, and vary according to image factors, including ISO, Picture Style, and Custom Function settings, as well as card brand, type, and speed.

Table 2.1 Image Quality, Size Options, and Burst Rates

Image quality		Approx. size in megapixels	File size (MB)	Maximum burst rate (UHS-I card)
JPEG	▲ L	20	6.6	40 (65)
	◢ L		3.5	130 (1920)
	▲ M	8.9	3.6	100 (1840)
	◢ M		1.8	3410 (3410)
	▲ S1	5.0	2.3	430 (2790)
	◢ S1		1.2	5200 (5200)
	S2	2.5	1.3	4990 (4990)
	S3	0.3	0.3	19380 (19380)
RAW	RAW	20	24	15 (16)
	M RAW	11	19.3	9 (10)
	S RAW	5	13.3	11 (13)
RAW + JPEG	RAW+▲ L	20 each	24 + 6.6 (30.6)	8 (8)
	M RAW+▲ L	11 and 20	19.3 + 6.6 (25.9)	8 (8)
	S RAW+▲ L	5 and 20	13.3 + 6.6 (19.9)	8 (8)

To set the image format and quality, follow these steps:

1. **On Shooting menu 1 (📷), high-light Image quality, and then press the Setting button (⊛).** The Image quality screen appears.

2. **Turn the Main dial (⚙) to highlight the RAW option you want.** If you don't want to capture RAW images, then select the minus sign.

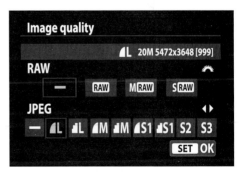

2.4 The Image quality screen enables you to select RAW file options using the Main dial, and JPEG options using the Quick Control dial.

3. **Turn the Quick Control dial (○) to highlight the JPEG option you want, and then press the Setting button (⊛).** If you don't want to capture JPEG images, select the minus sign.

To capture RAW+JPEG, choose a JPEG and RAW option in steps 2 and 3, respectively.

Processing RAW images in-camera

While shooting only RAW images is a fine option, what happens if you need a JPEG version of a RAW file while you're in the field to transmit to a website or to an agency? That's not a problem because the 70D enables you to process a full-size RAW file in the camera and save it as a JPEG. And if you want, you can process and save multiple JPEG files from a RAW file. While you don't have as much control over RAW conversion in-camera as you do on a computer, this option is handy when shooting only full-resolution RAW images that you need to print directly from the SD card — something you can't do with RAW files. It's also ideal when you want to post an image on the web or send it in an e-mail.

> **NOTE** Only full-size RAW files can be processed in-camera. Small (S RAW) and Medium RAW (M RAW) files can only be converted in Digital Photo Professional or another conversion program. Also, in-camera RAW processing can be used only when the camera is in a Creative Zone mode, such as Shutter-priority AE (**Tv**) or Aperture-priority AE (**Av**).

If you choose in-camera RAW conversion, you process the RAW file in the camera and save it as a JPEG. The original RAW image is also retained unaltered on the media card so you can convert it later. There is a good range of adjustments for RAW conversion in the camera. If the image was shot in Live View mode (◻) with an aspect ratio of 4:3, 16:9, or 1:1, the image is displayed with that aspect ratio.

In most cases, you can see the effect of the adjustments you make on the image preview. To verify the effect of subtle changes, press the Magnify button (🔍), and then press the Multi-controller (⋮) to move around the image to check the changes. Here are the adjustments you can make when processing a RAW file to a JPEG in the 70D:

▶ **Brightness (⊞).** Use this adjustment to brighten or darken the image 1/3-stop at a time up to plus or minus 1 stop. You can preview the brightness adjustments you make on the LCD screen.

▸ **White balance (AWB).** You can change the White balance option or choose the Color temp. option (**K**). If you choose the Color temp. (**K**) option, press the Info. button (**INFO.**), turn the Main dial (🎛) to set the color temperature, and then press the Setting button (⊛).

▸ **Picture Style (𝒂⁚ⁿ).** Use this option to change the Picture Style and to change the parame-

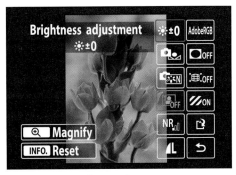

2.5 The processing options.

ters for the style. Turn the Quick Control dial (○) to choose a style. To change a style's parameters, highlight the Picture Style icon (𝒂⁚ⁿ), press the Setting button (⊛), and then press the Info. button (**INFO.**). Press up or down on the Multi-controller to select a parameter, and then press left or right on the Multi-controller (⁚⁚) to change the setting. The parameters are Sharpness, Contrast, Saturation, and Color tone. Press the Setting button (⊛) twice to exit the screen.

▸ **Auto Lighting Optimizer (🖼).** Adjust this setting to change the brightness and contrast of the image automatically. Three levels are available, as well as an Off option. If you have Highlight tone priority (**D+**) enabled on Shooting menu 3 (📷), then Auto Lighting Optimizer (🖼) can't be adjusted.

▸ **High ISO speed noise reduction (NR).** You can choose to apply a Low, Standard, or High level of noise reduction to images shot at high ISO settings. Alternately, you can choose Disable/OFF to apply no noise reduction at high ISO speed settings.

▸ **Image quality (◀L).** Use this option to set the image quality of the JPEG file that will be saved from the RAW image conversion.

▸ **Color space (AdobeRGB).** This option enables you to choose either the sRGB or Adobe RGB color space. If you choose Adobe RGB, the appearance of the image on the LCD screen does not change because the LCD screen isn't compatible with Adobe RGB; but the print reflects the color space you choose.

CROSS REF Color spaces are detailed in Chapter 5.

▸ **Peripheral illumination correction (○ON).** If you select the Enable option, then any darkening of the four corners, or *vignetting*, is corrected automatically. You can also use Digital Photo Professional to apply stronger vignetting correction when you edit the image on the computer.

▶ **Distortion correction (⬛).** This option corrects lens distortion, such as the barrel or pincushion distortion where the center of the image bows out or in, respectively, or other lens distortions that can happen with different lenses. If you correct the distortion, the edges of the image are cropped, making the image appear slightly larger, and making it a somewhat lower resolution due to the crop. The correction process can soften the image a bit, so you may then want to adjust the Picture Style (⬛) sharpness parameter before printing the image.

▶ **Chromatic aberration correction (⬛).** When this option is enabled, it corrects a lens phenomenon that bends different-colored light rays at different angles. This phenomenon causes unwanted color along the edges of elements in the image such as a purple or magenta fringe. To see the effect, press the Magnify button (⬛) to enlarge the image, and then look at the edge of an object, especially one that has high contrast, such as a tree limb against the sky. Press the Reduce button (⬛) on the back of the camera to zoom out when you finish.

> **TIP** If you don't like the adjustments, press the Info. button (**INFO.**) to return to the original image settings.

Before you begin, turn off Multiple exposure shooting mode (⬛), Wi-Fi on the Setup 3 menu (♥), and be sure the camera isn't connected to a computer. Then set the Mode dial to one of the Creative Zone modes such as Aperture-priority AE (**Av**) or Shutter-priority AE (**Tv**) mode.

To convert a RAW image to JPEG in-camera, follow these steps:

1. **Press the Playback button (⬛), and then turn the Quick Control dial to move to the RAW image you want to convert to JPEG.**

> **NOTE** To display images as an index, press the Index/Reduce button (⬛), and then turn the Main dial (⬛) to find the image you want.

2. **On Playback menu 1 (⬛), highlight RAW image processing, and then press the Setting button (⬛).** The camera displays the options for converting the image.

3. **Press the Setting button (⊜), press up, down, left, or right on the Multi-controller (⬩) to select an option you want to adjust, and then turn the Quick Control dial (◯) to adjust the setting.** You can also press the Setting button (⊜) to display a screen with all settings for the adjustment. Then, make the adjustment and press the Setting button (⊜).

4. **Select Save (◼), and then press the Setting button (⊜).** The Save as new file screen appears.

5. **Select OK twice.** With the first OK, a message appears giving you the folder and file number for the new image. A screen appears so you can convert another RAW image if you want.

Resizing JPEGs In-camera

If you need a smaller version of a JPEG image on the SD card, you can create it and size it to any of the next smaller JPEG image sizes. This is a convenient way to quickly create a file small enough to post on a website. When you resize a JPEG file, the camera creates a new, downsized JPEG file and saves the original JPEG file at its original size. You cannot resize Small 3 (◼) JPEGs or RAW files.

Be sure the Wi-Fi function is disabled, and then follow these steps to resize a JPEG:

1. **On Playback menu 2 (▶), highlight Resize, and then press the Setting button (⊜).** Only JPEG images are displayed on the LCD screen.

2. **Turn the Quick dial (◯) to move to the image you want to resize, and then press the Setting button (⊜).** Reduced file size options are displayed at the bottom of the LCD screen.

3. **Press left or right on the Multi-controller (⬩) to select the size you want, and then press the Setting button (⊜).** The Save as new file message appears.

4. **Select OK twice.** You can then choose another file to resize, or press the shutter button halfway to return to shooting.

Improving Image Quality

One of the main concerns in photography is getting the highest image quality that the camera can deliver. In addition to the factors that photographers consider first such as image resolution, exposure accuracy, level of fine detail, and tonal range and reproduction, there are other factors that influence the overall quality of the image. Those factors include the level of digital noise, the presence of color fringing or chromatic aberration, and lens vignetting that occurs from light falloff at the corners of the frame. With the 70D, you can deal with these quality issues directly in the camera.

Reducing digital noise in-camera

From the beginning of digital photography, noise has been an issue. *Digital noise* appears as unwanted multicolor pixels, particularly in the shadow areas, and as grain similar to film grain. Noise is always present in an electronic device that receives a signal. When you increase the ISO, the signal from the sensor is electronically amplified, and the amplification process creates its own electronic noise. Image data is also amplified. As you increase the signal-to-noise ratio (SNR) by cranking up the ISO, the noise also increases. Conversely, when the SNR is low, there is less noise.

Also, anything that heats up the image sensor also increases digital noise. For example, long exposures heat up the image sensor, thus producing digital noise. High ambient temperatures can also introduce digital noise. Another source of digital noise is underexposure that pushes the tonal range toward the shadows where digital noise is most prevalent.

As with other Canon EOS dSLRs, the 70D inherits the ability to reduce digital noise generated by both high ISO settings and long exposures. However, on the 70D, there is also a new Multi Shot Noise Reduction option (⬛ⁿᴿ) tucked into the High ISO speed noise reduction option on Shooting menu 4 (⬛). This approach to taming noise involves the camera making four images in quick succession, which are then aligned and merged to average out the noise. When all is said and done, you get a single JPEG that has higher quality (less noise) than a single image using the High level of noise reduction would have.

I try to balance low-light exposures to keep the ISO sensitivity and the exposure time as low as possible. For Figure 2.6, I set the ISO at 5000 after checking that the exposure time was a relatively fast 1/50 second. I used the Standard level for the High ISO speed Noise Reduction option, and the digital noise was very low.

For high ISO settings, you can choose one of these noise reduction options:

▶ **Off.** The camera performs some noise reduction on all images, not just high ISO images. With this option, no additional noise reduction is applied. Choose this option if you prefer to apply noise reduction during RAW image conversion or during image editing on the computer.

▶ **Low.** A minimum of noise reduction is applied to images. You may not see much difference between this option and Standard.

▶ **Standard.** This is the default setting that applies some color (chroma) and luminance noise reduction to images shot at all ISO sensitivity settings. If you use high ISO settings infrequently, this is a good option for everyday shooting in case you forget to set this option for the few times when you increase the ISO. This option is effective at moderately high ISO settings.

▶ **High.** More aggressive noise reduction is applied, and the loss of fine detail in the image may be noticeable. In addition, using this option can reduce the burst rate in Continuous drive modes (⊡).

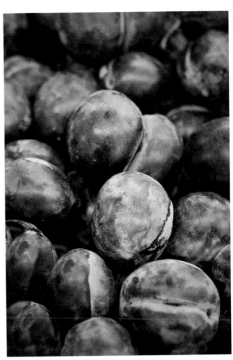

2.6 The Standard noise reduction level worked well for this image. Exposure: ISO 5000, f/4.0, 1/320 second.

▶ **Multi Shot Noise Reduction (⊞).** As mentioned previously, when you choose this option the camera takes four quick shots and merges them. Because digital noise is random, the camera can use the four shots to average out the noise in the final JPEG image it creates. In the right situations, this is a good choice because it minimizes noise without causing the smeared or watercolor look that high noise reduction settings can cause. Multi Shot Noise Reduction (⊞) isn't the solution for every situation because it requires a rock-steady camera and subject. However, it can be an excellent choice with a tripod and still subjects. Multi Shot Noise Reduction (⊞) does come with some caveats, however. It works only with JPEG capture, and cannot be used during movie recording, when in the Bulb exposure mode (**B**), or in Basic Zone camera modes, such as Portrait (♥) and Landscape (▲). Also, you can't use it with Long Exposure Noise Reduction, Multiple Exposure, and HDR mode (**HDR**) shooting. Multi Shot Noise Reduction (⊞) isn't a sticky setting. In other words, when you turn off the camera, it switches back to the default Standard setting. You can expect Multi Shot Noise Reduction (⊞) to take longer than single-shot noise reduction options, and the camera will display a Busy icon (**buSY**).

Likewise, if you use long exposures, you can apply noise reduction in the camera. You have the following three settings from which you can choose:

▶ **Off.** No noise reduction is performed. Use this setting if you want to apply noise reduction later during image conversion or editing, if necessary.

▶ **AUTO.** Noise reduction is applied for exposures of 1 second and longer if the camera detects noise. This is a good setting for everyday shooting. With this setting and the next setting, the noise reduction process takes as long as the original exposure. So, if the original exposure was 1 minute, then the noise reduction will take 1 minute as well. In a departure from previous cameras, you can continue shooting during the noise reduction process as long as you see the number 1 or a higher number as the maximum burst indicator in the viewfinder. Just be sure that you don't turn off the camera during the noise reduction process. Also, although you can continue shooting, the camera performance will be noticeably slower until the noise reduction process is finished.

▶ **ON.** The camera applies noise reduction for 1-second and longer exposures. This setting can reduce noise that isn't detected with the Auto setting. In Live View shooting mode (🎥), the LCD screen displays a Busy icon (**buSY**), and you can't continue shooting until noise reduction is finished. Images shot at ISO 1600 and higher may have more grain with this setting than with the other two.

The steps for setting noise reduction for high ISO settings and long exposures are similar, so I've combined them in the following steps:

1. **On Shooting menu 4 (📷), highlight either Long exp. noise reduction or High ISO speed NR, and then press the Setting button (⊛).** The Long exp. noise reduction or High ISO speed NR screen appears. If you can't select Multi Shot Noise Reduction (📷), check to see if the recording quality is set to RAW (**RAW**). If it is, then you need to choose a JPEG option instead.

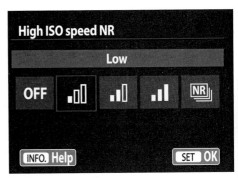

2.7 The High ISO speed noise reduction options.

2. **Turn the Quick dial (◌) to select the setting you want.**

3. **Press the Setting button (⊛).**

Correcting vignetting and color fringing

Characteristics of the lenses you use can also affect the overall image quality. Depending on the lens you use, you may notice some light falloff that creates darkening of the four corners of the frame. *Light falloff* describes the effect of less light reaching the corners of the frame as compared to the center of the frame, and that darkening effect is known as *vignetting*. Vignetting is most likely to happen with wide-angle lenses, when you shoot at a lens's maximum aperture, or when an obstruction such as the lens barrel rim or a filter reduces the light reaching the frame corners. Vignetting can be corrected by using the Lens Peripheral illumination correction option on the 70D.

You can correct vignetting for JPEG images in the camera. RAW images can be corrected during conversion in Digital Photo Professional, a RAW conversion program provided on the EOS Digital Solution Disk that comes with the 70D. Some photographers prefer not to correct vignetting. In fact, sometimes they add it because it directs the viewer's eye inward toward the subject, as shown in Figure 2.8.

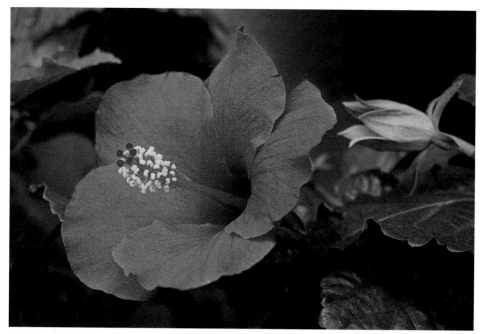

2.8 In this image, vignetting helps frame the subject. Exposure: ISO 100, f/5.6, 1/40 second.

You may want to test your lenses for vignetting before applying correction. To test the lens, photograph an evenly lit white subject, such as a white paper background or wall, at the lens's maximum aperture and f/8.0, and then examine the images for dark corners. Then you can enable Lens Peripheral illumination correction, repeat the shot, and compare the results.

Because the 70D comes preloaded with lens correction information for approximately 25 lenses, enabling the options for Lens Peripheral illumination correction and Chromatic Aberration Correction will automatically apply the corrections if you're using one of the registered lenses. You can also add correction settings for lenses that are not preregistered by registering them using the EOS Utility, a program included on the EOS Digital Solution Disk that comes with the camera. In any case, the correction data for the lens you're using has to be registered with the camera for the correction to have any effect.

If you use Lens Peripheral illumination correction for JPEG images, the amount of correction applied is just shy of the maximum amount. If you shoot RAW images, you can apply the maximum correction in Digital Photo Professional (DPP). Also, the amount of

correction for JPEG images decreases as the ISO sensitivity setting increases. If the lens has little vignetting, the difference in using Peripheral illumination correction may be difficult to detect. If the lens does not communicate distance information to the camera, then less correction is applied.

> **NOTE** For non-Canon lenses, disable both the Peripheral illumination correction and Chromatic Aberration Correction options, even if the lens appears to have correction information.

You can also correct for color fringing, which is also called *chromatic aberration*. The aberration appears as a red/cyan or blue/yellow fringe or outline around high-contrast edges within the image. Fringing is only one of several types of chromatic aberration.

When using these corrections, they are applied when images are taken and cannot be applied to images you've already shot. If you're shooting in Live View mode (◻) with the corrections and magnified view, you won't be able to see the corrections on the image on the LCD screen. However, the corrections will be applied to the final image. Also, if you're using a Canon lens that doesn't transmit distance information to the camera, then the correction amount will be lower than for lenses that supply the information.

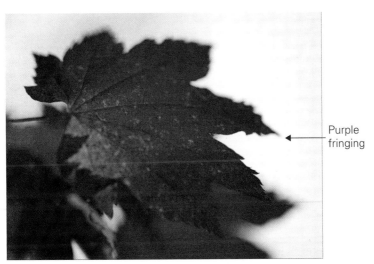

Purple
fringing

2.9 Purple fringing is most often seen along high-contrast edges, as shown here. Exposure: ISO 200, f/2.8, 1/500 second.

Both Peripheral illumination correction and/or Chromatic Aberration Correction are turned on by default. However, if you want to see if correction data is available for the lens you're using, or if you want to turn off either option, follow these steps:

1. **On Shooting menu 2 (📷), highlight Lens aberration correction, and then press the Setting button (⑯).** The Lens aberration correction screen appears showing the lens currently mounted to the 70D, and whether correction data is available. If correction data is not available, there is no need to continue with the remaining steps until you register the lens using the EOS Utility.

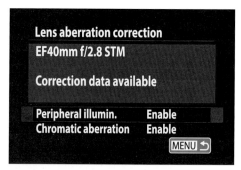

2.10 The Lens aberration correction options set to Enable.

2. **Select Peripheral illumin., and then press the Setting button (⑯).** The Enable and Disable options appear.

3. **If you want to turn off the correction, select Disable.** If you've turned it off previously and want to use it again, select Enable, and then press the Setting button (⑯).

4. **Select Chromatic aberration, and then press the Setting button (⑯).** The Enable and Disable options appear.

5. **If you want to turn off the correction, select Disable.** If you've turned it off previously and want to use it again, select Enable to correct chromatic aberration, and then press the Setting button (⑯). If you're shooting RAW with chromatic aberration correction in effect, then the correction may not be apparent when you play back the image. For the most effective view of the correction, view the image in Digital Photo Professional.

Working with Folders and Files

In addition to the default folder that the 70D creates automatically, you have the option to create additional folders to organize images on the SD card. Creating additional folders is a handy way to keep images from two or more shooting sessions separate.

Also, by default, the 70D names image files, but you can determine how the file number is used. Setting up folders and file numbering options helps make your workflow as efficient as possible.

Creating and selecting folders

Those who like to keep their pictures organized on SD cards will welcome the generous folder creation option on the 70D. You can create as many as 999 folders on the SD card, and each folder can store up to 9,999 images.

> **NOTE** When image 9,999 is recorded within a folder on the SD card, the camera displays an error message, and you cannot continue shooting until you replace the card, regardless of whether the card contains additional free space. This may sound innocuous, but it can cause missed shots. If the camera stops shooting unexpectedly, try replacing the SD card.

New folders must be created within the main folder, and folders can be created either in the camera or on the computer. Here are the folder guidelines for either option:

▶ **Creating folders in-camera.** Folders created in the camera are numbered sequentially starting from the folder that the camera automatically creates, 100CANON. If you create a new folder, the next folder is incremented by one, for example, 101CANON. When you create folders in the camera, the folder naming structure is preset and cannot be changed. If you insert an SD card from another Canon EOS dSLR, the folder will keep its existing name until you format the media card in the 70D.

▶ **Creating folders on the computer.** You can also create folders on the memory card by opening it on the computer and creating a new folder named DCIM. Within the DCIM folder you can create additional folders and get more flexibility in folder naming. However, you must follow the camera's naming conventions. Each folder must begin with a unique three-digit number from 101 to 999. Then you can use a combination of up to five letters (upper- and/or lowercase) and an underscore to complete the folder name. No spaces are allowed in folder names and the same three-digit number can't be repeated. So, you can create a folder named 102CKL_D, but not one named 102SKL_D because the three digits are the same.

If you format the SD card, the folders you created either in-camera or on the computer are erased, along with all images. The only folder that isn't erased is the default

100CANON folder. Thus, you need to create new folders after you format the card. To create a new folder, follow these steps:

1. **On Setup menu 1 (�’), high-light Select folder, and then press the Setting button (⊛).** The Select folder screen appears.

2. **Select Create folder, and then press the Setting button (⊛).** The camera displays a confirmation message to create a folder with the next incremented number.

2.11 The Select folder screen.

3. **Select OK, and then press the Setting button (⊛).** The Select folder screen appears with the newly created folder selected.

To select a folder on the SD card, repeat step 1, and then choose the folder you want on the Select folder screen. This screen shows the number of images in each folder and previews the first image.

Choosing a file numbering option

There may be times when you want to change the camera's default file-naming sequence or reset it, and you have three options. This section looks at each option, and some of the shooting scenarios in which each could offer an advantage.

NOTE By default, image filenames are prepended with IMG for both JPEG and RAW files, and movie files begin with MIV. JPEG files have the .jpg extension, RAW files use a .CR2 extension, and movie files use .mov.

Continuous file numbering

Continuous file numbering is the default setting on the 70D, and every file is numbered sequentially beginning with 0001 through 9999. Image files are stored in the 100CANON folder located at the top level on the SD card.

With Continuous file numbering, the file numbering continues uninterrupted unless you insert a media card that has images stored on it. If the highest file number on the card is higher than the last image number used on the 70D, file numbering typically continues from the highest-numbered image on the media card. This numbering sequence continues even after you insert an empty, formatted SD card. For example, although I had taken only 300 images with the 70D, when I inserted an SD card from another Canon EOS camera, the next image file number on the 70D was 4521, the next higher number on the SD card. Likewise, if an SD card contains multiple folders with images in them, the numbering sequence begins with the highest-numbered existing image in the folder that is being used.

If you insert an SD card that has a file number lower than the last highest file number taken on the 70D (stored in the camera's internal memory), file numbering continues from the last highest file number recorded and stored in the 70D's internal memory. In short, the camera uses the last highest number from either the card or the number stored in memory. If you want to keep file numbering continuous for this camera, always insert a freshly formatted SD card. Continuous file numbering is the default option, and it works well for many photographers — myself included.

2.12 The File numbering options.

Auto reset

With this option, the file numbering resets when you insert a media card or create a new folder on a media card. When you use Auto reset, image file numbers are reset to begin at 0001 if the card is freshly formatted.

Auto reset is handy for keeping images organized by subject when photographing different subjects on the same day. For example, if I'm photographing a wedding and someone asks me to make a family portrait, then I create a separate folder on the media card and save the family portrait to the new folder while keeping the original folder for the wedding pictures. Because the file numbers reset in each folder, it's easy to check each folder to see how many images I've taken for each subject. Additionally, the images are presorted when it's time to download them to the computer.

However, the Auto reset option isn't as straightforward as it seems. If you insert an SD card with existing images stored on it, the camera uses the highest existing image number, and continues numbering from there. So, if you want Auto reset to reset to 0001, be sure to format the SD card in the camera before shooting. In short, it pays to start a shooting day with an adequate supply of freshly formatted SD cards, and not swap them between cameras.

Manual reset

If you choose the Manual reset option, the 70D automatically creates a new folder and begins numbering images at 0001. By its name, it seems that you could force file numbering to reset to 0001 for a fresh start. That does happen, if the default 100CANON folder is empty. However, if the 100CANON folder has images in it, when you choose Manual reset, the camera creates a new folder and starts image numbering at 0001 in that folder. That behavior is also true for media cards that have multiple folders with images in each folder.

When is Manual reset handy? I use it anytime I want to quickly create a new folder and begin shooting at image number 0001. Using the same example as previous, if I'm shooting a wedding and have a request for a guest's portrait, I can select Manual reset and know that the camera will automatically create a new folder for the portraits, and record them to the new folder. This saves me the step of creating the folder needed with Auto reset. Of course, I have to remember to switch back to the wedding folder when I finish the portraits.

After you choose Manual reset, the 70D returns to the File numbering option that was in effect before the numbering was manually reset, either Continuous or Auto reset. Also, the new folder created is the next sequential number from the existing highest folder number on the SD card.

To change File numbering, go to Setup menu 1 (🔧), select File numbering, and then press the Setting button (⊛). Select the option you want, and then press the Setting button (⊛) again.

Using Wi-Fi

The 70D's built-in wireless function is a welcome feature for many reasons, one of which is that you can wirelessly upload images to your iOS or Android smartphone,

tablet, computer, and websites via online storage services, such as Canon's Image Gateway. You can also print images by sending them from the SD card to a wireless-enabled printer. The 70D Wi-Fi function also supports transferring images between Wi-Fi-enabled Canon cameras — and that's not all.

With Canon's free EOS Remote app, you can also control the camera remotely with your smartphone or tablet. The live scene is streamed from the 70D to your smartphone or tablet, where you can change exposure settings, focus on the subject, and trip the shutter — all without touching the camera. And finally, you can use the wireless function to preview images on a Digital Living Network Alliance- (DLNA) enabled device such as a TV.

NOTE When using Wi-Fi, Movie mode ('🎥) is disabled, as well as use of the USB connection.

The 70D's built-in Wi-Fi:

▶ Supports IEEE 802.11 b/g/n standards.

▶ Has a range of approximately 98.4 feet.

▶ Has a transmission frequency of 2412 to 2462 MHz, with channels 1 to 11 supported.

▶ Supports Wi-Fi Protected Setup.

▶ Security supports authentication methods including Open system, Shared key, WPA-PSK, WPA2-PSK, and encryption (WEP, TKIP, and AKES).

With the Wi-Fi function on the camera, you can set up, name, and save three connection profiles although the 70D can be connected to only one device at a time. In addition, the 70D can serve as an access point for connecting your mobile devices to the camera's network. You can also have the 70D connect to an existing wireless network, such as the wireless network in your home or studio.

It is beyond the scope of this book to provide details on all of the functions of connecting to different types of wireless networks and configuring the settings, but the following sections will help get you started using Wi-Fi with your 70D. While the connection process may seem daunting at first, once you have successfully made one connection, the process for connecting to other devices is similar. In this section, I

detail the basic Wi-Fi setup on the camera, and then provide steps for connecting to a smartphone and the Canon Gateway website to upload images.

Getting started

A few settings on the camera prepare it for wireless use. These include enabling Wi-Fi, setting a nickname or ID, for the camera, and setting up Wi-Fi functions for each connection. Follow these steps to set up the general Wi-Fi settings:

1. **On Setup menu 3 (♥), select Wi-Fi, press the Setting button (⊛), select Enable, and then press the Setting button (⊛) again.** When Wi-Fi is enabled, Movie recording and USB connections are disabled automatically. If you cannot select the Wi-Fi option, make sure the camera is disconnected from printers, computers, GPS's, or any other device. Then, try this step again.

2. **On Setup menu 2 (♥), select Auto power off, and then press the Setting button (⊛).** Time options appear after which the camera turns off if it hasn't been used.

3. **Select a long delay before power off, and if you're transferring images, select Disable.** If the camera turns off, the Wi-Fi connection is lost, although it is restored automatically when you awaken the camera.

Every network requires that devices be identified. To identify the 70D on a network, you have to give it a nickname that is then used by devices that connect with the camera. Before you begin, make sure Wi-Fi is enabled on Setup menu 3 (♥). To register a nickname, follow these steps:

1. **On Setup menu 3 (♥), select Wi-Fi function, and then press the Setting button (⊛).** The Wi-Fi function screen appears with a message confirming that you want to register a nickname.

2. **Press the Setting button (⊛) to select OK.** A screen with a keyboard appears.

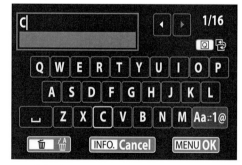

2.13 The keyboard screen.

3. **Press the Quick Control button (Ⓠ) to activate the keyboard, and then turn the Quick Control dial (◯) to select the first character (you can use up to 16) you want for the nickname.** You can use the direction keys on the Multi-controller (⬩) to select characters, or just touch the character on the screen.

4. **Press the Setting button (⑱) to enter the character.** Alternately, just touch the letter on the screen, and it is entered in the text box. If you make a mistake, press the Erase button (🗑).

> **NOTE** To enter lowercase characters and two sets of numbers and symbols, select the box at the far bottom right of the keyboard. Then, press the Setting button (⑱) one or more times to switch between input modes, or just touch the box one or more times.

5. **When you finish entering the nickname, press the Menu button (MENU), select OK, and then press the Setting button (⑱).** The Wi-Fi function screen appears. If you ever need to change the nickname, go to the Wi-Fi function screen, press the Info. button (**INFO.**), and then select Edit nickname on the General sett. screen.

> **TIP** To keep from disconnecting a Wi-Fi connection, don't use the shooting controls, such as the shutter or Playback (▶) buttons, or the Mode dial. Also, don't turn the LCD screen to face the camera.

Connecting to a smartphone

One of the handy functions that built-in wireless offers is the ability to connect the camera to your smartphone. When you do this, you can view pictures on the camera's SD card, transfer downsized pictures from the camera to the phone, and control the camera from your smartphone using Canon's free EOS Remote app.

It doesn't take long to figure out ways to use these new capabilities to your advantage. With remote control, you can place the camera in places and positions where you could not shoot with the viewfinder or in Live View mode (📷). As you decide where to place the camera, keep in mind that the maximum transmission range is 98.4 feet.

If you decide to change the exposure settings, the EOS Remote app enables you to set the aperture in Aperture-priority AE exposure mode (**Av**), the shutter speed in Shutter-priority AE exposure mode (**Tv**), and the aperture and shutter speed in Manual exposure mode (**M**). In all modes, you can change the ISO. In the Aperture-priority AE (**Av**) and Shutter-priority AE (**Tv**) modes, you can also set exposure compensation. Plus, you can move the AF point and focus remotely.

Make sure that both the phone or device and the camera have good battery charges before you begin the connection process. If you've enabled touchscreen functionality, you can simply touch the screen to select most of the options in these steps. Steps for connecting may differ depending on the model of your phone. To connect your smartphone to the 70D, follow these steps:

1. **Download the free Canon EOS Remote app onto your iOS or Android smartphone or tablet.** Before going to the next step, make sure that you know how to enable additional Wi-Fi connections on your device. For example, on the iPhone 5, enabling additional Wi-Fi networks is done using the Wi-Fi option on the Settings screen.

2. **Start the EOS Remote app, and then tap the icon in the upper left of the Home screen to open the Settings screen.** The Settings screen appears.

3. **For the Show AF button option, choose ON, and then tap the Home button in the upper-left corner of the screen.** Turning on the Show AF button option enables you to set the focus on the camera using the mobile device.

4. **On the 70D, go to Setup menu 3 (ᏕᏝ) and select Wi-Fi function.** The Wi-Fi function screen appears with options for wireless connections.

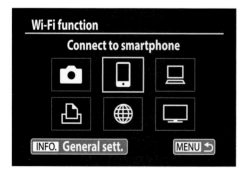

2.14 The Wi-Fi function screen with Connect to smartphone selected.

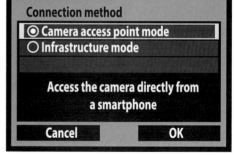

2.15 The Connection method screen.

5. **Turn the Quick Control dial (○) to select Connect to smartphone, and then press the Setting button (⊛).** The Connection method screen appears.

6. **Choose Camera as access point mode, and then choose OK.** The Network Settings screen reappears.

7. **Select Easy connection, and then choose OK.** A message appears telling you to connect to the access point using the information provided on the screen.

8. **On the smartphone, go to the Wi-Fi settings or the equivalent screen on your phone, and then tap the camera's network that appears with the nickname you chose for the camera.** A screen for the password or encryption key appears.

9. **Enter the encryption key or other information displayed on the 70D into the smartphone, and then choose Join (or the option presented on your device).** The connection is made, and a check mark appears next to the name of the camera's network.

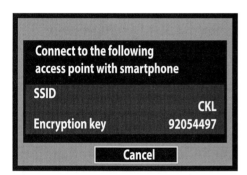

2.16 The network ID nickname and Encryption key screen provided on the 70D. Enter this encryption key on the smartphone to join the camera's network.

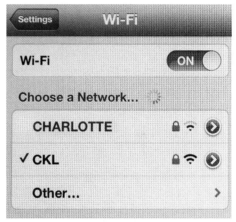

2.17 The smartphone Wi-Fi Settings screen with the camera's network active.

10. **On the smartphone Home screen, start the EOS Remote app.** The text at the top of the Home screen displays a message that the phone is connected to the 70D. You can click the camera connection and verify the network settings.

With the camera and phone now connected, you can view images on the camera's SD card, or you can use the phone or tablet to control the camera and take pictures.

To view images on the SD card, follow these steps:

1. **On the EOS Remote app home screen, tap Camera Image Viewing.** An index of images on the SD card appears along with the date the image was captured.

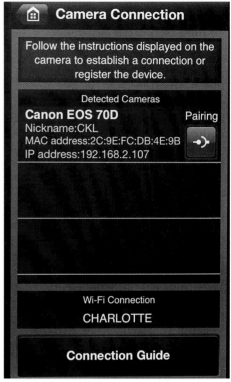

2.18 The Camera connection screen on the EOS Remote app.

2. **To view a single image, tap the image once to display it at a larger size.** A ribbon of controls appears at the bottom of the screen. With these controls, you can e-mail the displayed image, rate it from one to five stars, or delete it.

3. **In Single image view, press the Download button in the lower-left corner of the screen to download the currently displayed picture from the camera's SD card to the phone.** The camera downloads the picture to the phone and automatically reduces the size to 2.5 megapixels (1.3MB, 1920 × 1280 pixels). The size is reduced regardless of whether you're shooting Large JPEG or RAW images. To transfer images at full resolution, it's best to transmit from the camera to the computer directly, or into a Wi-Fi hotspot, and then transmit to the Canon iMAGE Gateway.

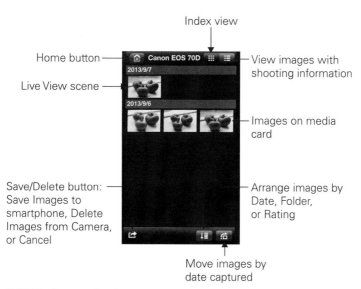

Index view

Home button

Live View scene

View images with shooting information

Images on media card

Save/Delete button:
Save Images to
smartphone, Delete
Images from Camera,
or Cancel

Arrange images by
Date, Folder,
or Rating

Move images by
date captured

2.19 The image viewing screen.

In addition to viewing images, you can control the camera from the smart device by following these steps:

1. **On the EOS Remote screen, tap Remote Shooting.** A live view from the camera appears on the phone screen, along with a shutter and focus button. The size of the screen reflects the LCD size.

2. **To change the exposure, tap the double-arrow icon on the lower-right side of the screen, and then tap the exposure option you want to change.** A slider for the chosen control appears. Just drag the marker to change the setting. In Aperture-priority AE mode (**Av**), you can change the aperture. In Shutter-priority AE mode (**Tv**), you can change the shutter speed. In Manual mode (**M**), you can change both the aperture and shutter speed. In Program AE mode (**P**), you can only change the ISO and set Exposure compensation. In Bulb mode (**B**), you can change the aperture. In all modes, you can change the ISO setting.

 NOTE The drive mode for remote shooting is whatever is currently set on the 70D. Thus, if High-speed continuous drive mode (**⊒H**) is set on the camera, you can press and hold the shutter button to fire a burst of images at 7 frames per second (fps) from the smartphone.

3. **To move the AF point, tap the phone screen, and then to focus, tap the focus button on the phone.** When focus is established, a green rectangle appears in the AF point.

4. **To make the picture, press the shutter button.**

Once you capture images, you can return to the EOS Remote app to review and rate them, or save them to the smart device. From there, you can share them as you would any other photo on your phone or tablet.

You can also specify which images on the camera's SD card can be viewed on mobile devices. On the Setup menu 3 (♥), select Wi-Fi function, and then choose Connect to Phone (▢). On the Connect to smartphone screen, choose Review/change settings, and then select Viewable imgs. On the Viewable imgs screen, select Images from past days, Select by rating, or File number range to limit the images that can be viewed on the mobile device. If you choose Images from past days, you can then specify either Images shot today, or set a specific number of days past.

Tap to show more or less of the current camera settings

Home screen button

Image rotation/Lock button

Tap to stop or start the Live View of the scene on the camera and phone

Camera battery level

Number of images remaining

Exposure and exposure compensation settings

Shutter button

After changing a setting, tap this button to return to the main screen. On the main screen, tap this button to display other exposure settings you can change.

Focus button

Exposure compensation control

Tap to reduce the size and configuration of the controls

Displays last image captured. Tap to display a film strip at the bottom of the screen.

2.20 The remote control screen on a smartphone with the Exposure compensation control activated. This screen changes depending on the controls you choose.

Uploading wirelessly to the Web

Another advantage of wireless functionality is the ability to upload images to the web. With the 70D wireless feature, however, you need to use Canon iMAGE Gateway.

Canon iMAGE Gateway is a free service that provides a bridge for you to upload images to iMAGE Gateway. From there, you can share images via e-mail, or with other websites, including Facebook, Twitter, and YouTube.

In addition to providing a bridge, the iMAGE Gateway enables you to store images, create albums, and print images. It offers a nice selection of useful features including up to 10GB of online storage space; just be sure to explore all the options scattered throughout the site.

The first step is setting up an account with Canon iMAGE Gateway. If you have not installed the programs on the EOS Digital Solutions Disk to your computer, be sure to install them now. At the end of the installation, you have an opportunity to register the 70D with Canon, and at that time, you can set up an account for the web service. Alternately, you can go to the Canon website at www.usa.canon.com/cusa/consumer and click the Sign In link at the top of the left column. Click Register Now to set up an account. You may be asked to upload pictures as the first step. If so, you can upload some pictures that you have on hand. With an account setup, you can move on to setting up the connection and uploading images to the website.

The next tasks assume that you have a Canon account that includes iMAGE Gateway, that you are signed into that account, and that you've installed the EOS Utility program. You will also need the interface cable provided in the camera box. Follow these steps to connect the camera to the Canon iMAGE Gateway and other websites:

1. **On Setup menu 3 (♥), choose Wi-Fi, and then choose Disable.** Wi-Fi must be disabled to connect the camera with a USB cord, which is the next step.

2. **Turn off the camera, connect the interface cable to the camera and the computer, and then turn on the camera.** The EOS Utility window appears.

3. **Click the Web Service Settings option on the EOS Utility screen.** If the latest SSL certificate hasn't been downloaded, a message appears asking you to download. Click OK, and then wait for the download to finish. The login screen for Canon iMAGE Gateway appears.

4. **On the Login screen, type your Username and Password, and then click Login.** The Setup Web Services first message appears.

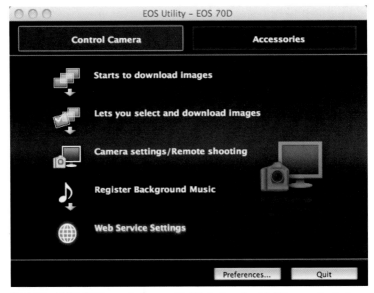

2.21 The EOS Utility window with Web Service Settings selected.

5. **Click OK, and then click the Edit button next to the service you want to use.** The options are Facebook, Twitter, YouTube, and e-mail.

6. **Complete the link settings questions, and then click the Back button.**

7. **Repeat the process for each service you want to use, and then click Finish.** The EOS Utility window appears with the Web Services you chose in the right column.

2.22 The Login screen for Canon iMAGE Gateway.

2.23 The Edit Facebook link settings page on the Canon iMAGE Gateway website.

8. **To add the web services to the camera, click one of the web services listed in the right column, and then click the arrow in the center column to add the service to Camera column on the left (see Figure 2.24).**

9. **Repeat step 8 for each service, and then click OK.** You have to choose the services one at a time to move them into the Camera column. Now the camera and the iMAGE Gateway site are configured so that you can post images to the services you set up.

10. **Turn off the camera and disconnect it from the computer.**

2.24 The EOS Utility window with Web Services added to the camera.

To upload images and videos to websites, follow these steps:

1. **On Setup menu 3 (♥), choose Wi-Fi, press the Setting button (⊛), choose Enable, and then press the Setting button (⊛) again.**

2. **On Setup menu 3 (♥), choose Wi-Fi function, and then press the Setting button (⊛).** The Wi-Fi function screen appears.

3. **Select the Upload to Web service option, and then press the Setting button (⊛).** The Upload to Web service screen appears with the web services you set up.

4. **Select the service you want, and then press the Setting button (⊛).** The Wireless LAN setup method screen appears.

5. **Select Find network, and then choose OK.** The Select wireless network screen appears with the network(s) it detected.

6. **Choose the network you want, and then choose OK.** The Key index screen appears.

7. **Choose a number, and then select OK.** The Key format screen appears.

2.25 The Wireless LAN setup method screen.

8. **Choose the key format your network requires, and then choose OK.** The keyboard appears.

9. **Enter the network passcode, and then choose OK.** The IP address set. screen appears.

10. **Choose Auto setting, and then choose OK.** A Connecting message appears. A message then appears confirming that the settings have been configured.

11. **Select OK.** The camera LCD displays the most recently captured image. You can only upload JPEG images, but the preview images are both JPEG and RAW images, if you shoot RAW. So, if you get an error message saying the image can't be uploaded, it's likely because it is a RAW file. To help find JPEG files, press the Info. button (**INFO.**) several times until the image data includes the file type.

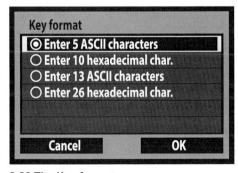

2.26 The Key format screen.

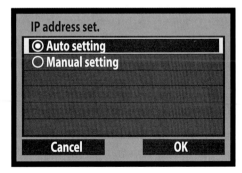

2.27 The IP address set screen.

12. **Choose Set at the bottom of the screen.** A ribbon of options then appears at the bottom of the screen so that you can resize the image, send the selected image, or send the image shown.

13. **To resize the image, choose Resize image, and then press the Setting button (⊛).** The Resize image options appear at the bottom of the screen.

14. **Choose the option you want, and then press the Setting button (⊛).** If you're uploading for Web display, choose the Resize:S2 or Resize:S3 option. If you want to send a full-resolution image to a printer, then choose the Orig size option. The Send options appear.

 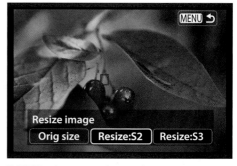

2.28 An image selected for Web upload. **2.29 The image resize options.**

15. **Select Send selected or Send img shown, and then press the Setting button (⊛).** A progress screen appears as the image is uploaded to the website, and then a message saying the images were sent appears.

16. **Choose OK.** The Upload to Web service screen appears so that you can choose another web service and upload another image.

In addition to the wireless tasks I've detailed here, you can also print images to a wireless printer, transfer images to another 70D or an EOS 6D camera, or display images on a DLNA viewing device, such as a TV. Now that you've had practice connecting the camera to other devices and local networks, you can use similar steps to connect printers and compatible wireless-enabled Canon cameras.

Controlling the camera remotely

One of the standard ways to shoot studio portraits and commercial still-life shots is to connect, or *tether*, the camera to a computer, and then use the EOS Utility to control

the camera. The EOS Utility is a program provided on the EOS Digital Solution Disk that comes with the camera. With the camera connected to the computer, the photographer had the advantage of viewing the scene on the large computer monitor and making adjustments to camera settings directly from the computer. The problem was that the length of the cable limited mobility. With the Wi-Fi function on the 70D, the short cable is no longer a restriction though the wireless range is limited to 98.4 feet.

While remote shooting with the EOS Utility isn't suited for every subject, it is a good option for indoor portraits, and some in-studio and outdoor still-life subjects. If you use this type of shooting often, then you can set this as one of the three connection profiles for easy retrieval.

Before you begin, make sure that the computer is already connected to the network and that you've installed the Canon EOS Digital Solution Disk on the computer.

2

NOTE Windows users should check page 61 in the Wi-Fi Instruction Manual for details on setting the Firewall before using the Pairing Software to establish a connection between the camera and computer.

The following steps use the Easy connection method to connect the camera to a local wireless network. If this method does not work, then you may need technical information about your network, including the IP address and a PIN. Follow these steps to connect the camera to a local wireless network and control it remotely from the computer:

1. **On Setup menu 3 (𝐘), select Wi-Fi function, select Remote control (EOS Utility 🖵), and then press the Setting button (☺).** The Wireless LAN setup method screen appears.

2. **Select Find network, and then choose OK.** The Select wireless network screen appears with a list of local networks it found. If it did not find the network you want, you can choose the Search again option, or you can choose the Enter connection option to connect to the network manually.

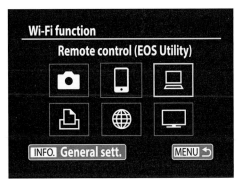

2.30 The Remote control (EOS Utility) option.

3. **Select the network you want to use, and then select OK.** The Key index screen appears.

4. **Select a number, and then select OK.** The Key format screen appears.

5. **Select the key format you want, and then select OK.** Before you make a choice on this screen, you need to know what format that your local network uses. For example, my LAN uses 10 hexidecimal characters. Check the documentation that came with your router to find the key format the network uses. The keyboard screen appears in the appropriate format.

6. **Enter the passcode for your network, and then press the Menu button (MENU) to select OK.** The IP address set. screen appears with two options.

7. **Select Auto setting, and then select OK.** Optionally, if you want to enter the network information, choose Manual setting on this screen. The Start pairing devices message appears.

8. **On your computer, open the EOS Utility folder, and then start the WFTPairing.app.** This folder is copied to your computer when you set up the EOS Digital Solutions Disk programs. On a Mac, you'll find the WFTPairing.app in the EOS Utility folder (Applications/Canon Utilities/EOS Utility). When the WFTPairing.app starts, a small icon appears on the taskbar.

9. **Click the pairing icon, and then choose Select Camera from the drop-down menu.** The WFT Pairing Software dialog box appears showing the camera model, and the MAC and IP addresses.

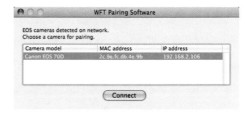

2.31 The WFT Pairing Software dialog box.

10. **Click Canon EOS 70D, and then click Connect.** A message appears on the computer saying to check the camera's LCD for further steps. The 70D displays a message saying that the computer was found and that the camera is now connected to the computer.

11. **On the 70D LCD screen, choose OK.** A message appears saying that settings are configured. Click Settings name if you want to change the name from the default Set 1 to something more descriptive. On the computer, the EOS Utility program appears.

12. **On the EOS Utility window, click Camera settings/Remote shooting.** The Remote Live View control panel appears on the computer monitor.

13. **On the Remote Live View control panel, click Live View shoot.** The reflex mirror flips up to preview the scene on the computer screen in the Remove Live View window. Now, you can use the settings in this window and the EOS 70D control panel to change the white balance, autofocus mode, exposure settings, Picture Style, metering mode, and so on, just as you would if you set the controls on the camera body. There is also a live histogram so that you can adjust settings to get the best exposure. To change a setting, just double-click (or click) the setting in either window, and then make the changes you want.

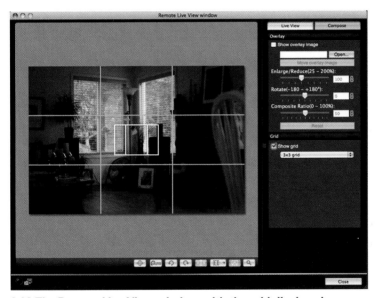

2.32 The Remote Live View window with the grid displayed.

14. **Press the shutter button on the computer screen to take the picture.** The Digital Photo Professional main window opens with the image selected. You can then edit the picture or continue shooting.

Miscellaneous Setup Options

Throughout the camera menus, there are many setup options that you can use to make shooting more enjoyable and efficient. You may have already implemented these settings, but in case you missed some, this section covers them.

General options

In the following tables, I include both camera options that you can set only once, and others that you may need to set for specific shooting scenarios.

> **NOTE** There are fewer menus and options available in the automatic shooting modes.

To change general setup options, press the Menu button (**MENU**), turn the Main dial (⟨⟩) to choose a menu, and then follow the instructions in Tables 2.2 through 2.7.

Table 2.2 Shooting Menu 1 Options

Turn the ⟨⟩ to select a menu option	Press ⑨ to display menu options	Turn the ⟨⟩ to select an option, and then press ⑨
VF grid display	Disable, Enable	Choose Enable to display a grid in the viewfinder to help you ensure that the lines in the scene you're shooting are square (straight) with the frame. The grid also helps you compose the image using the Rule of Thirds.
Viewfinder level	Hide, Show	Choose Show to display a small level on the LCD screen and at the bottom of the viewfinder to help you avoid tilting the camera.
Beep	Enable, Touch to 🔇, Disable	Choose Enable to hear a beep when the camera achieves focus, during touch-screen actions, and when using the Self-timer. Choose Touch to 🔇 to silence the beep for touch actions. Choose Disable to silence the beeper entirely. The last two options are useful in venues where noise is intrusive or unwanted.
Image review	Off, 2 sec., 4 sec., 8 sec., and Hold	Longer review durations of 4 or 8 seconds have a negligible impact on battery life except during travel when battery power may be at a premium.

Table 2.3 Playback Menu 3 Options

Turn the ◌ to select a menu option	Press ⊛ to display menu options	Turn the ◌ to select an option, and then press ⊛
Highlight alert	Disable, Enable	Choosing Enable causes blown high-lights to blink on the preview image displayed on the LCD screen. This is a handy way to know quickly if you need to set some negative exposure compensation and reshoot to retain highlight detail.
AF point display	Enable, Disable	Choosing Enable displays the AF point or points that achieved focus in red on the preview image. This helps you verify that the focus is set exactly where you want it in the image.
Playback grid	Off, 3 × 3, 6 × 4, 3 × 3+diag	Choosing 3 × 3 or 6 × 4 overlays a grid on the playback screen so you can see if the horizontal and vertical lines in the scene are square. The 3 × 3+diag option adds an X-shape on top of the 3 × 3 grid to aid in checking composition.

Table 2.4 Setup Menu 1 Options

Turn the ◌ to select a menu option	Press ⊛ to display menu options	Turn the ◌ to select an option, and then press ⊛
Auto rotate	On for camera and computer, On for computer, or Off	Choose On to rotate vertical images to the correct orientation automatically on the LCD screen and computer monitor. Choose On to rotate images only on the computer monitor. Choose Off for no rotation on the camera or computer. Choosing either of the first two options displays the image at a reduced size.

Table 2.5 Setup Menu 2 Options

Turn the ⊙ to select a menu option	Press ⑨ to display menu options	Turn the ⊙ to select an option, and then press ⑨
LCD brightness	Seven brightness levels	Watch both the preview image and the grayscale chart as you turn the ⊙ to adjust the LCD brightness. As you adjust brightness, ensure that all tonalities on the grayscale chart are clearly distinguishable.
LCD off/on btn	Remains on, Shutter btn. (Unavailable during movie recording)	Choosing Remains on causes the Shooting functions setting screen to appear on the LCD screen when you press the shutter button halfway to focus. This screen shows all of the settings for the camera, and from it you can turn the Mode dial to see the settings for any of the exposure modes. Press the **INFO.** button to dismiss the display. If you choose the Shutter btn. option, the display turns off when you press the shutter button halfway; it turns back on when you release the button.
Date/Time/ Zone	Date (year, month, day), Time (hour, min., sec.), Daylight saving time, Time zone	Setting these options is the first step after powering on the camera for the first time. You can revisit these settings if you're traveling to other time zones to reset the options for the current location.

Table 2.6 Setup Menu 3 Options

Turn the ⊙ to select a menu option	Press ⑨ to display menu options	Turn the ⊙ to select an option, and then press ⑨
Feature guide	Enable, Disable	Choosing Enable displays a brief description of the currently selected modes, and exposure settings, functions, and options on the camera. Choosing the Enable option dismisses the descriptive text. I recommend using the guide to help you learn the 70D.
Touch control	Standard, Sensitive, Disable	Sets the touch sensitivity of the LCD touch screen. The default is Standard, and it is very responsive, but you may prefer the Sensitive setting. The Sensitive setting may respond slower if you use quick touches.
INFO. button display options	Displays camera settings, Electronic level, Displays shooting functions	Choose an option to determine which screen is displayed by pressing the **INFO.** button. Camera settings displays the current exposure and camera settings on a static screen. Electronic level displays a level on the LCD to keep the camera level with the scene. Shooting functions displays a summary of exposure and camera settings where you can activate the screen by pressing ⑤ so you can change settings. This is also known as the Quick Control screen. Alternately, choose all three, and then you can press the **INFO.** button four times to cycle through the three displays, plus a blank screen.

Table 2.7 Setup Menu 4 Options

Turn the ⬭ to select a menu option	Press ⊛ to display menu options	Turn the ⬭ to select an option, and then press ⊛
Sensor cleaning	Auto cleaning: Enable, Disable, Clean now, Clean manually	Choose Auto cleaning/Enable to have the sensor cleaned every time you power the camera on and off. Choose Clean now to clean the sensor again, say, after changing a lens or if you do not use auto cleaning. Choose Clean manually to use specially designed tools to clean the image sensor yourself. With this option, press ⊛ to flip up the reflex mirror to expose the image sensor for cleaning. When cleaning is finished, turn the power switch off to flip the mirror down. Be sure the battery has a full charge before you begin manual cleaning.
Clear all camera settings	Return all camera settings to the factory defaults	Choose this function when you have settings that are not working well, or you feel that you've gone too far in making changes to camera settings. All the shooting (autofocus, metering, ISO, drive mode, and so on) and menu (Image quality, White balance, Color space, Image review time, and so on) settings are reset to their original settings. Custom Function settings remain unchanged.
firmware ver. *	Displays the current version of firmware installed in the 70D	Choose this function when you want to check the current version of firmware installed in the camera. The screen also provides the lens version. To update firmware, choose the Camera option.

* Be sure to check the Canon website periodically for firmware updates.

Registering Batteries

Like several other Canon cameras, the 70D uses the LP-E6 battery. You can register the battery pack and monitor its condition. The battery information is available on Setup menu 4 (♈) by selecting Battery info. The information includes:

▶ **Remaining capacity.** This includes a graphic indicator of remaining battery charge as well as the approximate percentage in 1 percent increments.

▶ **Shutter count.** Displays the number of still images taken on the current battery charge. The count resets with each charge. Movies are not counted.

▶ **Recharge performance.** This is arguably the most helpful if you're using a mix of old and new batteries because you can see if the battery performance is degrading, and by how much. Three green bars indicate good performance. Two green bars indicate slight degradation. One red bar indicates that it's time to replace the battery.

You can register up to six battery packs and monitor their condition. Note that if you insert a battery and get a *Use this battery?* message, you can still use the battery for shooting. The message indicates there may be miscommunication or no communication of battery information between the battery and the camera.

Here's how to register a battery on the camera (If you have multiple batteries, repeat this procedure for each one):

1. **On Setup menu 4 (♈), highlight Battery info., and then press the Setting button (⑤).** The Battery info. screen appears.

2. **Press the Info. button (INFO.).** If this and no other battery have been registered, the current battery appears grayed out. If another battery has been registered, then it appears at the top of the list with its last status displayed. If you have old batteries registered, you can choose the Delete info. option on this screen to delete the battery and make room for replacements.

3. **Highlight Register, and then press the Setting button (⑤).** A message appears confirming battery registration.

4. **Choose OK, and then press the Setting button (⑤).**

You can also write the battery registration number on a label, and then paste it on the end of the battery pack for quick reference.

NOTE The LP-E6 is a very reliable battery with a long life. You can expect to get approximately 1300 shots per battery charge at 73-degree temperatures with viewfinder shooting and no flash use. With 50 percent flash use, expect approximately 920 shots per charge. For movies, you can expect approximately 1 hour and 20 minutes of recording time.

Adding copyright information

Copyright identifies your ownership of images. On the 70D, you can append your copyright information to the metadata that is embedded with each image that you shoot. While including your copyright is a great first step in identifying ownership of the images you make, the process is not complete until you register your images with the United States Copyright Office. For more information, visit www.copyright.gov.

To include your copyright and the camera owner's name on your images, follow these steps:

1. **On Setup menu 4 (♥), highlight Copyright information, and then press the Setting button (⊛).** The Copyright information screen appears.

2. **Highlight the option you want, such as Enter author's name or Enter copyright details, and then press the Setting button (⊛).** A screen appears in which you can enter the name or details.

3. **Press the Quick Control button (Q) to activate the keyboard, use the direction keys on the Multi-controller (⊙) to move the cursor to the letter you want to enter, and then press the Setting button (⊛).** The currently selected letter is shown with a yellow rectangle. You can change the input mode to lowercase, numbers, or two sets of symbols by selecting the input mode key (Aa≑1@) one or more times.

4. **Press the Setting button (⊛) to insert the letter in the top portion of the screen.** To delete a character, press the Erase button (🗑). You can enter up to 63 characters, numbers, and symbols in the text area.

5. **Press the Menu button (MENU), and then choose OK when a confirmation message appears.** The Copyright information screen appears, in which you can type copyright details or the author's name, whichever you didn't choose in Step 2.

Playing Back and Rating Content

Viewing images and movies immediately after capture is the best way to know if the exposure, focus, color, composition, and other factors are on track. Of course, viewing images and movies on the 70D is as simple as pressing the Playback button (▶). If you're in Single image display, you can choose how much shooting and file information appears with the image. If you've turned on the Highlight alert and AF-point display options, the preview image shows these as well, with localized areas of overexposure displayed as blinking highlights.

To move through images and movies on the SD card, turn the Quick dial (◯) counterclockwise to view the next most recent image or movie, or clockwise to view the first. You can change the playback display by pressing the Info. button (**INFO.**) once to cycle through each of these four image-playback displays:

▶ **Single image.** The image fills the LCD screen with no shooting information overlaid. If you're showing subjects or friends the images you've captured, this display option provides a clean, uncluttered view of the image.

▶ **Single image with basic shooting information.** This also displays a large preview image, and overlays the shutter speed, aperture, exposure compensation, and folder and file numbers.

▶ **Histogram(s).** This display shows the three RGB (Red, Green, Blue) color channel histograms or a Brightness histogram, depending on what you selected on Playback menu 3 (▶). This display includes limited shooting and file information.

▶ **Shooting information display.** This display includes the Brightness or RGB histogram — whichever was not included in the

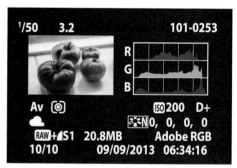

2.33 The playback screen with RGB histograms and image data displayed.

previous display. With this display, you can check the tonal distribution and bias, and verify key camera settings, including the exposure mode, metering mode, white balance, file size, image recording quality, and the current image number relative to the total number of shots on the media card.

NOTE The amount of shooting information displayed during playback depends on the exposure mode you used. Pictures made in automatic exposure modes, such as Portrait (❂) and Landscape (▲), display less information than those made with semiautomatic and manual exposure modes, such as Aperture-priority AE (**Av**) and Manual (**M**) modes.

Rating content

When you rate images and movies, it makes it easy to find your favorites because you can search images and movies by the rating you give them. You can also use the ratings to select images for in-camera slide shows and movie playbacks. If you use ImageBrowser, a program provided on the EOS Digital Solution Disk that comes with the camera, then you can also sort content by rating level on the computer.

To rate content, follow these steps:

1. **On Playback menu 2 (▶), highlight Rating, and then press the Setting button (⊛).** An image appears on the LCD screen with rating options displayed at the top.

2. **Turn the Quick dial (◯) to move to the image you want to rate, and then press the up or down key on the Multicontroller (⬙) to select a rating.** One or more stars appear on the image to reflect the rating.

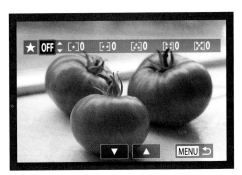

2.34 Image preview with the ratings options displayed.

3. **To continue rating images, repeat step 2, and then press the Menu button (MENU).**

Searching and moving through multiple files

To move through multiple images and movies quickly, you can display them as an index with either four or nine images per screen. Alternately, you can jump through images by a specified number of images at a time, and by date, folder, movies, or stills (still images).

Here's how to use both options:

▶ **Display as an index.** To display images as an index, press the Playback button (▶). Then, press the Index/reduce button (▦·�) to display four images. Press it again to display nine images. Turn the Main dial (🔆) to move to the next or previous index page. To show fewer images, press the Magnify button (◉) one or more times. Press the Setting button (⬛) to display just the selected image.

▶ **Jump through images.** Select Playback menu 2 (▶), select Image jump w/🔆, and then press the Setting button (⬛). On the Image jump w/🔆 screen, turn the Quick dial (○) to select the method for jumping — 1 image, 10 images, 100 images, Date, Folder, Movies, Stills, or Rating — and then press the Setting button (⬛). Press the Playback button (▶) to begin image playback, and then turn the Main dial (🔆) to display the jump scroll bar and to jump by the method you selected.

NOTE You can also play back content as a slide show. Just go to Playback menu 2 (▶), select Slide show, and then choose the images or movies you want. Then, select the Setup button to set the display time, use repeat, choose a transition effect, or use background music.

Erasing and Protecting Content

Deleting unwanted images and movies frees up space on an SD card when you need it, but only erase images and movies you're sure you don't want to keep. You can also protect images and movies to avoid accidentally deleting them.

Erasing files

The 70D offers three ways to erase images and movies: One file at a time, all files in a folder, or all files on the SD card. If you want to permanently erase a single image or movie, just navigate to the file you want to delete, press the Erase button (🗑), highlight Erase, and then press the Setting button (⬛).

To select and erase multiple files at a time, follow these steps:

1. **On Playback menu 1 (▶), highlight Erase images, and then press the Setting button (⬛).** The Erase images screen appears.

2. **Highlight Select and erase images, and then press the Setting button (⊛).** The Image playback screen appears with options at the top left to check mark the current file for deletion.

> **NOTE** In step 2 for erasing multiple images, you can also select to erase All images in folder or All images on card, and then press the Setting button (⊛) to erase the specified images and movies.

3. **Press the Setting button (⊛) to add a check mark next to the current file and mark it for deletion.** You can also turn the Quick dial (◯) to move to the file you want to delete, and then press the Setting button (⊛). You cannot mark files with protection applied.

4. **Press the Erase button (🗑).** The Erase Images screen appears with a message asking if you want to erase the selected images.

5. **Select OK, and then press the Setting button (⊛).** The marked files are erased, and the Erase Images screen appears.

Protecting files

Applying protection to images and movies helps prevent them from being accidentally erased on the SD card, much like setting a document on the computer to read-only status. Protected images can't be deleted using the Erase options detailed previously, but they are erased when you format the SD card. When you download a protected image, you're asked to confirm that you want to move or copy read-only files, which indicates that the images have protection applied. As with erasing images, you can protect images and movies by selecting them individually, or by protecting all images in a folder or on the SD card.

You can protect images and movies by following these steps:

1. **On Playback menu 1 (▶), highlight Protect images, and then press the Setting button (⊛).** The Protect images screen appears with options. You can select images and movies individually, or you can protect all files in the folder or on the SD card. This is also the menu to return to if you want to remove protection.

2. **Highlight Select images, and then press the Setting button (⊛).** The last captured file appears on the LCD screen. A small blue key icon appears at the top left of the file.

3. **Press the Setting button (⊕) to protect the displayed file, or turn the Quick dial (◯) to move to the file you want to protect, and then press the Setting button (⊕).** Another gray key icon (🔒) appears at the top middle of the file to show that it is protected.

4. **To protect additional files, turn the Quick dial (◯) to scroll to the one you want to protect, and then press the Setting button (⊕).**

Working with Exposure

Photographers often talk about exposure. But what does exposure mean? In a strict sense, exposure is the amount of light that falls on a light-sensitive surface such as the sensor in your EOS 70D. In the best of worlds, the amount of light will also be the correct amount to create a good exposure that retains details in the highlights and shadows and that has pleasing contrast. In real life, however, exposures cover a broad range. Exposures can be creative, challenging, or just bad. One thing is certain, though — exposure is one of the things you want to get right.

In this chapter, I discuss exposure from a workflow perspective, including goals, exposure modes, the camera's metering system, and how to evaluate and modify exposure when necessary. The new Multiple exposure and High-dynamic range (HDR) shooting options are also covered.

Regardless of the light, the 70D offers full control to get excellent exposures, with details in the highlights and shadows, as shown here. Exposure: ISO 200, f/5.6, 1/160 second.

Setting Exposure Objectives

If you are a new photographer, then I recommend adopting a goal for your photography — to *get the exposure right in the camera with every shot.* That is my goal, and it is the goal of most professional photographers. I emphasize this because many photographers are content to fix exposures later in Photoshop.

Certainly, many photos can be polished during image editing, but seasoned photographers know that no amount of Photoshop editing can rival the beauty of a spot-on in-camera exposure. In short, there is no substitute for getting the best possible in-camera exposure, and good exposure should never take a backseat to image editing.

Defining exposure goals

A good exposure has both aesthetic and technical components. Aesthetically, a good exposure captures and expresses the scene as the photographer saw and envisioned it. Technically, a good exposure maintains image detail through the bright highlights (or the most important subject highlights) and in the shadows, displays a full and rich tonal range with smooth tonal transitions, and has pleasing contrast. And, of course, the image must have sharp focus.

Getting good exposures can be challenging, but the fundamental and abiding goal is to capture the best possible exposure given the dynamics of the light, the subject, and the gear.

Practical exposure considerations

Should and can every exposure meet all the technical criteria of an excellent exposure? Not necessarily. Ideally, the exposure should help the photographer achieve his or her creative vision. Sometimes, there are lighting and other challenges that make it impossible to get a perfect exposure. In other cases, the exposure is manipulated to flatter the subject. A classic example of a technically imperfect exposure is when a photographer intentionally overexposes a portrait of a mature woman to minimize facial lines and wrinkles.

Other examples of imperfect-but-acceptable exposures are photos where the range from highlight to shadow is so great that you can properly expose only the most important part of the scene in a single frame. Of course, High Dynamic Range (HDR) imaging can be used in some of those scenes, and the 70D offers HDR shooting in the camera. However, HDR imaging isn't an option at concerts, plays, and other events where subjects move, so the practical consideration is to get a good exposure on the subject and let the rest of the scene fall where it may.

3

3.1 In this image, the exposure gave me the overall light and bright sensibility I wanted. Exposure: ISO 400, f/4.0, 1/30 second, +2/3 exposure compensation.

Other practical exposure considerations include exposing images differently depending on whether you're shooting RAW or JPEG images and balancing ISO and shutter speed to control digital noise. In short, practical exposure considerations have a significant influence on everyday shooting. The trick is to use your technical know-how skillfully with the 70D to get exposures that meet your creative vision for the image.

Exposure Basics

Technically, exposure is a mathematical expression that takes the light in the scene, and based on the ISO, determines the aperture and shutter speed combination that will expose the subject properly. For any one exposure, there are additional exposure settings that produce an equivalent exposure — a different combination of aperture and shutter speed that deliver the same amount of light to the sensor.

For example, if the camera's suggested exposure is f/5.6 at 1/60 second at a given ISO setting, then there are other equivalent aperture and shutter speed combinations that provide the same exposure. In this example, two equivalent exposures are f/4.0 at 1/125 second and f/8.0 at 1/30 second at the same ISO.

While the exposures are equivalent, the images look different because the depth of field (DOF) changes, as illustrated in the following images. Both were shot at ISO 200.

In the first image, the exposure is f/2.8 at 1/15 second with a negative 1/3-stop of exposure compensation to darken the dark tones of the star anise. The DOF is shallower than what I wanted for this subject — it didn't show enough detail in the star anise in the back. In the second image, the equivalent exposure is f/5.6 at 1/4 second and the DOF is more extensive with better detail, though not too much detail in the back spices, and that was more in keeping with my vision for this image.

Of course, when you change one exposure element, such as the aperture or shutter speed, it either doubles or halves the light reaching the image sensor or, in the case of ISO, of the sensor's sensitivity to light. For example, while keeping the ISO sensitivity setting the same, changing the aperture from f/8.0 to f/5.6 doubles the amount of light reaching the sensor, while a change from f/5.6 to f/8.0 halves the amount of light. Given the same ISO setting, a change in aperture requires a concurrent and proportional change in shutter speed to achieve a proper exposure.

Choosing an Exposure Mode

One of the first adjustments you make in setting up the camera for shooting is choosing an exposure mode. The exposure mode choice is made with an eye toward other choices you'll make, including the drive and autofocus modes. However, I start by discussing exposure modes. The 70D offers the traditional modes that range from giving you full manual to partial control over the exposure, and a complement of fully automatic exposure modes.

To set any of the exposure modes, just press the Lock/Release button on the Mode dial, and then turn the dial to line up the mode you want with the white mark on the side of the camera.

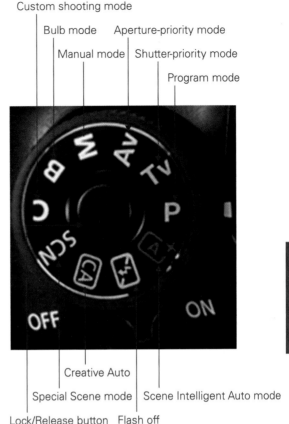

Custom shooting mode

Bulb mode Aperture-priority mode

Manual mode | Shutter-priority mode

Program mode

Creative Auto

Special Scene mode | Scene Intelligent Auto mode

Lock/Release button Flash off

3.2 The Mode dial includes automatic exposure modes, semiautomatic modes, Manual mode, Bulb mode, and one Custom exposure mode.

Automatic modes

One section on the Mode dial is devoted to a fully automatic and semiautomatic modes. These modes are Scene Intelligent Auto (⊞), a fully automatic mode, Creative Auto (CA), a semiautomatic mode, Flash off (⚡), an automatic mode, and Scene (SCN) mode. Setting the Mode dial to Scene mode (SCN) gives you access to more traditional automatic modes, such as Portrait (❀) and Landscape (▦), as well as new modes, including Handheld Night Scene (⬛) and HDR Backlight Control (⬛). As a group, these are called the Basic Zone modes.

In all Basic Zone modes except Creative Auto (CA), the camera sets the ISO, aperture, and shutter speed automatically. In addition, in all Basic Zone modes, the camera automatically sets the following:

▶ ISO (set to Auto)

▶ Auto Picture Style (⊞♦A)

▶ Auto White Balance (AWB)

▶ Auto Lighting Optimizer is turned on (⊞ON)

▶ sRGB is the color space

▶ AF mode and AF points for focusing are automatically selected by the camera except in Movie shooting mode ('🎥)

▶ The AF-assist beam is fired as necessary in all except Flash off (🚫), Landscape (🏔), and Sports (🏃) modes

▶ The Metering mode is set to Evaluative (⊙)

▶ In Movie mode ('🎥), the same settings are set, but you can choose any of the autofocus modes or focus manually if the lens allows. Also in Movie mode ('🎥), you can set the Sound recording, Time code, and Quick Control options.

Despite the automatic control of many camera functions, you can set or apply the following:

▶ Image quality, except RAW+JPEG or RAW if you're shooting in the Handheld night scene (🌃) or HDR backlight control (🌄) modes.

▶ Creative filters

▶ Peripheral illumination correction to prevent vignetting

▶ Chromatic aberration correction to prevent color fringing around high-contrast edges

▶ Use Continuous AF for Live View shooting

▶ Drive mode, except in Movie mode ('🎥)

▶ Using and controlling the built-in flash use depends on the mode you're using. However, in general, you can control all or most of the flash settings except in Flash off (⚡), Landscape (🏔), Sports (🏃), and HDR Backlight Control (🎨) modes. In Movie mode ('🎥), the built-in flash is diabled.

▶ For movie capture, you can also control the Digital zoom, Video snapshots, auto-focus mode, Sound recording, Time code, and Quick Control settings.

The Basic Zone modes are covered in the following sections.

Scene Intelligent Auto

Scene Intelligent Auto mode (🅰) is fully automatic — all you have to do is point and shoot. If you've had previous Canon cameras, this mode was called Full Auto. In this mode, the camera makes intelligent guesses about the scene, subject, and action or lack thereof to determine the exposure and focus settings. While the camera controls the key exposure settings, you can set the image quality, drive mode, and determine the flash settings.

> **NOTE** In Scene Intelligent Auto mode (🅰), there are noticeably fewer camera menus, tabs, and options as compared to other exposure modes.

Some photographers use Scene Intelligent Auto mode (🅰) often, while others never do. It can be good mode for quick snapshots. To make adjustments in Scene Intelligent Auto mode (🅰), press the Quick Control button (🅠), press a direction key on the Multi-controller (✥) to move to the setting you want to adjust, or tap the setting on the LCD screen, and then turn the Quick Control dial (◯) to adjust the setting. You can also press the Setting button (🆂🅴🆃) to display the settings screen for the selected camera control. More options are available on the camera menus.

Flash Off

In Flash Off mode (⚡), the 70D does not fire the built-in flash or an external Canon Speedlite, regardless of how low the scene light is. This is a good mode to use if

you're shooting in a museum or gallery where flash photography is prohibited and any time you do not want the flash to fire. If you're shooting in low-light scenes using Flash Off mode (⚡), be sure to use a tripod.

As with most automatic modes, the ISO is set automatically, and most of the time, the camera sets the ISO to a high setting. The high ISO gives you a faster shutter speed, and the faster shutter speed gives you a better chance of getting a sharp image when you handhold the camera. However, the high ISO setting also introduces digital noise that degrades the overall image quality. Even if you use a tripod and could get by with a low ISO setting, the camera is still likely to set a very high ISO. Sometimes, it's just better to switch to either the Shutter-priority AE (**Tv**) or Aperture-priority AE (**Av**) mode so you can control the ISO yourself, and thereby, keep the image quality as high as possible.

In Flash Off mode (⚡), the camera automatically sets AI Focus AF (**AI FOCUS**) with automatic AF-point selection. This means that the camera uses One-shot AF mode (ONE SHOT/AI SERVO↔), which is designed for still subjects, but automatically switches to the focus tracking mode AI Servo AF (**AI SERVO**) if the subject begins to move.

Creative Auto

Creative Auto (CA) mode displays visuals and text on the LCD screen to help you understand the results that you get from making various adjustments. This shooting mode gives you more control than Scene Intelligent Auto (🅰), but less than the Program AE (**P**), Shutter-priority AE (**Tv**), Aperture-priority AE (**Av**), or Manual (**M**) shooting modes.

To use Creative Auto mode (CA), turn the Mode dial to it, and then press the Quick Control button (**Q**). On the Multi-controller (✧), press up or down to highlight the option you want to adjust, or tap it. Then turn the Quick Control (◯) or Main (⟳) dial to adjust the setting unless otherwise noted in the following sections.

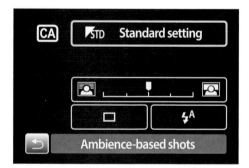

3.3 The Creative Auto screen offers more control over image appearance than other automatic modes, without the necessity of understanding exposure details.

To adjust the sliders on the screen, press the left or right keys on the Multi-controller (✧), or turn the Main (⟨⟩) or Quick Control (○) dials to make adjustments, or use touch to make changes. Once a setting is selected, you can also press the Setting button (⊛) to display a screen with the full options. You can change the following settings:

▶ **Select Ambience setting.** You can choose one of nine Ambience options from Standard to Monochrome.

CROSS REF Ambience options are covered in Chapter 5.

▶ **Background blur.** Adjust this control to softly blur or render the background with sharper detail by adjusting the slide control to the left or right, respectively. In other words, this adjustment changes the aperture (f-stop), and thus the depth of field. The camera also chooses the shutter speed to give a good exposure. For portraits, choose a blurred background, but for landscapes and large group portraits, choose more background sharpness. You can't adjust the Background blur setting when the flash is raised.

▶ **Drive mode.** The Drive mode determines the speed at which the camera captures images. You can choose Single shooting mode (□), in which each press of the shutter button makes one image; High-speed continuous drive mode (⃞H), in which pressing and holding the shutter button captures up to 7 frames per second (fps); Low-speed continuous drive mode (⃞) for 3 fps; Silent single shooting (□S) or Silent continuous (⃞S) to soften the sound of the shutter; the 10-second Self-timer/remote control mode (⏱) or the 2-second Self-timer/remote control (⏱2), in which shooting is delayed by 10 or 2 seconds so that you can be in the picture, or you can avoid camera shake by pressing the shutter button when you are shooting long exposures, macro images, or using a long telephoto lens.

▶ **Flash firing.** With the Flash control, you can choose to have the built-in flash fire automatically when the light is too low to get a sharp handheld image, have the flash fire for every image, or turn off the flash completely. If you choose to turn off the flash and the light is low, be sure to stabilize the camera on a tripod or a solid surface before shooting. Also, even if you turn off the flash, the flash may pop up so the camera can use the flash's AF-assist beam to help the camera focus in low light. Even if this happens, the flash will not fire during the exposure.

Portrait

In Portrait mode (✤), the 70D sets a wide aperture (small f-stop number) to create a shallow depth of field that blurs background details. Blurring background details helps prevent them from distracting the viewer's eye from the subject. Portrait mode (✤) is great, of course, for people portraits, but it's also good for taking pet portraits and indoor and outdoor still-life shots.

> **TIP** To enhance the Portrait mode effect of blurring the background, use a telephoto lens or move the subject farther from the background.

In Portrait mode (✤), the camera automatically selects One-shot AF (**ONE SHOT**) and automatically chooses the AF points. When the camera chooses the AF points, it looks for points in the scene where lines are well defined for the object that is closest to the lens and/or for points of strong contrast. In a portrait, the point of sharpest focus should be on the subject's eyes.

3.4 Portrait mode also works well for pet portraits. Exposure: ISO 1000, f/2.8, 1/25 second.

However, the eyes seldom meet the camera's criteria for setting focus, and the camera instead focuses on the subject's nose, mouth, or clothing. When you half-press the shutter button, watch in the viewfinder to see which AF points the camera

chooses. If the AF point or points aren't on the eyes, then shift the camera position slightly to try to force the camera to reset the AF point to the eyes. If you can't force the camera to refocus on the eyes, then switch to Aperture-priority AE mode (**Av**), set a wide aperture, such as f/5.6, and then manually select the AF point that is over the subject's eyes.

CROSS REF Selecting an AF point manually is detailed in Chapter 4.

Landscape

In Landscape mode (🏔), the 70D chooses a narrow aperture, a large f-stop number, to keep both background and foreground details in acceptably sharp focus, creating an extensive depth of field. The camera gives you the fastest shutter speed possible given the amount of light in the scene to help ensure sharp handheld images; and to do this, it may increase the ISO to a high setting. The high ISO setting can introduce digital noise in the image that degrades the overall quality.

So as the light fades, be sure to monitor the shutter speed in the viewfinder. If the shutter speed is 1/60 or 1/30 second or slower, or if you're using a telephoto lens, then steady the camera on a solid surface or use a tripod. This mode works well not only for landscapes, but also for cityscapes and portraits of large groups of people where a flash is not needed. To get a truly wide view of the scene, use a wide-angle lens or zoom setting.

In Landscape mode (🏔), the camera automatically sets One-shot AF mode (**ONE SHOT**) and automatic AF point selection. The built-in flash never fires, but an accessory Speedlite will fire.

Close-up

As in Portrait mode (👤), the camera sets a wide aperture to create a shallow depth of field in Close-up mode (🌷). It also sets as fast a shutter speed as

3.5 This image was taken in Close-up mode. I was able to achieve focus on the edge of the leaf after several small back and forth adjustments. Exposure: ISO 800, f/5.6, 1/125 second.

possible given the light. You can further enhance the close-up effect by using a macro lens. If you're using a zoom lens, zoom to the telephoto end of the lens. In Close-up mode (🌷), the camera automatically sets One-shot AF mode (**ONE SHOT**) with automatic AF point selection.

> **TIP** All lenses have a minimum focusing distance and it varies by lens. This means that you can't get sharp focus at distances closer than the minimum focusing distance of the lens. Watch the focus confirmation light in the lower right of the viewfinder. If it is lit continuously, the camera has achieved sharp focus. If the light blinks, move back a little, focus, and then check the focus confirmation light.

Sports

In Sports mode (🏃), the 70D sets a fast shutter speed to freeze subject motion. This mode is good for capturing athletes in mid-action or the antics of pets and children.

If you're shooting in low light, the shutter speed display in the viewfinder blinks to warn you of the potential for blur due to camera shake. Camera shake occurs from the natural shake of your hands when holding the camera. If you see the shutter speed blinking, stabilize the camera on a tripod or other solid surface. If the shutter speed is slow, then the subject motion will be blurred.

To give you a fast shutter speed, the 70D increases the ISO setting, sometimes to very high levels. It also counteracts the high ISO by automatically applying High ISO speed noise reduction.

In Sports mode (🏃), you begin focusing on the subject by placing the center AF point on the subject, and half-pressing the shutter button to establish focus using the Area AF frame. Be sure to watch the focus confirmation light in the viewfinder. If it is blinking, it means the camera could not lock in focus on the subject, so repeat the process until you see that the focus confirmation light is lit continuously. Also, there is a continuous soft beep during the time the camera is focusing.

Once focus is established, the camera should automatically track focus as the subject moves through the AF points. The focus is set the moment you fully press the shutter button. Also, if you're shooting a burst of images, you can continue to hold the shutter button down and the camera maintains focus. In Sports mode (🏃), the camera automatically sets AI Servo AF mode (**AI SERVO**) with automatic AF point selection. The built-in flash never fires in this mode, but an accessory Speedlite does fire.

> **TIP** High-speed continuous drive mode (⊒H) is the default drive mode in Sports mode (🏃), enabling you to shoot at up to 7 fps for a maximum burst rate of 65 Large/Fine JPEG images with a USH-I memory card. With other cards, expect 40 shots.

Night Portrait

In Night Portrait mode (▣), the flash usually fires providing proper exposure for the subject, and a long shutter speed provides proper exposure for the background. Together, the combination creates a natural-looking night portrait. Because this mode uses a long exposure, it's important that the subject remain stock-still during the exposure to avoid blur. Be sure to stabilize the camera. The flash fires depending on the existing light level, so in low light, ensure that the subject is within the range of the built-in flash.

> **CROSS REF** Flash ranges for the built-in flash are provided in Chapter 9.

You should use this mode when people are in the picture, rather than for general night shots, because the camera sets a wide aperture to blur the background the way it does in Portrait mode (🏵). For night scenes without people, use Landscape mode (🏔) or a Creative Zone mode and a tripod. In Night Portrait mode (▣), the camera automatically sets One-shot AF mode (**ONE SHOT**) with automatic AF point selection.

Handheld Night Scene

Normally with low light, the camera shutter speed is necessarily long to let enough of the limited available light into the camera to make a proper exposure. Even with high ISO settings, the shutter speed can be very slow. With Handheld Night Scene mode (▣), a single press of the shutter button makes four images in quick succession. The photos are then merged to produce a single image that has brighter exposure and less blur from camera shake than a single frame would have. This mode does not guarantee a tack-sharp image, but it helps you get a sharper image than you would otherwise.

Of course, you still have to keep the camera as steady as possible, and its position must remain constant through all four shots. Otherwise, the camera won't be able to align the four shots to create a sharp image. If you include people in the scene, then turn on flash firing by pressing the Quick Control button (◨), and then selecting the

Flash setting (✦) and choosing Flash on. Only the first frame uses flash to illuminate the person or people properly, and the other three frames are made without the flash. In Handheld Night Scene mode (▣), the camera automatically sets One-shot AF mode (**ONE SHOT**) with automatic AF point selection.

HDR Backlight Control

HDR Backlight Control mode (▣) is a handy mode that improves exposures in challenging light, specifically in scenes where the light behind the subject is much brighter than the light falling on the subject; in other words, in backlit scenes. Typically when photographing in backlit scenes, the camera correctly exposes the subject while the details in the much brighter background blow out to white. Backlit scenes are categorized as High Dynamic Range (HDR). In HDR scenes, the range of light from highlights to shadows as measured in f-stops is wider than the dynamic range of the image sensor. As a result, the camera has to sacrifice details, most often details in the highlights.

To solve the dynamic range problem, HDR Backlight Control mode (▣) takes three successive shots at different exposures — one reduced exposure to capture highlight detail, a standard exposure, and an increased exposure to capture shadow details. Then the shots are merged by the camera to create a single image with proper exposure in all areas. The HDR Backlight Control mode (▣) is echoed in the Creative Zone shooting modes with the HDR Shooting option. One major difference between the two modes is that with HDR Backlight Control mode (▣), you can't control the amount of exposure difference among the frames.

As with any mode in which the camera takes multiple frames, it is critical that you hold it steady or use a tripod, otherwise the three frames will not align perfectly during in-camera processing, and the edges of objects will be blurred, doubled, or tripled. In HDR Backlight Control mode (▣), the camera automatically sets One-shot AF mode (**ONE SHOT**) with automatic AF point selection.

Certainly, the automatic Basic Zone modes can be handy, and they produce nice images. However, if you want to control the way your images look, I encourage you to use the Creative Zone modes: Program AE (**P**), Shutter-priority AE (**Tv**), Aperture-priority AE (**Av**), and Manual (**M**).

Creative modes

Unlike the automatic Basic Zone modes, the semiautomatic and manual modes — Program AE (**P**), Shutter-priority AE (**Tv**), Aperture-priority AE (**Av**), and Manual (**M**) — give you full control of all camera functions and settings. Collectively, these modes are referred to as the Creative Zone.

NOTE Bulb mode (**B**) is also on the Mode dial. It isn't technically an exposure mode, but having it on the Mode dial allows quick access to it for exposures longer than 30 seconds, such as when photographing star trails.

Program AE

Program AE mode (**P**) is handy because it enables you either to shoot using the camera's recommended exposure, or to quickly change or shift to a different, but equivalent, exposure. Equivalent exposure means that both exposures deliver the same amount of light to the image sensor. Here is how it works. When you press the shutter button halfway, the 70D gives you its suggested aperture and shutter speed based on the ISO currently set. You can shoot with those exposure settings, or you can use a different aperture and shutter speed by simply turning the Main dial (🔆) to temporarily change, or *shift*, the aperture and shutter speed.

For example, if the camera initially sets the exposure at f/4.0 at 1/125 second, you can turn the Main dial (🔆) one click to the left to shift to an f/5.0 aperture and a 1/100 second shutter speed, which is equivalent to the initial exposure assuming the same ISO setting. Turning the Main dial (🔆) to the right results in a shift to f/3.5 at 1/200 second, and so on. This assumes, of course, that the ISO stays the same.

When you shift the exposure, the change is temporary. After you take a picture at the shifted exposure settings, the camera returns to its suggested (or standard) exposure for the next image. Also, if you shift the exposure, and then release the shutter button without taking the picture within a few seconds, the camera returns to its standard exposure.

NOTE At first glance, the Scene Intelligent Auto (🄰) and Program AE (**P**) modes seem similar. However, Program AE mode (**P**) gives you full control over the focus, white balance, metering mode, and so on. In Scene Intelligent Auto (🄰), you cannot change many of the camera settings.

To use Program AE mode (**P**), set the Mode dial to Program AE (**P**), and then press the shutter button halfway. If you want to shift the camera's standard exposure, turn the Main dial (⚙) to the left to make the aperture narrower and the shutter speed longer, or to the right to make the aperture wider and the shutter speed shorter.

3.6 In Program AE mode, the camera's standard exposure was f/3.5 for this bowl of blueberries, which created a very shallow depth of field. Exposure: ISO 200, f/3.5, 1/30 second.

3.7 I wanted a shot of the blueberries with a more extensive depth of field, so here, I shifted the exposure to f/8.0. Exposure: ISO 200, f/8.0, 1/6 second.

If the shutter speed shows 30" and the maximum aperture of the lens is blinking in the viewfinder, it means that the image will be underexposed. You can change to a higher ISO or use the built-in or an accessory flash. However, if you use a Speedlite, you cannot shift the exposure. Conversely, if the shutter speed shows 8000 and the lens's minimum aperture blinks in the viewfinder, the image will be overexposed. Use a lower ISO setting, or decrease the light with a neutral density (ND) filter or by using a *scrim* (that is, a material that cuts down the light falling on the subject).

Shutter-priority AE

When the primary concern is controlling the shutter speed, Shutter-priority AE (**Tv**) is the mode of choice. In this semiautomatic shooting mode, you set the shutter speed and the camera automatically calculates the appropriate aperture based on the current ISO setting and the light meter reading.

Controlling the shutter speed determines how subject motion is rendered in the image — either as frozen or blurred — and that makes Shutter-priority AE mode (**Tv**) a good choice for sports and action shooting. However, it's also the mode to use when you need to set a shutter speed fast enough to prevent blur from camera shake when you don't have a tripod. For example, if you are shooting in moderate to low light with a non-Image Stabilized (IS) lens at a focal length of 100mm, then you can set the shutter speed to 1/100 second — a shutter speed that is fast enough to handhold the camera and get sharp images at this focal length. In Shutter-priority AE mode (**Tv***), the shutter speed remains constant as you continue shooting.

On the 70D, you can select shutter speeds from 1/8000 second to 30 seconds, or switch to Bulb mode (**B**). To show fractional shutter speeds, the 70D shows only the denominator of the fraction in the viewfinder. Thus,

3

3.8 A slow shutter speed in Shutter-priority AE mode blurred the motion of the swings, while keeping the main ride structure in sharp focus. Exposure: ISO 200, f/14, 1/15 second, -1 exposure compensation.

1/8000 second is displayed as 8000 and 1/4 second is displayed as 4. Shutter speeds longer than 1/4 second are indicated with a double quotation mark that represents a decimal point between two numbers or following a single number. For example, 1"5 is 1.5 seconds, while 4" is 4 seconds.

Using the Quick Control Screen

The Quick Control screen is the quickest way to change the most frequently used camera settings. In the Program AE (**P**), Shutter-priority AE (**Tv**), Aperture-priority AE (**Av**), Manual (**M**) and Bulb (**B**) modes, you can control the most commonly adjusted functions on the 70D from this screen. Controls include the ISO, AF area selection mode, metering, and drive modes, AF-point selection, white balance, Picture Style, exposure and flash compensation, and Custom Controls.

To display the Quick Control screen on the LCD screen, press the Quick Control button (**Q**). Next, touch a setting to make changes, or press the direction keys on the Multi-controller (⁙) to select the setting you want to change. Turn the Quick Control dial (◎) or the Main dial (⌒) to change the setting. If you've disabled some settings, such as Wi-Fi, you must enable them on the camera menus rather than the Quick Control screen.

To use Shutter-priority AE mode (**Tv**), turn the Mode dial to it, press the shutter button halfway, and then turn the Main dial (⌒) to change the shutter speed. The camera automatically sets the appropriate aperture based on the current ISO and the light meter reading. If the lens's maximum aperture blinks, the image will be underexposed. Increase the ISO setting or decrease the shutter speed until the aperture stops blinking.

> **TIP** If you want to ensure that the exposure is correct in scenes in which the light changes quickly, you can enable Custom Function (see Chapter 6) I-6 Safety shift. Safety shift is useful in both the Shutter-priority AE (**Tv**) and Aperture-priority AE (**Av**) exposure modes.

In the default 1/3-stop increments, the following shutter speeds are available (in seconds): 1/8000, 1/6400, 1/5000, 1/4000, 1/3200, 1/2500, 1/2000, 1/1600, 1/1250, 1/1000, 1/800, 1/640, 1/500, 1/400, 1/320, 1/250, 1/200, 1/160, 1/125, 1/100, 1/80, 1/60, 1/50, 1/40, 1/30, 1/25, 1/20, 1/15, 1/13, 1/10, 1/8, 1/6, 1/5, 1/4, 0.3, 0.4, 0.5, 0.6, 0.8, 1, 1.3, 1.6, 2, 2.5, 3.2, 4, 5, 6, 8, 10, 13, 15, 20, 25, 30.

Shutter speed increments can be changed from the default 1/3-stop to 1/2-stop increments using C.Fn1-1 Exposure level increments. The 70D flash sync speed is 1/250 second or slower for Canon Speedlites.

Shutter Speed Tips

Shutter-priority AE mode (**Tv**) is handy when you want to set a shutter speed fast enough to handhold the camera and still get a sharp image, especially if you are using a long lens. If you are *not* using an Image Stabilized (IS) lens, a good guideline for determining the fastest shutter speed at which you can handhold the camera and lens, and get a sharp image is 1/focal length. Thus, if you are shooting at a 200mm focal length, the slowest shutter speed at which you can handhold the camera and get a sharp image is 1/200 second.

If you are shooting action scenes and want a shutter speed fast enough to stop subject motion with no motion blur, the following guidelines provide a good starting point:

▶ **Use 1/250 second when action is coming toward the camera.**

▶ **Use 1/500 to 1/2000 second when action is moving side to side or up and down.**

▶ **Use 1/30 to 1/8 second when panning with the subject motion.** Panning with the camera on a tripod is best.

▶ **Use 1 second and slower shutter speeds at dusk and nighttime to show a waterfall as a silky blur, capture light trails of moving vehicles or a city skyline, and so on.**

You can use a polarizing or neutral-density filter to capture moving water as a blur earlier in the day, both of which reduce the amount of light to give you a slower shutter speed. Besides reducing the light by 2 stops, a polarizer has the additional benefit of reducing reflections on the water.

Aperture-priority AE

When you want to control the depth of field, Aperture-priority AE mode (**Av**) is a good choice. In Aperture-priority AE mode (**Av**), you select the aperture (f-stop) that you want, and the 70D automatically sets the shutter speed based on the current ISO and the light meter reading.

The range of apertures available to you depends, of course, on the lens that you are using. On zoom lenses, the minimum aperture may vary by focal length. For example,

the EF 24-105mm f/4L IS USM lens has a minimum aperture of f/22 at 24mm, and f/27 at 105mm. The maximum aperture is f/4.0 at all focal lengths. On other lenses, the maximum aperture is variable, based on the focal length.

To use this mode, set the Mode dial to Aperture-priority AE (**Av**), and then press the shutter button halfway. Turn the Main dial (✺) to the right to set a narrower aperture, or to the left to set a wider aperture. The camera automatically calculates the appropriate shutter speed based on the light meter reading and the ISO.

Apertures from f/5.6 to f/1.4 are referred to as *large apertures* because the opening of the lens diaphragm is large and allows more light to reach the image sensor. Large or *wide* apertures create a shallow depth of field, in which the back- and foregrounds are blurred. Apertures from f/8.0 to f/22 are referred to as *small apertures* because the opening of the lens diaphragm is narrow, allowing less light to reach the sensor. Small apertures create extensive depth of field, in which most of the scene from fore- to background is in acceptably sharp focus.

3.9 A wide aperture coupled with an EF 180mm macro lens isolated the center of this flower and brought out the tiniest specs. Exposure: ISO 200, f/5.6, 1/13 second, +2/3 exposure compensation.

Practically speaking, you can also control the shutter speed using Aperture-priority AE mode (**Av**), just as you can control aperture in Shutter-priority AE mode (**Tv**). For example, if I am shooting outdoors in Aperture-priority AE mode (**Av**) and see a flock of birds coming into the scene, I can quickly open up to (set) a wider aperture, knowing it will give me a faster shutter speed. So, I simply adjust the aperture until I get a shutter speed that's fast enough to stop the motion of the birds. The same is true for Shutter-priority AE mode (**Tv**), albeit by adjusting the shutter speed to get to the aperture you want.

In 1/3-stop increments, and depending on the lens you use, the apertures are: f/1.2, f/1.4, f/1.6, f/1.8, f/2.0, f/2.2, f/2.5, f/2.8, f/3.2, f/3.5, f/4.0, f/4.5, f/5.0, f/5.6, f/6.3, f/7.1, f/8.0, f/9.0, f/10, f/11, f/13, f/14, f/16, f/18, f/20, f/22, f/25, f/29, f/32, f/36, f/40, f/45.

If you select an aperture and the exposure is outside the exposure range, the shutter speed value blinks in the viewfinder and on the LCD panel. If 8000 blinks, the image will be overexposed. If 30 blinks, the image will be underexposed. If this happens, adjust to a smaller or larger aperture, respectively, or choose a lower or higher ISO setting. You can preview the depth of field by pressing the depth-of-field preview button on the front of the camera.

Manual

As the name implies, Manual mode (**M**) eliminates the automatic aspects of setting the exposure so that you set the aperture, shutter speed, and ISO manually. This exposure mode is a good choice when you:

▶ **Determine the exposure settings by metering on a middle-gray area in the scene, or on a photographic gray card (such as the one available in the back of this book).**

▶ **Have predetermined settings for specific scenes or subjects, such as for fireworks, astral subjects, or when shooting with studio strobes.** In Figure 3.10, I used Manual mode and underexposed the scene slightly to create a low-key (darker) look for the tulips.

▶ **Want to intentionally underexpose or overexpose the scene or otherwise vary from the camera's standard exposure.**

3.10 I always switch to Manual mode in the studio because it allows me to create a high- or low-key (as shown here) look quickly. Exposure: ISO 100, f/22, 1/125 second.

▶ Want a consistent exposure across a series of photos, such as for a panoramic series.

▶ Use a handheld light meter to determining exposure settings.

Before you begin, be sure to set the ISO to the setting you want. To use Manual mode (**M**), follow these steps:

1. **Set the Mode dial to Manual mode (M), set the ISO, and then verify that the Lock switch on the back of the camera is unlocked (in the down position).** You can either set a specific ISO, or use Auto ISO. However, if you use Auto ISO, the camera will change the ISO to get to the camera's standard exposure rather than enabling you to vary from the standard exposure. You can press the AE Lock button (✳) to keep the ISO from changing when using Auto ISO, but I recommend setting a specific ISO instead of using Auto ISO.

2. **If you're using recommended or predetermined exposure settings, then turn the Main dial (⟨⟩) to set the shutter speed, and then turn the Quick Control dial (⟨⟩) to set the aperture to the recommended settings.** Use this technique when you've been given the ISO, aperture, and shutter speed settings to use for photographing the moon or stars, for example.

3. **To use the camera's recommended exposure or set it based on a photographic gray-card reading, press the shutter button halfway.** Turn the Main dial (⟨⟩) to adjust the shutter speed and/or turn the Quick Control dial (⟨⟩) to adjust the aperture until the tick mark is at the center of the Exposure level indicator displayed in the viewfinder. Next, focus and make the picture.

If you have enabled Auto Lighting Optimizer on Shooting menu 3 (📷), then the exposure will be adjusted automatically. For example, if you want a brighter exposure than the standard exposure, then Auto Lighting Optimizer will automatically darken the image. If you want to control the exposure, then turn off Auto Lighting Optimizer. If the image needs more or less exposure, you can adjust the aperture or shutter speed to get the exposure you want.

You can overexpose or underexpose up to +/-3 Exposure Values (EV), and the amount of exposure variance from the metered exposure is displayed on the Exposure Level Indicator. If the amount of exposure is greater than +/-3 EV, then the Exposure Level Indicator shows an arrow on one or the other side. You can then adjust the aperture, shutter speed, or ISO sensitivity setting until the exposure is within range. With the camera in Manual exposure mode (**M**), you cannot use Exposure Compensation. The aperture and shutter speed values detailed earlier in the chapter are also available in Manual mode (**M**).

What Does EV Mean?

An Exposure Value (EV) is an expression of the ISO, shutter speed, and aperture taken together as the amount of light given to the sensor. In traditional terms, EV is the amount of exposure required by the subject luminance and the ISO.

EVs are represented by whole numbers, with each sequential step doubling or halving the exposure. If you halve the amount of light that reaches the image sensor by either reducing the aperture or increasing the shutter speed, the EV increases by 1.

For example, in Program AE mode (**P**), you shift the exposure in EV by changing the shutter speed and/or aperture. Exposure compensation and exposure bracketing use exposure value to change the exposure.

Bulb

Bulb mode (**B**) enables you to keep the shutter open as long as the shutter button is fully depressed. Bulb mode (**B**) is handy for some night shooting, fireworks, celestial shots, and other exposures longer than 30 seconds.

> **CAUTION** Be sure that you have a fully charged battery before you begin an extended exposure.

To make a bulb exposure, turn the Mode dial to Bulb mode (**B**). With the camera on a tripod, set up the remote switch to the amount of time you want for the exposure. You can, of course, press and hold the shutter button for the exposure duration, but that can cause blur from camera shake, not to mention finger fatigue. I recommend using the accessory RS-60E3 remote switch to hold the shutter open. You can also enable Mirror lockup to reduce the chance of blur caused by the reflex mirror action. Mirror lockup is in Shooting menu 2 (**◘**). Select the aperture you want by turning the Main (✧) or Quick Control (○) dial, and then trip the remote switch. The camera displays elapsed exposure time in seconds on the LCD panel.

Because long exposures introduce digital noise and increase the appearance of grain, consider setting Long exposure noise reduction on Shooting menu 4 (**◘**) to either Auto or Enable (On).

Custom

One of the handiest options that the 70D offers is the ability to program an exposure mode with your favorite shooting settings and preferences. The Custom shooting mode (**C**) enables you to set up the camera with your most commonly used settings — including an exposure mode, white balance setting, color space, Picture Style, Custom Functions, and more — and then register those settings to that mode. When you want to use those specific settings again, simply turn the Mode dial to the Custom shooting mode (**C**).

> **CROSS REF** The Custom shooting mode (**C**) is detailed in Chapter 6.

Setting the ISO

As with other recent EOS cameras, the 70D has improved high-ISO performance. As a result, you have greater latitude in using high ISO settings in low-light scenes while getting lower levels of digital noise than in previous cameras.

If you're new to photography, the ISO setting determines the image sensor's sensitivity to light in general terms. In more technical terms, the ISO setting amplifies the electrical output of the image sensor. Higher amplification enables faster shutter speeds and the ability to use smaller apertures, as well as higher levels of digital noise in the image. High levels of noise also degrade the overall image quality. Because amplification increases digital noise and grain in the image, always shoot at the lowest ISO setting you can, given the existing light and your shooting needs.

3

3.11 With the clean images that the 70D produces, you can shoot at higher ISO settings with confidence that the images will maintain good quality. Exposure: ISO 640, f/2.8, 1/40 second.

How Much Noise Is Too Much?

Certainly the 70D offers improved high-ISO performance over its predecessors, but it pays to always be aware of the effects of digital noise in your images and judge how much it is affecting overall image quality.

If the digital noise is visible and aesthetically objectionable in an 8 × 10- or 11 × 14-inch print when viewed at a distance of approximately 1 foot or more, then the digital noise has degraded the image quality to an unacceptable level. This standard emphasizes the need to test the 70D at each of the higher ISO sensitivity settings, and then process and print images at the size you typically use. Evaluate the prints to see how far you want to take the 70D's ISO settings.

In Creative Zone exposure modes, you can set the ISO sensitivity in 1/3-stop increments. If you want to set them in 1-stop increments, change the C.Fn I-2 ISO speed setting increments to 1 stop. The 70D's standard range is ISO 100 to 12800, but you can expand this to include ISO 25600 on Shooting menu 3 (◻). Just choose ISO speed settings, and then you can set ISO range limits.

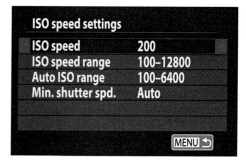

3.12 The ISO speed settings screen.

NOTE If you use the H setting, an exclamation mark is displayed in the viewfinder as a reminder to you that the ISO expanded setting is being used.

If you are concerned about controlling digital noise in images, and if you use Auto ISO, be sure to check the ISO setting in the viewfinder before shooting. If the camera sets the ISO very high, you can reduce the maximum ISO setting that can be used for Auto ISO. Alternatively, you can set the ISO manually, and that's a very good option — one that I use every day.

NOTE In Bulb mode (**B**) with Auto ISO, the ISO is set to 400 depending on the minimum and maximum Auto ISO range you've set.

You have good flexibility in setting up the ISO ranges for both the Auto ISO and manual ISO use. Also, with control over the maximum ISO, you can control the level of noise and overall quality of your images while having the advantage of automatic ISO adjustment.

> **NOTE** The maximum ISO for movie recording (see Chapter 8) is 6400 in general for all modes. But if you have the Maximum ISO range set to 12800/H, then 12800 will be used depending on the light. If you are shooting with manual exposure and have ISO 25600 set when you begin shooting a movie, then the camera automatically sets the ISO to 12800.

When I shoot in low light, I am always aware that both high ISO settings and long exposure times increase digital noise and grain in images. I try to balance the two by choosing a moderately high ISO that gives an exposure time of 1 second or less (if the light allows). I find that I get better image quality with that approach than with a blanket approach of just keeping the ISO low and letting the exposure go long.

Without question, the best approach is to test the camera in different venues at different ISO settings and at differing shutter speeds. Then evaluate the results. With those tests, you'll know how far and fast to push the ISO and exposure time, and how it affects overall image quality. Also, remember that the expanded ISO setting of 25600 purely and plainly will not deliver good image quality.

If you are new to photography, then remember that the lower the ISO, the better the image quality. Make it a habit to use the lowest ISO you can given the light. And get a good tripod. In many scenes, using a tripod can enable you to keep the ISO low so that the image quality stays high.

Here are some starting points for setting the ISO:

▶ **Outdoor light ranging from bright sun to overcast/cloudy: ISO 100 to 400.** In bright light, keep the camera set to ISO 100 or 200 and increase it only if you move to a shady area to shoot. On overcast days, keep a watchful eye on the shutter speed. If it falls to slower than 1/60-second, move to ISO 400, or use a tripod and keep the ISO at 100 or 200.

▶ **Indoor natural daylight (for example, a subject lit by window light): ISO 400 to 800, and up to 1600.** In my experience, it's better to use a tripod, and

keep the ISO between 400 and 800. ISO settings above 800 produce noise that will become noticeable in images. If you use the High ISO noise reduction option on Shooting menu 4 (◘), fine details in the image can be lost.

▶ **Evening, night venues, and indoor environments lit with artificial light: ISO 800 to 1600.** At ISO 1600, there will be visible noise in the images, although the quality will be better than cameras of previous generations. At ISO 12800, the noise and noise reduction process (if you use it) negatively (and noticeably) affects the overall quality of the image. However, sometimes, using a high ISO setting is the only way to get the picture, and it's great that the 70D can produce good images at these settings.

To set the ISO, press the ISO button above the LCD panel, and then turn the Main (✿) or Quick Control (◌) dial to set the ISO. The letter A indicates Auto ISO, meaning that the camera sets the ISO automatically. You can also set the ISO on Shooting menu 3 (◘) and the Quick Control screen. If you use the Highlight Tone Priority option on Shooting menu 4 (◘), you will not be able to set the ISO lower than 200.

> **NOTE** On the ISO speed menu screen, you can press the Info button (**INFO.**) to choose the Auto setting quickly.

Using Auto ISO simplifies shooting by removing one setting that you need to adjust. And while it's convenient to have the camera set the ISO for you, I recommend setting a maximum setting for Auto ISO. Auto ISO ranges for specific modes are as follows, although you can change these by setting the minimum and maximum ranges:

▶ **Basic Zone modes, except Landscape (🏔) and Handheld night scene (🌃): ISO 100 to 6400.** Landscape (🏔) goes up to ISO 1600 while Handheld night scene (🌃) goes up to ISO 12800.

▶ **Program AE (P), Shutter-priority AE (Tv), Aperture-priority AE (Av), and Manual (M) modes: ISO 100 to 12800.** This depends on the minimum and maximum ISO that you choose for the Auto ISO range.

▶ **Bulb mode (B) or when using a Speedlite: ISO 400.** In Bulb mode (B), this depends on the minimum and maximum ISO that you choose for the Auto ISO range.

While the very high ISO settings provide a safety net when there is no other way to capture an image, they aren't ones you want to select on a daily basis. And if you have tested the camera's ISO performance, you may have determined a range of ISO settings that provide acceptable image quality. You can use that range to set the minimum and maximum ISO ranges. Follow these steps to set an ISO range:

1. **On Shooting menu 3 (📷), highlight ISO speed settings, and then press the Setting button (⊞).** The ISO speed settings screen appears.

2. **Highlight either ISO speed range or Auto ISO range, and then press the Setting button (⊞).** The ISO speed range or the Auto ISO range screen appears, depending on the option you chose.

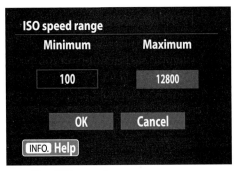

3.13 The ISO speed range screen.

3. **Select Minimum, press the Setting button (⊞), and then press the up or down key on the Multi-controller (✥) to set the value.** The minimum range for manually setting the ISO is 100 to 12800. For Auto ISO, the minimum range is 100 to 800.

4. **Press the Setting button (⊞).**

5. **Turn the Quick Control dial (◯) to select the Maximum value, press the Setting button (⊞), and then press the up or down key on the Multi-controller (✥) to set the value.** The maximum range for manually setting the ISO is 200 to H (25600). The Auto ISO maximum range is ISO 200 to 12800.

6. **Select OK, and then press the Setting button (⊞).** The ISO speed settings screen appears. Repeat these steps but select the option you didn't choose in step 2.

The Auto ISO minimum and maximum settings are used for Safety shift as well. If you have Safety shift C.Fn I-6 set to ISO speed, then when you manually set the ISO in Program AE (**P**), Shutter-priority AE (**Tv**), and Aperture-priority (**Av**) modes, it adjusts

automatically if the brightness changes. If you manually set an ISO higher than the Auto ISO maximum, then Safety shift uses an ISO up to your manual setting, disregarding the Auto ISO maximum setting.

You can also set the minimum shutter speed to use with Auto ISO. The minimum you set is used in (**P**) and (**Av**) modes. This helps avoid blur from camera shake when the shutter speed is too slow. The only times the minimum shutter speed isn't used is when you're using the flash or when the shutter speed will not produce the proper exposure, in which case, the camera will set a slower shutter speed.

To set a minimum shutter speed for Auto ISO, follow these steps:

1. **On Shooting menu 3 (⚙),** **highlight ISO speed settings,** **and then press the Setting** **button (⑯).** The ISO speed settings screen appears.

2. **Highlight Min. shutter spd.,** **and then press the Setting** **button (⑯).** The Min. shutter spd. screen appears.

3. **Press left or right on the Multi-** **controller (✛) to select Auto** **or the shutter speed you want,** **and then press the Setting** **button (⑯).** The ISO speed settings screen reappears.

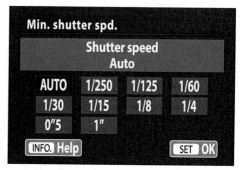

3.14 The Minimum shutter speed screen for Auto ISO.

For my shooting, I set my camera to ISO 100 as a matter of course, or if I'm using Highlight Tone Priority, then it's set to 200, the lowest ISO setting available. I increase the ISO only when the light in the scene forces me to, and then I increase it just enough to get the shutter speed that I need to either handhold the camera with the lens I am using, or to freeze subject motion if I'm shooting action. Doing this helps ensure that I get the highest image quality possible given the circumstances.

Metering Light and Adjusting Exposures

The starting point for every photographic exposure is the amount of light in the scene. So before the 70D can determine the exposure settings, it has to measure how much light is falling on the subject, and it does this by using the onboard reflective light meter. From the meter reading, the camera can then calculate the exposure settings. Depending on the subject and scene, you may want the meter to take into account the light in more or less of the scene. In those situations, you can choose from any of the four metering modes the 70D offers.

Before talking about metering modes, it's helpful to know more about the 70D metering system. Traditionally, camera light meters were colorblind, and recognized only black-and-white brightness levels or luminosity. But the 70D's meter is not entirely color blind. The dual-layer meter has 63 measurement zones to measure the full spectrum of Red, Green, and Blue (RGB). As a result, the meter makes more informed decisions about metering. Canon calls its autoexposure (AE) system *Intelligent Focus Color Luminosity metering*, or IFCL.

NOTE A side benefit of the IFCL metering system is that it helps the focusing sensor identify objects and their distances and improve focusing accuracy in unusual light such as sodium light.

In the default Evaluative metering mode (⊡), the 70D evaluates the light and color throughout 63 zones within the viewfinder. Because the autofocus (AF) zones are aligned with the Auto Exposure zones, the camera receives exposure information from all the AF points. The 70D uses the subject distance information provided by the lens and the AF sensor to assist in making exposure decisions. For example, the metering system looks at objects that are close to the subject — using both the AF point that achieved focus and those that nearly achieved focus. Then it combines those meter readings with readings from the other zones to provide more consistent exposures, even in difficult lighting situations. The bottom line is that you can expect precise and consistent exposures regardless of the metering mode that you select.

While the advanced metering system helps overcome some metering challenges, the meter can still be fooled by very light or dark subjects. In those scenes, you can

choose among the four metering modes to get more precise metering results, or you can opt to use any of several exposure modification techniques, all of which are detailed in the following sections.

Using metering modes

The 70D offers four metering modes from which you can choose when shooting in the Program AE (**P**), Shutter-priority AE (**Tv**), Aperture-priority AE (**Av**), Manual (**M**), or Bulb (**B**) exposure modes.

Here is a look at each of the four metering modes:

▶ **Evaluative metering mode (⊡).** This mode evaluates each of 63 zones in the viewfinder, as covered previously. It considers distance, light intensity, and color. It biases metering toward the subject's position, which is indicated by the active AF point(s). It also compares the light values of adjacent AF points at distances that nearly achieved focus, and takes into account back- or frontlighting. Evaluative metering mode (⊡) works well for scenes with an average distribution of light, medium, and dark tones, backlit scenes, and scenes with reflective surfaces, such as glass or water.

3.15 Whether a scene is average (like this one), backlit, or something in-between, Evaluative metering produces consistently excellent exposures. Exposure: ISO 200, f/11, 1/320 second.

▶ **Partial metering mode (⬚).** This mode hones in on a much smaller area (approximately 7.7 percent) of the scene at the center of the viewfinder. By concentrating the meter reading more specifically, this mode gives good exposures for backlit and high-contrast subjects, and when the background is much darker than the subject is.

3.16 Here, I used Partial metering and metered on the balloon to the left of the flame. I then locked the exposure, recomposed, focused, and made the image. Exposure: ISO 800, f/2.8, 1/100 second.

▶ **Spot metering mode (⬚).** In this mode, the metering concentrates only on a 3 percent area of the viewfinder at the center — the circle that is in the center of the viewfinder when the camera is set to Spot mode (⬚). This mode is good for metering a middle-gray area in the scene or a photographic gray card to calculate exposure. Spot mode (⬚) is useful when shooting subjects with more extreme contrast, backlit subjects, and subjects against a dark background. You can also

use Spot mode (⊡) to keep the meter from being influenced by surrounding areas in the scene or subject. For Figure 3.17, the light on the flower bud was brighter than the background. I wanted to ensure that the bright area of the flower bud was exposed properly, so I used Spot metering and it produced an excellent exposure in the highlights, as well as in the rest of the scene.

▶ **Center-weighted Average metering (⊡).** This metering mode weights exposure calculation for the light at the center of the scene shown in the viewfinder, and then evaluates light from the rest of the scene to get an average for the entire scene. The center area encompasses an area larger than the Partial metering area. As the name implies, the camera expects that the subject will be in the center of the frame. This mode gives good results in scenes with even lighting and brightness.

3.17 Spot metering delivered an excellent exposure of this image. Exposure: ISO 200, f/2.8, 1/250 second.

> **NOTE** In automatic shooting modes, such as Scene Intelligent Auto (🅐), Portrait (🏃), and Landscape (🏔), the camera automatically uses Evaluative mode (⊙).

Partial (⊙), Spot (⊡), and Center-weighted Average (⊡) metering all assume that the subject is at the center of the viewfinder. If you're using Partial (⊙) or Spot (⊡) metering and the subject isn't in the center of the scene, move the camera so that the center AF point is over the area you want to meter, press the shutter button halfway, and then press the AE Lock button (✳) to lock the exposure. Then you can move the camera, focus, and press the shutter button.

3.18 An image in which the subject is in the center of the frame is a good opportunity to use Center-weighted Average metering. Exposure: ISO 200, f/5.6, 1/400 second.

To change the metering mode, press the Metering mode start button (⊡) above the LCD panel, and then turn the Main dial (🔄) to choose the mode you want.

Evaluating exposures

After you make an image, the next step is to evaluate the exposure to see if adjustments are needed. The 70D's Brightness and RGB histograms are great tools for exposure evaluation, especially with JPEG capture. The histogram shows you immediately if the highlights retained detail or are blown out, and if the shadows retain detail or are blocked (go completely black too quickly). There are two types of histograms, and each provides important information for evaluating images.

NOTE A *histogram* is a bar graph that shows the distribution and number of pixels captured at each brightness level. The horizontal axis shows the range of values from black to white, and the vertical axis displays the number of pixels at each location.

Brightness histogram

The Brightness histogram is a snapshot of the exposure bias and the distribution of tones in the image. The brightness values are shown along the horizontal axis of the histogram. Values range from black (level 0 on the left side of the histogram) to white (level 255 on the right side of the histogram). Note that although the 70D captures 14-bit RAW images, the image preview and histogram are based on an 8-bit JPEG rendering of the RAW file.

The Brightness histogram shows whether the image has blown highlights (on the right side) or blocked-up shadows (on the left side). Blown highlights are indicated by a spike of pixels against the right side of the histogram. Once the highlight detail is blown, it is gone for good. Blocked-up shadows are indicated by a spike of pixels against the left side of the histogram. If the shadows are blocked up, you can, of course, lighten them in an editing program. However, lightening the shadows reveals the digital noise that is most prevalent in the shadows.

Overall underexposure is shown when there is a gap between the end of the highlight pixels and the right edge of the graph. Overexposure is indicated by a spike of pixels on the right side of the graph. If any of these exposure problems is indicated, you can reshoot using an exposure modification technique described later in this section.

> **TIP** The 70D's Highlight alert causes blown highlights to appear as blinking areas on the image preview during playback. You can turn on Highlight alert in Playback menu 3 (▶).

The Brightness histogram simply reflects the tones in the image. In an average scene, the pixels are distributed fairly evenly across the histogram. In a scene with predominately light tones, such as a high-key image of a child in a white dress against a white background, more pixels are concentrated on the right side of the histogram. Likewise, in an image with predominately dark tones, or a low-key image, more pixels are concentrated toward the left side of the graph. The histogram for Figure 3.19 shows an excellent exposure, with detail in the highlights and shadows. By using the histogram, I knew to add 1/3 stop of extra exposure to get the full tonal range in this image.

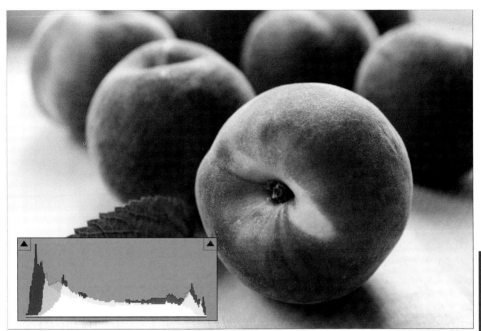

3.19 Here, a bit of positive exposure compensation helped create an excellent exposure. Exposure: ISO 200, f/3.2, 1/125 second, +1/3 exposure compensation.

3

RGB histogram

RGB histograms show the distribution of brightness levels for the Red, Green, and Blue (RGB) color channels. Each color channel has its own histogram so that you can evaluate the color channel's saturation, gradation, and bias. As with the Brightness histogram, the horizontal axis shows how many pixels exist for each color brightness level and the vertical axis shows how many pixels exist at that level.

More pixels to the left indicate that the color is darker and less prominent, while more pixels to the right indicate that the color is brighter and denser. If pixels spike on the left or right side, then color information is either lacking or oversaturated with no detail, respectively.

Differences in JPEG and RAW Exposure

With JPEG images, it is important to expose images to ensure that highlight detail is retained in the subject area. If you don't capture the highlight detail, it is gone forever in a JPEG exposure. To ensure that images retain highlight detail, you can use HDR (High Dynamic Range) shooting, or exposure modification techniques, such as Auto Exposure Lock or exposure compensation.

However, for RAW exposure, the goal is to ensure that you capture the first full f-stop of image data. That is important because CMOS sensors are linear devices in which each f-stop records half the light of the previous f-stop. And the first f-stop contains *half* the total image data. Thus, it is very important to capture the first f-stop and to avoid underexposure that sacrifices image data. So when you shoot RAW images, it's important to bias exposures toward the right of the histogram.

A right-biased exposure results in a histogram with highlight pixels just touching or nearly touching the right edge of the histogram. With a right-biased exposure, the image preview on the LCD may look a bit light, but you can adjust the brightness during image conversion with the assurance that you captured all the image data the 70D image sensor can deliver.

In addition, you have more latitude with RAW images because slight overexposures can be recovered during image conversion in Canon Digital Photo Professional, Adobe Camera Raw, Adobe Lightroom, or other conversion programs.

Both types of histograms are great tools for evaluating JPEG images because the histograms are based on the JPEG format. However, if you shoot RAW images, the histogram is based on a less-robust JPEG version of the RAW image. The nature of the RAW image data does not make it feasible to display a histogram of the linear image data, so the camera makes a JPEG version of the image and uses it for the preview image and the histogram. If you shoot RAW, just know that the RAW image is richer in data than what you see on the histogram. Some photographers set the Picture Style to a lower contrast to get a better overall sense of the RAW exposure. Despite the JPEG rendering, the histogram is still an invaluable tool for evaluating RAW exposures in the field.

To display a histogram, press the Playback button (▶). If the histograms aren't displayed, press the Info button (**INFO.**) two to three times until they appear with the image preview.

You can set the type of histogram that is displayed by default when you review images during playback, and if you like to see all the histograms, this can save you a couple of presses of the Info button (**INFO.**) to change displays.

To change the default histogram display, go to Playback menu 3, (▶), highlight Histogram disp, and then press the Setting button (⊛). Choose either Brightness or RGB, and then press the Setting button (⊛).

Modifying and bracketing exposures

With the ability to review the image histogram immediately, you know right away whether you need to modify the exposure. If you need to make exposure modifications, the 70D offers both automatic and manual options to modify exposure. The options include Auto Lighting Optimizer, Highlight tone priority, Safety shift, Auto Exposure Lock, Exposure Compensation, and Auto Exposure Bracketing.

Auto Lighting Optimizer

One of the 70D's automatic exposure adjustments is Auto Lighting Optimizer (🔅), which brightens images that are too dark and/or that have low contrast. While the corrections are automatic, you can choose the level of optimization you want.

Auto Lighting Optimizer is used in all automatic Basic Zone modes, but it's optional in the Creative Zone modes. Also, it's not applied in the Manual (**M**) or Bulb (**B**) exposure modes, although you can enable it. It's also not applied to RAW image files, but you can apply it during image conversion in Canon's Digital Photo Professional (DPP) program. Finally, Auto Lighting Optimizer is automatically disabled if you use Highlight Tone Priority, and it is temporarily disabled when you switch to HDR and Multiple-exposure shooting, features detailed later in this chapter.

If you most often print images directly from the media card, then Auto Lighting Optimizer can help you get better prints. It can also be helpful when you record movies. However,

if you care about controlling the exposure yourself, then don't use Auto Lighting Optimizer because it adjusts the image appearance, and masks the effects of exposure modifications, including exposure compensation, and Auto Exposure Bracketing (AEB).

Also, a downside of Auto Lighting Optimizer is that as it brightens the shadow areas in the image, digital noise becomes visible, just as it does when shadows are lightened in an image-editing program. So, if you use Auto Lighting Optimizer, use it with a dose of caution. If, however, you don't want or like to edit images on the computer, then Auto Lighting Optimizer may be a good option for you.

You can adjust the level of Auto Lighting Optimizer from the default Standard setting to Low or High, or you can turn off optimization entirely for images shot in the Program AE (**P**), Shutter-priority AE (**Tv**), and Aperture-priority AE (**Av**) exposure modes. Just go to Shooting menu 3 (◻), choose Auto Lighting Optimizer, and then press the Setting button (⊛). Choose the level you want or choose Disable to turn it off. On the same screen, you can enable Auto Lighting Optimizer for Manual (**M**) and Bulb (**B**) modes. On the Auto Lighting Optimizer screen, if a check mark (✓) is displayed next to the text, *Disabled in M or B modes*, it means that the optimization is turned off. If you want to enable it, press the Info button (**INFO.**) to remove the check mark.

> **NOTE** In automatic exposure modes, Auto Lighting Optimizer (🖾) is automatically applied at the Standard level to JPEGs.

Highlight tone priority

Highlight tone priority is designed to help retain highlight detail in bright elements in the scene. Highlight detail is improved by extending the range between 18 percent middle gray and the maximum highlight tones in the image, effectively increasing the dynamic range. It provides up to one additional stop of image detail in the highlight areas. Using Highlight tone priority also makes the gradations between gray tones and highlights smoother.

Highlight tone priority is especially useful when shooting very light objects, such as a wedding dress or white tuxedo, bright white sand on a beach, or light-colored products. If you enable Highlight tone priority, the lowest ISO is adjusted to 200.

Highlight tone priority takes advantage of the higher ISO baseline so that the image sensor pixel wells do not fill, or saturate. Also, with the 70D's 14-bit analog/digital

conversion, the camera sets a tonal curve that is relatively flat at the top in the highlight area to compress highlight data. The result is almost a full f-stop increase in *dynamic range* (the range from highlight to shadow tones in a scene as measured in f-stops). The trade-off, however, is a more abrupt move from deep shadows to black — a reduced range of shadow tones that also increases the potential for digital noise in the shadows.

To enable Highlight tone priority, set the Mode dial to a Creative Zone mode, and then follow these steps:

1. **On Shooting menu 4 (🗅), select Highlight tone priority, and then press the Setting button (⊛).** Two options then appear.

2. **Select Enable Highlight tone priority (D+).**

3. **Press the Setting button (⊛).** Shooting menu 4 (🗅) appears.

> **NOTE** If you enable Highlight tone priority, it is denoted in the viewfinder and on the LCD panel with this icon, **D+**, which indicates Dynamic range.

Safety shift

Another automatic exposure control option that can be very useful is Safety shift. With Safety shift, the camera automatically changes the manually selected aperture or shutter speed if the light changes dramatically enough to make the current exposure inaccurate when you shoot in the Aperture-priority AE (**Av**) or Shutter-priority AE (**Tv**) exposure modes. Alternatively, you can set Safety shift to adjust the ISO setting to get a standard exposure in sudden light shifts.

Having Safety shift change the exposure may seem intrusive, but in some scenarios such as action shooting, Safety shift can be welcome insurance in getting the best exposure. And it enables you to concentrate on capturing the moments of peak action.

To enable Safety shift, set the Mode dial to a Creative Zone mode, and then follow these steps:

1. **On the Custom Functions menu (.🗅.), highlight C.Fn I: Exposure, and then press the Setting button (⊛).** The screen for the last Custom Function you used in this group appears.

2. **Press left or right on the Multi-controller () until the number 6 appears in the box at the upper right of the screen, and then press the Setting button ().** The camera activates the function options.

3. **Turn the Quick Control dial () and select one of the following options:**

 - **0: Disable.** This turns off Safety shift.

 - **Shutter speed/Aperture.** Choose this option to have the camera automatically change either the shutter speed you set in Shutter-priority AE mode (**Tv**) or the aperture you set in Aperture-priority AE mode (**Av**) to get a good exposure if the light changes enough to require an exposure adjustment.

 - **ISO speed.** Choose this option to have the ISO you set change automatically in Program AE (**P**), Shutter-priority AE (**Tv**), and Aperture-priority AE (**Av**) modes to get a good exposure if the light changes.

4. **Press the Setting button ().** Press the shutter button halfway to return to shooting.

Auto Exposure Lock

If you've used the 70D for very long, then you know that when you focus, the exposure is also set at the same time. In most situations, this setting works well, but sometimes, you want the camera to meter and set the exposure on an area of the scene that is not where you want to focus. The only way that you can meter and lock the exposure on one area of the scene, and then focus on a different area is by using Auto Exposure Lock (AE Lock). You can also use AE Lock to lock and hold the exposure for a series of images taken under unchanging light.

> **TIP** AE Lock is a great tool to use with Spot metering mode () when you meter on a middle tone, lock the exposure, and then focus on another area of the scene.

Be aware that AE Lock works a bit differently in different metering modes as detailed in Table 3.1. You can use AE Lock in Program AE (**P**), Shutter-priority AE (**Tv**), and Aperture-priority AE (**Av**) modes. You cannot use AE Lock in the Basic Zone modes.

Table 3.1 Using AE Lock in Metering Modes

Metering modes	Manual AF-point selection	Automatic AF-point selection	Using Manual Focus
⊡	AE Lock is set at selected AF point	AE Lock is set at AF point or points that achieved focus	AE Lock is set at the center AF point
⊡,⊡,⊡	AE Lock is set at the center AF point	AE Lock is set at the center AF point	AE Lock is set at the center AF point

In cases in which the center AF point is used, be sure to point the center AF point over the part of the scene or subject on which you want to base the meter reading, and then press the AE Lock button (✱). The camera stores the locked meter reading for a few seconds while you move the camera to recompose the image, focus, and make the picture.

Exposure compensation

Another way to modify the camera's standard exposure is by increasing or decreasing the exposure by a specific amount using exposure compensation. You can set the exposure compensation up to +/-5 stops in 1/3-stop increments. While the 70D offers 5 stops of compensation, the LCD panel and viewfinder can only display 3 stops of compensation. To set the full 5 stops, use the Quick Control screen (press the Quick Control button Q), or use the Auto Exposure Bracketing (AEB) screen covered later in this chapter.

The classic use of exposure compensation is to override the camera's suggested exposure settings for subjects that are predominately white or black to get whiter whites and blacker blacks. You may have noticed that the camera tends to render snow scenes as grayish white and black train engines as grayish black. That's because the camera meter expects that scenes will reflect an average of 18 percent of the light, and that translates to middle gray on a tonal scale. If a scene reflects more than 18 percent of the light, then the camera darkens the image to get it to the average reflectance. That's how you get gray snow and train engines.

3

To get true whites and blacks, you have to override the standard exposure, and you can do that using exposure compensation. For example, setting +1 or +2 stops of compensation renders snow as white instead of grayish white. For a jet-black train engine, -1 or -2 stop of compensation renders it as true black. Of course, the goal is to set just enough compensation to get true whites without blowing out highlights, and to get true blacks without blocking up the shadows. For example, in Figure 3.20, I added 1/3 stop of extra exposure to get true whites in the flower. In bright light, less compensation is needed than in in moderate light. I also checked the histogram as I was shooting to ensure that the highlights retained details.

3.20 A slight amount of exposure compensation produced whiter whites in this daisy. Exposure: ISO 200, f/10, 1/800 second, +1/3 exposure compensation.

Exposure compensation is also useful when you want to modify the camera's metered exposure for a series of shots. Here are some points to know about exposure compensation:

▶ Exposure compensation can be used in Program AE (**P**), Shutter-priority AE (**Tv**), and Aperture-priority AE (**Av**) shooting modes. It cannot be used in Manual (**M**) or Bulb (**B**) modes.

► In Shutter-priority AE mode (**Tv**), setting exposure compensation changes the aperture by the specified amount of compensation. In Aperture-priority AE mode (**Av**), it changes the shutter speed. In Program AE mode (**P**), compensation changes both the shutter speed and aperture by the exposure amount you set.

► The amount of exposure compensation you set remains in effect until you change it.

► Automatic exposure correction features, such as Auto Lighting Optimizer, can mask the effect of compensation. I recommend turning off Auto Lighting Optimizer (⊞) on Shooting menu 3 (◘) if you are using exposure compensation.

► Exposure compensation is set by turning the Quick Control dial (○). As a result, it is possible to inadvertently set or change compensation. To avoid this, set the Lock dial to the up position. When you want to set compensation, just set it to the down position.

To set exposure compensation, watch in the viewfinder and turn the Quick Control dial (○) to the left to set negative compensation or to the right to set positive compensation. As you turn the Quick Control dial (○), the tick mark on the exposure level meter moves in 1/3-stop increments up to +/-3 stops.

If you want to set 4 or 5 stops of compensation, go to the next section on AEB. Also, if you set more than 3 stops of compensation, the exposure level indicator in the viewfinder displays left and right arrows. To cancel exposure compensation, move the tick mark back to the center position of the exposure level indicator.

Auto Exposure Bracketing

Auto Exposure Bracketing (AEB) enables you to capture a series of three images, at three different exposures. AEB is a often used when capturing a series of High Dynamic Range (HDR) images, or to photograph scenes in difficult light to ensure that one of the three exposures is good. Traditionally, the bracketing sequence is one image at the camera's standard exposure, one at increased exposure, and one at less exposure up to +/-3 stops. Thus, if the scene has high contrast, highlight detail is better preserved in the darker exposure than in either the standard or lighter exposure. Conversely, the shadows may be more open in the brighter exposure than in either of the other two.

With the 70D, you can shift the entire bracketing range to below or above 0 (zero) on the exposure level indicator. As a result, you can set all three bracketed exposures to be brighter or darker than the camera's standard exposure.

Exposure bracketing provides a way to cover the bases — to get at least one printable exposure in scenes with challenging lighting, scenes that are difficult to set up again, or scenes where there is only one opportunity to capture an elusive subject.

Today, however, exposure bracketing is most often used for High Dynamic Range (HDR) imaging. With the 70D, you can combine both exposure compensation and AEB to set exposure values up to 8 stops from the metered exposure. In practical application, combining exposure compensation and AEB provides a bracketing range that is more than adequate for most HDR work if you choose to do it manually rather than using the HDR mode on the camera. The in-camera HDR feature on the 70D is covered later in this chapter.

Regardless of how you use the bracketed exposures, keep these points in mind when using AEB:

▶ AEB is available in the Program AE (**P**), Shutter-priority AE (**Tv**), Aperture-priority AE (**Av**), and Manual (**M**) exposure modes, but not in Bulb (**B**) mode.

▶ AEB cannot be used with the built-in or an accessory flash unit, Multi Shot Noise Reduction, or Creative Filters.

▶ Settings for AEB are good only for the current shooting session. Turning off the camera, popping up the built-in flash, or turning on an accessory Speedlite cancels AEB. If you want to retain the AEB settings even after turning off the camera, you can set C.Fn1-3, Bracketing auto cancel to Off to retain the settings.

▶ In the High-speed (⬛H), Low-speed (⬛), and Silent (⬛S) continuous drive modes, pressing the shutter button once takes all three bracketed exposures. Likewise, in the 10-second (🕙10) or 2-second (🕙2) Self-timer modes, the bracketed shots are taken in succession after the timer interval elapses.

▶ In the Single (⬜) and Silent single shooting (⬜S) drive modes, you have to press the shutter button three times to get all of the bracketed shots.

▶ The order of bracketed exposures begins with the standard exposure, followed by the decreased and increased exposures. You can change the order of bracketing using C.Fn1-4, Bracketing sequence.

▶ You can use C.Fn I-5 to change the number of bracketed shots from the default 3 shots to 2, 5, or 7. The higher numbers are useful for HDR shooting.

▶ You can change the default 1/3-stop exposure increment to 1/2 stop using C.Fn1-1, Exposure level increments.

If you combine AEB with exposure compensation, the bracketed exposures are based on the amount of exposure compensation that you set.

To set AEB, set the Mode dial to Program AE (**P**), Shutter-priority AE (**Tv**), Aperture-priority AE (**Av**), or Manual (**M**) mode, and then follow these steps:

1. **On Shooting menu 3 (◻), highlight Expo. comp./AEB.**

2. **Press the Setting button (⊛).** The Exposure comp./AEB setting screen appears.

3. **Turn the Main dial (✻) clockwise to set the bracketing amount, and then press the Setting button (⊛).** As you turn the Main dial (✻), two additional tick marks appear and move outward from the center in 1/3-stop increments. If you want to shift the bracketing sequence above or below 0 (zero), turn the Quick Control dial (◯). You cannot shift the bracketing sequence in Manual mode (**M**).

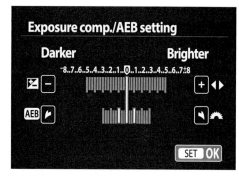

3.21 The AEB screen set for +/-1 stop of bracketing from the standard exposure.

Multiple-exposure Images

The 70D offers two new shooting techniques: Multiple-exposure images and HDR shooting. With both techniques, you have a nice range of options for setting up shots and choosing the final look of the image. Both techniques expand your creative opportunities with the camera. The following sections describe how to use both techniques.

Until recently, Canon digital photographers could not make multiple exposures in the camera. That changes with the 70D's Multiple exposure option. With the Multiple exposure option, it's possible to capture two to nine images and have the camera composite them into a single image. You can either shoot all new images, or choose an image on the media card as the base image. (The existing image you choose cannot have been captured with Highlight tone priority enabled, or have an aspect ratio other than 3:2.)

> **TIP** Shooting in Live View mode (📷) with the Multiple exposure option enabled allows you to watch each new image merge with the previous one.

Here are some things to know about multiple-exposure shooting:

▶ **Image quality and image settings.** You can use any of the JPEG image quality settings, and full-resolution RAW, S-RAW, and M-RAW for individual images, but the final image will be a full-resolution, RAW image. If M-RAW or S-RAW is selected when shooting begins, the camera automatically switches to RAW. You can shoot RAW+JPEG as well. The current settings for image quality (Picture Style, ISO, High ISO speed noise reduction, and so on), are used for the series. Multiple exposure shooting does not use the Auto Picture Style (⧉A). If it's selected, the camera automatically changes it to the Standard Picture Style (⧉S). For the best multiple-exposure image quality, keep the ISO low, the exposure time brief, use fewer rather than more exposures, and use a tripod in low light unless you're going for a creative blur effect. Also, test the mode in advance to see how image blending works. For example, I've found that the first image in the series has a higher blend opacity in the final image using the Average exposure option.

▶ **Some camera settings are disabled during Multiple exposure mode.** When shooting in Multiple exposure mode, you must shoot in one of the Creative Zone modes. Also, Auto Lighting Optimizer, Highlight tone priority, Peripheral illumination correction, and Chromatic aberration correction are disabled. These settings are not used even if they were in use for an existing RAW image that you select to use as the first image. Anything else that is grayed out on the menus is, of course, unusable.

▶ **Multiple exposure shooting can't be used in some modes.** Multiple exposure shooting is disabled if you have chosen White Balance Bracketing (WB☑), HDR mode, Movie mode ('🎥), Wi-Fi, or any of the automatic modes including Creative Auto (CA).

▶ **You should avoid changing or adjusting certain things on the camera when shooting multiple exposures.** Don't turn off the camera or replace the battery, because it will cancel multiple-exposure shooting. It's also cancelled if you start shooting in one exposure mode, and then switch to the Custom shooting mode (**C**), although the single images you've shot are saved to the media card. The series is cancelled if you move from Custom shooting mode (**C**) to Aperture-priority AE (**Av**) or another exposure mode. In short, don't switch among exposure modes during shooting. It is also cancelled if the camera powers off automatically. If you think that it will take several minutes or longer to shoot the series, then disable the Auto power off option on Setup menu 2 (**Y**).

▶ **Only the composite image is saved.** Individual images used for the series are not saved: Only the composite is saved. So, if there are images that you want to save individually, capture those images before you begin shooting the series.

Multiple exposure mode options

The Multiple exposure submenu on Shooting menu 4 (📷) has all the following options to set up the camera for shooting:

▶ **Multiple exposure.** This option is set to Disable by default. To enable multiple-exposure shooting, choose Enable.

▶ **Multi-expos ctrl.** This is where you determine the exposure calculation for the series. You can choose one of the following:

 • **Additive.** Every image exposure is cumulative, with each exposure adding to the next. To get a final image with a good exposure, set negative exposure compensation before shooting each image. The more exposures you make, the higher the negative compensation needed per exposure. As a starting point, Canon recommends setting the following negative exposure compensation: 1 stop for 2 exposures, 1.5 stops for 3 exposures, and 2 stops for 4 exposures. When you use Additive, the image on the LCD may look noisy. However, noise reduction is applied to the final image for an improved appearance. Also, this option takes more time than the Average option.

- **Average.** Choose this option when you want the camera to automatically figure out the amount of negative exposure compensation to set based on the number of images you choose for the series. This works well when you photograph the same scene multiple times. In that scenario, the camera moderates the exposures to keep the background and overlapping highlight areas from overexposing. I find that option works well, even if there are moderate changes in light among the exposures. For Figure 3.22, I used two exposures and Average exposure control. The contrast of the composited image was very low, so I increased it during image editing.

▶ **No. of exposures.** You can choose from two to nine images. Alternatively, you can use an image on the media card as the starting image. If you do that, then it counts as the first image. Thus, in a three-image composite that uses an existing image on the card, you shoot two images to complete the series.

▶ **Continue Mult-exp.** Your choices are 1-shot only or Continuously. Each does what it says it will. If you choose Continuously, then be sure to come back to choose Disable for the Multiple exposure option on Shooting menu 4 (**◻**) to return to normal shooting.

▶ **Select image for multi. expo.** The Multiple exposure screen provides this option so you can use an existing full-resolution RAW (**RAW**) image as the starting image for the composite. You cannot use M/RAW (**M RAW**) or S/RAW (**S RAW**), or JPEG images. You can choose this option, and then press the Setting button (**SET**) to navigate to the RAW image on the media card you want to use as the first image. As mentioned earlier, there are restrictions, including

3.22 A two-image multiple-exposure using Average. Exposure: ISO 200, f/5.6, 1/600 second.

that the image was not captured with Highlight tone priority. The camera settings, including the Picture Style, ISO, and color space used for the base image will be used for the rest of the images in the series.

Shooting in Multiple exposure mode

An important step in getting a successful multiple-exposure image is planning the content of the composited image, and having a clear vision of the story. Before you begin capturing new images for a series, ensure that the Mode dial is set to Program AE (**P**), Shutter-priority AE (**Tv**), Aperture-priority AE (**Av**), Manual (**M**), or Bulb (**B**) exposure mode. Next, follow these steps:

1. **On Shooting menu 4 (<img_1-icon>),** **choose Multiple exposure,** **and then press the Setting** **button (⊜).** The Multiple exposure screen appears.

2. **Select Multiple exposure, and** **then press Set (⊜).** Two options appear.

3. **Choose Enable, and then press** **the Setting button (⊜).** The Multiple exposure screen options reappear.

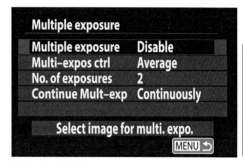

3.23 The Multiple exposure screen.

4. **Select Multi-expos ctrl, and then press the Setting button (⊜).** The Additive and Average options appear.

5. **Choose an option, and then press the Setting button (⊜).**

6. **Choose No. of exposures, and then press the Setting button (⊜).**

7. **Press up or down on the Multi-controller (⌖) to select the number of exposures you want, and then press the Setting button (⊜).** You can choose from 2 to 9 shots. In my experience, fewer images are generally better.

8. **Select Continue Mult-exp, and then press the Setting button (⊜).** The 1 shot only and Continuously options appear.

9. **Choose the option you want, and then press the Setting button (⊛).** With 1 shot only, multiple-exposure shooting stops automatically when the selected number of shots is made. With the Continuously option, you have to specifically go back to steps 1 and 2 and choose Disable in step 3.

To choose an existing RAW (RAW) image as the starting image, repeat steps 1 and 2 in the previous list, and then follow these steps:

1. **On the Multiple Exposure screen, turn the Quick Control dial (○) to highlight Select image for multi. expo., and then press the Setting button (⊛).** The most recent image captured appears on the LCD screen.

2. **Turn the Quick Control dial (○) to select the starting RAW image you want to use, and then press the Setting button (⊛).**

3. **Select OK.** The image file number appears at the bottom of the screen, and the number of images in the series is reduced by one image. Then you can shoot the remaining images in the series.

As you shoot the images, the number of images left in the series is displayed in the lower right of the LCD screen and in the viewfinder, and new images are composited with earlier images. If you're using Live View mode (□), you can see the images as they are merged.

To check the images captured so far, press the Playback button (▶). Next, press the Erase button (🗑) to use the following controls:

▶ **Return to previous screen (↩).** This option takes you back to the previous screen.

▶ **Undo last image (□).** Select this option, and then press the Setting button (⊛) to confirm and delete the last image. After the deletion, the remaining number of images in the series increases by one, and the controls disappear so you can continue shooting.

▶ **Save and exit (□).** Select this option, and then press the Setting button (⊛) to confirm that you want to merge the images captured as the final multiple-exposure image. Choose OK on the Save and exit confirmation screen.

▶ **Exit without saving (□).** This cancels the multiple-exposure series, and all images are deleted.

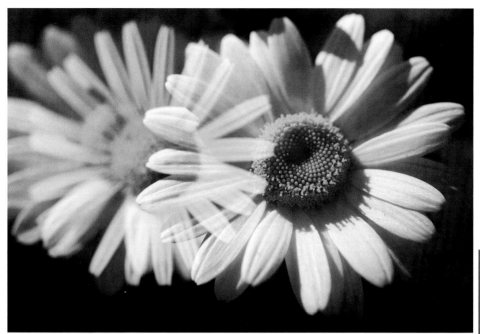

3

3.24 This three-shot exposure (set to Additive) interlaces the front and middle image elements in an interesting way. Exposure: ISO 200, f/3.5, 1/1250 second, +2/3-stop exposure compensation.

Shooting HDR images

HDR shooting is a technique that has gained wide acceptance and popularity among photographers. HDR shooting captures a series of bracketed images, with one or more exposures set to maintain the highlights, other exposures optimized for the mid-tones, and other exposures optimized for shadow detail. In traditional HDR shooting, three, five, seven, or more bracketed frames are merged into the final composite image in a specialized HDR program or in Photoshop. The resulting image has a dynamic range beyond what the camera can capture in a single frame. Various image-processing options create image looks that range from traditional photographic renderings to those with very high contrast and detail to artistic renderings.

> **NOTE** HDR images are always bracketed by shutter speed rather than by aperture to avoid shifts in focal lengths among shots.

Now, it is much easier to use HDR for everyday shooting because the 70D offers in-camera HDR capture, compositing, and processing. The in-camera processing doesn't offer the options that full-blown HDR programs offer, but it is still a very capable and handy feature.

> **NOTE** With any HDR shooting, use a tripod so that the combined images align perfectly. Also, because the images are bracketed by shutter speed, it's even more important to stabilize the camera for low-light scenes.

Here are some things to know about HDR shooting:

► **Image quality and saved image.** You cannot shoot RAW (RAW) or RAW+JPEG (RAW+◢ L) images. The three bracketed JPEG images are composited, and saved as a single JPEG file. If you shoot using Large/Fine quality (◢ L), then the final image will be Large/Fine (◢ L) quality. Otherwise, if you're shooting at a lower JPEG quality, then the resulting HDR image will match that quality setting. Only the final composited JPEG image is saved — the bracketed images are not saved.

► **About Auto Align.** The main thing to know about using HDR shooting and Auto Align is that you should stabilize the camera. Really. It's true that you can set Auto Image Align, and the 70D will automatically line up the edges as best it can. However, the natural shake of your hand while holding the camera during a slow shutter speed can cause images to misalign, as can subject movement. If the images are far off, then Auto Align may not be used at all. In addition, the alignment may not be perfect when shooting in very bright or dark exposures. If you don't enable Auto Align and if you handhold the camera for a series of HDR images, then the images may not align due to camera shake and the expanded dynamic range effect may be minimal. Also, when the images are aligned, the camera may crop the edges of the composited image giving a smaller than usual final image. Scene and subject conditions such as repetitive patterns and flatly lit subjects can throw off alignment as well.

► **Image settings and capture.** You can use HDR only in Creative Zone modes. Image settings, including the quality, ISO, Picture Style, High ISO speed noise reduction, and so on, that are in effect for the first image will also be used for the remaining two images. Note that if you're using the Auto Picture Style (⌗A), HDR shooting automatically sets it to the Standard Picture Style (⌗S). When

you press the shutter button to capture the three images, the camera fires them off relatively quickly. However, if you've set the drive mode to High-speed Continuous (⊒H), the capture rate will be slower than usual. Note also that color accuracy may be off when shooting in fluorescent light or with an LED.

▶ **When HDR can't be used.** HDR shooting won't work if you have set Auto Exposure Bracketing (AEB), White Balance Bracketing, Multi Shot Noise Reduction, Multiple exposure shooting, or an expanded ISO (the ISO range is 100 to 12800 for HDR). It also won't work in Bulb (**B**), Movie ('**🎥**), or automatic modes, or with the Wi-Fi function enabled.

▶ **What's disabled with HDR shooting.** Neither the built-in flash or an accessory Speedlite will fire when shooting HDR images. When you enable HDR shooting, the camera disables Auto Lighting Optimizer, Highlight tone priority, and Exposure simulation (if you're shooting in Live View mode 📷). Other menu items are also disabled.

The HDR Mode screen provides the following options for HDR shooting:

▶ **Adjust dyn range.** With this menu option, you can set the bracketing range to plus/minus 1, 2, or 3 EV. Or choose Auto to let the camera determine the bracketing amount. Only the shutter speed changes, and that's done to avoid focal-length shifts. While each scene differs, generally, the higher the contrast and the brighter the light in the scene, the wider the bracketing difference you should use.

▶ **Continuous HDR.** This menu option enables you to capture one HDR shot or shoot HDR for all images until you change this option.

▶ **Auto Image Align.** This is another menu option with which you can have the camera automatically align the images. With automatic alignment enabled, the camera can correct minor misalignments among the images for handheld images. In the alignment process, you can expect the composite image to be slightly cropped. If camera shake from handholding causes too much difference among images, then Auto image align won't be used. If you are using a tripod, then choose Disable.

To set up for HDR shooting, set the Mode dial to a Creative Zone mode (except Bulb **B**), and then follow these steps:

1. **On Shooting menu 4 (📷), select HDR Mode, and then press the Setting button (⑤).** The HDR Mode screen appears.

2. **Select Adjust dyn range, and then press the Setting button (⬤).**

3. **Turn the Quick Control dial (◯) to choose the setting you want, and then press the Setting button (⬤).** The options are described earlier in this section.

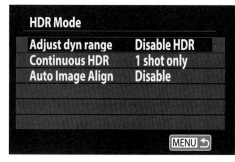

HDR Mode

Adjust dyn range	Disable HDR
Continuous HDR	1 shot only
Auto Image Align	Disable

MENU ↩

3.25 The HDR Mode screen.

4. **Select Continuous HDR, and then press Set (⬤).** The 1 shot only and Every shot options appear. If you choose Every shot, be sure to come back to the HDR Mode screen and disable HDR mode shooting when you finish shooting.

5. **Turn the Quick Control dial to select the option you want, and then press Set (⬤).** The HDR Mode options reappear.

6. **On the HDR Mode screen, select Auto Image Align, and then press Set (⬤).** The Enable and Disable options appear.

7. **Choose the option you want, and then press Set (⬤).** Choose Enable if you're hand-holding the camera, or choose Disable if you're using a tripod.

8. **Press the shutter button once to take the three bracketed images.** After a short wait, the composited JPEG image appears on the LCD screen. The interme-diate images used to make the final HDR image are not saved.

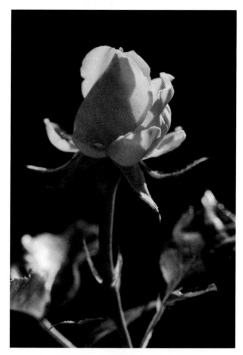

3.26 The HDR composite of a backlit rose bud. Exposure: ISO 200, f/7.1, 1/320 second.

Getting Sharp Focus and Setting Drive Modes

For anyone who had the Canon EOS 60D and waited for the 70D, one of the top items on the wish list was an upgraded autofocus system. That upgrade came in spades with the 70D. Going from what now seems like a paltry nine autofocus (AF) points, the 70D has 19 AF points for viewfinder shooting. The new revolutionary autofocus in Live View (📷) and Movie ('🎥) modes also promises to set new industry standards.

Whether you are shooting one image at a time or you are blasting out the maximum burst of images as players move across a soccer field, the 70D's autofocus is quick and accurate, and it offers three autofocus modes and an array of new focusing options to refine focusing for different subjects and scenes.

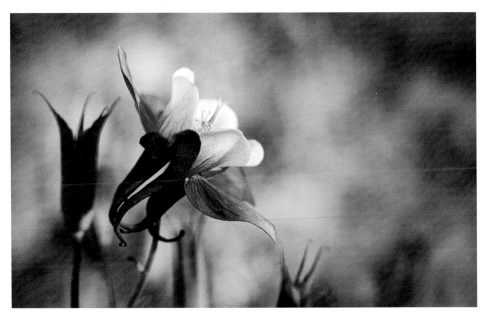

The 70D provides fast, sharp focus, as well as a wide selection of focusing options. Exposure: ISO 200, f/5.6, 1/320 second+1/3 exposure compensation.

Understanding the Autofocus System

It's important to know that sharp focus ultimately involves three factors: The resolving power of the lens, the resolution of the sensor, and the resolution of the printer. Printing images is beyond the scope of this book, and I hope that you're using high-quality lenses. That leaves one remaining factor — the sensor and internal autofocus system. The 70D's excellent autofocus system, inherited from the popular Canon EOS 7D, delivers high focus accuracy for shooting through the viewfinder, as well as improved subject tracking.

One step for improving autofocus and tracking performance was to incorporate cross-type AF sensors and a center high-performance, dual-cross-type AF point in the 70D. If you understand what cross-type AF points offer, you can use them to get the best performance from the autofocus system.

Canon uses a variety of cross-type sensors, as well as high-precision autofocus sensors, that offer two to three times greater autofocus accuracy at the sensor with a wide-aperture lens than standard sensors. As focus technology evolved, engineers discovered that the farther apart the two sensors were, the finer the focus could be adjusted. However, there is a physical limit to how far apart the two sensors can be, and that limit is the widest aperture of the lens.

This is why every sensor requires a lens of a certain aperture (or wider) to operate optimally. (The autofocus sensor requires either a certain aperture, or an aperture and extender combination.) The spacing of standard-precision sensors requires an f/5.6 or faster lens. However, high-precision sensors require an f/2.8 or faster aperture lens to get a large enough beam of light to cover the sensors that are spaced farther apart. If you use an f/5.6 maximum aperture lens, then the high-precision f/2.8 sensors do not function and the camera usually uses standard-precision sensors instead.

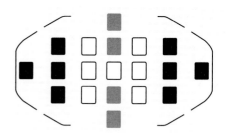

Illustration courtesy of Canon

4.1 In this illustration, the white AF points are cross-type sensors with lenses that have a maximum aperture of f/3.2 to f/5.6. The gray AF points detect vertical lines, and the black AF points are sensitive to horizontal lines within the subject or scene.

On the 70D, the cross-type functionality depends on the maximum aperture of the lens and the specific lens that you're using. So, with the following lenses with a maximum aperture of f/3.2 to f/5.6, the peripheral AF points

detect either vertical or horizontal lines, but not both: EF 35-80mm f/4-5.6, EF 35-80 f/4.5-5.6 II, EF 35-80mm f/4.5-5.6 III, EF 35-80mm f/4.5-5.6 USM, EF 35-105mm f/4.5-5.6, EF 35-105mm f/4.5-5.6 USM, EF 80-200mm f/4.5-5.6 II, and the EF 80-200mm f/4.5-5.6. In other words, the center and the three AF points to the left and right of center function as cross-type sensors. The rest of the AF points do not offer cross-type line detection.

> **NOTE** Maximum aperture is the widest aperture of a lens. The maximum aperture varies by lens. Many wide-angle and normal focal-length lenses have faster maximum apertures of f/2.8 or wider. Some telephoto lenses have f/2.8 maximum apertures, while others have f/4 or f/5.6.

For fast lenses with apertures of f/1.0 to f/2.8, the center AF point becomes a high-precision AF point, particularly for vertical line detection. With the fast lenses, the remaining AF points offer cross-type functioning as they do with lenses that have a maximum aperture of f/3.2 to f/5.6. The only exceptions are the EF 28-80mm f/2.8-4L USM and the EF 50mm f/2.5 Compact Macro lens.

If you're new to using a digital SLR camera, then this type of information may seem overwhelming, and you may wonder why it's important. It is important because it can help you get more accurate (and faster) focus if you have the lenses listed.

Setting Up and Using Autofocus

The 70D's autofocus system has many more features than the EOS 60D and other Canon cameras, and gives you ample opportunity to refine how the focus system operates. At the same time, some aspects of the autofocus system haven't changed from previous cameras. For example, there are still three autofocus modes, but for AI Servo AF mode (**AI SERVO**), there's now a host of configuration and customization options. This section details how to choose an AF mode, manually select an AF point, and use AF area selection modes.

Choosing an autofocus mode

Perhaps the easiest part of setting up autofocus is choosing the AF mode you want to use. There are three autofocus modes that are designed to help you achieve sharp focus based on the type of subject you are photographing.

Here is a summary of the autofocus modes and when to use them:

▶ **One-shot AF (ONE SHOT).** This mode is designed for photographing stationary subjects that will remain so. Choose this mode when you shoot landscapes, close-ups, portraits, architecture, and interiors. Unless you are shooting sports or action, One-shot AF mode (**ONE SHOT**) is good for everyday shooting. With the default setting, the camera won't allow you to make the image until focus is achieved. In One-shot AF mode (**ONE SHOT**) and with Evaluative metering mode (⊡), the exposure is also set when you focus on the subject.

4.2 For this shot, I used One-shot AF mode, manually selected a single AF point, and focused on the center of the cookie. Exposure: ISO 200, f/6.3, 1/8 second, +1/3 exposure compensation.

▶ **AI Servo AF (AI SERVO).** This mode is designed for photographing action subjects, and is typically used with Continuous drive mode (⊡) for shooting in burst mode at 7 frames per second (fps). The 70D offers a variety of options to customize AI Servo AF mode (**AI SERVO**). To start focus tracking, select the starting AF point or AF area, and then press the shutter button halfway to focus on the subject. The camera will maintain focus as long as the subject stays within the bank of AF points or the Area of AF points (covered later in this chapter). The focus and exposure are set at the moment the image is made.

▶ **AI Focus AF (AI FOCUS).** This mode is designed for photographing still subjects that may begin moving. AI Focus AF mode (**AI FOCUS**) starts out in One-shot AF mode (**ONE SHOT**), but if the subject moves, it automatically switches to AI Servo AF mode (**AI SERVO**). If the camera switches to AI Servo AF (**AI SERVO**), it con- firms focus with a soft beep (but only if you have turned on this sound in Shooting menu 1 **◘**). The focus confirmation light in the viewfinder does not light. Choose this mode when photographing wildlife, pets, children, or athletes who alternate between being stationary and moving. A disadvantage to this focus mode is that if you focus, and then move the camera to recompose the shot, the camera may incorrectly detect the camera movement as subject movement and switch into AI Servo AF mode (**AI SERVO**). This can cause soft focus. Alternately, if the sub- ject begins moving, AI Focus AF mode (**AI FOCUS**) may be slower to respond and track subject focus than AI Servo AF mode (**AI SERVO**).

TIP If you routinely focus, and then keep the shutter button pressed halfway as you wait to get the right shot, this shortens battery life. To maximize power, anticipate the shot, and then press the shutter button halfway just before taking the picture.

In the Program AE (**P**), Shutter-priority AE (**Tv**), Aperture-priority AE (**Av**), and Manual (**M**) Creative Zone modes, you can set any of the three autofocus modes. However, in Basic Zone modes, such as Scene Intelligent Auto (**🖾**), Portrait (**♥**), and Landscape (**🏔**), the mode is set automatically, and you cannot change it.

4

In Scene Intelligent Auto (**🖾**), Flash off (**🚫**), and Creative Auto (**CA**), AI Focus AF mode (**AI FOCUS**) is set. In Sports mode (**🏃**), AI Servo AF mode (**AI SERVO**) is set. In all the other Basic Zone modes, One-shot AF mode (**ONE SHOT**) is selected.

To select a focus mode, first ensure that the camera is set to Program AE (**P**), Shutter- priority AE (**Tv**), Aperture-priority AE (**Av**), Manual (**M**), or Bulb (**B**) mode, and that the lens switch is set to autofocus.

Press the AF button (**AF**) above the LCD panel, and then turn the Main dial (🔆) to select the autofocus mode you want. The name of the mode is displayed on the LCD panel.

TIP If the camera has trouble focusing in low light, use the AF-assist beam (see Chapter 6) with either the built-in flash or an accessory Speedlite.

Refining focus for action subjects

If you shoot action, such as sports, events, or wildlife, then you know that not all movement is created equal, and a single tracking and focusing system does not work for every subject. The 70D offers a generous amount of control over AI Servo AF mode (**AI SERVO**), the mode of choice when photographing action. While Custom Functions are detailed in Chapter 6, I cover the ways that you can refine AI Servo AF (**AI SERVO**) here for convenience.

On the Custom Functions menu (.💿.), you can customize the way AI Servo AF mode (**AI SERVO**) behaves to suit the subjects you're photographing. To make adjustments, just think about the action subjects that you most often photograph, and then adjust the settings for the subject's movement characteristics.

Here are the Custom Functions for refining focus:

▶ **C.Fn II-1 Tracking sensitivity.** This setting determines how the system responds to either maintain focus on the original subject or switch focus to a subject that suddenly enters the frame or if the subject moves out of the AF point array. The adjustment can have the camera either respond quickly and focus on the new subject or it can wait slightly so you can find the subject again. The scale ranges from Locked on to Responsive. Here are the options:

- **0.** The default setting is middle of the road, and the one Canon says is good for most moving subjects. I recommend shooting action subjects with this setting first to know to see if it works well for your typical action subjects. Then you'll have more information for choosing another option.

- **Locked on: -2/Locked on: -1.** With this option there is a noticeable delay before the camera focuses on the new subject if another subject or object enters the scene. A -2 setting extends the delay. Use this when you want to keep focus on a specific player, instead of switching focus to a player who comes between the camera and your original subject. The downside of this setting is that if the camera hasn't focused on the correct subject, then getting it to switch to the right subject is slower and more challenging.

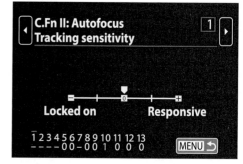

4.3 The Tracking sensitivity screen.

- **Responsive: +2/Responsive +1.** This option determines the speed with which the camera focuses on a new subject, with +2 being faster than +1. A +2 setting can cause the camera to focus on the wrong subject. The setting you choose depends on the subject. If you are following a star soccer player across the field, then a -1 setting is a good choice. Conversely, if you're shooting the finish line of a track meet, then use a +1 setting so the camera switches focus to new athletes as they enter the frame.

▶ **C.Fn II-2 Accel./decel. tracking.** With the acceleration/deceleration tracking function, you adjust how the AF system responds to subjects that start, stop, and change direction erratically and unpredictably. AI Servo AF mode (**AI SERVO**) is designed to predict the subject's movement based on its speed and direction. You can fine-tune its response based on the subject's motion. The options are:

- **0.** This is the default, and it is designed to provide good focus tracking for a subject moving at a steady speed. Set this parameter to 0 to track subjects that are moving, and are likely to continue moving in the same direction at a predictable speed; for example, cyclists or long-distance runners on a straightaway. A 0 (zero) setting is the least responsive to subject speed changes.

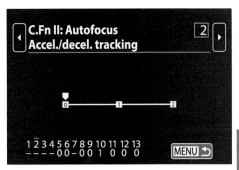

4.4 The Accel./decel. tracking screen.

- **+2/+1.** A plus setting tells the system to expect erratic direction shifts and sudden starts and stops and to keep focus on the subject; for example, the motion of a soccer player. A +1 or +2 setting can help keep focus on subjects coming toward the camera at varying speeds, thus avoiding focusing on subjects behind the main subject. A +2 setting does a better job of tracking subjects with significant changes in speed. A high sensitive level can cause momentary focus instability as the camera responds to even small subject movements.

▶ **C.Fn II-3 AI Servo 1st image priority.** Use this and the next Custom Function, AI Servo 2nd image priority, when you use continuous focus tracking coupled with one of the continuous drive modes. Use the options here to prioritize subject focusing, shutter release, focus tracking, or shooting speed for the first

image during continuous shooting. Your choice depends on your priorities and the subject. If the subject is moving across the frame at the same distance through the frame and through the burst of images, then you may choose to give priority to subject focus for the first shot and shooting speed for the second shot. However, if the subject distance varies, then you may want subject focus as the first shot priority and focus tracking for subsequent shots. Here are the options.

- **Equal priority.** This is the default. It is the middle of the road so that both focusing and shutter release have the same priority. This allows fast shooting, but the subject may or may not be in sharp focus.

- **Release priority.** Choose this if you want to be able to take the picture regardless of whether the camera has had time to establish sharp focus. I have trouble envisioning a scenario in which I would use this option because, for me, if the subject isn't in focus, the picture goes in the trash. However, if you must have a picture with or without sharp focus, then this option works.

- **Focus priority.** Choose this option if you want to help ensure an in-focus subject at the cost of maybe missing a shot because the camera hasn't been able to establish focus yet. As you might have guessed, I use this option.

▶ **C.Fn II-4 AI Servo 2nd image priority.** This tells the 70D what priority to use for the second and subsequent images when you're shooting a continuous burst of images. Here are the options:

- **Equal priority.** This is the default, and again, it is the middle of the road in that both focusing and shutter release — for example, shooting speed — have the same priority. Because the camera prioritizes focus equally, you can shoot only as fast as the camera is able to establish focus. Thus, in dim light or when subjects don't have strong contrast, shooting may slow down noticeably.

- **Shooting speed priority.** Choose this if you want to be able to take the picture regardless of whether the camera has had time to establish sharp focus.

- **Focus priority.** Choose this option if you want an in-focus picture at the expense of maintaining a fast shooting speed.

There are more focus-related Custom Functions covered in Chapter 6, but these are the main functions that will help you fine-tune focus when using AI Servo AF mode (**AI SERVO**). To set a Custom Function, follow these steps:

1. **On the Custom Function menu (.🔧.), select C.Fn II: Autofocus, and then press the Setting button (⊛).**

2. **Press left or right on the Multi-controller (⬧) until you see the number of the function you want in the box at the top-right corner of the screen, and then press the Setting button (⊛).** For example, if you want to adjust C.Fn II-4, press left or right until the number 4 appears in the box. When you press the Setting button (⊛), the function options are activated.

3. **Press down on the Multi-controller (⬧) to select the option you want, and then press the Setting button (⊛).** The choices you make remain in effect until you change them.

Choosing an AF point manually

Setting the autofocus mode is only one step in using the 70D's autofocus system. The next step is ensuring that you get sharp focus precisely where it should be in the image. And to do that, you need to choose an AF point or an AF zone.

In the photography courses I teach, I find that many photographers let the camera automatically choose the AF point(s). As a result, in many of their portraits, the subject's nose is in tack-sharp focus while the eyes are a little soft — just the opposite of how it should be. It's a light-bulb moment when they learn how to manually choose and use one AF point to place sharp focus precisely where it should be in the scene.

4.5 For this image, I used One-shot AF mode with manual AF point selection on the subject's right eye. Exposure: ISO 160, f/14, 1/125 second.

To select a single AF point manually, set the Mode dial to a Creative Zone mode, and then follow these steps:

1. **Press the AF-point Selection/Magnify button (⊞) or the AF area selection mode button (⊡).** The AF points are displayed in the viewfinder.

2. **Press the direction keys on the Multi-controller (⸙) in the direction of the AF point you want to select.** Choose the AF point that is on top of the part of the scene or subject that should have the sharpest focus. You can also turn the Main dial (⌖) to move horizontally through the AF points, or turn the Quick Control dial (◯) to move vertically. Press the Setting button (⊛) to quickly select the center AF point.

3. **Press the shutter button halfway to focus using the AF point, and then press it completely to take the picture.** The autofocus confirmation light in the viewfinder is lit continuously when focus is achieved.

Choosing an AF area

In addition to the traditional technique of choosing a single AF point, the 70D adds the ability to choose autofocus areas with five zones or clusters of AF points when you choose a Creative Zone mode. Autofocus areas enable you to limit the AF points used for focusing.

These are the three AF area selection modes:

▶ **Single-point AF Manual selection (⊡).** This is the classic single AF point. It works well when you want to place the point of sharp focus precisely, especially with still subjects. Single-point AF can be problematic when there is insufficient or no detail or texture at the focus point to establish focus. If that's the case, then switch to another mode.

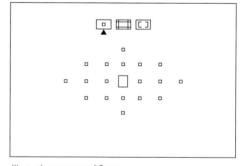

Illustration courtesy of Canon

4.6 The Single-point AF uses only one AF point (the rectangle shown here) for precise focusing.

▶ **Zone AF Manual selection of zone (⊞).** With this mode, the 19 AF points are grouped into five zones comprised of four or nine AF points. Then, you choose the zone that's used for focusing. The camera automatically

- -

chooses the AF point(s) to use from within the zone of AF points. The camera is prone to focusing on whatever is nearest to it, and getting it to switch focus to another point in the scene can be difficult. You can choose the zone of AF points, although you cannot change the AF points used in the zone or area, or the number of AF points used. This mode works well when you want the focus on the nearest subject. With the larger,

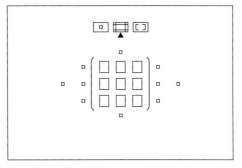

Illustration courtesy of Canon

4.7 Zone AF with Manual zone selection. This shows the center zone, or area of AF points selected.

nine-AF point zone, it is easier to keep the subject in the zone of AF points. This option works best when nothing blocks the view of the AF points.

Illustration courtesy of Canon

4.8 The five AF zones from which you can select when you use AF Area Selection modes.

▶ **19-point automatic selection AF (⊟).** This is the traditional automatic AF-point selection mode where the camera makes an educated guess on what and where the subject is in the frame, and then it chooses the AF points for focusing. In One-shot AF mode (**ONE SHOT**), the nearest subject will likely get the focus. You can see the AF points that achieve focus in the viewfinder. In AI Servo mode (

AI SERVO), you choose a starting AF point that identifies the sub-ject to the camera. The camera tracks focus on the subject as long as the subject stays within the 19 AF point array. With this option the camera typically focuses on the nearest object. This works best if the subject is small in the frame. You can see the progress through the AF points in the viewfinder or you can turn off the tracking display.

Illustration courtesy of Canon

4.9 The 19-point automatic selection AF.

As you read the descriptions of the AF area selection modes, you may know immediately which ones you'll use. There may be some that you never use. You can add and subtract the AF area selection modes that you can choose using Custom Function II-7.

Before you begin, ensure that the camera is set to Program AE (**P**), Shutter-priority AE (**Tv**), Aperture-priority AE (**Av**), Manual (**M**), or Bulb (**B**) mode. Here's how to change the AF area selection mode:

1. **As you look through the viewfinder, press the AF point selection/Magnify button (⊞) or the AF area selection mode button (⊡).**

2. **Press the AF area selection mode button (⊡) one or more times until the AF area selection mode you want is indicated in the viewfinder with an arrow under its icon.** The icon order in the viewfinder is Single-point AF (Manual selection, ▢), Zone AF (▦, Manual zone selection), and 19-point automatic selection AF (▣). The mode you choose stays in effect until you change it.

3. **To change the zone (see Figure 4.8), press a direction key on the Multi-controller (⸬).**

4. **Press the shutter button halfway to focus.** The AF points within the zone are displayed in the viewfinder. If you want to use different AF points, shift the camera a little and refocus.

> **NOTE** You can have the 70D remember and automatically select your favorite AF point or AF area selection mode for three different camera orientations: horizontal, vertical with grip up, and vertical with grip down. Just register them using Custom Function II-9 (see Chapter 6).

Adjusting lens focus

In years past, if lenses needed adjustment, you had to send your camera and lens to Canon, where technicians would make the adjustments. Now you can make the adjustments yourself. The do-it-yourself approach saves time and money, but it's not necessarily an easy or foolproof operation.

Making microadjustments entails taking a picture, preferably of a calibration target that is specifically designed for lens alignment. Then you evaluate the picture on the computer to identify focus misalignment such as back and front focusing. If there is a

focusing misalignment, you can adjust the lens on the camera. Then repeat the process until the focus is precisely where it should be. Typically, you adjust individual lenses. However, Canon also offers the option of making a single global adjustment that is applied to all the lenses used on the camera.

I recommend you buy a calibration target designed specifically for lens adjustment. I use LensAlign from Michael Tapes Design (http://michaeltapesdesign.com). The Michael Tapes Design website also provides step-by-step instructions for making microadjustments to the focus.

> **NOTE** Not all lenses need to be adjusted. Do so only if you notice consistent back or front focusing on one or more lenses, or on all of your lenses when shooting with the 70D.

Here are some things to remember about microadjustment with the 70D:

▶ **You can adjust and register adjustments for up to 40 lenses if you adjust lenses individually.** If you reach the 40-lens mark, you have to delete an existing lens before you can add another lens.

▶ **If you have more than one copy of a lens, you can only adjust one of them.** The copies are identified by the serial number that's entered during the alignment process. If an asterisk appears in front of the lens's 10-digit serial number during the adjustment process, it cannot be registered.

▶ **The serial number from the lens that you enter during the adjustment process may be different from the one displayed on the camera screen.** Canon says this is not an error.

▶ **Enter only numbers for the serial number even if it includes letters.** If your lens doesn't have a serial number, you can make one up during the registration process.

▶ **Make microadjustments at both the wide and telephoto ends of zoom lenses.** If you adjust individual lenses, then once you make the adjustment to the wide and telephoto ends of a zoom lens, the intermediate focal length is automatically adjusted as well. If you choose to adjust all lenses by the same amount, then you cannot adjust for the wide and telephoto ends of zoom lenses.

4

▶ **Canon recommends making microadjustments on location because the subject and scene conditions, and the zoom position of the lens, can influence the adjustment.** Practically speaking, it's unlikely that the average shoot has time built in to the schedule to adjust each lens in the camera bag. So, be aware that even if you've adjusted the lenses you're using, the scene and subject conditions can cause previous focus adjustments to be less than perfect.

▶ **You can make adjustments for a lens and lens extender combination.** If you do, then be sure to use the extender when you use the lens.

▶ **The focus adjustments you make are used only in Quick focusing mode (AFQuick) in Live View mode (📷).**

▶ **Use Large JPEG image quality to check the adjustments, rather than a lower-quality JPEG or RAW setting.**

▶ **Use a tripod and ensure that the calibration target is stable.**

If you lose your nerve while making adjustments, or if you find that focus is worse after an adjustment than before, just press the Erase button (🗑) when you see a Clear all option at the bottom of the AF Microadjustment screen. This screen appears during the adjustment process. Selecting the option clears all lens adjustments for individual lenses and for adjustments made with the All by same amount option.

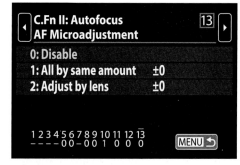

4.10 The AF Microadjustment screen.

Note that if you choose the Clear all Custom Func. (C.Fn) option on the Custom Functions menu (.📷.), the lens adjustments are *not* cleared, but the setting is set to option 0: Disable for C.Fn II-13. Also, the lens adjustments are not cleared if you choose the Clear all camera settings option on Setup menu 4 (🔧). Again, the setting will be set to Disable.

On the adjustments screens, you can make adjustments in 20 steps in two directions, either shifting the point of sharp focus in front of the standard (zero) mark by moving it to the negative side of the scale, or by shifting it to the rear of the standard focus by moving it to the positive side of the scale.

Before you set the same AF for all lenses, make sure the camera is in Program AE (**P**), Shutter-priority AE (**Tv**), Aperture-priority AE (**Av**), Manual (**M**), or Bulb (**B**) mode. Follow these steps to set the same AF Microadjustment for all lenses:

1. **On the Custom Function menu (.⚙.), select C.Fn II: Autofocus, and then press the Setting button (⑯).**

2. **Press left or right on the Multi-controller (⚬) until you see the number 13 in the box at the top-right corner of the screen, and then press the Setting button (⑯).** The options are activated.

3. **Press down on the Multi-controller (⚬) to select option 1: All by same amount, and then press the Quick Control button (Q).** The AF Micro-adjustment, 1: All by same amount screen appears.

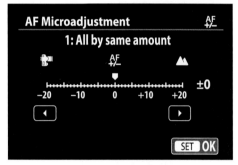

4. **Press left on the Multi-controller (⚬) to move the point of focus in front of the standard (zero) focus, or press right on the Multi-controller (⚬) to shift the focus behind**

4.11 The AF Microadjustment screen using option 1: All by same amount.

the standard setting, and then press the Setting button (⑯). Check the result by taking a picture and checking the focus. If necessary repeat until the focus is neither in front of or behind the subject.

I use a calibration target to adjust my lenses, but you can use something as simple as a ruler.

NOTE Before you attempt to calibrate an individual lens, make sure that you have its serial number handy. You'll find the serial number on the side of the lens box or inscribed on the lens itself.

Follow the steps below to calibrate a single lens:

1. **Set up the calibration target so that the target and image plane are parallel.** Ensure that the camera and the target are stabilized. I try to keep the camera-to-target distance at approximately 4 feet.

2. **Set the AF area selection mode to Single-point AF Manual selection (□),** **and select the center AF point.**

3. **If you're using a zoom lens, zoom to the telephoto end of the lens, focus on** **the target, take a picture, and then zoom to the wide focal length and take** **another picture.**

4. **Download the image(s) and evaluate the focus.** You are looking to see if the focus is in front of or behind where you focused, or if the focus is where you set it. If there is a focus misalignment, continue to the next steps. If not, then no microadjustment is necessary for that lens.

5. **On the Custom Function menu (.⚙.), select C.Fn II: Autofocus, and then** **press the Setting button (⑤).** The AF Microadjustment screen appears.

6. **Press left or right on the Multi-controller (⟐) until you see the** **number 13 in the box at the** **top-right corner of the screen,** **and then press the Setting button (⑤).** The C.FnII: Autofocus, AF Microadjustment screen appears. The lens currently mount-ed on the 70D is displayed on the screen as well.

4.12 The AF Microadjustment screen using option 2: Adjust by lens.

7. **Press down on the Multi-controller (⟐) to select 2: Adjust** **by lens, and then press the Quick** **Control button (Q).** The AF Micro-adjustment screen appears with the lens name.

8. **Press the Info button (INFO.).** The Review/edit lens information screen appears. This screen displays the 10-digital serial number.

9. **Review the lens information and if it's correct, select OK.** If the serial number is not displayed, go to the next step.

Improving Autofocus Accuracy and Performance

Autofocus speed depends on many factors, including the size and design of the lens, the speed of the lens-focusing motor, the speed of the autofocus sensor in the camera, the amount of light in the scene, and the level of subject contrast. Given these variables, here are some tips for getting the best autofocus performance and focus:

▶ **Light.** In low-light scenes, the autofocus performance depends (in part) on the lens speed and design. The faster the lens, the faster the autofocus performance. If there is enough light for the lens to focus without an AF-assist beam, lenses with a rear-focus optical design, such as the EF 85mm f/1.8 USM, focus faster than lenses that move their entire optical systems, such as the EF 85mm f/1.2L II USM. Regardless, the lower the light, the longer it takes to focus.

▶ **Contrast.** Low-contrast subjects and subjects in low light slow down focusing speed, and can cause autofocus failure. With a passive autofocus system, autofocusing depends on the sensitivity of the AF sensor. Autofocus performance is always faster in bright light than in low, and this is true in both One-shot AF (**ONE SHOT**) and AI Servo AF (**AI SERVO**) modes. In low light, consider using an accessory EX Speedlite's AF-assist beam as a focusing aid.

▶ **Focal length.** The longer the lens, the longer it takes to focus because the range of defocus is greater on telephoto lenses than on normal or wide-angle lenses. To improve the focus speed, set the lens in the general focusing range manually, and then use autofocus.

▶ **AF-point selection.** Selecting one AF point manually provides faster autofocus performance than automatic AF-point selection because the camera does not have to determine and select the AF point(s) to use.

▶ **Subject contrast.** Focusing on low-contrast subjects is slower than focusing on subjects with higher contrast. If the camera cannot focus, shift the camera position to an area of the subject that has higher contrast.

▶ **EF extenders.** These reduce the speed of the lens-focusing drive.

▶ **Small apertures.** Sharpness can be degraded by diffraction when you use small apertures. Diffraction happens when light waves pass around the edges of an object, softening fine detail. To avoid diffraction, avoid using small apertures.

4

10. **Press left or right on the Multi-controller (⊹) to go to the digit you want to enter, and then press the Setting button (⊛) to activate the first digit control.**

11. **Press up or down on the Multi-controller (⊹) to enter the first digit in the ten-digit lens serial number, and then press the Setting button (⊛).** Repeat steps 10 and 11 until you've entered all 10 digits.

12. **Choose OK, and then press the Setting button (⊛).** The AF Microadjustment screen for this lens appears.

13. **Turn the Quick Control dial (◯) to the left to move the point of focus in front of the standard (zero) focus, or to the right to shift the focus behind the standard setting, and then press the Setting button (⊛).**

14. **Choose OK, and then press the Setting button (⊛).**

15. **Take another picture of the calibration target with the adjusted settings, and then evaluate the accuracy of the point of focus.** If necessary, repeat the process until the focus is accurate.

Selecting a Drive Mode

The EOS 70D offers drive modes that provide the speed you need for shooting every-thing from action to still life. It may seem unusual to read about drive modes in a chapter primarily devoted to autofocus. However, very often, you combine autofocus modes with drive modes to suit the subject or scene you're photographing. The most common example is shooting sports and action. In these situations, you would most often couple AI Servo AF mode (**AI SERVO**) with High-speed continuous drive mode (⊒H) — to both track focus on a moving subject and shoot at a high burst rate.

You can choose from the following seven drive modes when you shoot in any of the 70D exposure modes:

▶ **Single shooting (▢).** In this mode, one image is captured with each press of the shutter button. This is a good choice for still subjects and any other unhur-ried shooting scenarios.

▶ **High-speed continuous shooting (⊒H).** In this mode, press and hold the shut-ter button to shoot up to 7 frames per second (fps) for approximately 40 Large/Fine JPEGs, 15 RAW images, or eight RAW+JPEG (Large/Fine) images. The

actual frames per second and the number of frames in a burst depends on the shutter speed, Picture Style, ISO speed, brand and type of media card, battery charge level, lens, and the light in the scene.

▶ **Low-speed continuous shooting (🖵).** This mode also delivers a maximum of 3 fps when you keep the shutter button completely depressed.

▶ **Silent single shooting (□S).** This is the same as Single shooting mode (□), but with quieter camera operation. There is a slight delay from when you press the shutter button to when the image is taken.

▶ **Silent continuous shooting (🖵S).** This is the same as Low-speed continuous drive mode (🖵) but with quieter camera operation at a 3 fps rate. There is a slight delay from when you press the shutter button to when the image is taken.

▶ **Self-timer/Remote control modes: 10-second (⏱️) and 2-second (⏱️2).** In Self-timer/remote modes, the camera delays taking the picture for 10 or 2 seconds after the shutter button is fully depressed. The 10-sec. self-timer/remote control mode (⏱️10) is handy when you want to include yourself in a picture. In addition, you can choose Self-timer mode 2 seconds remote (⏱️2) for close-up shooting to avoid blur from your finger when pressing the shutter button. It can be combined with Mirror lockup mode (⌦) to prevent vibration from the reflex mirror action. In that scenario, you have to press the shutter button once to lock the mirror and again to make the exposure.

To switch to a different drive mode, press the Drive button (**DRIVE**) above the LCD panel, and then turn the Quick Control dial (◯) to select the drive mode you want.

4

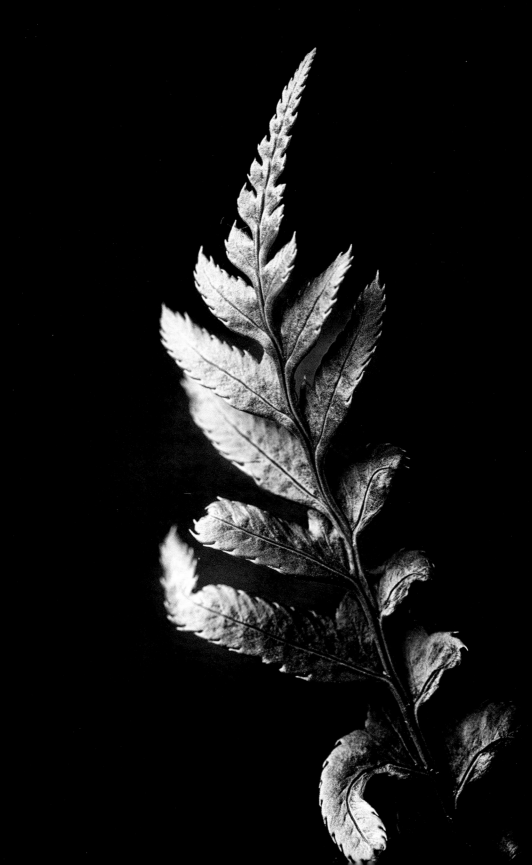

Working with Color and Creative Effects

In the days of film, you bought film based on the light in which you would be shooting. Often, color-correction filters were necessary to further modify the color. Next you had to trust the lab to deliver good color in the prints. All that is, thankfully, history. Now you control how good the color is in images, and the 70D offers a full complement of settings to ensure that images have beautiful color, including white balance and Picture Styles. The more faithful you are in setting the white balance and Picture Style for JPEG shooting, the less time you'll spend correcting color on the computer. You can also apply filters to create artistic looks for your images.

In this chapter, I cover when and how to use each of these options to get the best color and fine-tune it for any type of light.

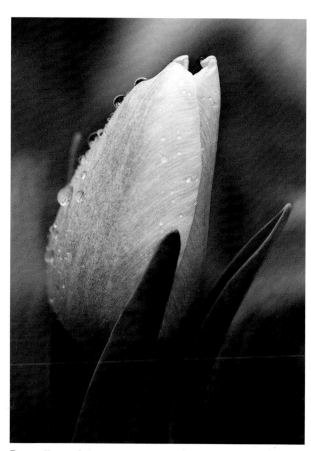

Regardless of the type of light in the scene, you can get stunning color by using the white balance settings and Picture Styles. Here, I used the Cloudy white balance setting and Neutral Picture Style. Exposure: ISO 250, f/5.6, 1/80 second.

Working with Color

Without question, you can save yourself a lot of time on the computer simply by getting the color right in the camera. The settings that affect the range of colors captured and the color rendering include the color space, white balance, and Picture Style options when you're shooting in the Creative Zone exposure modes (Program AE **P**, Shutter-priority AE **Tv**, Aperture-priority AE **Av**, and Manual **M**).

Except for color space, there are comparable settings that you can use in many of the automatic exposure modes, such as Portrait (**?**) and Scene Intelligent Auto (**⛰**) mode. Here is a quick summary of the options:

► **Color space.** A color space determines the gamut of colors that can be reproduced by a device, such as a printer or computer monitor. On the 70D, you have two choices: Adobe RGB or sRGB. Adobe RGB encompasses a broader range of colors than sRGB. Choosing a color space also affects your overall image workflow. Typically, you want to keep the color space consistent from image capture through editing and printing. The Color Space option is one that most photographers set at once and seldom change. You can choose a color space when you're shooting in the Program AE (**P**), Shutter-priority AE (**Tv**), Aperture-priority AE (**Av**), or Manual (**M**) modes.

► **White balance setting.** To get accurate color, you must tell the camera what type of light is in the scene. You do this by setting a white balance that matches the scene light or by setting a custom white balance. White balance is a setting that you should change every time the light changes. You can set the white balance in the Creative Zone exposure modes. In many of the automatic modes, such as Portrait (**?**) and Landscape (**▲**), you can change the lighting or scene type.

► **Picture Styles.** Picture Styles create a certain look in images, much like different films did. Each style has individual settings that render image colors more or less vivid and saturated, and that affect the image sharpness and contrast. How often you change the Picture Style depends on your preferences and the type of scene or subject that you are photographing. Picture Styles are available in Creative Zone modes. In most automatic exposure modes, you can use Ambience selections, such as Warm or Vivid.

Each of these settings plays a unique role in determining image color. The following sections provide more detail on using these settings in everyday shooting.

Choosing a Color Space

A *color space* is a mathematical system that describes colors numerically. In less technical terms, it defines the range of colors that can be reproduced and the way that a device — a digital camera, computer monitor, or printer — reproduces colors. Colors are created and described numerically by their RGB values. For example, a shade of pink can be expressed as R (Red) 253, G (Green) 158, and B (Blue) 188. For a computer, printer, or other device to know how to decode the values and display colors accurately, they must have an accompanying guide — the *color profile*. The 70D image files do not have a color profile appended. So, you'll want to embed a color profile during RAW image conversion or while editing JPEG images.

There are several considerations in choosing a color space. The Adobe RGB color space supports a wider gamut of colors than the sRGB color space. And, as is true with all aspects of image capture, the more data captured in the camera, the richer and more robust the file will be. And the more robust the file, the better it can withstand image editing. When I'm shooting, I want to capture all the 70D image data possible, which is, after all, why I bought a high-resolution camera like the 70D, and so I use Adobe RGB. If I later need to make a copy of the image and change it to the sRGB color space, that's easy to do during image editing. While I can easily convert images to a smaller color gamut during editing, I cannot go the other way – in other words, I cannot add in colors that were not captured during shooting.

The second consideration is keeping a consistent color space through the workflow — from capture to editing to printing. Using the same color space in the camera, in your image-editing program, and on your printer lessens color loss or alteration during color space conversions. When an image moves from a large color space to a smaller color space, the device — a computer or printer, for example — must decide which colors to keep, which to alter, and which to throw out. The fewer conversions, the better the color.

Another consideration when choosing color space is that the 70D captures color-rich 14-bit files that have 16,384 colors for each of the three color channels (Red, Green, and Blue). In contrast, 8-bit files offer only 256 values per color channel. Thus, the color loss is significant.

5

NOTE The 70D's 14-bit RAW files can be processed in a conversion program, such as Adobe Camera Raw, Lightroom, or Apple Aperture, as 16-bit files.

Comparing color spaces

To see the difference that color space choice makes, compare the histogram for an image in each color space. You're probably familiar with reading a histogram, so you know that a spike on the right edge of the histogram indicates that highlight image data is clipped or discarded from the image. A spike on the left indicates clipped shadow data. The higher the spike, the more data clipped. Ideally, you do not want colors to clip at all, or as little as possible. Predictably, the larger the color space, the less clipping that occurs. In short, more image color is retained by using the larger Adobe RGB color space. Capturing more color data translates into richer files.

Figure 5.1 shows a RAW image with two histograms as displayed in Adobe Camera Raw. With the bright light, the shadows clip in both color spaces, but notice how the highlight pixels are well contained in the tonal range in the histogram on the left that shows the image in Adobe RGB. The histogram on the right shows the image in the sRGB color space. The highlights on the right of the graph show consider-able clipping (discarding pixels).

Color space also factors into printing. Adobe RGB is the color space of choice for printing on inkjet printers and for printing by some, though not all, commercial printers. If you print at a commercial lab, be sure to ask which color space it uses and then provide files in that color space.

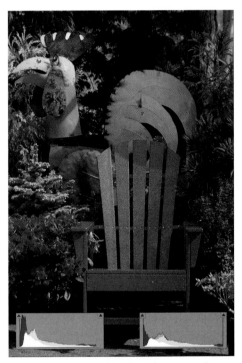

5.1 The histogram on the left shows the Adobe RGB color space of this image, while the one on the right shows the sRGB color space. Exposure: ISO 200, f/7.1, 1/400 second.

While Adobe RGB is a great color space for capturing a wide range of colors, it doesn't provide the best image color for online display. In fact, when you view an image that's in the Adobe RGB color space outside of an image-editing program or online, the image colors look dull and flat. For online display, the sRGB color space provides the best color.

It may sound difficult to choose color spaces, for most photographers it translates into using Adobe RGB for capturing images, editing, and printing. When an image is needed for the web or e-mail, it's easy to make a copy and convert it to the sRGB color space in an editing program such as Photoshop.

Canon typically notes in its manuals that Adobe RGB is an advanced setting. If you're new to photography or only shoot as a hobby, and want to keep things simple, then by all means, use sRGB. With sRGB, your images will look good in an editing program and websites or in e-mails with no effort on your part. In the meantime, you know that you can then explore the option of using a larger color space for more nuances of colors and richness in your prints.

Here are some additional things to consider when choosing a color space:

▶ You can choose a color space when you are shooting in the Creative Zone modes.

▶ Filenames for images shot with Adobe RGB are preceded by an underscore (_).

Setting the color space

With this background on the two color space options, you can now choose the one that fits best into your overall image workflow.

To choose a color space, follow these steps:

1. **On Shooting menu 3 (◘), highlight Color space, and then press the Setting button (⊛).** The sRGB and Adobe RGB options appear.

2. **Highlight the option you want.**

3. **Press the Setting button (⊛).** The color space you chose remains in effect until you change it.

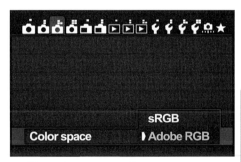

5.2 The color space options.

Setting the White Balance

If you want pleasing and accurate color straight from the camera, make it an unfailing habit to choose the white balance setting that matches the light in the scene. Setting the white balance tells the camera the type of light in the scene. That's important because the camera is not as adept as the human eye at seeing color in different

lights. When the light changes, our eyes immediately adjust to changes so we see a white shirt as being white whether it's seen in sunlight or in tungsten (household) light. Our ability to see that same color regardless of light is called color constancy or chromatic adaptation. Cameras, unfortunately, do not have chromatic adaptation, and the camera will record the white shirt as yellow in tungsten light. So, if you want white shirts to be white in your images, make it a habit to set the white balance to match the scene light.

The 70D offers seven white balance settings, including preset options for common light sources. In addition, you can set a Custom white balance (◣◢) to set the light temperature to the specific light in the scene, or you can set a specific color temperature.

Your choice of white balance setting may be affected by the amount of time you have to shoot a scene, the type and consistency of light, and whether you shoot RAW or JPEG capture. If you're new to white balance settings, here is a summary for using the different options:

▶ **Auto white balance (AWB).** The AWB option provides a best guess at the light temperature in the scene. This is an educated guess that tries to remove the colorcast from neutral colors, such as white or gray, in the scene. However, if there is no white or gray in the scene, the results are not as good. The AWB setting uses a color temperature (detailed later in this chapter) of approximately 3000 to 7000 degrees Kelvin. In my experience, AWB has a bluish (cool) color bias. I recommend using AWB in mixed light scenes when you don't have time to set a Custom white balance (◣◢) and when there is a neutral color in the scene. Otherwise, you'll get better color by choosing one of the other light-specific options.

▶ **Preset white balance.** A preset white balance setting, such as Daylight (☀), is a good choice when there is a single light source in the scene that clearly matches one of the preset white balance options. The preset white balance options are Daylight (☀, 5200 Kelvin), Shade (⌂, 7000K), Cloudy, Twilight, Sunset (☁, 6000K), Tungsten (※, 3200K), White fluorescent (※, 4000K), and Flash (⚡). Each option has very good color accuracy.

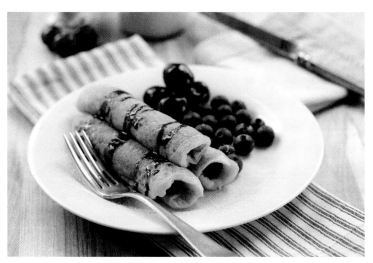

5.3 Here, I used the Auto white balance setting which gives the image an overall cool colorcast. Exposure: ISO 2050, f/5.6, 1/30 second, +1 exposure compensation.

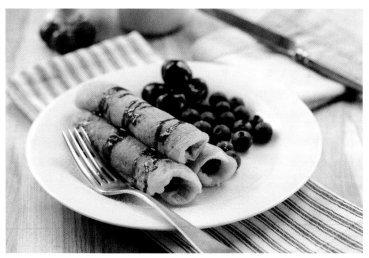

5.4 This image was taken using the Cloudy white balance setting. The colors are true to the original scene. Exposure: ISO 200, f/5.6, 1/30 second, +1 exposure compensation.

5

▶ **Custom white balance (◻•◢).** A Custom white balance (◻•◢) sets image color specifically for the light in the scene, whether it's a single light source or mixed light. This is the option to use with mixed lighting and when the light source doesn't clearly match one of the preset white balance options. Setting a Custom white balance (◻•◢) takes a bit more time, but it provides very accurate color. It is worth the extra steps, especially when shooting a series of JPEG images in the same light. The Custom white balance (◻•◢) light temperatures range from 2000 to 10,000K. If you are shooting RAW, then shooting a white or gray card and balancing images during RAW image conversion is often faster than setting a Custom white balance (◻•◢). This technique is covered later in this chapter.

▶ **Kelvin color temperature (◼K).** With the Kelvin white balance option (◼K), you set the specific light temperature on the 70D between 2,500 to 10,000K in 100K increments. This is good for studio shooting when you know the temperature of the strobes or continuous lights. If you are fortunate enough to have a color-temperature meter, setting the specific color temperature is a good option.

To change to a preset white balance, follow these steps:

1. **Set the Mode dial to a Creative Zone mode, and then press the Quick control button (◻Q).**

2. **Press the up, down, left, or right key on the Multi-controller (⬚) to select a white balance option.**

3. **Turn the Main dial (⬚) to choose the setting that matches the scene's light source.** Instructions for using the K white balance (◼K) option are detailed in the next sections.

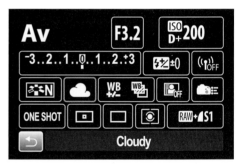

5.5 Choose the white balance option on the Quick control screen and change it to match the light in the scene.

Setting a Custom white balance

Because setting a Custom white balance (◻•◢) adjusts image color precisely for the light that is in the scene, a Custom white balance (◻•◢) produces the most accurate color in any light. It's especially good in scenes where the light doesn't match any of the preset white balance settings, and in scenes with multiple types of light. You can set a Custom white balance (◻•◢) in any Creative Zone mode.

Getting Accurate Color with RAW Images

A great way to ensure accurate color for RAW images is to photograph a white or gray card that is in the same light as the subject. Then you can use the card as a reference point for color correction when you convert the RAW images on the computer.

When you take a portrait, ask the subject to hold the gray card under or beside his or her face for the first shot, and then continue shooting without the card in the scene. If the light changes, take another picture with the gray or white card. When you begin converting the RAW images on the computer, open the picture that you took with the card and all the images made in that light. Select the picture with the white or gray card, and then select all the images with it. Click the card with the White Balance tool to correct the color. All the images are instantly color corrected. In a few seconds, you can color balance 10, 20, 50, or more images. Alternately, with some programs, you can copy the correction to one image, select other images taken with the same light, and paste the adjustment to them.

Before you begin, set the Mode dial to a Creative Zone mode, that the White balance isn't set to Custom, and that the Picture Style is not set to Monochrome (⊡⋅M). To set a Custom white balance (◻⋅◿), complete all of these steps:

1. **In the light used for the subject, position a piece of unlined white paper so that it fills the center of the viewfinder, and then take a picture of it.** To focus on the paper, switch the lens to Manual focus mode (**MF**) if the lens offers manual focusing. Ensure that the card isn't under- or overexposed.

2. **On Shooting menu 3 (◻), highlight Custom White Balance, and then press the Setting button (⊛).** The camera displays the most recent image captured, and that should be the picture of the white piece of paper. A Custom white balance icon (◻⋅◿) and the words *Set* and *menu* are displayed on the screen. If the image of the white paper is not displayed, turn the Quick Control dial (◯) until it is.

3. **Press the Setting button (⊛).** The 70D displays a confirmation screen asking if you want to use the white balance data from this image.

4. **Choose OK, and then press the Setting button (⊛).** A second screen appears reminding you to set the white balance to Custom (◻⋅◿).

5

5. **Press the Setting button (⊛) to choose OK, and then press the shutter button to dismiss the menu.** The camera imports the white balance data from the selected image and returns to Shooting menu 3 (◖▣).

6. **Press the Quick Control button (⊡) on the back of the camera.** Press the up, down, left, or right key on the Multi-controller (⁑) to select the white balance option.

7. **Turn the Main dial (�) to choose the Custom white balance (◣▱) option.** The Custom white balance (◣▱) remains in effect until you change it. Be sure to reset the Custom white balance (◣▱) if the subject light changes.

Setting a color temperature white balance

There are times when you know the exact temperature of the light in the scene, and in those instances, simply dial in the color temperature using the K Color Temperature white balance options (**K**). For example, I know that the temperature of my studio lights is 5300K, so I use the K Color Temperature white balance (**K**) to set the exact temperature. Then, I can continue shooting without further adjustments to the white balance because the light temperature of the strobes remains constant.

5.6 Here, I used the color temperature K white balance setting and set the color to 5300K to match the temperature of my studio lights. Exposure: ISO 200, f/32, 1/125 second.

Alternately, you can use K Color Temperature white balance (**K**) to introduce a specific mood to the image. For example, you can use a higher color temperature to introduce a warm colorcast that mimics sunset.

> **NOTE** If you look up Kelvin Color Temperature scale on the Internet, you find illustrations showing color temperatures at different times of the day. For example, a cloudy day is approximately 6000-6500K, a sunny day is 4800-6500, outdoor shade is 7000-8000K, tungsten is 2500-2900K, fluorescent is 3200-75000K, and a candle is 1850-1930K.

Before you begin, set the Mode dial to a Creative Zone mode. Follow these steps to set a specific color temperature:

1. **Press the Quick Control button (Q), and then press the direction keys on the Multi-controller (⁙) to highlight White balance.**

2. **Press the Setting button (⊛).** The White balance screen appears.

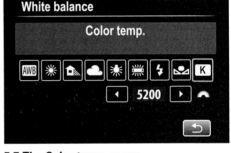

5.7 The Color temp. menu.

3. **Turn the Quick Control dial (◯) to highlight K Color temp.** If you have previously changed the temperature for the K Color Temperature white balance setting (**K**), the screen reflects the last temperature you set.

4. **Turn the Main dial (⁙⁙) to the left to decrease the color temperature number or to the right to increase it, and then press the Setting button (⊛).** The Quick Control screen appears with the white balance set to K Color Temperature (**K**).

If you use a color temperature meter, you'll need to do some testing to compensate for differences between the camera's temperature settings and the meter's reading. And if you are setting a known temperature for a venue light such as an indoor gymnasium, you may need to modify the white balance toward magenta or green using White Balance Correction, which is described in the next section.

Fine-tuning white balance

Given the wide range of lights for household and commercial use, some color correction may be necessary to get accurate color. Alternately, in images where the color is accurate, you may want a warmer or cooler rendering than a preset white balance option provides.

To compensate for differences in specific light temperatures and to fine-tune a preset white balance setting, you can use White Balance Auto Bracketing (⬛) and/or White Balance Correction (⬛). Both options enable you to bias image color in much the same way that color-correction filters did for film.

White Balance Auto Bracketing

When the color isn't quite accurate or pleasing, but you're not sure how much color correction to apply, then using White Balance Auto Bracketing (⬛) should produce at least one image with pleasing color. Bracketing produces three images with varying levels of color correction with a magenta/green or blue/amber bias. The bias is set in ±3 levels in one-step increments.

Using White Balance Auto Bracketing (⬛) predictably reduces the camera's maximum burst rate by one-third. You can also combine White Balance Auto Bracketing (⬛) with exposure bracketing. When used together, the camera makes six images, a combination that not only reduces shooting speed to a virtual crawl, but also fills an SD card in very short order. However, in scenes that you can't go back to and where image color is critical, White Balance Auto Bracketing (⬛) is a good insurance policy for getting pleasing color.

As with all the options discussed so far in this chapter, you can use White Balance Auto Bracketing (⬛) in the Program AE (**P**), Shutter-priority AE (**Tv**), Aperture-priority AE (**Av**), and Manual (**M**) modes, but not in the automatic exposure modes.

To get all three bracketed shots, you have to press the shutter button three times in Single shooting mode (☐). However, in High- (⬛H) and Low-speed (⬛) continuous shooting modes, pressing the shutter once fires off the three bracketed images.

Because White Balance Auto Bracketing (⬛) and White Balance Correction (⬛) involve similar steps, I've combined the steps for both in the next section.

White Balance Correction

White Balance Correction (WB) sets a single and specific color bias rather than bracketing in two directions as White Balance Auto Bracketing (WB) does. This is the technique to use when you know the bias type and amount needed to get the image color you want. Using White Balance Correction (WB) is similar to using color-compensation and color-correction filters with film, with the advantage of not needing to buy, carry, or protect multiple filters.

You can correct color in any of four directions: Blue, green, amber, and magenta. Each level of color shift is the equivalent of 5 mireds of a color temperature conversion filter. A *mired* is a unit of measurement that indicates the density of a color temperature conversion filter.

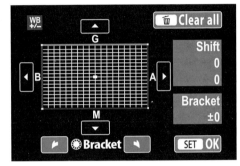

5.8 The White Balance correction/White Balance bracketing screen.

NOTE The menu screen for White Balance Correction (WB) uses the term *shift* for the White Balance correction techniques.

Before you begin, set the Mode dial to a Creative Zone mode. To set White Balance Auto Bracketing (WB) or White Balance Correction (WB), follow these steps:

1. **On Shooting menu 3 (◻), highlight WB Shift/Bkt., and then press the Setting button (⑤).** The WB +/- screen appears.

2. **To set White Balance Auto Bracketing (WB), turn the Quick Control dial (○) clockwise to set a blue/amber bias, or counterclockwise to set a magenta/green bias.** As you turn the dial, three tick marks appear and separate to indicate the direction and amount of bracketing. The bracketing amount is displayed alphanumerically under the Bracket section of the screen.

3. **To set White Balance Correction (WB), press the direction keys on the Multicontroller (⁙) in the direction of the shift you want.** The direction and amount of shift are displayed in the Shift section of the screen.

4. **Press the Setting button (⊕).** If you change your mind and want to start over, press the Erase button (🗑). Bracketed images are taken with the Standard white balance first, followed by the blue (or magenta) bias, and then the amber (or green) bias. If you set White Balance Correction, the icon (**WB**) is displayed in the viewfinder and on the LCD panel during shooting.

Soon after I began shooting with digital cameras, I learned that making my workflow as efficient as possible was the key to spending more time behind the camera and less time in front of the computer. One of the most important efficiency steps was moving to RAW capture. As a result, I seldom use white balance adjustments because most of my color correction involves the technique of shooting a white card covered earlier in this chapter. Even for individual images, I often place a white card in the scene, and then use it during RAW image conversion to correct color in all the images shot in the same light. Not only does this save time, but I also get great color.

Using lighting or a scene type

In Portrait (♥), Landscape (▲), Close-up (♣), and Sports (🏃) automatic shooting modes, you can't change the white balance, but you can change the lighting or scene type, which function much the same way as the preset White Balance settings; however, their names are slightly different in some cases. In the Scene Intelligent Auto (🄰), Flash Off (🚫), Creative Auto (CA), and Night Portrait (🌙) automatic shooting modes, the 70D automatically chooses the Default setting.

The 70D includes these lighting and scene types:

▶ **Default setting.** The 70D makes its best guess at the light and light temperature in the scene. Typically, this is a good choice when you have mixed light sources.

▶ **Daylight.** This setting delivers the most accurate color under sunny skies for nature, landscape, and people shots.

▶ **Shade.** This setting corrects the blue color characteristic of cool light in the shade.

▶ **Cloudy.** This is good to use when the sky is fully overcast because it warms up colors nicely.

▶ **Tungsten light.** Use this setting for traditional incandescent household light bulbs to reduce the yellow/orange color they produce. (Not available in Landscape mode ▨).

▶ **Fluorescent light.** This setting is best for all types of fluorescent lighting. (Not available in Landscape mode (▨).

▶ **Sunset.** This setting renders the warm colors of sunset accurately.

NOTE If you use a flash in the Basic Zone modes, the lighting or scene type changes automatically to the Default setting.

You can combine a lighting type selection with an Ambience setting, detailed later in this chapter. If you do, be sure to set the Lighting or Scene type first so that the camera records the image color correctly before the camera shifts the color, as it does with some Ambience options.

In addition, if you're using a Lighting or Scene type that creates warm image colors, such as Sunset, and then you choose an Ambience setting that further increases the color warmth, such as Warm, the combination may create an unnatural, over-the-top look. You can use Live View to ensure that the lighting or scene type and Ambience combination creates a pleasing result.

Here is how to change the lighting or scene type:

1. **Set the Mode dial to Special Scene (SCN), and then press the Quick Control button (Q).** The Quick control screen appears.

2. **Press a direction key to select the mode icon in the upper left of the screen, and then press the Setting button (⊜).** The scene mode icons appear.

3. **Turn the Quick Control dial (○) to the mode you want, and then press the Setting button (⊜).** You can choose Portrait (❾), Landscape (▨), Close-up (❀), or Sports (❅) mode.

4. **Be sure the Live View shooting/Movie shooting switch is set to Live View shooting (❒), and then press the Start/Stop button (START/STOP).** A live view of the scene appears on the LCD screen. The advantage of using Live View is that you get an approximation of the Lighting or Scene type effect. The disadvantage is that it is difficult to see the effect on the LCD screen in bright light.

5

5. **Press the Quick Control button (⊡) to display the Quick Control screen, and then press up or down on the Multi-controller (⊙) to highlight Default setting.** Be sure the text at the bottom of the screen says Light/scene-based shots.

6. **Turn the Main dial (⟳) to select the Lighting or Scene Type you want.** If you're using Live View, the preview scene on the LCD changes to reflect the setting you choose. If the color does not appear to your liking, choose another lighting type until it does. Then make the picture.

Working with Picture Styles

One of the great things about shooting with film was that each film type had its own special characteristics and look. Photographers chose film specifically to get the edgy, saturated colors that Fujifilm Velvia produced, or the ethereal skin tones and subdued contrast that Kodak's Portra film provided.

That was then and this is now, and film is hard to find. However, the desire for that classic film look is as strong as ever. Canon provides the next best thing to film with seven Picture Styles. For example, to mimic Portra film, try using the Portrait Picture Style (⊡⋅⊡P), which is characterized by its subdued color, excellent skin tones, and moderate contrast. To capture nature and landscape scenes with the punchy, saturated colors and snappy contrast of Velvia, set the camera to the Landscape Picture Style (⊡⋅⊡L). If you want to shoot so that there is room to make post-capture edits to contrast, saturation, and color rendering, then the Neutral (⊡⋅⊡N) and Faithful Picture Styles (⊡⋅⊡F) give you that latitude.

One of the goals of Picture Styles was to produce pictures that need little or no post-processing, so that you can print JPEG images directly from the memory card and get polished prints.

If you shoot RAW images, then you can apply Picture Styles during shooting or image conversion in Digital Photo Professional (DPP), a Canon conversion program that comes with the camera. Alternately, you can use the RAW image conversion feature on the 70D and apply the Picture Style during in-camera conversion from RAW to JPEG.

> **NOTE** RAW images retain Picture Styles only if you convert them in Canon's Digital Photo Professional software. Programs such as Adobe Lightroom, Apple Aperture, and so on, do not recognize Picture Styles.

Picture Styles are a collection of parameters including the tonal curve, color rendering and saturation, and sharpness, and you can adjust those parameters if you want. Alternatively, the Auto Picture Style (⊡⋮A) evaluates the scene and changes the settings based on what the camera detects within the scene. Table 5.1 shows the styles and default settings. The parameters are listed in order of sharpness, contrast, color saturation, color tone, and for Monochrome, the Filter and Toning effects.

Table 5.1 Picture Styles

Picture Style	Description	Default settings
⊡⋮A	Varies by scene, but generally renders colors as vivid and saturated.	3, 0, 0, 0
⊡⋮S	Bright colors and saturation, moderately high sharpness	3, 0, 0, 0
⊡⋮P	Natural, soft and flattering skin tone rendering, slightly high color saturation, and low sharpness	2, 0, 0, 0
⊡⋮L	Vivid blues and greens in skies and foliage, high contrast and sharpness	4, 0, 0, 0
⊡⋮N	Low saturation, contrast, and sharpness, resulting in rich detail and less chance of overexposure.	0, 0, 0, 0
⊡⋮F	True rendition of colors when shooting in daylight light (5200K). Colors are adjusted to match the subject/scene colors precisely.	0, 0, 0, 0
⊡⋮M	Black-and-white or toned images with slightly heightened sharpness. Unlike with previous EOS cameras, you cannot later convert monochrome images to color.	3, 0, NA, NA

With the Monochrome Picture Style (⊡⋮M), only the sharpness and contrast parameters can be changed. However, you can apply the following:

▶ **Monochrome filter effects.** Filter effects mimic the same types of color filters that photographers use when shooting black-and-white film. The Yellow filter makes skies look natural with clear white clouds. The Orange filter darkens the sky and adds brilliance to sunsets. The Red filter further darkens a blue sky and makes tree leaves look crisp and bright and renders skin tones realistically. The Green filter brightens foliage while rendering skin tones as subdued.

▶ **Monochrome toning effects.** You can apply creative toning effects with the Monochrome Picture Style (⊡⋮M). The toning effect options are N: None, S: Sepia, B: Blue, P: Purple, and G: Green.

5

NOTE In automatic shooting modes, the camera automatically selects the Auto Picture Style (⊒∷A), which you cannot change. But you can use Ambience options that change the look of the images as well. Ambience options are detailed later in this chapter.

Choosing and customizing Picture Styles

You can use Picture Styles at their default settings, or you can change them. For me, changing the settings is a great way to create a more distinctive look for my images. Plus, the adjustments can be made with an eye toward keeping computer editing to a minimum. You can modify any or all of the existing styles, and you can create and save three styles that are based on the Canon styles. You get a lot of latitude in adjusting parameters with seven adjustment levels for sharpness and eight levels of adjustments for contrast, saturation, and color tone.

In addition, you can use the Picture Style Editor to customize and save changes to Picture Styles that you create on the computer, and then copy the style to the camera. The Picture Style Editor is included on the Canon EOS Digital Solution Disk that comes with the camera.

Customizing Picture Styles is a great way to adjust the look of JPEG images so they meet your creative vision, and your editing and printing needs. For example, if you prefer to edit images on the computer before printing, then the Neutral (⊒∷N), Portrait (⊒∷P), and Faithful (⊒∷F) Picture Styles offer latitude for post-capture edits. If you want to print from the media card, then the Auto (⊒∷A), Standard (⊒∷S), and Landscape Picture Styles (⊒∷L) produce snappy prints. Alternately, if the results are not quite what you want, you can modify a Picture Style to suit your needs.

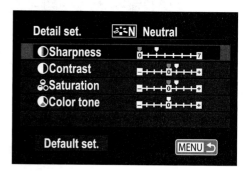

5.9 The Picture Style settings for a modified version of the Neutral Picture Style.

Here are the parameters you can adjust:

▶ **Sharpness: 0 to 7.** Level 0 (zero) applies no sharpening and renders a soft look. If you routinely print images directly from the memory card, then use a higher sharpness level. However, if you prefer to edit images on the computer, then a 0–2 level is adequate. The low setting also helps prevent sharpening halos when you sharpen images in an image-editing program.

▶ **Contrast: -4 to +4.** The Contrast parameter adjusts the image's tonal curve. A negative adjustment produces a flatter look but helps prevent clipping. A positive setting increases the contrast and can stretch the tonal range. Higher settings can also lead to clipping (discarding highlight and/or shadow pixels). I prefer to get a slightly flatter look out of the camera, and then set a tonal curve in Photoshop that is to my liking.

▶ **Saturation: -4 to +4.** This setting affects the strength or intensity of the image's color. A negative Saturation setting produces low saturation, and vice versa. As with the Contrast parameter, a high Saturation setting can cause individual color channels to clip. A +1 or +2 setting is adequate for snappy JPEG images destined for direct printing. For images that you edit on the computer, a 0 (zero) setting allows latitude for post-capture edits.

▶ **Color tone: -4 to +4.** This setting modifies the hue of the image. Negative settings produce tones that are redder, while positive settings produce more yellow tones.

After you evaluate and print pictures using different Picture Styles, you may want to adjust the Picture Style parameters to get the image look and rendering that suits your vision and workflow.

I have adjusted Pictures Styles with good results. Several years ago, I was having trouble with the camera oversaturating colors, particularly red objects in images. I talked to a friend from Canon, and he suggested that I modify the Neutral Picture Style. He gave me a starting point for the adjustments, and over the years, I have adjusted the parameters slightly.

The adjusted style has performed beautifully on several different Canon camera bodies, including the 70D. This modified style helped reduce oversaturation of red colors. So for almost all of my photography, I use a modified Neutral Picture Style (▨:N). Because I shoot RAW, I often use Digital Photo Professional to process images so that the Picture Style is retained.

A couple of notes about this modified style are important. First, this style moderates color saturation, contrast, and sharpness so that I can interpret those characteristics to my liking during editing on the computer — something I always do. Second, in portraits this modified Neutral Picture Style (▨:N) creates subdued, lovely skin tones with a nice level of contrast as long as the lighting is not flat.

Here is how I set the modified Neutral Picture Style (▨:N) for my work. These settings work best when the lighting isn't flat and the image isn't underexposed. The settings are Sharpness +2, Contrast +1, Saturation +1, and Color tone 0.

5

Figures 5.12 through 5.15 compare some of the Picture Styles, and show the kinds of changes you can make, and the look you can expect when using them.

In Figure 5.10, I used the Neutral Picture Style (). If you compare it with Figure 5.11, you see how much lower the contrast and color saturation is with this style. In Figure 5.11, I used the Landscape Picture Style. The increased blue and green color saturation is evident, as is the higher contrast and sharpness as compared to Figure 5.10. The Standard Picture Style would be very close to this, but with less color saturation in the greens and blues.

For the image shown in Figure 5.12, I used my modified Neutral Picture Style. I wanted to moderate the contrast knowing it would help preserve detail in the highlights and shadows, and this style delivered on both counts. For portraits of women and children, I generally prefer the Portrait Picture Style.

5.10 This picture of the valley in Snohomish, Washington was shot with the Neutral Picture Style. Exposure: ISO 200, f/11, 1/500 second.

5.11 This the same scene captured using the Landscape Picture Style. Exposure: ISO 200, f/11, 1/640 second.

5.12 This image was made using a modified Neutral Picture Style. Exposure: ISO 160, f/16, 1/125 second.

5

Figure 5.13 uses the Standard Picture Style (⬚⋮S). The snappy contrast and vivid colors are what most people expect to see in images. The Auto Picture Style (⬚⋮A) is very much like the Standard Picture Style (⬚⋮S) in scenes like this. Figure 5.14 is an example of the Faithful Picture Style (⬚⋮F). Colors are very accurate to real life. The contrast is reduced, but it can be adjusted during editing.

5.13 **The Standard Picture Style. Exposure: ISO 200, f/6.3, 1/8 second, +1/3 exposure compensation.**

5.14 **The Faithful Picture Style. Exposure: ISO 200, f/6.3, 1/8 second, +1/3 exposure compensation.**

For Figure 5.15, I used the Monochrome Picture Style (⊞M) with a Green filter effect to subdue the skin tones and the Sepia Toning effect.

5.15 Monochrome images are a favorite of many of my clients. Exposure: ISO 200, f/16, 1/125 second.

To modify a Picture Style, follow these steps:

1. **On the Shooting menu 4 (📷), highlight Picture Style, and then press the Setting button (⬤).** The Picture Style screen appears.

2. **Press the down key on the Multi-controller (⟐), select the Picture Style you want to modify, and then press the Info button (INFO.).** The Detail Set. screen for the selected style appears.

3. **Turn the Quick Control dial (◯) to select the parameter you want to adjust, and then press the Setting button (⬤).** A screen for adjusting the control appears.

5

4. **Turn the Quick Control dial (○) to change the parameter, and then press the Setting button (⊛).** Negative settings decrease sharpness, contrast, and saturation, and positive settings provide higher sharpness, contrast, and saturation. Negative color tone settings provide reddish skin tones, and positive settings provide yellowish skin tones.

5. **Repeat steps 3 and 4 to change additional parameters, and then press the Menu button (MENU).** The modifications are saved and remain in effect until you change them.

Creating a new Picture Style

For a greater range of Picture Styles, you can create three additional Pictures Styles. These User Defined Picture Styles are based on an existing style, and then adjusted to get the image rendering that you want. These options expand the range of looks you can get from the 70D.

NOTE There is also the option to create a User Defined style on the computer using the Canon Picture Style Editor, a program included on the EOS Digital Solution Disk.

Here's how to create and register a User-Defined Picture Style:

1. **On Shooting menu 4 (📷), highlight Picture Style, and then press the Setting button (⊛).** The Picture Style screen appears.

2. **Select User Def. 1 (▨▨1), and then press the Info button (INFO.).** You have to scroll down using the Quick Control dial (○) to get to the User Def. styles. The Detail set. User Def. 1 screen appears.

3. **With the Picture Style option selected, press the Setting button (⊛).** The Picture Style screen appears with a list of the Picture Styles.

4. **Turn the Quick Control dial (○) to select a base Picture Style, and then press the Setting button (⊛).** You can select any of the preset styles as the base style. The Detail set. User Def.1 screen appears.

5. **Turn the Quick Control dial (○) to select a parameter, such as Sharpness, and then press the Setting button (⊛).** The parameter's control is activated.

6. **Turn the Quick Control dial (○) to set the level of change, and then press the Setting button (⊛).**

7. **Repeat steps 5 and 6 to change the remaining parameters.** The remaining parameters are Contrast, Saturation, and Color tone.

8. **Press the Menu button (MENU).** The Picture Style is registered and the Picture Style selection screen appears. The base Picture Style is displayed to the right of User Def. 1. This Picture Style remains in effect until you change it.

You can repeat these steps to set up the two remaining User Defined styles.

TIP Canon offers additional Picture Styles — including Studio Portrait, Snapshot Portrait, Nostalgia, Clear, Twilight, Emerald, Autumn Hues, and Video Camera X Series Look — on its Picture Style website at http://web.canon.jp/imaging/picturestyle/file/index.html.

Using Creative Filters and Ambience Settings

With the 70D, you can use in-camera image processing for creative renderings by using Creative filters and Ambience options. Creative filters can be applied to images during playback. They can also be applied to RAW images. The RAW images are then processed in-camera and saved as JPEGs. A good way to apply filters is in Live View mode (📷) so you can preview the effect. The Ambience effects can be used in select automatic shooting modes.

NOTE If you cannot apply Creative Filters, check to see if Wi-Fi is enabled on Setup menu 3 (🔧). If it is, turn it off, and then you can use the filters.

5

Applying Creative filters

To add some fun and a creative edge to your images, you can choose from seven Creative filter effects. The filters are applied after the image is captured, and the image is saved as a new file, leaving the original image unchanged. Because the filters are applied in the camera, you can print with the filter applied directly from the media card.

There are a few considerations to keep in mind when using Creative filters. You can apply them to JPEG and full-resolution RAW images shot in all shooting modes, but you can't apply them to the smaller Medium (**M RAW**) or Small (**S RAW**) RAW images. If you shoot RAW+JPEG images, the filter is applied to the RAW image and then it's converted to and saved as a JPEG file. However, if you shoot Medium (**M RAW**) or Small (**S RAW**) RAW +JPEG, the filter is applied to the JPEG image.

Here are the Creative filters you can select:

▶ **Grainy B/W ().** This filter creates a classic, high-grain look of older black-and-white images. You can adjust the contrast to change the overall look of the image.

▶ **Soft focus ().** This filter softens the image sharpness to create a soft blur. You can control the amount or strength of the blur.

▶ **Fish-eye effect ().** This effect creates the 180-degree circular fish-eye look by enlarging the image from the center and then creating a circular, or barrel, distortion look. During the transition, some of the image will be cropped to create the effect, and with the center of the image being enlarged, image quality is reduced. Be sure to check the effect as you apply it to keep it from degrading the center of the image too much.

▶ **Art bold effect ().** This filter is designed to create a painterly look to the image while adding a sense of depth. With this filter you can say goodbye to smooth tonal gradations because the processing disrupts the gradations in favor of a more edgy look. Noise is also added, so check to see if it is more than you can tolerate. You can modify the contrast and color saturation with this filter.

▶ **Water painting effect ().** This filter simulates watercolor painting by subduing the colors in the image. Your only adjustment option is color density or strength — an important characteristic in watercolor painting. If you apply this filter to images shot in low light or at night, digital noise can be revealed and tonal gradations are no longer smooth.

5.16 This image has the Grainy B/W filter applied. Exposure: ISO 640, f/5.6, 1/160 second.

5.17 The Fish-eye filter effect. Exposure: ISO 800, f/5.6, 1/125 second.

► **Toy camera effect (⬚).** This filter replicates the popular Holga- and Diana-camera look that includes a color shift and *vignetting*, a darkening of the image corners. You can adjust the color tone and colorcast.

► **Miniature effect (⬚).** This filter mimics the effect of a diorama, a sort of mini-ature, three-dimensional visual illusion introduced in 1821 by Louis Jacques Mandé Daguerre. You can press the Info Button (**INFO.**) to change the orientation of the white frame that indicates which area of the image will be sharp.

5

To apply a Creative filter, follow these steps:

1. **On Playback menu 1 (▶), highlight Creative filters, and then navigate to the picture you want.** The last captured image appears. To move to a different image, press left or right on the Multi-controller (✣).

2. **Press the Setting button (☉), and then press left or right on the Multi-controller (✣) to select the filter you want.** The Creative filter options are displayed at the bottom of the image preview.

3. **Press the Setting button (☉), press left or right on the Multi-controller (✣) to set the level, and then press the Setting button (☉) again.** The filter is applied to the image at the selected level. A message appears asking if you want to save the image as a new file. The original file remains on the card untouched.

4. **Select OK, and then press the Setting button (☉).** The camera displays a message giving you the folder and file number. With the Miniature filter (🖉), you can press up or down on the Multi-controller (✣) to move the frame to the area of the image that stays sharp. The rest of the frame is blurred. Press the Setting button (☉).

5. **Choose OK.** The image is saved.

Using Ambience settings

Ambience options are somewhat like Picture Styles, but with a more pronounced effect. You can apply Ambience settings only when you're shooting in Creative Auto (CA), Portrait (♞), Landscape (🏔), Close-up (🌷), Sports (🏃), or Night Portrait (🌙) modes. Once you choose an Ambience option, you can apply it at a Low, Standard, or Strong setting.

If you check the exposure settings for the Ambience effects, you can see how the effect is achieved in most cases. For some Ambience effects, the 70D increases or decreases the saturation and contrast, just as can be done when using Picture Styles.

CAUTION Some Ambience settings, such as Brighter, can cause blown highlights, so use them with care.

Here are the Ambience options you can select:

▶ **Standard (⬤STD).** The default setting has punchy contrast and color.

▶ **Vivid (⬤V).** At the Standard level, this setting punches up the colors and sharpness.

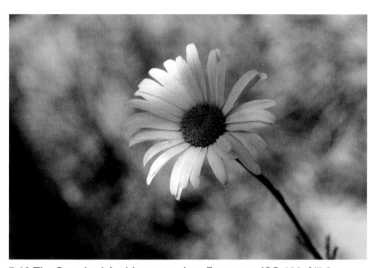

5.18 The Standard Ambience setting. Exposure: ISO 100, f/5.6, 1/200 second.

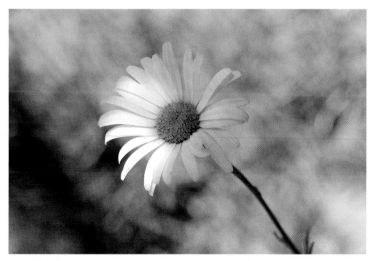

5.19 The Soft Ambience setting. Exposure: ISO 125, f/5.6, 1/160 second.

5

▶ **Soft (✦S).** This option noticeably decreases color saturation and intensity as well as overall contrast so images tend to have a flat look. However, for dainty or delicate subjects, it can be a good choice.

▶ **Warm (✦W).** This setting adds a noticeable shift to bolder yellows and reds, warming up skin tones and everything else in the image. Be careful using this Ambience option along with the Sunset Lighting or Scene type because it can cause over-the-top warming in the image.

▶ **Intense (✦I).** Just as the name implies, this setting darkens the image making colors look more saturated and making shadows look deeper. This is not the option to use if you want to show good detail in the shadows because it tends to block up the shadows. However, it is a good choice to create a moody or evocative image with the right subject, and it adds some punch to subjects in flat light.

▶ **Cool (✦C).** This option delivers extremely blue skies and a cool (bluish) tint in foliage. The contrast and color saturation are both higher than in the Standard setting (✦STD).

▶ **Brighter (✦B).** This setting lightens the image overall, including opening up shadow detail. It is a reasonable option for a scene or subject with predominately light tones; in other words, a high-key scene or subject. This is not a good setting to use in bright light, when the highlights are on the verge of blowing out or are already blowing out.

▶ **Darker (✦D).** This setting creates a darker image, but not quite as dark as Intense (✦I) and with a lower contrast.

▶ **Monochrome (✦M).** This option offers a blue, sepia, and black-and-white option. The black-and-white option delivers bright whites and deep blacks with moderate overall contrast.

To apply an Ambience setting, follow these steps:

1. **Set the Mode dial to Creative Auto (CA) or Special Scene mode (SCN).** If you use Special Scene mode (SCN), then choose Portrait (🚶), Landscape (🏔), Close-up (🌷), Sports (🏃), or Night Portrait (🌃) mode.

2. **Be sure the Live View shooting/Movie shooting switch is set to Live View shooting (📷), and then press the Start/Stop button (START/STOP).** A live view of the scene appears on the LCD screen. If you don't want to use Live View mode (📷) to set the Ambience, then skip to step 3. The advantage of using Live View mode (📷) is that you get an approximation of the Ambience effect.

3. **Press the Quick Control button (Ⓠ), and then press up or down on the Multi-controller (✺) to highlight the Standard setting (⚐STD).** A live view of the scene appears and the text *Ambience-based shots* appears at the bottom of the LCD screen with left and right arrows.

4. **Press left or right on the Multi-controller (✺) to select the Ambience option you want.** The preview scene on the LCD screen changes to approximate the look of adding the Ambience effect.

5. **Press up or down on the Multi-controller (✺) to display the ambience levels, and then press left or right to set the strength: Low, Standard, or Strong.** The text at the bottom of the LCD screen shows the current selection.

6. **Compose, focus, and make the image using Live View mode (⬛).** You can dismiss the Live View screen by pressing the Start/Stop button (START/STOP).

5

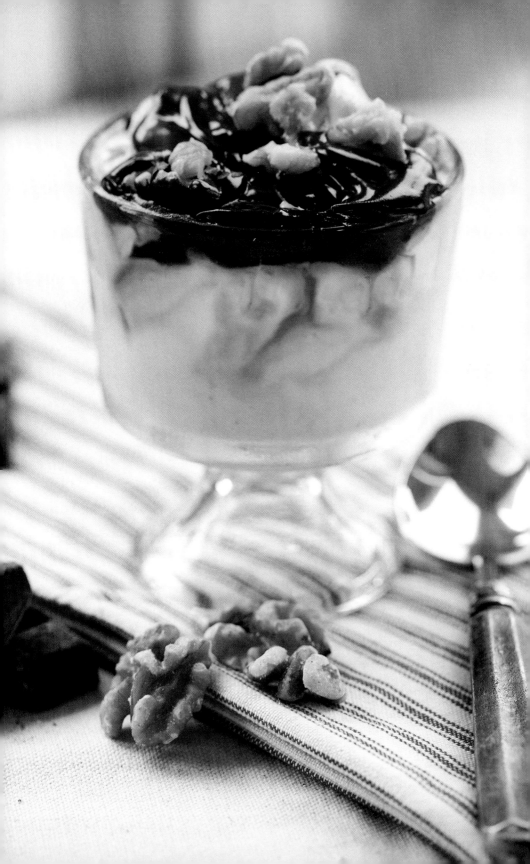

Customizing the Canon EOS 70D

The Canon EOS 70D offers a full complement of options, so that you can customize it to suit your style and shooting preferences. The 70D offers three major categories of customization. First are the Custom Functions that enable you to change camera controls and behavior, as well as to set up the camera for both general and venue-specific shooting situations. The Custom mode (**C**) enables you to set up virtually everything on the camera, save all the settings, and then recall them by switching to the Custom mode (**C**). In My menu (★), you can place your six most frequently used menu items for quick access.

These three features not only save time, but they also offer shooting advantages that are well worth the time it takes to set them up.

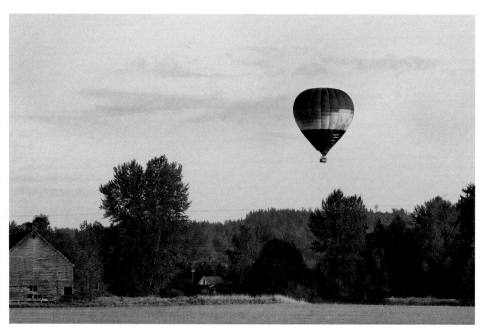

One of the first things I do with a new camera is set the Custom Functions to suit my personal preferences, so I'm always ready to capture scenes like this. Exposure: ISO 400, f/8.0, 1/250 second.

Exploring Custom Functions

The 70D has 23 Custom Functions that enable you to tailor the camera to your shooting preferences. Some Custom Functions have a broad range of uses, and others are useful for specific shooting specialties, subjects, and scenes.

If you're new to setting Custom Functions, the functions may seem intimidating, as they did when I began as a photographer. However, I assure you that setting the functions will pay off in time saved and making shooting more pleasurable. If you don't like your changes or want a do-over, you can go back to the camera's original (default) settings by choosing Clear all Custom Functions on the Custom Function menu (.📷.).

Canon organized the 23 Custom Functions, abbreviated as C.Fn, into three groups: C.Fn I: Exposure; C.FnII: Autofocus; and C.Fn III: Operation/Others. The three groups are listed on the Custom Function (.📷.) menu.

These are the Exposure functions (and any limitations) by shooting mode:

▶ **Exposure level increments.**

▶ **ISO speed setting increments.** These are available in Movie mode ('🎥) only when using Manual mode (**M**).

▶ **Bracketing auto cancel.** This setting is unavailable in Movie mode ('🎥) unless you're shooting a still image with White Balance Bracketing (🔲).

▶ **Bracketing sequence.** This option is unavailable in Movie mode ('🎥) unless you're shooting a still image with White Balance Bracketing (🔲).

▶ **Number of bracketed shots.** This setting is unavailable in Movie mode ('🎥) unless you're shooting a still image with White Balance Bracketing (🔲).

▶ **Safety shift.** This option is unavailable in Movie mode ('🎥).

These are the Autofocus functions (and any limitations) by shooting mode:

▶ **Tracking sensitivity.** This function is unavailable in the Live View (📷) and Movie shooting ('🎥) modes.

▶ **Acceleration/deceleration tracking.** This option is unavailable in the Live View (📷) and Movie shooting ('🎥) modes.

▶ **AI Servo 1st image priority.** This function is unavailable in the Live View (📷) and Movie shooting (🎥) modes.

▶ **AI Servo 2nd image priority.** This option is unavailable in the Live View (📷) and Movie shooting (🎥) modes.

▶ **AF-assist beam firing.** This function is available in the Live View shooting mode (📷) when using the AF Quick focus mode (AFQuick).

▶ **Lens drive when AF impossible.** This is available in Live View mode (📷) when using AF Quick focus mode (AFQuick).

▶ **Select AF area selection mode.** You can select this option in Live View mode (📷) when using AF Quick focus mode (AFQuick).

▶ **AF area selection method.** This option is available in Live View mode (📷) when using AF Quick focus mode (AFQuick).

▶ **Orientation linked AF point.** You can use this function in Live View mode (📷) when using AF Quick focus mode (AFQuick).

▶ **Manual AF-point selection pattern.** This function is available in Live View mode (📷) when using AF Quick focus mode (AFQuick).

▶ **AF-point display during focus.** This option is unavailable in the Live View (📷) and Movie shooting (🎥) modes.

▶ **VF display illumination.** This function is unavailable in the Live View (📷) and Movie shooting (🎥) modes.

▶ **AF Microadjustment.** This option is available in Live View (📷) when using Quick focus mode (AFQuick).

These are the Display/Operation functions (and any limitations) by shooting mode:

▶ **Dial direction during Shutter-priority AE (Tv)/Aperture-priority AE (Av).** This option is available in the Live View (📷) and Movie shooting (🎥) modes.

▶ **Multi-function lock.** This is available in the Live View (📷) and Movie shooting (🎥) modes.

▶ **Warning icon (①) in viewfinder.** This function is unavailable in the Movie (🎥) and Live View shooting (📷) modes.

▶ **Custom Controls.** This controls the customization settings in the Movie (🎥) and Live View shooting (📷) modes. Availability depends on the setting.

Setting Custom Functions

After reviewing the functions and options, there may be specific functions that you can identify immediately as being helpful for your daily shooting. Other functions may be suited for scene-specific shooting. Whether used separately or together, Custom Functions can significantly enhance your use of the 70D.

To set a Custom Function, follow these steps:

1. **On the Custom Functions menu (), press down on the Multi-controller () to highlight the Custom Function group you want, and then press the Setting button ().** The last visited screen for that Custom Function group appears.

2. **Press left or right on the Multi-controller () to navigate to the Custom Function number you want, and then press the Setting button ().** A number box at the top right of the screen displays the function numbers. When you press the Setting button (), the function options are activated.

3. **Turn the Quick Control dial () to select the option you want, and then press the Setting button ().** Refer to the descriptions earlier in this chapter to select the function and the option number that you want. Some options require you to set a check mark. The steps for setting those options are detailed in previous sections.

If you want to reset one of the Custom Functions, repeat these steps to change it to another setting or the default setting. If you want to restore all the Custom Functions to the default settings, go to the Custom Functions menu (). Press down on the Multi-controller () to highlight Clear all Custom Func. (C.Fn). Press the Setting button (), and then choose OK. All Custom Functions are restored to their defaults, except the Custom Controls you set and the micro-adjustments made to lenses.

The following sections describe the Custom Function options that you can set. As I detail each one, consider how you can use them in specific shooting situations. If you use Custom Functions thoughtfully as they pertain to your shooting, you will be surprised by how much difference they make in every-day shooting.

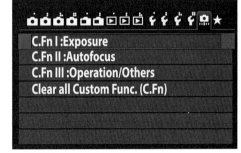

6.1 The Custom Functions menu.

C.Fn I: Exposure

The Exposure Custom Functions are described here followed by the options that you can choose for each function.

C.Fn I-1 Exposure level increments

With this function, you can set the exposure increment that is used for shutter speed, aperture, exposure compensation, and Auto Exposure Bracketing (AEB) changes. The increment you choose is displayed in the viewfinder and on the LCD screen with either one or a double set of tick marks at the bottom of the Exposure Level Indicator. Your choices are:

▶ **0: 1/3 stop.** By default, the 70D uses 1/3 stop as the exposure level increment, providing a fine level of change. For day-to-day shooting, this is a good option. If you choose this option, a single tick mark is displayed under the Exposure Level Indicator in the viewfinder and on the LCD screen to show the exposure change.

▶ **1: 1/2 stop.** This option sets 1/2 stop as the exposure level increment for a larger exposure change than Option 0. The 1/2-stop increment can be useful if you bracket images for later compositing in an image-editing program. If you choose this option, double tick marks are displayed under the Exposure Level indicator in the viewfinder and on the LCD screen.

C.Fn I-2 ISO speed setting increments

With this function, you can set the level of change that is used when you change the ISO sensitivity setting. For most shooting, the 1/3-stop option is a good choice because if you increase the ISO, you get less digital noise in the image with a smaller increase. If you are increasing the ISO incrementally to get to a fast enough camera handholding speed, the 1/3-stop option gets you there and keeps the ISO as low as possible. The 1-stop option gets you there faster, but you may end up setting the ISO higher than it needs to be, and high settings introduce digital noise to the image. This function is available in Movie mode ('🎥) only when using Manual exposure mode (**M**). Your choices are:

▶ **0: 1/3 stop.** This is the default increment. With this option set, the ISO speeds are Auto, 100, 125, 160, 200, 250, 320, 400, 500, and so on.

▶ **1: 1 stop.** This option sets 1 f-stop as the ISO adjustment-level increment. With this option set, the ISO speeds are Auto, 100, 200, 400, 800, 1600, and so on.

6

C.Fn I-3 Bracketing auto cancel

With this function, you can choose to have the camera completely or temporarily can-cel AEB and White Balance Bracketing (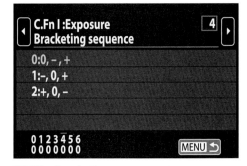) settings when you turn off the camera, use the flash, or switch to Movie mode (🎥). Very often, AEB and White Balance Bracketing (WB) are specific to a scene. Therefore, these are not settings that you want to retain. It is also easy to forget that you have set either bracketing option, and you end up shooting with the bracketing inadvertently set. Unless you often shoot with AEB and White Balance Bracketing (WB), I recommend using the default 0: On option. This function is not available in Movie mode (🎥) unless you're shooting a still image with White Balance Bracketing (WB). Your choices are:

▶ **0: On.** Both AEB and White Balance Bracketing (WB) are permanently cancelled when you turn the power switch Off, use a flash, or switch to Movie mode (🎥).

▶ **1: Off.** Both the AEB and White Balance Bracketing (WB) settings are retained even after you turn off the camera. If you use the built-in or an accessory flash, or switch to Movie mode (🎥), bracketing is temporarily cancelled, but the cam-era keeps the AEB range.

C.Fn I-4 Bracketing sequence

With this function, you can change the sequence of both exposure-bracketed and white-balance bracketed images. The White Balance Bracketing (WB) depends on how you set the Blue/Amber or Magenta/Green direction. For example, with a Magenta/Green direction, the under (-) is the Magenta bias and the over (+) is the Green bias. This option is unavailable in Movie mode (🎥) unless you're shooting a still image with White Balance Bracketing (WB).

Your choices are:

▶ **0: 0, -, +.** Zero is standard expo-sure and white balance. The minus sign (-) means decreased exposure, and less blue or magenta white-balance bias. The plus sign (+) means increased exposure, and more amber and green white-balance bias.

6.2 The Bracketing sequence screen.

▶ **1: -, 0, +.** The minus sign (-) means decreased exposure, and less blue or magenta white-balance bias. Zero is the standard exposure and white balance. The plus sign (+) is increased exposure, and more amber and green white-balance bias.

▶ **2: +, 0, -.** The plus sign (+) means increased exposure, and more amber and green white-balance bias. Zero is standard exposure and white balance. The minus sign (-) means decreased exposure, and less blue or magenta white-balance bias.

CROSS REF White Balance Bracketing (WB) is covered in Chapter 5.

C.Fn I-5 Number of bracketed shots

With this function, you can change the number of bracketed shots that the camera makes for exposure and white balance bracketing. The traditional number is 3 shots: a standard exposure or white balance, and then an under- and over the standard exposure or color bias. However, now you can choose 2, 5, or 7 shots, as well as the default 3 shots. If you use High Dynamic Range shooting often, the 5- and 7-shot options are handy for getting a good range of shadow, standard, and highlight exposures. This setting is unavailable in Movie mode ('🎥) unless you're shooting a still image with White Balance Bracketing (WB). The options are:

▶ 0: 3 shots

▶ 1: 2 shots

▶ 2: 5 shots

▶ 3: 7 shots

If you set the Bracketing sequence Custom Function to the 0, -, + option, and choose to make three shots, then the shot sequence is standard, under, and over. However, if you choose to bracket two, five, or seven images, then the exposures or color-biased images are made as shown in Table 6.1 in 1-stop increments. For the two-shot option, you set whether you want an over or under shot when you set the AEB range on the camera.

6

Table 6.1 Bracketing Sequence for 2, 5, and 7 Shots

C.Fn I-5 Option	Shot 1	Shot 2	Shot 3	Shot 4	Shot 5	Shot 6	Shot 7
0: 3	0 (Standard)	-1	+1	—	—	—	—
1: 2	0 (Standard)	+ or - 1	—	—	—	—	—
2: 5	0 (Standard)	- 2	- 1	+1	+2	—	—
3: 7	0 (Standard)	- 3	-2	-1	+1	+2	+3

C.Fn I-6 Safety shift

With this Custom Function, the 70D automatically adjusts the exposure settings if there is a sudden shift in lighting that would cause an improper exposure at the current exposure settings. With the first option, Safety shift adjusts the aperture or shutter speed in Shutter-priority AE (**Tv**) and Aperture-priority AE (**Av**) exposure modes to get a proper exposure. With the second option, Safety shift adjusts the ISO in Program AE (**P**), Shutter-priority AE (**Tv**), and Aperture-priority AE (**Av**) modes. Safety shift isn't used in Manual mode (**M**).

Safety shift can be very helpful in scenes with sudden changes in lighting such as stage and theater venues where performers move from bright spotlit areas to shadows. This function is also helpful outdoors. Say you're photographing a deer at 1/1000 second with the aperture set to f/22, which is the minimum aperture for the lens. Then the deer moves into very bright sunlight, and the change in light calls for closing down another f-stop. However, you've run out of apertures. This is where Safety shift steps in to set a faster shutter speed to get a correct exposure. Or say that you've set a fast shutter speed, and the light dims so that even the lens's maximum aperture won't provide an accurate exposure. Safety shift sets a slower shutter speed instead of producing an underexposed image. As you might guess, a slower shutter speed can cause blur from handshake or subject movement, so use this function with the understanding that there can be unwanted consequences. This option is unavailable in Movie mode (**'🎥**).

The options are:

▶ **0: Disable.** The exposure you set is maintained regardless of lighting changes.

▶ **1: Shutter speed/Aperture.** In Shutter-priority AE (**Tv**) and Aperture-priority AE (**Av**) exposure modes, the shutter speed or aperture shifts automatically if the subject brightness suddenly changes.

▶ **2: ISO speed.** This option adds Program AE mode (**P**) to Shutter-priority AE (**Tv**) and Aperture-priority AE (**Av**) modes from the first option, and changes the ISO setting to get a correct exposure if the scene brightness changes. If you change the ISO speed range manually or set the minimum shutter speed on Shooting menu 3 (**◉**), Safety shift over-rides your settings if necessary.

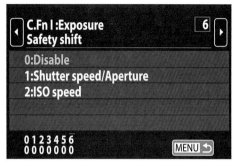

6.3 The Safety shift screen.

The minimum and maximum ISO settings used will be the Auto ISO Range you set in Shooting menu 3 (**◉**). If the shutter speed, aperture, or ISO is set, Safety shift will be used even if you use a flash.

C.Fn II: Autofocus

With the 70D, you have a good number of ways to fine-tune autofocus, particularly for action shooting when you're using AI Servo AF mode (**AI SERVO**). Many of these Custom Functions are detailed in Chapter 4, the chapter about the autofocus system for all exposure modes except Live View (**◉**) and Movie (**'📹**) modes. I include the functions here with a brief description, but see Chapter 4 for more detailed information.

C.Fn II-1 Tracking sensitivity.

This setting determines how AI Servo AF (**AI SERVO**) responds to either maintain focus on the original subject or switch focus to a subject that suddenly enters the frame, and how to respond when the subject moves out of the AF-point array. This function is unavailable in the Live View (**◉**) and Movie shooting (**'📹**) modes. Here are the choices:

▶ **0:** The default setting that is a general-purpose setting for most moving subjects.

▶ **Locked on: -2/Locked on: -1.** With this option, the camera endeavors to keep the original subject in focus. There is a noticeable delay before the camera focuses on the new subject if another subject or object enters the scene. A -2 setting extends the delay.

6

▶ **Responsive +2/Responsive +1.**
Use this when you want the
camera to focus on successive
subjects that are at different dis-
tances. Also, this option deter-
mines the speed at which the
camera focuses on a new sub-
ject, particularly the subject that
is closest to the camera. A +2
setting is faster than +1. A +2
setting can cause the camera to
focus on the wrong subject.

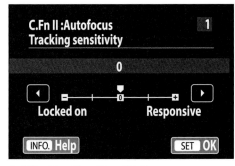

6.4 The Tracking Sensitivity screen.

C.Fn II-2 Accel./decel. tracking

With the acceleration/deceleration tracking function, you adjust how the AF system
responds to subjects that start, stop, and change direction erratically and unpredict-
ably. This option is unavailable in the Live View (⬛) and Movie shooting ('📹) modes.
Here are the options:

▶ **0:** This is the default. It is designed to provide good focus tracking when the
subject's speed is steady.

▶ **+2/+1:** A plus setting tells the system to expect erratic direction shifts and sud-
den starts and stops and to keep focus on the subject; for example, the motion
of a soccer player.

C.Fn II-3 AI Servo 1st image priority

This and the next Custom Function, AI Servo 2nd image priority, are useful when you
use focus tracking coupled with one of the continuous drive modes. Use the options
here to prioritize subject focusing, and shutter release for the first image during con-
tinuous shooting. This function is unavailable in the Live View (⬛) and Movie shooting
('📹) modes. Here are the options:

▶ **Equal priority.** This is the default that gives equal priority to focusing and shutter
release. You can shoot fast, but the subject may or may not be in sharp focus.

▶ **Release priority.** Choose this if you want to be able to take the picture regard-
less of whether the camera has had time to establish sharp focus.

▶ **Focus priority.** Choose this option if you want an in-focus picture even if you
might miss a shot because the camera hasn't yet established focus.

C.Fn II-4 AI Servo 2nd image priority

This tells the 70D what priority to use for the second and subsequent images when you shoot a continuous burst of images. This option is unavailable in the Live View (📷) and Movie shooting ('🎥) modes. You have the following choices:

▶ **Equal priority.** This is the default with which both focusing and shutter release (for example, shooting speed) have the same priority.

▶ **Shooting speed priority.** Choose this if you want to be able to take the picture, regardless of whether the camera has had time to establish sharp focus.

▶ **Focus priority.** Choose this option if you want an in-focus picture at the cost of shooting speed.

C.Fn II-5 AF-assist beam firing

This determines whether the built-in or accessory flash fires a series of light bursts to illuminate a subject in low light or when the contrast is low to help the camera establish focus. With this option enabled, when you press the shutter button halfway, the flash fires a series of short flashes so the camera can establish focus.

In the Program AE (**P**), Shutter-priority AE (**Tv**), Aperture-priority AE (**Av**), Manual (**M**), and Bulb (**B**) modes, flip up the built-in flash, and a series of beams fires (without actually firing the full flash) anytime the camera needs extra light to focus. In Creative Auto (CA) and some other automatic exposure modes, such as Scene Intelligent Auto (🄰⁺), Portrait (🧑), and Close-up (🌷), the AF assist beam fires along with the flash in low light scenes. However, the assist beam never fires in Flash Off (🚫), Landscape (🏞), or Sports (🏃) modes. The assist beam also never fires in any exposure mode when the autofocus mode is set to AI Servo AF (**AI SERVO**). This function is available in the Live View shooting mode (📷) when using the AF Quick focus mode (AFQuick). Here are the options for this function:

▶ **0: Enable.** The built-in flash or external Speedlite's focus-assist light is used to establish focus whenever necessary. This is useful in low-light scenes and when the subject contrast, texture, and detail are low. This is the default setting.

▶ **1: Disable.** The AF-assist beam isn't used. Use this in venues where flash isn't allowed or when the series of assist beams may disturb others.

▶ **2: Enable external flash only.** The assist beam fires only when an accessory Speedlite is on the camera and turned on. For this to work, the Speedlite's Custom Function for AF-assist beam firing must be enabled.

6

▶ **IR: IR AF-assist beam only.** If your accessory Speedlite has an infrared AF assist beam, then only that beam is used if you choose this option. The advantage is that the IR beam is used instead of the Speedlite firing a series of small flashes and that can be less intrusive. Also, if the Speedlite has an LED, the LED doesn't automatically turn on for AF assist. For accessory Speedlites, if you've set the Custom Function on the Speedlite itself to disable AF-assist beam firing, then that setting overrides the settings on the 70D. To use the AF-assist beam, just change the Custom Function on the Speedlite to Enable.

C.Fn II-6 Lens drive when AF impossible

This is a handy function to explore if you often shoot scenes on which the lens cannot focus, but continuously tries to find focus. You've probably been in situations in which the lens goes far out of focus range while attempting to find focus, particularly with telephoto and super-telephoto lenses. Setting this function to option 1 stops the lens from seeking focus and going into extensive defocus range. This is available in Live View mode (▢) when using AF Quick focus mode (AFQuick). Here are the choices:

▶ **0: Continue focus search.** The default where the lens continues to seek focus.

▶ **1: Stop focus search.** This stops the lens drive if it cannot find focus, and it keeps it from going into extreme defocus range. Use this option if you shoot with super telephoto lenses.

C.Fn II-7 Select AF area selection mode

If you routinely use only one or two of the AF area selection modes, then you can limit the number of modes that you can select while shooting. For this function, first press Setting button (⊛) to activate the options. Then, press the left and right key on the Multi-controller (⬡) to select the mode you want, and then press the Setting button (⊛) to place a check mark (✓) beside the mode. Select OK. The default, 1-point AF manual selection mode cannot be deselected. You can select this option in Live View mode (▢) when using AF Quick focus mode (AFQuick). Here are the options:

▶ ▢ **Manual selection: 1 pt AF.** Single-AF point selection.

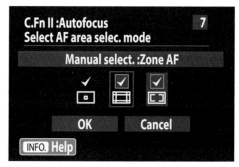

6.5 The AF area selection mode screen.

▶ ⊞ **Manual select: Zone AF.** To use this mode, choose the five AF zones.

▶ ⊡ **Auto selection: 19-point AF.** Choose this mode to be able to use 19-point automatic AF-point selection.

C.Fn II-8 AF area selection method

The options for this function enable you to customize the buttons you use to switch among the AF area selection modes. The choice is personal for every photographer, but I find that the second option that uses the Main dial (⚙) is easier and quicker. It creates a bit of a conflict, though, because the Main dial (⚙) is also used to move horizontally through the AF points during manual AF-point selection.

This option re-assigns the Main dial (⚙) to choose a selection mode instead of choosing an AF point. However, you can easily work around that by using the direction keys on the Multi-controller (⊙) to move horizontally through the AF points. This option is available in Live View mode (◻) when using AF Quick focus mode (AFQuick). Here are the options:

▶ **0:** ⊞ **(then press)** AF area selection button. This is the standard way to select an AF area by pressing the AF-point Selection button (⊞), and then pressing the AF area selection mode button (⊡) one or more times until you get to the mode you want. This leaves the Main dial (⚙) free for cycling horizontally through AF points, as mentioned earlier.

▶ **1:** ⊞ **(then turn the) Main dial**. With this change, you use the Main dial (⚙) to move among AF area selection modes instead of pressing the AF area selection mode button (⊡) repeatedly.

C.Fn II-9 Orientation linked AF point

This very cool and handy function allows you to set the AF point or AF area selection mode to use when the camera is in the horizontal or one of the two vertical (grip up, grip down) orientations. Then, when you change the camera orientation, your go-to AF point and AF area selection mode is selected automatically. You can use this function in Live View mode (◻) when using AF Quick focus mode (AFQuick). Here are the choices:

▶ **0: Same for both vertical/horizontal.** This is the default with no remembered AF point, AF area selection mode or zone.

▶ **1: Select separate AF points.** You choose and register three manually-selected AF points or zones — Horizontal, vertical with grip up, and vertical with grip down.

6

C.Fn II-10 Manual AF point selection pattern

Use the options in this function to control how you cycle through AF points when you manually select one. As you cycle through, you can have the cycle stop at the edges or cycle back through continuously. The option you choose works when you manually select an AF point and when you use 19-point automatic selection with AI Servo AF (**AI SERVO**). This function is available in Live View mode (📷) when using AF Quick focus mode (AFQuick). Here are the options:

- ▶ **0: Stops at AF area edges.** As the description says, when you reach the end of the row of AF points, the selection stops. It's annoying at times, but not if your next move is in the opposite direction and you want to stay on the outer edge of the bank of AF points.

- ▶ **1: Continuous.** This option provides endless cycling through a row of AF points from left to right or top to bottom and back again.

C.Fn II-11 AF point display during focus

Some people are sensitive about what they see in the viewfinder, particularly when focusing and making the picture. For some, the constant display of the 19 AF points while they are composing and focusing is distracting. To other photographers, hiding the AF point display is equally annoying. Canon puts the control in your hands with this Custom Function. This option is unavailable in the Live View (📷) and Movie shooting ('🎥) modes. Here are the choices:

- ▶ **0: Selected (constant).** Choose this option to have the selected AF point displayed all the time. If you are shooting anything other than action subjects, you likely want to know which AF point is selected so that you can change it if necessary to place sharp focus precisely where it should be in the scene.

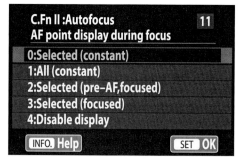

6.6 The AF point display during focus screen.

Screen text:
C.Fn II :Autofocus 11
AF point display during focus
0:Selected (constant)
1:All (constant)
2:Selected (pre–AF,focused)
3:Selected (focused)
4:Disable display
INFO. Help SET OK

► **1: All (constant).** This option does just what it says — you see all 19 AF points all the time. With this option, you see the AF points when you're selecting the AF point, when the camera is ready for shooting but you haven't started focusing yet, during focusing, and when the camera has established focus.

► **2: Selected (pre-AF, focused).** The selected AF point(s) is displayed when you select the AF point, when the camera is ready to shoot but you haven't started focusing, and when the camera establishes focus. With AI Servo AF (**AI SERVO**), the AF point isn't displayed when focus is achieved.

► **3: Selected (focused).** You see the AF point(s) when you select an AF point and when the camera achieves focus. With AI Servo AF (**AI SERVO**), the AF point isn't displayed when focus is achieved.

► **4: Disable display.** This option turns off AF point display except when you select an AF point. If you want a clean display in the viewfinder, this is your best choice.

C.Fn II-12 VF display illumination

As with the previous function, this one gives you control over the viewfinder display by illuminating the AF points and grid in red based on the amount of light in the scene. Alternately, you can turn it off. However, when you press the AF-point Selection button (⊞) or the AF area selection mode button (⣿), the AF points and grid are automatically lit in red, and choosing an option for this function does not change that behavior. With AI Servo AF (**AI SERVO**), the AF point is not illuminated in red when the camera achieves focus.

This function is unavailable in the Live View (🄳) and Movie shooting ('🎥) modes. Here are the options:

► **0: Auto.** This is the default where the camera displays the illuminated grid and AF points in red when the scene light is low.

► **1: Enable.** If you want to see the grid and AF points illuminated in red all the time, choose this option.

► **2: Disable.** If you don't want to see the grid and AF points in red, this is the option to choose.

6

C.Fn II-13 AF Microadjustment

Using this function, you can fine-tune the camera's focus. This option is unavailable in the Live View (📷) and Movie shooting ('🎥) modes.

CROSS REF The AF Microadjustment option is covered in Chapter 4.

C.Fn III: Operation/Others

This group of Custom Functions gives you control over many of the dials and controls of the camera, as well as some display settings. The Custom Controls option is the most extensive in giving you the ability to reassign functions to 10 of the camera controls.

C. Fn III-1 Dial direction during Tv/Av

If the direction of the camera dials for changing the aperture and shutter speed seem backward to you, use this Custom Function to change the direction in Shutter-priority AE (**Tv**) and Aperture-priority AE (**Av**) shooting modes. This option is available in the Live View (📷) and Movie shooting ('🎥) modes. Here are the options:

▶ **0: Normal.** The default dial directions are used. Turning the Main dial (🔛) to the right in Aperture-priority AE (**Av**) shooting mode results in a smaller aperture.

▶ **1: Reverse direction.** Turning the Main dial (🔛) to the right in Aperture-priority AE mode (**Av**) makes the aperture larger. In Shutter-priority AE (**Tv**), turning the Main dial (🔛) to the right makes the shutter speed slower instead of faster. In Manual mode (**M**), both the Main (🔛) and Quick Control (🔘) dial turning directions are reversed. However, for setting exposure compensation in Manual mode (**M**), the Quick Control dial (🔘) direction is not reversed. In the remaining exposure modes, only the direction of the Main dial (🔛) is reversed.

C. Fn III-2 Multi function lock

With this Custom Function, you can prevent changes to the exposure and other camera settings by choosing to lock the Main (🔛) and Quick Control (🔘) dials, and/or the Multi-controller (🔅) when the Lock switch (ʟᴏᴄᴋ) is set to the up position. This helps prevent changes when other people handle

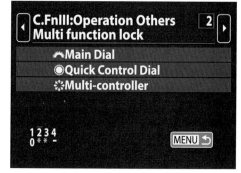

6.7 The Multi function lock screen.

the camera and when you move the camera in and out of the gear bag. This is available in the Live View (⬛) and Movie shooting ('📹) modes.

As a reminder, the camera displays an L in the viewfinder, on the LCD screen, and on the camera settings screen when you try to use a locked control. Even with the Lock switch (ʟᴏᴄᴋ) in the locked position, you can still use the controls to navigate the camera menus and the Quick Control screen.

To choose a control, press the Setting button (⑤) to activate the options. Next, press the down key on the Multi-controller (⬡) to select one of the options, and then press the Setting button (⑤) to add a check mark indicating that the control is included. Select OK. Here are the options:

▶ 〰 Main Dial

▶ ◯ Quick Control Dial

▶ ⬡ Multi-controller

C.Fn III-3 Warnings in viewfinder

Some settings on the camera are typically scene- or subject-specific. As a result, you want to change to different settings after shooting, but it's easy to forget to make the changes. This function gives you an alert for the settings that you choose so that you remember to change them. A warning icon (①) at the bottom right of the viewfinder is displayed as a reminder. You can have a warning icon (①) displayed for one or all of the items. This function is unavailable in the Movie ('📹) and Live View shooting (⬛) modes.

To choose a control, press the Setting button (⑤) to activate the options. Next, press the down key on the Multi-controller (⬡), press the Setting button (⑤) to add a check mark (✓) indicating that the control is included, and then select OK. Items with a check mark will display the Warning icon (①) in the viewfinder. Here are the options:

▶ **When monochrome (✧M) set.** This warning is displayed when the Monochrome Picture Style (✧M) is set. You can't convert a monochrome image back to color, so it's advisable to make this one of your choices.

▶ **When WB is corrected.** This reminds you that White Balance Correction is set. Because White Balance correction is usually scene-specific, this is a good reminder to reset the correction.

▶ **When ISO expansion is used.** This reminds you if you've set ISO H (25600). You definitely do not want to use this ISO for normal shooting, so I recommend adding a check mark here.

▶ **When spot meter. is set.** If you've switched to Spot metering mode (⊡) for one or a series of images, this reminds you to switch back to Evaluative (⊡) or another metering mode when you finish.

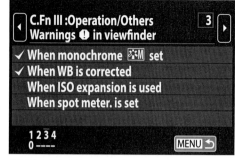

6.8 The Warnings in viewfinder options with the first two checked.

C.Fn III-4 Custom Controls

If you've ever wanted to customize virtually everything on the camera to your liking, this Custom Function is a wish-come-true. The Custom Controls screen gives you a diagram of the camera from which you can change the function of many buttons and dials. Availability of this function in the Movie ('🎥) and Live View shooting (📷) modes depends on the setting.

> **NOTE** For all step-by-step tasks in this chapter, be sure that the Mode dial is set to a Creative Zone mode, such as Aperture-priority AE (**Av**) or Shutter-priority AE (**Tv**).

This screen is different from most of the other Custom Function screens, but you can follow these steps to use it:

1. **On the Custom Functions menu (.Ω.), highlight C.FnIII: Operation/Others, and then press the Setting button (⊛).** The C.Fn III: Operation/Others screen appears.

2. **Press the Multi-controller (⁖) left or right until the number 4 is displayed in the box at the upper right of the screen, and then press the Setting button (⊛).**

3. **Turn the Quick Control dial (○) to highlight the name of the button or dial you want to customize, and then press the Setting button (⑤).** A screen appears with the functions that you can assign to the button or dial.

4. **Turn the Quick Control dial (○) to select the function you want to assign to the button or dial, and then press the Setting button (⑤).**

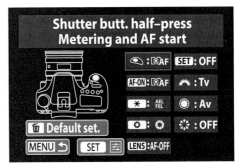

6.9 The Custom Controls screen.

5. **Repeat step 4 to continue setting additional Custom Controls.**

If you get confused and want a do-over, just press the Menu button (**MENU**) to get back to the main Custom Controls screen, and then press the Erase button (🗑) The changes you make to the camera controls are not cancelled when you choose the Clear all Custom Func. (C.Fn) option on the Custom Functions menu (.⊡.).

In the following list, the first item is the camera control and action (if applicable), followed by the default setting of the camera control — the setting that you can change. Note that the LENS button is the AF stop button that is available only on super-telephoto Image-Stabilized (IS) lenses. The 70D instruction manual provides more detail and a chart that is useful in reassigning button functions. Here are the choices:

▶ ⊡AF: **Metering and AF start.** Instead of metering and focusing when you press the shutter button halfway, you can assign these functions to the AF-ON (**AF-ON**), AE lock (✱), or AF stop (**AF-OFF**) button.

▶ AF-OFF: **AF Stop.** Pressing the button you choose stops the camera from focusing. You can use this to lock focus during AI Servo AF (**AI SERVO**). This function can be assigned to the AF-ON (**AF-ON**), AE lock (✱), or Lens buttons.

▶ ⬛⬛: **One-shot (switch) AI Servo.** Pressing the button you choose switches from One-shot autofocus mode to AI Servo AF mode, and vice versa. In AI Servo AF (**AI SERVO**), it switches to One-shot AF (⬛⬛) only as long as you press the button. Use this when the subject starts and stops. While the AI focus AF mode (**AI FOCUS**) switches between One-shot and AI Servo (**AI SERVO**) focusing, you may find it more convenient to control it with the press of a button rather than relying on the camera to detect subject movement, especially if there are multiple subjects in the scene, such as at a sporting event. This function can be assigned to the Depth of Field Preview (⬛) or Lens buttons.

▶ ⊞: **AF-point selection.** This enables you to choose an AF point using the Multi-controller (⬛) without first needing to press the AF-point selection (⊞) or the AF area selection mode (⬛) button. You can assign this function to only the Multi-controller (⬛).

▶ ⬛: **Metering start.** Pressing the shutter button halfway performs metering rather than metering and focusing. You can assign this functionality to the shutter button.

▶ ⬛: **AE lock/FE lock.** When you are not shooting with the built-in flash or an accessory Speedlite, the button you choose will meter the light and lock the exposure — the traditional AE lock functionality. When you're using a flash, pressing the button fires a preflash to determine the correct flash output, and locks the flash exposure (FE). You can assign this to the AF-ON (**AF-ON**), AE lock (⬛), Depth of Field Preview (⬛), or Lens buttons.

▶ ✱: **AE lock.** You can change the button used for AE lock. AE lock temporarily locks the exposure settings from the most recent meter reading, so that you can meter for exposure in one area and focus on a different part of the scene. The exposure is retained as long as you see the AE lock symbol (✱) in the viewfinder. You can reassign this function to the AE lock button (✱) to the AF-ON (**AF-ON**), Depth of Field Preview (⬛), or Lens buttons.

▶ ✱: **AE lock (while button pressed).** The exposure is locked only as long as you press the shutter button. You can assign this only to the shutter button.

▶ ⬛: **AE lock hold.** This enables you to hold a locked exposure until you no longer need it. The exposure remains locked until you press the button that you assigned to this function again. This is a good option if you want to take a series of pictures at the same locked exposure settings. You can assign this to the AF-ON (**AF-ON**), AE lock (✱), Depth of Field Preview (⬛), or Lens button.

▶ **FEL: FE lock.** Pressing the button you assign to this function causes the flash to fire preflashes, calculate, and then hold the correct flash exposure for the scene. You can assign this to the AF-ON (**AF-ON**), AE lock (✳), Depth of Field Preview (🔳), or Lens button.

▶ ISO⫶: **Set ISO speed (hold the button and turn 🔆).** With this option, you can set the ISO sensitivity, by holding down the Setting button (⑯) as you turn the Main dial (🔆). If you had the ISO set to Auto, this switches it to manual. In Manual mode (**M**), this option means that you can make exposure changes using the ISO, while maintaining the current aperture and shutter speed. You can assign this only to the Setting button (⑯).

▶ **Tv: Shutter speed setting in M mode.** Using this option, you can set the shutter speed in Manual mode (**M**) by turning the Main (🔆) or Quick Control (◯) dials. Normally, you can use only the Main dial (🔆). You can assign this to either the Main dial (🔆) or Quick Control dial (◯).

▶ **Av: Aperture setting in M mode.** Using this option, you can set the aperture in Manual mode (**M**) by turning the Main (🔆) or the Quick Control (◯) dials. Normally, you can use only the Quick Control dial (◯). You can assign this to either the Main (🔆) or Quick Control (◯) dial.

▶ 🔣: **Flash exposure compensation.** This and the next three options enable you to assign a function to the Setting button (⑯) so that it has a function during shooting. With this option, you can press the Setting button (⑯) to display the Flash Exposure Compensation setting screen on the LCD screen. Of course, you can assign this only to the Setting button (⑯).

▶ 🔲: **Image quality.** This is the second option for assigning a function to the Setting button (⑯). You can press it to display the Image Quality setting screen, in which you can change the image quality. You can assign this to the Setting button (⑯).

▶ ⟨🔳: **Picture Style.** This is the final option for assigning a function to the Setting button (⑯) during shooting, and here you can press it to display the Picture Style screen. You can assign this to the Setting button (⑯).

▶ 🔳: **Depth-of-field preview.** When you press the button assigned to this function, the lens aperture stops down so that you can preview the depth of field in the viewfinder.

6

► (🖐): **IS start.** Pressing the button you assign to this function starts Image Stabilization on the lens, provided, of course, that the IS switch is set to the On position. You can assign this to the Depth-of-field preview (🔅) or Lens buttons.

► **-📷-: VF electronic level.** Press the button you assign to this function to use the AF points to display an electronic level and grid before you make the picture. You can assign this to the Depth-of-field preview button (🔅).

► **MENU: Menu display.** With this function, you can press the Setting button (SET) to display the menu on the LCD screen. You can assign this only and predictably to the Setting button (SET).

► **OFF: No function (disabled).** Use this setting to turn off the functionality for the button you choose. You can assign this to the AF-On (**AF-ON**), AE lock (✱), Depth-of-field preview (🔅) or Setting (SET) button, or the Multi-controller (✧).

Registering Custom Mode Settings

With the Custom mode (**C**) on the Mode dial, you can preset the 70D with your favorite shooting mode, exposure settings, drive and autofocus modes, and Custom Functions. Then, when you're ready to shoot, just switch to the Custom mode (**C**) on the Mode dial. If you need to, you can change the settings as you shoot. If you want to save an adjustment for future use in Custom mode (**C**), you can turn on automatic update.

It does not take long to think of a plethora of ways to use Custom mode (**C**). For example, you could be set up for shooting nature and landscape with the camera preset to the exposure mode you prefer, with exposure bracketing, mirror lockup, as well as to your favorite drive, autofocus, and exposure modes, and Picture Style. You could also preset it for shooting studio portraits, weddings, concerts, or whatever works for you.

> **TIP** If you forget the settings you've registered for the Custom mode (**C**), just press the Info button (**INFO.**) to display them.

When you register camera settings, the following are saved and recalled when you turn the Mode dial to Custom mode (**C**):

► **Shooting settings.** These shooting settings are saved in Custom mode (**C**): Exposure mode, ISO, aperture, shutter speed, AF operation, AF point, metering and drive mode, and the amounts set for exposure compensation and Flash Exposure Compensation.

▶ **Menu settings.** In Custom mode (**C**), the following settings are registered:

- **Shooting menus (📷).** Shooting menu 1: Image quality, VF grid display, Viewfinder level, Beep, Release shutter without card, Image review. Shooting menu 2: Lens aberration correction, Flash control, E-TTL II metering, Flash sync. speed in Aperture-priority AE mode (**Av**), Red-eye reduction, Mirror lockup. Shooting menu 3: Exposure compensation/AEB, ISO settings, Auto Lighting Optimizer, White balance, Custom white balance, White balance Shift/Bracketing, Color space. Shooting menu 4: Picture Style, Long exposure noise reduction, High ISO speed Noise Reduction (NR), Highlight tone priority, Multiple exposure (options), HDR mode (options).

- **Live View menus (📹).** Live View shooting menu 1: Live View shooting, AF method, Continuous AF, Grid display, Aspect ratio, Exposure simulation. Live View shooting menu 2: Silent LV shooting, Metering timer.

- **Movie menus (🎥).** Movie shooting menu 1: AF method, Movie Servo AF, Silent LV shooting, Metering timer. Movie shooting menu 2: Grid display, Movie recording size, Digital zoom, Sound recording, Movie recording count, Movie play count, Video snapshot.

- **Playback menus (▶).** Playback menu 2: Slide show (options), Image jump with the Main dial (⚙). Playback menu 3: Highlight alert, AF point display, Playback grid, Histogram display, Movie play count.

- **Setup menus (🔧).** Setup menu 1: File numbering, Auto rotate. Setup menu 2: Auto power off, LCD brightness, LCD off/on button. Setup menu 3: Touch control, Info button (**INFO.**) display options. Setup menu 4: Auto cleaning.

- **Custom Function menus.** C.Fn I: Exposure: Exposure level increments, ISO speed setting increments, Bracketing auto cancel, Bracketing sequence, Number of bracketed shots, Safety shift. C.Fn II: Autofocus: Tracking sensitivity, Acceleration/deceleration tracking, AI Servo 1st image priority, AI Servo 2nd image priority, AF-assist beam firing, Lens drive when AF impossible, Select AF area selection mode, AF area selection method, Orientation linked AF point, Manual AF point selection pattern, AF point display during focus, VF display illumination, AF Microadjustment. C.Fn III: Operation/Others: Dial direction during Shutter-priority AE/Aperture-priority AE (**Tv**)/(**Av**), Multi function lock, Custom Controls.

- **My Menu (★).** The My Menu settings are not registered.

6

Before you register the camera settings, ensure the camera is set to Program AE (**P**), Shutter-priority AE (**Tv**), Aperture-priority AE (**Av**), or Manual (**M**) mode.

Follow these steps to register camera settings:

1. **On the camera, choose all the settings that you want to register.** The settings will be the ones registered for this mode.

2. **On the Setup menu 4 (𝚈), highlight Custom shooting mode (𝐂), and then press the Setting button (⑱).** The Custom Shooting mode (𝐂) screen appears.

6.10 The Custom shooting mode screen.

3. **Select Register settings, and then press the Setting button (⑱).** The Register settings screen appears.

4. **Choose OK, and then press the Setting button (⑱).** The Custom shooting mode screen appears.

5. **If you want any of the changes you make while shooting in the Custom mode (𝐂) to be saved, highlight Auto update set., and then press the Setting button (⑱).** The Disable and Enable options appear.

6. **Highlight Enable, and then press the Setting button (⑱).** Changes you make during shooting are saved as part of the mode settings. You can set the Mode dial to Custom mode (𝐂) and begin shooting.

In Custom shooting mode (𝐂), neither the Clear all Camera settings on the Setup menu 4 (𝚈), nor the Clear all Custom Function option on the Custom Functions menu (.ᄋ.) can be used. If you want to clear the registered user settings, choose Clear settings on the Custom shooting mode (𝐂) screen in step 2.

Customizing My Menu

The My Menu option (★) on the 70D is a timesaver. With it, you can add your six most frequently used menu items and options. In addition to frequently used menu items, you can also add your most-often used Custom Functions to My Menu (★).

You can arrange the menu items, and you can easily add or delete items from the menu. You can also set the 70D to display My Menu (★) first when you press the Menu button (**MENU**). The only drawback to My Menu (★) is that you can only register six items. So before you begin registering, evaluate the menu items and Custom Functions and carefully choose your six favorite items.

As an example, I usually register Multiple exposure, HDR Mode, External Speedlite control, Mirror lockup, High ISO speed NR, and Custom white balance. I have also set up My Menu (★) as the first menu that is displayed when I press the Menu button (**MENU**).

Here is how to add items to My Menu (★):

1. **On the My Menu screen (★), highlight My Menu settings, and then press the Setting button (⊛).** The My Menu settings screen appears.

2. **Highlight Register to My Menu, and then press the Setting button (⊛).** The Select item to register screen appears with a scrollable list of all menu items and Custom Functions available on the camera. To scroll through the list, turn the Quick Control dial (◌).

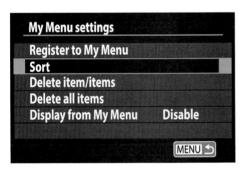

6.11 The My Menu settings screen.

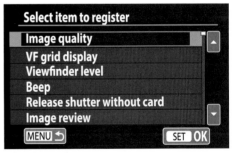

6.12 The Select item to register screen.

3. **Highlight the menu item you want to register, and then press the Setting button (⊛).** The Select item to register confirmation screen appears.

4. **Choose OK, and then press the Setting button (⊛).** The Select item to register screen reappears so that you can select the next item.

5. **Repeat steps 3 and 4 until all the menu items you want are registered, and then press the Menu button (MENU).** The My Menu settings screen appears. If you want to sort your newly added items, jump to step 2 in the following set of steps.

To sort your registered items, follow these steps:

1. **Repeat steps 1 and 2 in the adding items to My Menu task, if necessary.**

2. **On the My Menu settings screen, highlight Sort, and then press the Setting button (⑤).** The Sort My Menu screen appears.

3. **Highlight the item you want to move to another position, and then press the Setting button (⑤).** The camera activates the sort control arrows to the right side of the menu item.

4. **Turn the Quick Control dial (◯) to move the item up or down in the list, and then press the Setting button (⑤).**

5. **Repeat steps 3 and 4 to move other menu items in the order that you want.**

6. **Press the Menu button (MENU) twice to display your customized menu.** Lightly press the shutter button to dismiss the menu.

You can follow these general steps to access My Menu settings. Once there, you can delete one or all items from the menu and have My Menu (★) displayed each time you press the Menu button (**MENU**).

Now you have a good idea of how you can set up the 70D not only to make it more comfortable and efficient for your preferences but also to have the camera ready in advance for different shooting scenes and subjects.

Shooting in Live View Mode

At times, composing images with the viewfinder can be inconvenient or even impossible. That's when Live View shooting offers a good alternative. With Live View shooting mode (◻), you can use the camera's large 3-inch LCD monitor to compose and capture images. Further, with the addition of Canon's revolutionary Dual Pixel CMOS Autofocus technology, focusing is both fast and accurate. The new autofocus technology, also used in Movie mode, may be enough to convert photographers from viewfinder to Live View shooting.

Live View shooting (◻) is a good option for still-life, product, macro shooting, and more. As you shoot, you can monitor the exposure using the live histogram. You can also change settings, such as the white balance, and Picture Style, or apply Creative filters and see the effect immediately by using exposure simulation.

I composed this scene in Live View mode and used the histogram to confirm it was a good exposure. Exposure: ISO 200, f/5.0, 1/200 second, -2/3 exposure compensation.

About Live View Shooting

Using the LCD screen to shoot images has become commonplace, whether you're using a cell phone or a point-and-shoot digital camera. Until the past several years, viewing a live scene on the LCD screen of a dSLR wasn't possible because the shutter and reflex mirror blocked the view to the image sensor. However, the 70D overcomes this blind spot with a mechanical shutter that stays completely open and a mirror that stays up during Live View shooting to give you a real-time view of the scene.

Live View mode (■) offers several advantages over viewfinder shooting. For example, you can use the new Dual Pixel CMOS Autofocus feature in several focus modes, zoom in, and set precise focus manually, or use the option for silent shooting that reduces the noise of the shutter cocking. You can also position the camera in places you cannot get to, and use the articulated LCD screen to view and compose images when you cannot use the viewfinder.

The Live View shooting mode (■) is handy, but it comes with the following caveats:

▶ **Temperature affects the number of shots you can get.** With a fully charged LP-E6 battery, you can expect 230 shots without flash use in normal temperatures of 73 degrees. In freezing temperatures, expect 210 shots without flash use. If you use the flash half the time, then you'll get approximately 210 shots in normal temperatures and 200 in cold temperatures. With a fully charged battery, you get approximately 1 hour and 50 minutes of continuous Live View shooting in normal temperatures before the battery is exhausted.

▶ **High temperatures, high ISO speeds, and long exposures can degrade image quality.** In short, anything that heats up the sensor — whether it's high internal or external temperatures — can cause image problems, as can high ISO settings. Even before the camera warns you of a high internal temperature, using high ISO settings with high temperatures can result in images with both digital noise and inaccurate image colors. A little common sense prevents most problems. If the camera has been in the sun or in hot temperatures, then let it cool before you use it. If you're shooting long exposures, let the camera cool down between exposures. The camera warns you when the temperature is high. The first warning displays a white thermometer on the LCD screen warning you to let the camera cool. If you continue shooting, a blinking red icon warns you that the camera will automatically stop shooting very soon (and it does). Then you have to wait for the camera to cool down before you can use it again.

CAUTION When you shoot in Live View mode (📷), the camera heats up, and it can irritate or even blister your skin if you hold the camera too long without changing position. This is true even if the camera doesn't feel like it's too hot to hold. Using a tripod helps prevent irritation from handholding the camera for extended times, and it helps you capture more sharply focused images.

▶ **Certain conditions can cause Live View mode (📷) not to reflect the captured image accurately.** Image brightness may not be accurately reflected in low- and bright-light conditions. If you move from low to a bright light and if the LCD brightness level is high, the Live View may display *chrominance* (color) noise, but the noise will not appear in the captured image. Also, suddenly moving the camera in a different direction can throw off accurate rendering of the image brightness. Light source changes can also cause the image to flicker. Just stop Live View shooting mode (📷), and then restart it. If you focus and capture an image in magnified view, the exposure and focus may not be correct. Be sure to return to normal display before shooting.

▶ **Some settings and features don't work in Live View mode (📷).** You cannot use the focus preset on super-telephoto lenses. You also cannot use Flash Exposure Lock (**FEL**) or modeling flash if you shoot with a Speedlite. However, if the accessory Speedlite has an LED, it will light to help the camera find focus when necessary. Certain Custom Function settings (.🔧.) are also ignored in Live View shooting mode (📷).

CROSS REF Custom Functions are detailed in Chapter 6.

Enabling Live View Shooting

Before you begin using Live View mode (📷), it's good to know what is the same and what is different as compared to viewfinder shooting. The following sections cover the differences and similarities. As you read, you can also set the options that you want to use.

The exposure mode you choose affects how many features and options that will be available to you on the camera menus and on the Quick Control screen. In the Creative Zone modes such as Aperture-priority AE (**Av**) or Shutter-priority AE (**Tv**) mode, all the features are available. In Basic Zone modes, fewer menus and settings are available.

The settings in Live View shooting menus 1 and 2 (🗖) activate the Live View shooting mode (🗖) and enable you to set your preferences. If you are anxious to get started, follow these steps to enable Live View shooting mode (🗖):

1. **Set the camera to the shooting mode you want.** I typically use Aperture-priority AE (**Av**) or Shutter-priority AE (**Tv**) mode, but you can choose any of the 70D's exposure modes.

2. **Set the Live View/Movie shooting switch to Live View shooting mode (🗖).**

3. **Press the Menu button (MENU), and then go to Live View Shooting menu 1 (🗖).** Live View Shooting menu 1 (🗖) is displayed.

Live View shoot.	Enable
AF method	FlexiZoneAF □
Continuous AF	Enable
Touch Shutter	Enable
Grid display	Off
Aspect ratio	3:2
Expo. simulation	Enable

7.1 The options available on Live View Shooting menu 1. If you're using a Basic Zone exposure mode, fewer options are available.

4. **Press down on the Multi-controller (⬙) to highlight Live View shoot., and then press the Setting button (⊛).** The Enable and Disable options appear.

5. **Select Enable, and then press the Setting button (⊛).**

6. **On the back of the camera, press the Start/Stop button (START/STOP).** A real-time view of the scene appears on the LCD screen.

> **NOTE** Before you begin shooting in earnest, be sure to set up the camera using the options on Live View Shooting menus 1 and 2 (🗖), which are detailed later in this chapter.

The operation of the camera during Live View shooting mode (🗖) is easy once you get started. However, just a few minutes of watching the real-time view on the LCD screen will convince you that a tripod is necessary. With any focal length approaching telephoto, Live View mode (🗖) provides a real-time gauge of just how steady or unsteady your hands are.

Additionally, the Live View Quick Control screen offers handy access to commonly used controls. With a live view of the scene displayed, press the Quick Control button

(**Q**) to display the Quick Control screen. From the Live View Quick Control screen in any exposure mode, you can set the AF method, Drive mode, Image-recording quality, and Creative Filters. In Program AE (**P**), Shutter-priority AE (**Tv**), Aperture-priority AE (**Av**), Manual (**M**), and Bulb (**B**) exposure modes, you can also set the Metering mode, White balance, Picture Style, and Auto Lighting Optimizer. In the Basic Zone modes, additional functions are available depending on the exposure mode you're using.

CROSS REF Picture Styles and Creative Filters are detailed in Chapter 5.

To use the Quick Control screen press up or down on the Multi-controller (✛) to select a function. The options appear at the bottom of the screen. Then turn the Main dial (✌) to choose the option. For Picture Style, you can press the Info. button (**INFO.**) to change the Picture Style parameters.

The Quick Control screen also gives you access to Creative Filter Effects, such as Grainy B/W, Soft focus, Toy camera, and others. These filters are available in all shooting modes except HDR Backlight Control (🖼) and Handheld night scene (🖼). Creative filters can be used for JPEG images, but not for RAW (**RAW**) or any of the RAW plus JPEG settings. Filters also cannot be used if Auto Exposure Bracketing (🖼), White Balance Auto Bracketing (🖼), or Multi Shot Noise Reduction (🖼) is set. The live histogram isn't displayed during use of the filters.

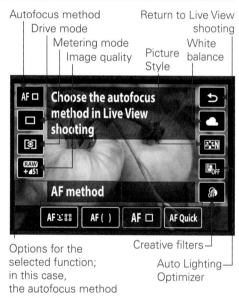

Autofocus method
 Drive mode
 Metering mode
 Image quality
 Picture
 Style

Return to Live View
 shooting
 White
 balance

Options for the selected function; in this case, the autofocus method

Creative filters
 Auto Lighting
 Optimizer

7.2 The Live View Quick Control screen.

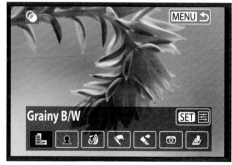

7.3 The Creative filters on the Live View Quick Control screen.

The buttons above the LCD panel on top of the camera work in Live View mode (📷) just as you would expect. Just press the button, and the settings screen for the function is displayed. Then you can turn the Quick Control (○) or Main (⚙) dial to adjust the settings. If you set Partial (◙) or Spot (⊡) metering modes, then a metering circle appears in the center of the LCD screen. Use that center area for metering in these modes. In Basic Zone modes such as Portrait (♥) and Landscape (🏔), some of these functions cannot be set.

Setting up for and Shooting in Live View Mode

Now that you've had a chance to work with Live View mode (📷), take some time to learn about the different focus options, Continuous AF, using the Metering timer, grid, Exposure simulation, and setting an aspect ratio. The following sections will help you get the most out of Live View mode (📷).

Live View focus options

Among the differences between viewfinder and Live View shooting (📷) are the focus options. Without question, Canon's new Dual Pixel CMOS Autofocus technology, which is available in the Live View (📷) and Movie (🎥) modes merits discussion.

Dual Pixel CMOS Autofocus uses phase-detect focusing. Right off the bat, that sounds like geek mumbo jumbo. However, this technology is a big deal, even if you're not technically inclined. For example, if you've ever wished the camera would just hurry up and focus, this technology can make that a reality.

With Canon's breakthrough implementation of phase-detect focusing, the camera can measure precisely how far out of focus the subject is and quickly tell the lens exactly how much correction is needed to get the subject in focus. This can also make focus hunting — when the lens moves back and forth trying to find focus — outdated. With

its precise measurements, it can also put an end to back- and front-focusing — both of which do just what the names say, they focus behind or in front of the subject.

With phase detection, the camera evaluates the light rays coming in from opposite sides of the lens and determines if they line up. And if they do not, it knows by how much they are off and can tell the lens precisely what direction to move and by how much to achieve sharp focus. If you've ever used the old split-screen focusing of film cameras, then you have a mental model of how phase detection works, but today's version is, of course, electronic.

The bottom line is that Dual Pixel CMOS Autofocus is fast and precise. It also holds the promise of providing focus over a very large area of the sensor because every pixel on the sensor has phase-detect capability. Just the lure of Dual Pixel CMOS Autofocus could be enough to convert even die-hard viewfinder photographers to Live View mode (◻) photographers. The Dual Pixel CMOS Autofocus technology is available when you use the Face Detection+Tracking (AF☺╬), FlexiZoneMulti AF (AF◖◗), and FlexiZoneSingle AF (AF◻) focus methods in Live View shooting mode (◻). The Quick mode focus option uses the onboard autofocus sensor that's also used with traditional viewfinder (non-Live View) shooting.

> **NOTE** Canon notes that even if you choose one of the Dual Pixel Autofocus modes, the camera may change from phase detection to contrast detection depending on the lens you're using and the options you've chosen, such as whether you're using magnified view or digital zoom (in Movie mode '🎥). If the method switches, you'll likely notice a slowdown in focus speed.

Contrast detection is an older focusing technique in which the camera looks at the scene to determine how much edge contrast (that is, the difference in brightness) there is between side-by-side pixels across the AF frame. Focusing then is a matter of getting the maximum overall contrast in the subject. So, the camera moves the lens a bit in one direction or the other, and checks to see if it increases the contrast until maximum contrast is reached. While contrast detection works, it's a time-consuming process.

As you review the options in Live View shooting mode (◻), be sure to try them so that you know which is best for different scenes and subjects. Then, you can choose

the one you want on Live View Shooting menu 1 (■) or the Quick Control screen. Many of these focus modes are also used for shooting movies.

The Live View shooting mode (■) focusing options are:

▶ **Face Detection+Tracking (AF꙰).** In this mode, the camera automatically looks for and focuses on a human face, and then tracks it if the person moves. A large AF point (rectangle) appears on top of the face the camera selects. If the camera does not choose the face of the subject you want or if there are multiple faces in the scene, then you can press the direction keys on the Multi-controller (⁙) to move the focusing frame to the correct face. If multiple faces are found, then the AF point displays arrows on the left and right indicating that you can move the AF point over another face using the Multi-controller (⁙). If the camera cannot detect a face, then the AF point reverts to the center AF point, and you can manually move the AF point to the face you want, or tap the screen to select the face. Then half-press the shutter button to focus. The AF point turns green when focus is achieved and a beep confirms focus. (The AF point turns orange if the camera can't establish focus.) The camera may have trouble finding faces in the scene if your subjects are far from the camera. You can turn on Continuous AF on Live View Shooting menu 1 (■), so the camera keeps the scene generally in focus. This prevents subjects from going into severe defocus range. However, using Continuous AF is costly in terms of battery life, so use this with caution. Face detection does not work with extreme close-ups of a face, with distant subjects, or when subjects are too bright or dark, partially obscured, or tilted horizontally or diagonally. Also, the camera can't focus if the subject is at the edges of the frame, and you cannot magnify the scene with this focus method. In low light, establishing focus may slow down. Unfortunately, you also cannot use the AF-assist beam on an EX Speedlite to help the camera focus. However, if you have an EX-series Speedlite with an LED, such as the 320EX, then the LED will automatically light to help the camera find focus.

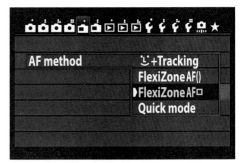

7.4 The focusing options available on Live View Shooting menu 1.

NOTE The number of AF points differ if you have changed the aspect ratio from the default 3:2 that offers 31 AF points. There are 25 AF points when the 4:3 and 1:1 ratios are set. There are 21 AF points and three rather than nine zones with the 16:9 aspect ratio.

▶ **FlexiZoneMulti AF (⬛).** The focusing method is the same as that for Face Detection+Tracking (⬛), except that it does not look for a human face, and the focus area can cover up to 31 AF points. The first response after reading the last sentence may be to argue that the camera has only 19 AF points. That's also true for viewfinder focusing, but with this mode, the number increases significantly. In addition, the 31-AF point area can be subdivided into nine zones so you can focus by selecting one of the zones. To switch between the full 31-AF point area and zone selection, press the Setting (⬛) or Erase (⬛) button. Press the direction keys on the Multi-controller (⬛) to select the zone you want. To move quickly to the center zone, press the Setting (⬛) or Erase (⬛) button again. Press the shutter button halfway to focus. The AF point turns green when focus is achieved. (The AF point turns orange if the camera cannot establish focus.) Then press the shutter button completely to make the picture. You can also select or tap Magnify (⬛) on the screen one to three times to focus while the scene is magnified (up to 10X). This is the focus method I use for macro shooting.

> **TIP** In FlexiZoneMulti AF (⬛), do not focus in a non-zoomed view, and then magnify the scene and try to focus again. Instead, zoom in on the subject first, and then focus to get tack-sharp results. It's a good practice to use a tripod anytime the scene is magnified.

▶ **FlexiZoneSingle AF (⬛).** This focusing method is the same as FlexiZoneMulti AF (⬛), but it uses a single AF point for focusing. This is my choice for portraits, still-life, and nature images because I can set the focus more precisely than with the other methods. To move the AF point, just press the direction keys on the Multi-controller (⬛). To move quickly to the center zone, press the Setting (⬛) or Erase (⬛) button again. To focus, press the shutter button halfway to focus, and then press it completely to take the picture.

▶ **Quick focus mode (⬛).** This focusing mode uses the camera's autofocus sensor, the same one that's used with viewfinder shooting. To use the onboard

autofocus sensor, the camera has to flip up the reflex mirror long enough to establish focus, and during that brief time, your view of the live scene is blocked. As with viewfinder shooting, you can manually select the AF point unless you are using 19-point automatic selection AF. And when you're shooting in the automatic modes, automatic AF point selection is used by default. If you have Continuous AF enabled on Live View Shooting menu 1 (◼), and you then choose Quick focus mode (**AFQuick**), Continuous AF is automatically disabled. To maintain continuous focus, the autofocus sensor must have a view of the scene. However, that view is disrupted when the reflex mirror flips down to establish focus in Quick focus mode (**AFQuick**). To focus with Quick focus mode (**AFQuick**), press the AF Area Selection Mode button (**⋯**) one or more times to select the selection mode you want. If you set the focus method to FlexiZoneSingle AF (**AF □**), the AF point is a small, white rectangle, and you can select which AF point you want to use. In FlexizoneMulti AF (**AF ◖**) with Zone AF, a larger bracketed focus area is displayed on the screen, and you can choose the zone you want to use. In both cases, just press the direction keys on the Multi-controller (✦) in the direction of the AF point or zone you want. To focus, half-press the shutter button. The reflex mirror flips up, the camera establishes focus, and the mirror flips down. If focus is established, the AF point or zone momentarily turns green. When the live view image appears on the LCD screen again, you can press the shutter button completely to take the picture.

NOTE The Touch shutter button ([**📷**]) on the lower left of the LCD screen turns the Touch shutter on and off. If you turn on the Touch shutter, you can focus and release the shutter simply by touching the LCD screen with your finger.

▶ **Manual focus (MF).** Manual focusing, while not a menu option, is a precise way to focus in Live View mode (◻), and you get the best results when you magnify the image for focusing. With manual focusing, the live view is not interrupted as with Quick Focus mode (**AFQuick**). The prerequisite is having a lens that offers Manual focus (**MF**). To focus manually, set the lens switch to Manual focus (**MF**), and then move the focusing frame by pressing the direction keys on the Multi-controller (✦) or by tapping to move it. Press the Magnify button (**🔍**) or tap the icon on the screen one to three times to zoom in to 1X, 5X, or 10X. Then, turn the focusing ring on the lens to focus.

NOTE If you use Live View mode (📷) with Continuous drive mode (🔁), the exposure is set for the first shot, and is used for all images in the burst.

Continuous AF

When you enable Continuous AF, the camera maintains general focus on the subject so that when it comes times to focus sharply, the lens is not in significant defocus range. Enabling Continuous AF speeds up focusing, but it also drains the battery quickly, as the lens must continue to operate even when you're not shooting.

Continuous AF works with all of the AF methods except Quick focus mode (⏹AFQuick). If you have Continuous AF enabled, and you switch from one focus mode to Quick focus mode (⏹AFQuick), and then back again, Continuous AF begins operating again. If you want to switch to Manual focus (**MF**) while Continuous AF is operating, switch out of Live View mode (📷) first, and then set the lens switch to Manual focus (**MF**).

Touch shutter

By enabling this option, you can touch the LCD screen to both focus and release the shutter to make the picture. To enable it, choose Touch shutter on Live View Shooting menu 1 (📷), press the Setting button (⚙), and then choose Enable. You can also start Live View shooting mode (📷), and then tap the Touch shutter icon ([📷OFF]) on the lower left of the LCD screen. Then, just touch the LCD to place the AF point or zone where you want it, focus, and release the shutter.

With Touch shutter enabled, the drive mode automatically switches to Single-shot (⬜) regardless of what other drive mode you've set. You can't use Touch shutter when the LCD view is magnified. Also, if you have set the camera controls to functions other than their defaults using Custom Function III-4, Custom Controls, then half-pressing the shutter button may not cause the camera to focus.

You can use Touch shutter to start a Bulb exposure (**B**), but I'm not convinced that I would ever do this since the last thing you want during a long exposure is movement of any kind on the camera. However, you can try it if you're so inclined. Just tap the LCD screen twice to start a Bulb exposure (**B**), and then tap it twice again to stop the exposure.

Grid display

With this option, you can choose among three grids that will be superimposed on the LCD screen. These help you keep the vertical and horizontal lines in the scene square with the frame to help you compose the scene. The choices are 3 × 3, 6 × 4, or 3 × 3+diag. If you do not want to use a grid, select Off.

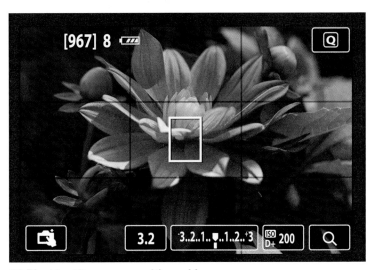

7.5 The Live View screen with a grid.

Aspect ratio

Another feature unique to Live View mode (📷) is the ability to set an aspect ratio so that you can capture JPEG images pre-cropped to a specific size. *Aspect ratio* refers to the relationship of the image width to height. Standard print sizes have aspect ratios that may be different from the image's aspect ratio. For example, a 4 × 6-inch print has a 3:2 aspect ratio, while an 8 × 10-inch print has a 5:4 aspect ratio. By setting an aspect ratio for JPEG images, you can fit the image to the print's aspect ratio with varying amounts of cropping to make the image fit the paper size. To figure out the print size that each aspect ratio produces, multiply each number in the ratio by 2. A 3:2 aspect ratio translates to 6 × 4, or if you transpose the numbers, a 4 × 6-inch print.

When you set the aspect ratio, a non-printing black mask is added to the Live View display to show the cropped image area and help you compose the image. If you're shooting JPEG images, the images are saved at the aspect ratio you choose. If you shoot RAW, the aspect ratio can be applied during RAW image conversion if you use the Canon Digital Photo Professional software that comes with the camera.

The aspect ratio you set affects only images shot in Live View mode (📷). Table 7.1 shows the aspect ratios from which you can choose and the resulting image resolutions.

Table 7.1 Live View Mode Aspect Ratio Options**

Image quality	Approximate image pixel dimensions/Megapixels			
	3:2	**4:3**	**16:9**	**1:1**
L RAW	5472 × 3648 (20 MP)	4864 × 3648 (17.7 MP)	5472 × 3072* (16.8 MP)	3648 × 3648 (13.3 MP)
M	3649 × 2432 (8.9 MP)	3248 × 2432* (7.9 MP)	3648 × 2048* (7.5 MP)	2432 × 2432 (5.9 MP)
M RAW	4104 × 2736 (11.2 MP)	3648 × 2736 (10 MP)	4104 × 2310* (9.5 MP)	2736 × 2736 (7.5 MP)
S1/S RAW	2736 × 1824 (5 MP)	2432 × 1824 (4.4 MP)	2736 × 1536* (4.2 MP)	1824 × 1824 (3.3 MP)
S2	1920 × 1280 (2.5 MP)	1696 × 1280* (2.2 MP)	1920 × 1080 (2.1 MP)	1280 × 1280 (1.6 MP)
S3	720 × 480 (350,000 pixels)	640 × 480 (310,000 pixels)	720 × 408* (290,000 pixels)	480 × 480 (230,000 pixels)

*The pixel count doesn't exactly match the aspect ratio, and the image area displayed in Live View mode is slightly larger than the recorded area.

**Information courtesy of Canon.

Exposure simulation

If you enable Exposure simulation (Exp.SIM), the image you see on the LCD screen replicates what the final image will look like at the current exposure settings and with exposure modifications, including Auto Lighting Optimizer (🔳) and Highlight tone priority (D+). In addition, the image approximates the effect of the selected Picture Style, white balance and correction if set, Creative filters, Ambience and Lighting/scene options, exposure and metering, Peripheral illumination correction, Chromatic aberration correction, and aspect ratio, if you've set one.

You have the following three choices for exposure simulation on Live View Shooting menu 1 (📷):

▶ **Enable (Exp.SIM).** Turns on exposure simulation. The final exposure is simulated on the LCD display during Live View shooting (📷).

▶ **During DOF (❀).** With this option, you can choose to view the exposure simulation only when you hold the Depth-of-Field preview button (❀). Otherwise, the image is displayed at standard LCD brightness.

▶ **Disable (⊡DISP).** The image is displayed at the standard LCD brightness with no exposure simulation. While the image is easy to view, you can't see the result of exposure modifications you make, such as applying exposure compensation or using Auto Lighting Optimizer (🖼ON). If you choose this option, be sure to press the Info button (**INFO.**) to display the Brightness histogram so you know if the exposure needs adjustment.

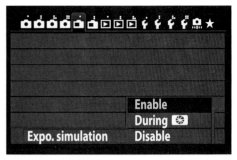

7.6 The Exposure simulation options.

Silent shooting modes

On Live View Shooting menu 2 (■), you can set one of two Silent shooting modes, and you can even use quiet shooting during continuous shooting. In either Silent LV shooting mode 1 or 2, the shutter noise is noticeably reduced. One caveat, though, is that silent shooting isn't possible with flash units.

The following is a summary of the two Silent shooting modes and the Disable option:

▶ **Mode 1.** In this mode, the shutter cocking noise is reduced significantly. In Quick focus mode (AFQuick), the sound of the mirror action is still noisy, but the shutter sound is significantly reduced. If you're shooting an event and keeping the noise level low is important, then use this mode because you can use High-speed continuous shooting (⊒H) at 7 fps.

▶ **Mode 2.** This mode delays shutter noise after you take a picture as long as you keep the shutter button pressed, thus delaying the recocking sound of the shutter. If the camera is in Continuous drive mode (⊒), only one image is made because the shutter does not re-cock until you release the shutter button. If you choose this option and use remote control shooting with the accessory RS-60E3 remote release, then the result is like using Mode 1.

▶ **Disable.** This is the setting to choose if you use a *tilt-and-shift* (TS-E) lens other than the TS-E17mm f/4L or the TS-E 24mm f/3.5L II lenses, and you make vertical shift or tilt movements. You would also choose this setting if you're using extension tubes on the lens or a non-Canon flash; otherwise, the flash will not fire.

Metering timer

The second option on Live View Shooting menu 2 (■) is the Metering timer. This is where you determine how long the last meter reading is used by the camera. This essentially determines the AE lock (✱) duration from the last time you pressed the shutter button halfway. If the light in the scene remains constant, then you can speed up shooting by using the existing meter reading for a longer amount of time. If the light changes frequently, then set a shorter amount of time.

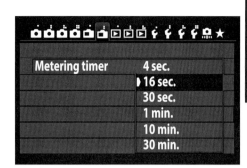

7.7 The Metering timer options in Live View shooting menu 2.

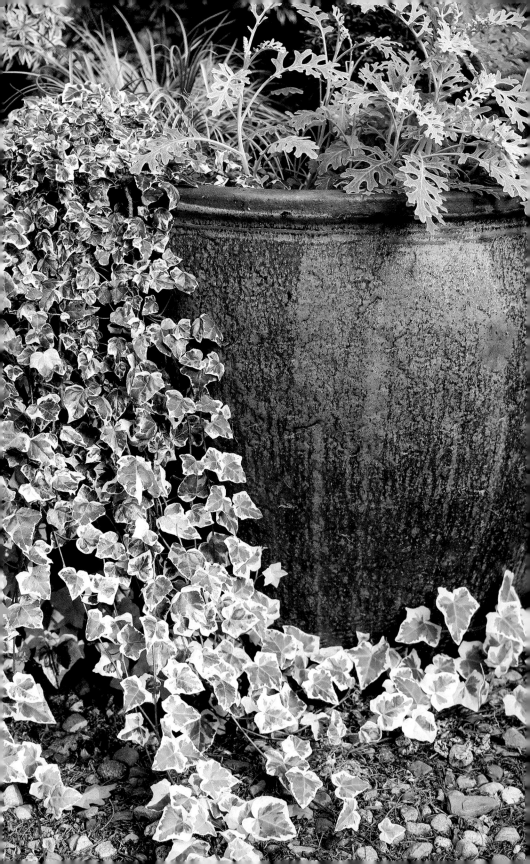

Using Movie Mode

Making high-quality movies isn't new for dSLRs, but the 70D adds new technology that makes video focusing faster and more accurate, even when tracking a moving subject. Focus transitions are smooth, and when you use one of Canon's stepper-motor (STM) lenses, the focus motor operation is very quiet. You can also just touch the LCD screen to focus.

You also get Canon's DIGIC 5+ image processor for fast processing and real-time correction of common problems, including chromatic aberration. Movie shooting options also include a choice of file-compression options, continuous shooting with the camera automatically creating new files when the current file reaches the 4GB limit, a time code feature, improved sound recording and sound adjustment options, and a drop-frame control. In this chapter, I cover how to set up the camera and begin shooting movies.

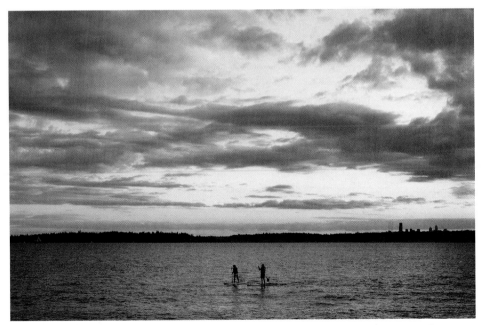

Many improvements, especially in focus technology, make the 70D a very capable camera for capturing HD video. Exposure: ISO 200, f/9.0, 1/80 second.

About Movies

The ability to shoot movies offers two obvious benefits: It expands your creative options with the camera, and, if you shoot professionally, it has the potential to increase your income by shooting both stills and videos for clients.

If you're new to recording movies, then get set to learn a new set of technical details and terms. There's no better place to begin than with a discussion of the industry standards.

Video standards

Learning about industry standards opens the door to understanding some of the language related to video and how the 70D features and options fit into those standards. In the world of video, there are several industry standards, including the following resolutions: 720p, 1080i, and 1080p.

The numbers 720 and 1080 represent vertical resolution. The 720 standard has a resolution of 921,600 pixels, or 720 (vertical pixels) × 1280 (horizontal pixels). The 1080 standard has a resolution of 2,073,600 pixels, or 1080 × 1920. It seems obvious that the 1080 standard provides the highest resolution, and so you would think that it would be preferable. But that is not the entire story.

More of the story is contained in the *i* and *p* designations. The *i* stands for *interlaced.* Interlacing is a method of displaying video where each frame is displayed on the screen in two passes — first, a pass that displays odd-numbered lines, and second, a pass that displays even-numbered lines. Each pass is referred to as a *field*, and two fields comprise a single video frame. This double-pass approach was engineered to keep the transmission bandwidth for televisions manageable. The interlaced transmission works only because your mind automatically merges the two fields, so that the motion seems smooth with no flickering. Interlacing, however, is the old way of transmitting moving pictures.

The newer way of transmitting video is referred to as *progressive scan,* hence, the *p* designation. Progressive scan quickly displays a line at a time until the entire frame is displayed. Also, the scan happens so quickly that you see it as if it was being displayed all at once. The advantage of 720 standard resolution progressive scanning is most apparent in scenes where either the camera or the subject is moving fast. With

interlaced transmission, fast camera action or moving subjects tend to blur between fields. That is not the case with progressive scan. And as it happens, a 720p video provides a smoother rendering of motion than 1080i. So while 1080i offers higher resolution, 720p can provide a better video experience, particularly when there are fast-action scenes.

Another piece of the digital video story is the frame rate. In the world of film, a frame rate of 24 frames per second (fps) provided the classic cinematic look of old movies. In the world of digital video, the standard frame rate is 30 fps. Anything less than 24 fps provides a jerky look to the video. The TV and movie industries use standard frame rates, including 60i, which produces 29.97 fps and is used for NTSC; 50i, which produces 25 fps and is used for PAL, a standard used in some parts of the world; and 30p, which produces 30 fps, a rate that produces smooth rendition for fast-moving subjects. With this very brief background on video, you can look at the digital video options on the 70D.

8

> **NOTE** NTSC is the standard for North America, Japan, Korea, Mexico, and other countries. PAL is the standard for Europe, Russia, China, Australia, and other countries.

> **TIP** Videographers who want a cinematic look prefer cameras that convert, or *pull down,* 30 fps to 24 fps.

Video on the 70D

If you're new to video, then you probably have questions, including how the 70D compares to industry standards, how long you can record, and how big the files are. The following is a rundown of the digital video recording options that you can choose on the 70D:

▶ **Full HD (Full High-Definition) at 1920 × 1080p at 30 fps (actual 29.97), 25 fps when set to PAL, or 24 (actual 23.976) fps.** With the 70D, you choose not only the resolution and frame rate but also the type of compression, either IPB or ALL-I (detailed later in this chapter). With IPB compression, you get approximately 16 minutes of recording on a 4GB memory card, and 1 hour, 4 minutes

with a 16GB card. The file size is 235MB per minute. With ALL-I compression, you get approximately 5 minutes of recording time with a 4GB card and approximately 22 minutes with a 16GB card. The file size is 685MB/minute with ALL-I. The aspect ratio is 16:9.

▶ **HD (High-Definition) at 1280 × 720p at 60 fps (actual 59.94) and 50 fps when set to PAL.** With IPB compression, you get approximately 18 minutes of recording time with a 4GB card, and 1 hour, 14 minutes with a 16GB card. The file size is 205MB/minute. With ALL-I, you get approximately 6 minutes of recording on a 4GB card and 25 minutes on a 16GB card. The file size is approximately 610MB/minute. The aspect ratio is 16:9.

▶ **SD (Standard recording) at 640 × 480 at 30 fps (actual 29.97) or actual 25 fps when set to PAL.** The only compression you can choose is IPB, and you get 48 minutes of recording time with a 4GB card, and 3 hours and 14 minutes with a 16GB card. The file size is 78MB per minute. The aspect ratio is 4:3.

So, you have two high-quality video options, albeit at different frame rates. The 30 fps option is the traditional recording speed for online use, whereas the actual 29.97 speed is the TV standard in North America (NTSC). As a result, the 30 fps option is suitable for materials destined for DVD or display on a standard-definition or HD TV. Although 24 fps is more film-like, it can produce jerky motion for moving subjects, and it requires slower shutter speeds. In addition, the actual 29.97 frame rate makes it easier to sync audio when it is recorded separately using a video-editing program.

Here are some other aspects about shooting video on the 70D to consider:

▶ **Audio.** You can use the 70D's built-in stereo microphone, which provides reasonable audio if you do not want to invest in a separate audio recorder and microphone. If you use the built-in microphone, be aware that all the mechanical camera functions are recorded, including the sound of the Image Stabilization (IS) function on the lens, the focusing motor, as well as ambient noise on the set. However, using one of Canon's STM lenses reduces noise generated by the focusing motor. The built-in microphone features a wind-cut filter and attenuator that is on at all times when using the internal microphone to reduce the sound of wind, of course, and the attenuator reduces sound distortion. With the 70D, you can control the audio recording up to 64 levels. If you use an accessory microphone, a 3.5mm stereo input jack on the side of the camera records at 48 kHz/16 bit sampling rate, and can be plugged into the microphone IN terminal.

Understanding Video Compression

The 70D offers two file compression options. Here is a summary of both:

▶ **IPB (Interframe Predictive Bidirectional differential compression).** This option provides the highest compression and smallest file sizes. IPB is an interframe compression system — compression across a series of frames. It stores data in a Group of Pictures (GOP), a group of, say, 15 frames. The GOP is subsequently reduced to one complete frame. Instructions for re-creating the frames are embedded in the file during recording. Then during playback, missing frames are reconstructed when the playback device reads the cues, or instructions, for re-creating missing frames. The instructions, for example, might tell the playback device to make frame 4 from frame 1, 2, and 3. This type of reconstruction, or decoding, is processor intensive because the playback device must reconstruct complete frames in the clip. The *P* in IPB stands for *predictive* and the *B* stands for *bidirectional differential compression*. Thus, the system predicts the content of upcoming frames by looking at previous and subsequent frames. IPB compression is not a good choice for video clips that require frame-by-frame editing. Choose IPB for videos that have a long running time, such as speeches and conferences, and for clips that don't require detailed editing. A 4GB file at 1920 × 1080 produces approximately 16 minutes of continuous recording with IPB compression.

▶ **ALL-I compression.** This option offers the lowest compression and largest file sizes. With this intraframe compression option, each frame is processed as a single image, providing high-quality video that can be edited frame-by-frame with no quality degradation. However, the overall file sizes are three times larger than with IPB compression. This compression method is a good choice for short videos where you expect extensive editing and where the ability to edit anywhere in the clip may be needed, and for clips with action. Because there is less decoding required by the playback device, ALL-I compression is less processor intensive. A 4GB file at 1920 × 1080 produces approximately 4.5 to 5 minutes of video recording with ALL-I compression.

▶ **Exposure and camera settings.** Exposure control ranges from fully automatic to full manual, with semiautomatic modes such as Aperture-priority AE (**Av**) and Shutter-priority AE (**Tv**) enabling you to have more control even with automatic exposure. Shutter speeds are linked to the frame rate. For example, the slowest frame rate at 30, 25, or 24 fps is 1/30 second, and at 60 or 50 fps, it is 1/60 second. The maximum shutter speed is 1/4000 second for all frame rates. The ISO can be set automatically or manually. Manual ISO settings range from 100 to the expanded 12800 setting. In automatic and Basic Zone modes, the ISO is automatically set from 100 to 6400. You can also use AE Lock (✱) and set exposure compensation of +/-3 stops for movies or +/-5 stops for still images. You can't use Auto Exposure Bracketing (AEB) during movie shooting. The Picture Style, white balance, still-image quality, and other settings in Movie mode ('🎥) can also be adjusted.

▶ **Battery life.** At normal temperatures, you can expect to shoot for approximately 1 hour and 20 minutes, regardless of ambient temperature changes.

▶ **Video clip size and lengths.** The upper limit of a single video file is 4GB. When the movie approaches the 4GB point, the *time code,* or elapsed time display, blinks. Then the camera automatically creates a new file while you continue recording uninterrupted. Given sufficient space on the memory card, you can record up to 29 minutes and 59 seconds of video, with the videos stored in a series of 4GB files. During editing, individual clips can be placed sequentially for a continuous movie, with no evidence of file transitions or dropped frames.

▶ **Memory cards.** The 70D supports SD, SDHC, or SDXC cards. If you use IPB compression, Canon recommends memory cards with a 6MB/second or faster write speed. If you use ALL-I compression, then Canon recommends a write speed of 20 MB/second or faster. And if you shoot still images during recording, go with a faster card than the ones recommended. With slower cards, the movie may not record correctly.

NOTE Shooting HD at 50 or 60 fps using ALL-I recording puts the greatest demand on a media card, with HD 720p requiring 14MB/sec for SD (SecureDigital) cards.

▶ **Image simulation.** The LCD screen simulates the final video, including the exposure, Picture Style settings, white balance, lens corrections, Highlight tone priority, and other settings.

▶ **Still-image shots during recording.** You can capture, or grab, a still image at any time during video recording by pressing the shutter button completely. This results in a 1-second pause in the video, and then movie shooting resumes. The still image is captured at the quality set on Shooting menu 1 (⬤) and is recorded as a separate file on the media card. The aspect ratio is 16:9, except when the 640 × 480 movie recording size is used — in that case, it is 4:3. The camera automatically sets the aperture and shutter speed when you're using autoexposure shooting. If you're using manual exposure movie shooting, then you can manually set the shutter speed and aperture as with regular shooting. The ISO range is 100 to 6400 for autoexposure movie shooting. With manual shooting, it varies according to what you have set as the ISO speed range's maximum setting. If you've set 12800/H as the top ISO speed, then the maximum ISO for movies will be 12800. But if you set the maximum to 12800, then the auto ISO for movies is 6400. If you're shooting a long movie, be aware that shooting still shots will cause changes between the actual time and time code of the movie making it harder to synchronize video and audio.

▶ **Temperature cautions.** As with Live View shooting (⬛), the camera's internal temperature increases faster when shooting video. The camera displays a white thermometer-like icon as a first warning. If you keep shooting, a blinking red temperature icon appears to encourage you to let the camera cool down. If you still keep shooting, the camera stops recording automatically, and it won't start again until it has cooled off sufficiently. If you shoot while the white warning icon is displayed, the movie quality won't suffer, but still images you capture may show degradation.

Setting Up to Record Movies

A little planning, or even a lot of planning, goes a long way in creating interesting and polished videos. And the 70D offers a goodly number of setup choices that deserve discussion. The following sections walk through the controls and options you can set to suit your recording preferences. Some of the setup options are the same as, or similar to, those offered in Live View shooting mode (⬛). In particular, some of the focusing modes are the same.

This section discusses resolution, exposure, focusing, white balance, Picture Style, and other options you can set before you begin recording.

Choosing the resolution and exposure mode

The choices for setting up and shooting video are many and varied. The first decision is what resolution to use. For example, progressive video capture is best if you want to do frame-by-frame editing of the move, and it is compatible with DVD and Blu-ray players. The frame rate you choose may depend on the look you want to achieve as well as on the area in which you live. For example, choose 30 or 60 fps for NTSC TV format used in North America, Japan, Korea, Mexico, and other areas. But choose 25 or 50 fps if you are shooting for the PAL TV format used in Europe, Russia, China, Australia, and other countries.

To choose the resolution, frame rate, and compression method, go to Movie Shooting menu 2 (📹), highlight Movie rec. size, press the Setting button (⑨), and then choose a size and compression method, as shown in Figure 8.1.

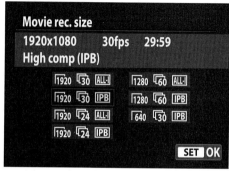

8.1 The Movie rec. size screen.

Using High ISO Settings for Movies

Although using high ISO sensitivity settings for movies is not recommended, the high settings may be required in low-light scenes. If you want to record at ISO 12800, the ISO speed range option on Shooting menu 2 (📷) must be set to the 12800/H option, rather than 12800 (without the H designation), and you must also be shooting in Manual exposure mode (**M**). ISO settings of 8000, 10000, and 12800 are all considered high settings, and an H is displayed on the screen as a reminder.

If you're using autoexposure in the Program AE (**P**), Shutter-priority AE (**Tv**), or Aperture-priority AE (**Av**) modes, then the ISO can be set to 12800. If you're using autoexposure in any of the automatic exposure modes, then the ISO range is 100 and 6400. You cannot set the Auto ISO range or Minimum shutter speed options on Shooting menu 3 (📷) during movie capture.

The lowest ISO setting for movies is 100, unless you have Highlight tone priority (**D+**) enabled, and then it is 200.

Another decision you need to make is whether you want to control all or none of the exposure settings. Your choices are automatic or manual exposure.

> **NOTE** With automatic exposure, the actual exposure settings are never displayed on the LCD screen, nor are they recorded in the EXIF data of the movie file. During recording, you can press the shutter button halfway, and the ISO and shutter speed appear at the bottom of the screen. These exposure settings apply only if you take a still image, and may be different for a movie.

If you use autoexposure in the Basic Zone modes, the camera automatically detects the type of scene and sets the exposure appropriately based on the scene. To determine the exposure settings, the camera looks for the focus method and shooting mode you choose — for example, Portrait (🧑) or Landscape (🏔) — and the light (or lack of it) in the scene, as well as for backlighting, spotlighting, or sunset light. An icon that represents the type of scene the camera detected is displayed on the LCD. Also in Basic Zone modes, there are fewer options on the Movie menus (🎥). Avoid zooming the lens during filming because it can change the exposure, even if the lens isn't at its maximum aperture. You can't magnify the scene during recording.

If you choose Manual exposure (**M**), then much of the camera settings and operation are the same as with still-image shooting. For example, to choose the autofocus method and drive mode, press the buttons above the LCD panel on the top of the camera. The setting screen appears on the LCD screen and you can turn the Main (⌢) or Quick Control (◯) dial to adjust the settings.

In Manual mode (**M**), if you choose Auto ISO, you can press the AE Lock button (✶) and lock the ISO at the current setting. While you can change the aperture and shutter speed during shooting, these adjustments cause visible shifts in the video that are distracting and unattractive, so avoid making those changes. Also, Canon notes that changing the shutter speed under fluorescent lighting can cause flickering in the movie.

Regardless of the exposure mode you choose, the same cautions apply to Movie shooting ('🎥) as apply to Live View shooting (📷). Because the camera's reflex mirror is open, never point the camera toward the sun or a bright light source to avoid internal damage to the sensor and internal components. Tables 8.1 and 8.2 summarize the exposure settings, the changes you can make, and how to make them.

Table 8.1 Movie Mode Autoexposure Options

Modes	ISO	Aperture	Shutter speed
All auto modes	100 to 6400 set automatically.	Set automatically	Set automatically
P, B, Tv, Av	100 to 12800 set automatically.	Press the AE Lock button (✱) to lock the current exposure for the amount of time set metering on the Movie shooting menu 1 (📹). Press the AF area selection button (⊞) to unlock the exposure.	Set automatically

Table 8.2 Manual Exposure Shooting

Mode	ISO	Aperture	Shutter speed
M	Press the ISO button (ISO) to choose the setting.	Press the shutter button halfway to check the Exposure level indicator. Turn the ○ to set the aperture.	Turn the ⌂ to set 1/4000-1/30 second for 30, 25, and 24 fps. 1/4000-1/60 second when using 60 and 50 fps. For moving subjects, 1/30 to 1/125 second gives smoother movement.

If you cannot set the exposure settings, check that the Lock (Lock) is in the down position. Before you begin shooting, take a few minutes to go through the camera menus to choose the autofocus method you want to use, and to set many other important settings.

Menu setup

The 70D has Movie shooting menus 1 and 2 (📹), which are dedicated to movie setup. The following sections detail the options on both menus and how to use them.

To set up the 70D for shooting movies, turn the Live View shooting/Movie shooting switch to the Movie position ('📹). Then, navigate to Movie shooting menu 1 (📹). There are fewer menu options in the Basic Zone modes than there are in the Program AE (**P**), Shutter-priority AE (**Tv**), Aperture-priority AE (**Av**), and Manual (**M**) modes.

> **NOTE** Some menu options are on the Quick Control screen. Just press the Quick Control button (Q) to display the screen. Press up or down on the Multi-controller (:) to select an option, and then press left or right to choose a setting.

Movie shooting menu 1

Here are the options from which you can choose on Movie shooting menu 1 (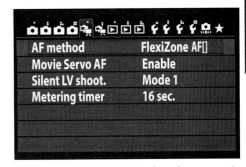):

▶ **AF method.** You can choose, Face Detection+Tracking (), FlexiZone–Multi (), or FlexiZone–Single (). These options operate in the same way as they do for Live View shooting (, covered in Chapter 7). Of course, you can also use Manual focusing (**MF**), provided the lens you're using offers it. With the new focusing technology, the Face Detection and FlexiZone focus methods are fast, accurate, and make smooth transitions between subjects.

▶ **Movie Servo AF ().** When you enable this option, the camera maintains focus as the subject moves without needing to half-press the shutter button. Maintaining subject focus takes battery power, so keep an eye on the battery level if you enable this option. Also, the sound of the lens focusing motor is recorded if you use the built-in

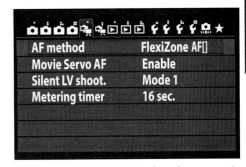

8.2 The options in Movie shooting menu 1.

microphone. Canon's STM lenses provide quieter autofocus operation than other lenses, and if the noise is too intrusive, consider using a commercial accessory microphone. During servo focusing, zooming the lens or magnifying the image will pause focusing. You can't use servo focusing together with Digital zoom. Also, avoid moving the camera with the motion of the subject (panning) because it can change the image magnification. To stop servo focusing, tap the Movie Servo AF icon () on the lower left of the screen, and then press the Flash button (). If you choose Disable, then to focus, you can press the shutter button halfway or press the AF-ON (**AF-ON**) button to focus before you begin recording the movie. If you assigned a camera button to the AF Stop function using Custom Function III-4, Custom controls, you can use it to stop and start Movie Servo AF ().

▶ **Silent LV shooting.** These options are used only when you make still images during movie recording. Choose Mode 1 to reduce the sound of the shutter even during continuous shooting. Choose Mode 2 to delay the sound of the shutter re-cocking until you release the shutter button. Choose Disable if you don't need silent operation.

▶ **Metering timer.** Choose 4, 16, or 30 seconds, or 1, 10, or 30 minutes to determine how long the camera retains the exposure. If the light changes often, choose a shorter time.

Movie shooting menu 2

The Movie shooting menu 2 (📹) offers features that are new to the camera, including Time code and Drop frame control. The options on the Movie shooting menu 2 (📹) are:

▶ **Grid display.** Choose a 3 × 3, 6 × 4, or 3 × 3+diag grid to help you align horizontal and vertical lines in the scene. Select Off if you do not want to use a grid.

▶ **Movie rec. size.** The options, including the compression options, are discussed earlier in this chapter.

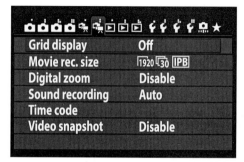

8.3 The options in Movie shooting menu 2.

▶ **Digital zoom.** At Full HD recording size, you can optionally choose to bring the scene closer by using 3 to 10x digital zoom. Unlike using a telephoto lens to bring the scene closer, digital zoom magnifies the scene, and then crops the edges to make the scene appear larger. Cropping, of course, reduces the overall resolution and quality of the movie. You can set the zoom up to 10x. With Digital zoom, you can't use Movie Servo AF (📷), and the focus changes from whatever option you've chosen to contrast-detection, a slower focusing method. The maximum ISO is 6400, and you cannot magnify the scene while using Digital zoom. As you're shooting, the image quality may appear lower and imperfections and digital noise may be visible. Scene icons are not displayed, and you cannot shoot a still image during Digital zoom. To use Digital zoom, select this option on the menu, and then press the Setting button (🔘). Choose Approx. 3-10x, and then press the Setting button (🔘). While recording the movie, press up or down on the Multi-controller to display the zoom bar. Then, press up or down on the Multi-controller (✧) to zoom in or out, respectively. It's a good idea to use a tripod when shooting with Digital zoom.

▶ **Sound recording.** This option enables you to control the sound recording with the built-in stereo microphone or with an accessary stereo microphone. In Basic Zone modes, only the On/Off options are available with automatic adjustment and with no Wind filter. In other modes, choose Auto to have the camera auto-matically control the audio level. You can also choose Manual to record sound using the built-in stereo microphone. Audio is recorded at a 16-bit, 48 kHz sam-pling rate in both the left and right channels. (You cannot adjust the sound vol-ume balance per channel.) With this option, you can adjust the recording level to one of 64 increments using the Quick Control dial (◯). Then choose Rec. level (Recording level). The sound recording options include:

8

 • **Rec. level.** Adjust the meter so that it occasionally hits the 12 (-12 dB) mark on the peak hold indicator at the bottom of the screen. Choose Disable if you don't want sound recorded.

 • **Wind filter/Attenuator.** On the Sound recording screen, select Windfilter/Attenuator. The Wind filter/Attenuator screen appears so that you can select and enable the Wind filter and/or the Attenuator. Enable the Wind filter option only if you're using the built-in micro-phone. It reduces the sound of wind for outdoor shoot-

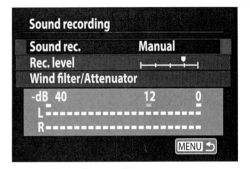

8.4 The Sound recording screen.

ing. Enabling the Wind filter also reduces low bass sounds, so be sure to disable the Wind filter if there is no wind on the set for better audio. Enable the Attenuator to reduce noise distortion if there are loud sounds on the set before you begin recording.

NOTE If you use an accessory stereo microphone, the camera automatically switches audio recording to the external microphone.

▶ **Time code.** The 70D offers Time code and Drop frame options. In video record-ing, a *time code* is a frame-counting function. Time codes follow the standard set by the Society of Motion Picture and Television Engineers (SMPTE) for

counting frames by hour:minute:second:frame, with the frame count running from 00 to 29 frames. You can set the time code in several ways. Just choose one of the following options:

- **Count up: Rec. run, Free run.** You can choose either Rec. Run or Free Run. Rec. Run means the time code advances only during movie recording. This is a good option if only one camera is filming so that you can organize clips in chronological order. Changing or formatting the media card or deleting a movie file does not reset the count. On the other hand, the Free Run option continues counting even if no movie is being recorded. Choose this option if several cameras are used to record the movie. Clips from the cameras can then be arranged chronologically during editing. However, if you change the time, time zone, or set Daylight saving time, the time code will also be affected.

- **Start time setting: Manual input setting, Reset, Set to camera time.** With this option, you can choose the Manual input setting, where you manually enter the hour, minute, second, and frames for beginning the time code. Alternately, you can choose Reset to the time you set with Manual input setting and Set to camera time so the counter is set to all zeros. If you choose Set to camera time, the current time on the camera's internal clock is used and frames are set to 00.

- **Movie recording count: Rec time, Time code.** This option determines what is displayed on the LCD during movie recording. You can choose Rec. time to display the elapsed time on the LCD during recording. You can also opt for Time code to display the time code during recording.

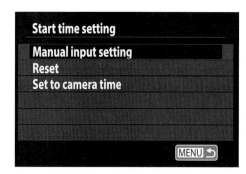

8.5 The Start time setting screen.

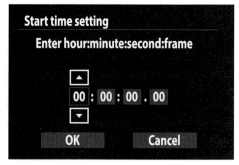

8.6 The Start time setting screen with the Manual option to input the start time.

Time Code and Drop Frame Options

A time code is an essential tool for referencing and synchronizing audio and video. Counting frames sounds simple enough until you recall that 30 fps actually records at 29.97 fps, and 60 fps actually records at 59.94 fps. So when the camera is recording at 30 fps, the time code counts frames to 29, and then 1 second is added to the 30th frame to return the counter to 00. This compensation is a little like having leap year compensate for the earth not spinning at exactly 24 hours a day. The compensation is less problematic with short videos and more problematic with long videos.

A drop frame compensates for the frame-rate discrepancy. *Drop frame* is something of a misnomer because no frames are actually dropped; rather, the time code is adjusted to compensate as described previously. On the 70D, you can opt to use a time code, and you can determine how to compensate for dropped frames.

8

NOTE If you shoot a still image during movie recording, then the actual time and time code will not match.

- **Movie playback count.** This option determines what is displayed during movie playback. You can choose Rec time (Record time) or Time code. The Rec time option displays the elapsed time after shooting starts during playback. Time code displays the time code during playback. This setting is tied to Playback menu 3 (▶) Movie play(back) count so that if you change one, the other changes as well.

- **Drop frame.** You can choose Drop frame when the frame rate is set to 30 fps or 60 fps and when the Video system is not set to PAL. Enabling this option corrects the discrepancy between the actual time and time code (see previous sidebar). The frame counter will periodically skip two frames from its count total (typically, frames 00 and 01) so the frames counted are the same as the actual number of frames. You can also choose Disable so no correction is made and no frames are skipped. When enabled, the time code is displayed as (DF) 00:00:00 (00:00:00.00 during playback). When drop frame is disabled, the time code is (NDF) 00:00:00 (00:00:00:00 during playback).

▶ **Video snapshot.** This option enables you to shoot short videos of 2, 4, or 8 seconds that you can combine as an album. This menu provides album options to Create a new album and Add to existing album. Creating Video snapshots and albums is detailed later in this chapter.

Setting the ideal shutter speed

In movie recording, the available speeds are linked to the frame rate, as detailed earlier. But it's also important to use a shutter speed for the best rendering of motion. The general formula for determining the best shutter speed is 1/(fps*2). For 24p, this translates to 1/48 second (round it up to 1/50 second). For 30p, it's 1/60 second, and for 60p it's 1/120 second (round it up to 1/125). For still photographers, these shutter speeds may seem too slow, but in video, slow shutter speeds translate into smooth motion. You can, of course, use faster shutter speeds, but speeds faster than 1/125 second tend to make motion look jerky. Taken together, this formula effectively limits the range of good shutter speeds. For example, if you're shooting at 24p, the shutter speed range is 1/50 to 1/125 second, although technically, you can shoot from 1/30 to 1/4000 second.

If the light is too bright for the shutter speed you need, and if the aperture is set for the depth of field you want, then you can use various filters to help modify the shutter speed. Here are some of the filters you can use:

▶ **Neutral density (ND) filters.** ND filters reduce the amount of light entering the lens without changing its color. ND filters are available in different strengths, called *factors* that represent their optical density or equivalent f-stop reduction, including 2, 4, and 8.

▶ **Variable neutral density filters.** Variable neutral density filters enable you to continuously control the amount of light passing through the lens up to 8 stops. This makes it possible to get slow shutter speeds even in brightly lit scenes. These filters are pricey, but a good addition to your gear bag for motion and still shooting.

If the light is too low, use a higher ISO or a faster lens.

Selecting the right color, audio, and lighting

Just as with still images, getting the color right during capture saves a lot of time post-capture in color-correcting video. And it is more of a challenge to color-correct video

than still images. So be sure to set the white balance to match the light. For the best color, set a Custom white balance for scenes where the light remains constant throughout the clip.

It is also a good idea to maintain the same Picture Style throughout the video for visual consistency. I normally do not recommend using the automatic exposure adjustment features on the camera, but I make an exception for movies when Auto Lighting Optimizer (⊞▲₀ₙ) can produce nice results, especially in challenging lighting.

Another critical component of your video is the audio recording. While the onboard 48 kHz, 16-bit stereo microphone can be used, its recording quality isn't as good as commercial microphones, and its position makes it susceptible to recording both internal camera and lens noises.

If you want a professional-quality video, invest in an accessory microphone. There are many types of accessory microphones — dynamic, condenser, mono, and stereo. Also, you can connect the 70D to an external mic using the 3.5mm stereo mic jack that records at a 48 kHz/16-bit sampling rate.

With high-definition video, lighting is an important element. Many video shooters agree that HD video offers a broad contrast range, and softer lighting is favored. Continuous fluorescent, quartz, HMI, and tungsten lighting systems produce excellent color and brightness.

Recording Movies

If you've followed along so far, then your 70D is set up and ready to record movies. While some of the camera controls are the same for movies as for still-image shooting, there are some differences. If you are using semiautomatic or manual exposure, this section provides some tips on setting the shutter speed and aperture. If you're concerned that the options you've chosen so far may not be ideal, record some test movies and see which settings work best for you.

It is wise to make as many adjustments as possible before recording and as few as possible during filming. For example, if you change an exposure setting during recording, the change in brightness can be visually intrusive during playback. Also, if you're using the built-in microphone, think through camera adjustments that you can make before you begin shooting to keep the camera sounds they produce to a minimum during recording. The fewer changes you make during recording, the smoother the

movie will be. If you have to make adjustments during shooting, the Quick Control screen is a good place to make them.

Here are some pointers to help you make engaging movies:

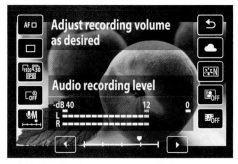

▶ **Storyboard the video scene by scene.** Create storyboards based on a script or on your vision of the story you're telling. Then you can easily plan locations, props, lenses, and lighting for each frame

8.7 Pressing the Quick Control button displays settings you can change during recording. Here, the audio level control is selected.

of the movie. Even if you're shooting spontaneously, you'll want a beginning, middle, and end to the movie, so watch for scenes that provide those elements.

▶ **Choose lenses for story-telling effect.** Know the characteristics of lenses as detailed in Chapter 10, and then use those characteristics as devices to help set scenes and tell the story. Every film has a point of view and perspective that is established by the focal length. Be aware of focal length during each segment of the movie and don't change it unnecessarily.

▶ **Use a lens hood or a matte box to avoid lens flare.** A matte box is slightly larger than, and shaped differently from, a lens hood. Matte boxes are designed specifically for video shooting.

▶ **Avoid wide-angle lens distortion.** Distortion is most apparent at the edges of the frame, so keep important elements of the scene and story away from the edges.

▶ **Make slow and steady moves.** Always move the camera slowly and steadily to avoid distortion and *rolling shutter* artifacts that happen when you pan the camera quickly. Also, if the camera is panned too fast, diagonal lines in the scene skew or lean.

▶ **Avoid unnecessary pans and zooms.** Pans, no matter how smoothly executed, can seem unsettling to the viewer. Use them sparingly. The same advice goes for using zooms.

▶ **Check that the red record light is lit in the upper-right corner of the LCD screen.** More than a few photographers have thought that they pressed the Start/Stop button (⏺) only to find out too late that nothing was recorded.

You can change the amount of information displayed on the LCD screen by pressing the Info button (**INFO.**) one or more times. One press displays the Exposure level indicator at the bottom of the screen along with a minimum of exposure and battery information. Pressing the Info button (**INFO.**) twice displays shooting, white balance, Picture Style, memory card, recording quality, audio level, and basic information. If you want to add the Electronic Level to the display, press the Info button (**INFO.**) a third time.

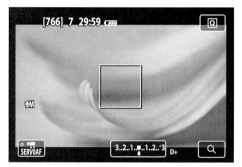

8.8 The Movie shooting display with basic information displayed.

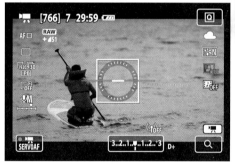

8.9 The Movie shooting display after pressing the Info button twice.

You can also create Video snapshots, which are short clips of approximately 2, 4, or 8 seconds. As you shoot each video snapshot, you can create an album and add more video snapshots to it, as well as background music. It's easy to come up with ideas for video snapshots and albums. They would be great for recording birthday parties, segments of a wedding, and the reception or a holiday family get-together.

The snapshots and albums offer good flexibility, but there are a few caveats. Albums can contain only video snapshots of the same duration. If you're shooting a video snapshot, do not change the movie recording size, change the Sound recording options, or update the firmware. Doing any of these things will cause a new album to be created. You also can't shoot a still image when shooting a video snapshot.

To set up for Video snapshots, follow these steps:

1. **On Movie shooting menu 2 (⬚🎬), select Video snapshot, and then press the Setting button (⑤).** The Video snapshot screen appears.

2. **Choose Enable, and then press the Setting button (⑤).**

3. **Choose Album settings, and then press the Setting button (⑤).** The Album settings screen appears.

4. **Select Create a new album, and then press the Setting button (⑤).** The Create a new album screen appears.

5. **Press the Setting button (⑤), and then press up or down on the Multi-controller (✦) to set the video snapshot length.** The options are 2, 4, or 8 seconds.

6. **Press the Setting button (⑤), select OK, and then press the Setting button (⑤) again.**

7. **Press the Menu button (MENU) to dismiss the menu, and then press the Start/Stop button (START/STOP) to begin shooting.** A blue bar appears indicating the remaining time of the video to snapshot. When the time is up, a ribbon of options appears at the bottom of the screen so you can save the video to the album. Other options include:

 • **Save as album.** Choose this option if this is the first snapshot you've recorded.

 • **Add to album.** Choose to add to the most recent album recorded.

 • **Save as a new album.** Choose this option to create a new album (new file) automatically and save the clip to it as the first snapshot.

 • **Play back video snapshot.** Choose to review the most recently recorded video snapshot. The controls for playback are similar to those used to play back regular videos detailed later in this chapter.

 • **Do not save to album, or Delete without saving to album.** Choose to delete the most recent video, and then select OK.

8. **Select the Save as album button at the bottom left of the screen, and then press the Setting button (⊛).** Then you can continue to shoot more clips for the album.

9. **To stop shooting video snapshots, repeat step 1 but choose Disable, and then press the Setting button (⊛).**

You can also do basic editing of video snapshot albums. During playback, choose the Edit button (✖) at the bottom right of the screen. Editing options include moving the snapshot to a different location in the album, deleting a video, and playing the edited album. If you want to include background music, copy the music to the media card first using the EOS Utility, a program included on the EOS Solutions Disk. Be sure to respect the copyright of the artist(s) who created the music.

Playing Back Movies

For a quick preview of your movies, you can play them back on the camera's LCD screen. Of course, with the camera's high-definition quality, you will enjoy the movies much more by playing them back on a television or computer.

To play back a movie on the camera LCD screen, press the Playback button (▶), and then turn the Quick Control dial (◯) to navigate to a movie file. Movie files have a SET icon in the upper left and a large right-facing arrow in the center of the screen. Then, you can do any of the following:

▶ **Press the Setting button (⊛) to display the toolbar at the bottom of the screen.** Press the Playback button (▶) to begin playing the movie. To pause the movie, press the Setting button (⊛). To see the playback controls, tap the icon at the upper left of the screen.

▶ **Turn the Main dial (⚙) to adjust the volume.**

▶ **Press left or right on the Multi-controller (⬚) to select a playback function displayed at the bottom of the screen.**

During playback, time in minutes: seconds appears at the top left of the screen. The controls at the bottom of the screen include the play button, as well as the following:

▶ **Slow motion (I▶).** To slow down the video playback press left or right on the Multi-controller (⬚). The speed is displayed at the upper right of the screen.

▶ **First frame (I◀◀).** Goes to the first frame in the video.

▶ **Previous frame (◀II).** Press the Setting button (⑤) to move to the previous frame. Continue pressing the Setting button (⑤) to step back frame–by–frame.

▶ **Next frame (II▶).** Press the Setting button (⑤) to move forward frame–by–frame through the movie. Hold down the Setting button (⑤) button to fast forward through the movie.

▶ **Last frame (▶▶I).** Select to jump to the last frame in the movie.

▶ **Background music (♫).** Select to play back a movie with background music.

▶ **Edit (✖).** Choose to do basic editing to the video.

▶ **Playback position (▶).** Displays the playback position.

You perform basic edits on video clips in-camera by choosing the Edit function in the Playback toolbar. In Edit mode (✖), you can cut the beginning and end of the clip, choose Play to move to other frames, save your changes, and exit.

Another way to playback videos is by connecting your camera to your TV. You can buy an HDMI (HTC-100) cable or a stereo AV (AVC-DC400ST) cable. Using an HDMI cable with an HDTV provides improved image quality when you view Full HD and HD movies.

Working with Flash

When you use the built-in flash or pair the EOS 70D with a Canon Speedlite, a new world of light and light control opens for you. The 70D enables you to control functions of both the built-in flash and an accessory Speedlite directly from the camera menu. You can set the metering, flash sync speed in Aperture-priority AE mode (**Av**), Flash Exposure Compensation, bracketing, shutter synchronization, flash ratio, and Custom Functions for compatible EX-series Speedlites. In addition, you can use wireless flash with radio or optical transmission depending on the Speedlite you're using. The camera's built-in flash serves as the master control unit to trigger one or more Speedlites. So, whether you use only the built-in flash or multiple Speedlites, learning to use flash broadens your shooting possibilities in both practical and creative ways.

This image was made with one Canon Speedlite mounted to a stand and a large silver reflector camera-right. The flash was diffused with an umbrella. Exposure: ISO 160, f/16, 1/125 second.

Deciding When to Use Flash

Some photographers hate using flash and others love it. For years, I avoided flash, not only because it was difficult to use, but also because, in my opinion, it created a sterile, unappealing light that neither added to the story of the image, nor complemented the subject.

However, times have changed. Thankfully, flash photography has come a long way. I am now one of the many photographers who consider flash an indispensable tool. With the plethora of light-shaping tools, in-camera flash controls, wireless triggers, and other accessories, I have as much control over portable flash units as I do over my studio strobes.

Even if you hate using flash, I hope you'll consider experimenting with the built-in flash and with one or more off-camera Speedlites. This chapter is by no means a definitive flash guide, but it does give you the basics to help you get started.

Calculating Flash Exposure

If you cringe to think of figuring out the flash exposure, you can rest easy because with E-TTL, the camera automatically calculates the flash exposure. However, knowing the elements that factor into flash exposures enables you to use flash within its limits and to troubleshoot the settings when the exposure isn't what you expected. Whether you use the built-in flash, an accessory Speedlite, or a third-party flash unit, the same factors go into calculating flash exposure.

Flash exposure begins with the flash unit's guide number. The guide number indicates the relative power of the flash, and you can use the guide number to compare the power outputs of different flash units. The higher the guide number, the more powerful the flash. The guide number is easily found on Canon Speedlites in the name. For example, the Canon 600EX-RT has a guide number of 60, the first two numerals in the name.

A guide number is typically measured at ISO 100 for a 105mm focal length. From the guide number, you can determine what aperture to set given the subject distance and the ISO. The guide number for the Canon Speedlite 600EX-RT is 60 meters/197 feet at 200mm flash coverage and at ISO 100. Once you know the guide number, you can divide the guide number by the flash-to-subject distance to determine the appropriate aperture to set.

Understanding Light Falloff

When working with light, it is important to understand the dynamics of light fall-off and how to compensate for it. The inverse square law — a law that applies to flash as well as to studio lights — describes the characteristics of light falloff.

The inverse square law states that the quantity or intensity of light is inversely proportional to the square of the distance from the light source. If this is as clear as mud, it can be restated thusly: An object that is twice as far from a point light source as another object receives a quarter as much light as the closer object. Move the subject three times as far away, and the subject receives only 1/9 the light. This is true because a point light source — a flash unit or studio light — spreads out like a cone as the subject's distance from the light source increases, thus diminishing the light reaching the subject. You have likely seen the effect of the inverse square law in flash images where subjects close to the camera received sufficient light for a good exposure while subjects a few feet away received noticeably less light, as the following illustration shows.

9

©Charlotte Lowrie

Thus, if you double the distance of the subject from the light source, you need four times the amount of light to compensate for the light falloff. You can achieve this by either opening up 2 f-stops or by using a flash that has four times more power. There are exceptions to the inverse square law, such as when you use Fresnel lenses, elliptical, optical spotlights, and light sources modified by a grid. Also, light from softboxes and scrims at close working distances falls off less than the inverse square law predicts.

The relationship between the aperture and the flash-to-subject distance is Guide Number ÷ Aperture = Distance, and Guide Number ÷ Distance = Aperture for optimal exposure. Thus, to calculate flash exposure in feet, if the subject is 15 feet from the camera, just divide 197 (the guide number in feet) by 15 feet (camera-to-subject distance) to get f/13 at ISO 100.

What do you do if you want to shoot at a different aperture? You can change the camera-to-subject distance, or you can increase the ISO sensitivity setting on the camera. When you increase the ISO, the camera needs less light to make the exposure, and it simultaneously increases the range of the flash. For example, when you increase the ISO from 100 to 200, the guide number increases by a factor of 1.4x; increasing from 100 to 400 doubles the guide number.

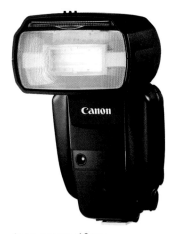

Image courtesy of Canon

9.1 The 600EX-RT is the most powerful Speedlite in Canon's flash lineup with a guide number of 60.

The last factor to consider is the focal length of the lens. The flash covers a fixed area, or a fixed angle of view. Thus, when you use a wide-angle lens, the flash may not cover the entire area, causing dark areas on the periphery. And with a telephoto focal length, some of the light may spill outside the lens's angle of view. For example, the Canon 580EX II Speedlite has default coverage from 24mm to 105mm while the 600EX-RT has coverage of 20mm to 200mm. Both flash units include a pull-out wide panel that extends flash coverage to 14mm.

Using E-TTL II Technology

Canon flash units use *E-TTL II technology*. To make a flash exposure using Evaluative metering (⊡), the camera takes a reading of the light in the scene when you half-press the shutter button. When you fully press the shutter button, a pre-flash is fired and read by the camera. The camera compares the available light and pre-flash readings to determine the best flash output, and then stores that information in its internal memory. The camera also detects when there is a difference between the available and flash light readings, and it assumes that the difference is the subject. If the camera detects areas where there are large differences in readings, it attributes them to a highly reflective surface, such as glass or a mirror, and ignores them when calculating the exposure.

At the same time, the flash unit also receives information from the camera, including the focal length of the lens, distance from the subject, and exposure settings, and this information confirms if the subject distance from the flash reading is correct. The flash also automatically figures in the angle of view. Thus, the EX-series Speedlites automatically adjust the flash zoom mechanism to get the best flash angle and to illuminate key areas of the scene, which also conserves power.

E-TTL II technology also enables high-speed sync flash with accessory Speedlites. High-speed sync flash allows flash synchronization at a shutter speed faster than the camera's flash sync speed of 1/250 second. The advantages are that you can sync at all shutter speeds and use fill flash in brightly lit scenes, such as outdoors. Also, you can open up the lens to a wide aperture when shooting a backlit subject to create a shallow depth of field while shooting at shutter speeds faster than 1/250 second.

9.2 This portrait was made with the 600EX-RT Speedlite shooting into an umbrella and a 580EX II to the right of the subject. Exposure: ISO 200, f/16.0, 1/125 second.

Using the Built-in Flash

Many people complain that the built-in flash isn't powerful enough and that it isn't in the best position. These are valid complaints, but the built-in flash *is* handy and, in many cases, it gets the job done. In Creative Zone modes, such as Aperture-priority AE (**Av**) or Shutter-priority AE (**Tv**), just pop it up if you need some fill flash for a portrait or some extra light in a dim venue. Plus, it serves as a nice trigger when you're using an accessory Speedlite.

The built-in flash offers coverage for lenses as wide as 17mm and sync speeds ranging from 1/250 to 30 seconds, and a recycle time of approximately 3 seconds. Tables 9.1 and 9.2 show what you can expect when you use the built-in flash in various exposure modes, and it provides flash range estimates.

Table 9.1 The 70D Exposure Settings Using the Built-in Flash

Shooting mode	Shutter speed	Aperture
P	The 70D automatically sets the shutter speed in the range of 1/250 second to 1/60 second.	The 70D automatically sets the aperture. With flash use, you cannot shift, or change, the exposure in **P** mode.
Tv	You set the shutter speed from 1/250 second to 30 seconds. If you set a shutter speed faster than 1/250 second, the camera automatically readjusts it to 1/250.	The camera automatically sets the appropriate aperture.
Av	The camera automatically sets the shutter speed from 1/250 second to 30 seconds depending on the ambient light. Because the shutter speed can go very slow, you can go to Shooting menu 2 (📷), choose Flash control, and then choose Flash sync. speed in **Av** mode. Then choose 1/250-1/60 sec. or 1/250 sec. (fixed) to prevent slow shutter speeds. If you use slow-speed flash sync, use a tripod with slow shutter speeds.	You set the aperture and the camera sets the shutter speed.
M	You can set the shutter speed in the range of 1/250 second to 30 seconds.	You set the aperture manually.
B	The exposure lasts as long as you hold down the shutter button.	You set the aperture.
Ⓐᵗ, CA, 🌙, 🌷, 🏃, 🖼	The 70D automatically sets the shutter speed in the range of 1/60 second to 1/250 second.	The 70D automatically sets the aperture.

Table 9.2 Built-in Flash Ranges*

ISO sensitivity setting	Wide-angle lens @ f/3.5 (feet/meters)	Telephoto lens @ f/5.6 (feet/meters)
100	3.3-11.2 (1-3.4)	3.3-7 (1-2.1)
200	3.3-15.9 (1-4.8)	3.3-9.9 (1-3)
400	3.3-22.5 (1-6.9)	3.3-14.1 (1-4.3)
800	4-31.8 (1.2-9.7)	3.3-19.9 (1-6.1)
1600	5.6-45 (1.7-13.7)	3.5-28.1 (1.1-8.6)
3200	8-63.6 (2.4-19.4)	5-39.8 (1.5-12.1)
6400	11.2-90 (3.4-27.4)	7-56.2 (2.1-17.1)
12800	15.9-127.3 (4.8-38.8)	9.9-79.5 (3-24.2)
H (25600)	22.5-180 (6.9-54.9)	14.1-112.5 (4.3-34.3)

* Information courtesy of Canon.

From the information in Table 9.1, you can see that flash use differs based on the exposure mode you choose. In Aperture-priority AE (**Av**) and Shutter-priority AE (**Tv**) modes, the 70D balances the available light with the light from the flash to provide fill flash. Fill flash uses the light in the scene for the exposure, and provides just enough flash illumination to fill shadows and brighten the subject. Fill flash provides more natural-looking exposures than when you use the flash as the primary light source.

In Aperture-priority AE mode (**Av**), you can choose the aperture you want, but because more available light is used for much of the exposure, it's usually up to you to ensure that the shutter speed is fast enough to prevent the blur that can occur when you handhold the camera. You can monitor the shutter speed in the viewfinder when you use the flash in Aperture-priority AE mode (**Av**). If the shutter speed is too slow, you can use a wider aperture or a tripod, or use a higher ISO setting. Better yet, use the Flash syc. Speed in the Av mode option on Shooting menu 2 (◻), Flash control to set a shutter speed range. This option, covered later, will help ensure a fast enough shutter speed to prevent the blur that can occur when handholding the camera.

In Shutter-priority AE mode (**Tv**), you can set a shutter speed that is fast enough to prevent camera shake. However, if you set a shutter speed that is out of range for the amount of light in the scene, the aperture value flashes in the viewfinder, alerting you that the camera cannot record enough of the available light to get a balanced fill-flash exposure. In those cases, set a slower shutter speed, use a tripod, or increase the ISO setting.

In Manual mode (**M**), you have full control over the balance between existing and flash light. With fast shutter speeds, less of the existing light is captured — unless the existing light is very bright — and the background goes dark. If you choose a very slow shutter speed, you run the risk of camera shake if you're handholding the camera or if the subject moves, but the background will be brighter because more of the existing light factors into the exposure.

Setting up the built-in flash

The built-in flash features options you can use to control the flash output to get natural-looking flash images. These options include Flash Exposure Compensation (FEC) (◪) and Flash Exposure Lock (FE Lock) (**FEL**). In addition, you can set flash functions using the Flash Control options on Shooting menu 2 (◻) when you shoot in the Creative Zone modes, such as Shutter-priority AE (**Tv**), and Aperture-priority AE (**Av**).

> **NOTE** To use the flash in Creative Zone exposure modes, you have to press the flash button to pop up the flash. In Basic Zone modes except Flash Off (⚡), Landscape (🏔), Sports (🏃), Night Portrait (🌃), and Handheld night scene (📷) modes, the flash pops up and fires automatically when the 70D determines that additional light is needed.

Red-eye reduction

One of the first things you should set before using the built-in flash for photos of people and animals is Red-eye reduction. The red appearance in a person's eye is caused when the bright flash reflects off the retina, illuminating the blood vessels in the reflection. The Red-eye reduction option fires a pre-flash that causes the pupils of the subject's eye to contract when the subject looks at the pre-flash, thereby reducing the appearance of redness in the eyes. Just be sure to ask the person to look at the pre-flash light when it fires.

You can enable Red-eye reduction on Shooting menu 2 (📷). Just highlight Red-eye reduc., press the Setting button (⚙), and then choose Enable. Press the Setting button (⚙) again to confirm the change.

Modifying Flash Exposure

There are times when the flash doesn't produce the image that you envisioned. There are also times when you want to increase or decrease the flash exposure, or avoid hot spots on the subject. In these situations, you can modify the flash output using either Flash Exposure Compensation (⚡) or Flash Exposure Lock (**FEL**). You can set these options for the built-in flash and for an accessory Speedlite.

Flash Exposure Compensation

Flash Exposure Compensation (⚡), or FEC, enables you to adjust the flash output manually, without changing the aperture or shutter speed when shooting in Program AE (**P**), Shutter-priority AE (**Tv**), Aperture-priority AE (**Av**), Manual (**M**), or Bulb (**B**) modes. FEC is effective when you want to adjust the balance between the fore- and background exposure, and it can help compensate for highly or non-reflective subjects.

FEC is also useful for balancing lighting in unevenly lit scenes and reducing the dark background shadows that often happen with flash use. When you are using the flash as the primary light, FEC gives good results. If you're using the flash for fill light, then you can use FEC (🔅) as a dimmer switch to turn the amount of light up or down.

NOTE *Fill flash* is using the flash at reduced power to add a little extra light on the subject, while reducing shadows and increasing brightness. Fill flash is very effective when shooting outdoor portraits.

With FEC, you can increase the flash output up to +/-3 stops in 1/3-stop increments. As a result, you can maintain the camera's original E-TTL (Evaluative Through-the-Lens) readings while manually increasing or decreasing the flash output.

If you use an accessory Speedlite, you can set FEC (🔅) on either the camera or Speedlite. However, the compensation that you set on the Speedlite overrides any that you set using the 70D's FEC function on Shooting menu 2 (📷). In short, set compensation either on the Speedlite or on the camera, but not on both. For me, it's easier to set FEC on the 70D because the LCD screen is big, and the controls are more straightforward than those on a Speedlite are.

TIP If you're using the built-in flash to fill shadows on the subject's face in sunny conditions or when the subject is backlit, the flash loses its effectiveness when you are more than 6 to 8 feet from the subject. Even using positive FEC may not help. The solution is to move closer to the subject.

FEC can also be combined with exposure compensation. If you shoot a scene in which one part is brightly lit and another is much darker — for example, an interior room with a view to the outdoors — then you can set exposure compensation to -1 and FEC to +1 to make the transition between the two areas appear more natural.

NOTE Auto Lighting Optimizer (📷) can mask the effect of FEC (🔅). If you want to see the effect of the compensation, turn off Auto Lighting Optimizer (📷) by setting it to Disable on Shooting menu 3 (📷).

Before you begin, ensure that the camera is set to Program AE (**P**), Shutter-priority AE (**Tv**), Aperture-priority AE (**Av**), Manual (**M**), or Bulb (**B**) mode.

To set FEC for the built-in flash, follow these steps:

1. **Press the Quick Control button (Q), and then select the Flash exposure compensation button (⊞±0).** The Flash exposure compensation screen appears.

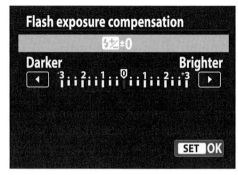

9.3 The Flash exposure compensation screen.

2. **Turn the Main dial (⟨≋≋⟩) to set the amount of compensation you want.** You can also use the touchscreen to drag the tick mark. Setting the tick mark to the left of 0 (zero) decreases the flash output, and setting it to the right increases it.

3. **Press the Setting button (⊛).** To remove FEC, repeat these steps, but in step 2, move the tick mark back to 0 (zero). The compensation you set remains in effect until you change it.

Flash Exposure Lock

Flash Exposure Lock (**FEL**) is a great way to control flash output for any part of the scene or subject. For example, you might want to set the flash exposure for a subject's skin in a portrait or for a photographic gray card. When you press the shutter button halfway, FE Lock fires a pre-flash that reads from a small area at the center of the viewfinder — it takes a Spot meter reading from 3 percent of the viewfinder at the center. So be sure to point the center of the viewfinder over the part of the scene or subject from which you want to take the meter reading. This pre-flash meter reading is stored for 16 seconds so that you can move the camera to recompose the scene, focus, and make the image.

If you're accustomed to using gray cards, then you can use the one provided in the back of this book, or identify a middle-gray tonal value in the scene and lock the flash exposure on it. If the area from which you take the meter reading is brighter or darker than middle gray, you may need to set some Flash Exposure Compensation to compensate for the difference. Regardless of your approach, FE Lock is a technique that you want to add to your arsenal for flash images.

> **TIP** If you are shooting a series of images under unchanging light, then Flash Exposure Compensation is a more efficient approach to modifying flash exposure than the Flash Exposure Lock (**FEL**).

Before you begin, be sure the camera is set to Program AE (**P**), Shutter-priority AE (**Tv**), Aperture-priority AE (**Av**), Manual (**M**), or Bulb (**B**) mode. To set FE Lock, follow these steps:

1. **Press the Flash button to raise the built-in flash.** The flash icon appears in the viewfinder when you half-press the shutter button.

2. **Point the center of the viewfinder over the area of the subject where you want to lock the flash exposure or over a gray card, and then press the FE Lock button (✦*) on the back of the camera.** The camera fires a pre-flash. FEL is displayed momentarily in the viewfinder, and the flash icon in the viewfinder displays an asterisk beside it to indicate that flash exposure is locked. If the flash icon in the viewfinder blinks, the subject is beyond the flash range, so move closer and repeat the process.

3. **Move the camera to compose the image, press the shutter button halfway to focus, and then completely press the shutter button to make the image.** Ensure that the asterisk is still displayed to the right of the flash icon in the viewfinder before you make the picture. As long as the asterisk is displayed, you can take other images at the same compensation amount, for about 16 seconds.

Setting Flash control options

You can set most of the built-in flash settings using the Flash control option on Shooting menu 2 (⬛). This menu offers an array of adjustments, and the settings change depending on the options you choose. In automatic modes, such as Scene Intelligent Auto (⬛), and Creative Auto (⬛), you can only set the Red-eye reduction option.

Before you begin, be sure the camera is set to Program AE (**P**), Shutter-priority AE (**Tv**), Aperture-priority AE (**Av**), Manual (**M**), or Bulb (**B**) mode. If you have the wireless function for the Built-in flash settings set to Disable, not all of these options are available. Also, the options change depending on the wireless function you choose.

Here are some things you should know as you review the Flash control screen:

▶ **A colon (:) represents ratio control between the built-in and Speedlite flash units.** Ratios and stops are equivalent. One stop is twice as bright as the other. With each stop being twice as bright, the formula is $2 \times 2 \times 2 = 8$. An 8:1 ratio represents a 3-stop difference.

▶ **A plus sign (+) means that the built-in and Speedlite flash units act as one flash system.**

▶ The letters **A, B, C** represent groups with one or more flash units in a group.

▶ Ratio control (such as A:B ratio) determines the relative power or brightness between two flash groups.

To set Flash Control options, select Flash Control on Shooting menu 2 (📷), and then press the Setting button (⑨).

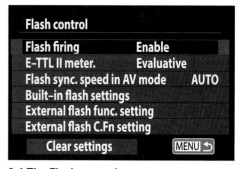

9.4 The Flash control screen.

The Flash control screen appears. Turn the Quick Control dial (⊙) to highlight the setting that you want to change (see Table 9.3), and then press the Setting button (⑨).

Table 9.3 Flash Control Menu Options

Setting	Option(s)	Suboptions/Notes
Flash firing	Enable, Disable	Enable turns the flash on so that you can use it in Creative Zone modes such as **Av** and **Tv**. If you choose Enable, just press the Flash button to pop up the flash when you want to use it. Disable prevents flash use in Creative Zone modes.
E-TTL II meter.	Evaluative, Average	Evaluative metering samples the entire scene and biases the exposure for the subject area. Average metering averages the exposure for the entire scene. With Average metering, you may need to set Flash Exposure Compensation to get a pleasing exposure.
Flash sync. speed in Av mode	AUTO, 1/250–1/60 sec. auto, or 1/250 sec. (fixed)	This determines the flash sync speed when you're shooting in **Av** mode. Auto sets the sync speed between 1/250 to 30 seconds depending on the existing light. This option biases the exposure for the scene, but it may result in shutter speeds that are too slow for handholding the camera. If you choose this option, monitor the shutter speed as you're shooting and use a tripod when necessary. You can use high-speed sync with this option as well. 1/250–1/60 sec. auto prevents the slow shutter speeds that can happen when you use the Auto setting. The slowest, 1/60 second setting permits handholding for focal lengths up to short telephoto for Image Stabilized (IS) lenses. For non-IS lenses, monitor the shutter speed and use a tripod with slow shutter speeds. Depending on the shutter speed, the background will be dark to very dark. High-speed sync in **Av** mode cannot be used. 1/250 sec. (fixed) ensures a fast enough shutter speed to prevent camera shake when using non-IS telephoto lenses up to 200mm. With the flash providing the primary illumination, the background will go very dark. High-speed sync in **Av** mode cannot be used.

Setting	Option(s)	Suboptions/Notes
Built-in flash settings	Flash mode	ETTL (E-TTL II flash metering), a good choice for use with Canon EX Speedlites. Choose M (Manual flash) when you want to meter the exposure with a handheld flash meter, or when you want to determine the flash exposure based on the guide number or distance measurement.
	Shutter sync	1st curtain: Flash fires at the beginning of the exposure. Can be used with a slow sync speed to create light trails in front of the subject. 2nd curtain: Flash fires just before the exposure ends. The sequence is for the camera to fire a pre-flash to determine the flash output, then the exposure begins, and the flash fires just before the second curtain closes at the end of the exposure. You can use this option with a slow sync speed to create light trails behind the subject.
	Wireless func.	Choose Disable when you do not want to use the built-in flash to trigger one or more accessory Speedlites. In other words, choose when the built-in flash is the only flash you are using. Choose Speedlite: Built-in flash when shooting with one Speedlite and the built-in flash. This represents ratio control for Speedlites that you set as slave units and the built-in flash. Choose Speedlite (only) for automatic shooting with a single Speedlite. Choose Speedlite + Built-in flash for shooting with the built-in flash and one or more Speedlites. All the flash units work together, although you still have ratio control for multiple Speedlites in multiple groups. This is an advanced setting.
	Channel	This option appears only when the Wireless func. is set to one of the options that includes Speedlites. Choose a channel from 1 to 4. You may need to change from the default Channel 1 when you're shooting in areas where other photographers are shooting to prevent interference.
	[Flash] exp. comp	Press ⊕ to activate the Flash exposure level indicator, and then you can set +/-3 stops of Flash Exposure Compensation to either increase or decrease the flash output while using E-TTL metering.
	Flash ratio	This option appears only when the Wireless func. is set to one of the options that includes Speedlites. Choose the ratio of one flash to the other: 8:1, 4:1, 2:1, or 1:1.

Working with Speedlites

Canon offers a full line of accessory Speedlites. The latest Speedlite at this writing is the 600EX-RT with built-in radio transmission (RT) capability. Radio Transmission makes it possible to position one or more flash units in places where older, optical flash units could not be because they required line of sight to the camera or transmitter. This opens up many creative opportunities. However, the 600EX-RT isn't the only

excellent flash gun in the lineup. There are eight Speedlites, ranging in price from $150 to $550. In most cases, you can mix and match Speedlites for a multiflash setup. Plus, you can use the built-in flash as an optical transmitter to trigger wirelessly one or more Speedlites positioned around the scene.

Further, the 70D offers a high level of control over the flash units directly from the camera. For example, you can set the metering mode, Av mode sync speed, wireless functions, zoom, shutter sync, and make flash exposure modifications directly from the 70D's camera menus. You can also set the Custom Functions for the Speedlite from the camera.

By now, you know how handy the Quick Control screen is for changing settings on the 70D. The equivalent to that screen for the flash is the Flash function settings screen — a handy screen with the most commonly used flash settings.

The options displayed on the Flash function settings screen vary depending on the Speedlite you're using. For earlier or other models of Speedlites, some options covered in this section may not be available. None of these options is available in the Basic Zone shooting modes.

Here are the options for setting up and controlling an external Speedlite (in this case, the 600EX-RT):

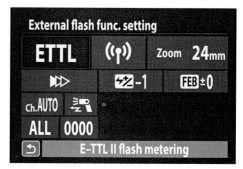

9.5 The External flash func. setting screen for a Speedlite 600EX-RT.

▶ **ETTL.** This is a good choice for automatic flash exposure with EX-series Speedlites.

▶ **M.** Manual flash is the option to choose if you're using a handheld flash meter to determine the flash exposure. You can set the flash output from full to 1/128 power in 1/3-stop increments.

▶ **MULTI.** MULTI flash (stroboscopic) enables you to capture successive movements of the subject when shooting with a slow shutter speed using stroboscopic flash. You can set wireless for radio or optical transmission, or no wireless, and you can set the number of flashes, the flash frequency (Hz), and the flash output level from 1/128 power to 1/2.

NOTE Speedlites are daylight balanced — that is, the light from the flash is the same color temperature as the midday sun. As a result, you can shoot outdoors or in a daylight studio using the flash because the colors are so similar.

▶ **Ext.A or Ext.M.** These modes use the Speedlite's built-in external metering sensor to measure the light that is reflected from the subject back to the Speedlite. Then it adjusts the flash output for achieving a standard exposure. The A and M designations stand for Auto and Manual. With Auto, the Speedlite automatically adjusts the flash output; with Manual, you set the flash output with the ISO and aperture settings on the camera.

▶ **Gr.** Individual group control gives you control over groups of flash units designated by letters from A to E. For each group, you can set the Flash mode with options for E-TTL, Manual flash, and AutoExtFlash. Or you can choose Disable. Then, you can also set Flash Exposure Compensation for each group.

▶ **Wireless functions.** The choices are Off, Wireless: Radio transmission, or Wireless: Optical transmission. You can use radio transmission only with the 600EX-RT flash and with the Speedlite Transmitter ST-E3-RT. Wireless optical transmission is compatible with Speedlites previous to the 600EX-RT. You can use the 600EX-RT as part of an optical wireless multiple-flash

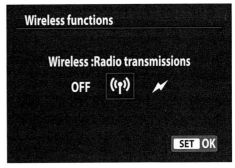

9.6 The Wireless functions screen for a 600EX-RT Speedlite.

setup. When you choose a wireless setting, the options on the Flash function settings screen change. For example, if you choose Radio transmission, then the Flash function settings screen adds options to set the radio channel, whether the master flash fires, the firing of flash groups, and the flash ratio for groups. You can also set the wireless radio ID. If you have flash units set in groups, then when you choose the firing of flash group, you can choose ALL to fire all units at the same power, choose A:B, or choose A:B C. For optical wireless multiflash shooting, you can set the channel from 1 to 4, the master flash firing, the flash ratio, and the flash group firing with options for ALL, A:B, or A:B C.

▶ **Zoom.** This function enables you to have the Speedlite automatically detect the focal length of the lens, or manually set the focal length on the Flash zoom screen to set flash coverage.

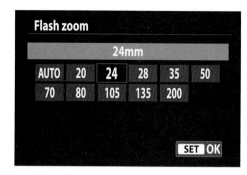

▶ **Shutter synchronization.** The options here are:

9.7 The Flash zoom screen.

- **First-curtain synchronization.** This is the most commonly used setting and causes the flash to fire immediately after the exposure starts.

- **Second-curtain synchronization.** With this option, the flash fires just before the shutter closes. Two flashes fire: one at the beginning and one just before the exposure ends. If you use this option and set the shutter speed to 1/30 second or faster, then first-curtain sync is automatically used. So, set the shutter speed at 1/125 second or slower, down to 1/30 second. Second-curtain is a good option for creating traffic trails from car lights when using a slow shutter speed.

- **High-speed synchronization.** This enables use of the flash at shutter speeds faster than 1/250 second. With High-speed sync, the faster the shutter speed, the shorter the flash's range. The effective flash range is displayed on the LCD screen.

▶ **Flash exposure compensation (⊠).** This option is much like Exposure compensation on the camera. It enables you to dial the flash exposure up or down in 1/3-stop increments up to plus/minus 3 stops to balance the foreground and background tones. To set compensation, choose this option, press the Setting button (⊛), and then turn the Quick Control dial (◯) to the left to reduce flash output, or the right to increase it.

NOTE Auto Lighting Optimizer (⊡) can mask the effect of FEC. If you want to see the effect of the compensation, turn off the Auto Lighting Optimizer (⊡) by setting it to Disable on Shooting menu 3 (⬛).

▶ **Flash Exposure Bracketing (FEB).** Bracketing is a good way to cover your bases to get a flash exposure that is pleasing, and it is similar to using Exposure bracketing on the camera. The bracketing sequence includes three images, one with positive flash exposure compensation, one with the standard flash output, and one with negative flash

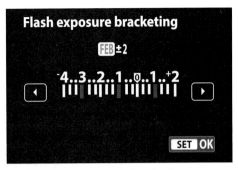

9.8 The Flash exposure bracketing screen.

exposure compensation. Bracketing can be set in 1/3-stop increments up to +2/-4 stops. To set bracketing, choose this option, press the Setting button (⊜), and then turn the Quick Control dial (◯) to the right to set bracketing in 1/3-stop or 1/2-stop increments (depending on the Speedlite). Next, press the Setting button (⊜). Bracketed images take a bit of time to complete because the flash has to recycle after each exposure. To bias the exposure to either over or under the standard exposure, you can combine Flash Exposure Bracketing (FEB) with Flash Exposure Compensation (🄱).

▶ **Channel (CH).** Optical channels range from 1 to 4. Radio channel options are Auto, or 1 to 15. Be sure that the flash units are set to the same channel. Set a channel when working around other photographers using wireless flash to keep from firing another photographer's flash.

▶ **Master flash firing (🄱/🄱).** Enable this option to have the external Speedlite control flash units that you've set up as slave units. The other option is Disable.

▶ **Flash group.** This option gives you ratio control over flash groups. For example, A:B ratio determines the relative power or brightness between the two flash groups A and B. You can choose All, or you can choose A:B, or A:B C.

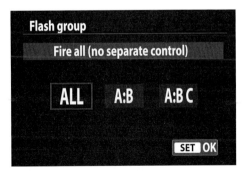

9.9 The Flash group firing screen.

▶ **Wireless radio ID.** This option appears when you enable the Wireless function. You can manually enter a four-digit ID.

▶ **A:B fire ratio**. This option sets the lighting ratio of external flashes. You can choose 2:1, 1:1, or 1:2.

> **NOTE** If you want to use flash with Live View shooting mode (📷), you must use a Canon flash. Third-party flashes will not fire in Live View mode (📷).

To set any of these options, mount the Speedlite to the camera, turn it on, and then follow these steps:

1. **On Shooting menu 2 (📷), highlight Flash control, and then press the Setting button (⊛).** The Flash control screen appears.

2. **Turn the Quick Control dial (◎) to highlight External flash func. settings, and then press the Setting button (⊛).** The External flash func. setting screen appears.

3. **Turn the Quick control dial (◎) to select the option that you want to change, and then press the Setting button (⊛).** Alternately, just touch the option on the screen. The settings screen appears for the option you chose.

4. **Turn the Quick Control dial (◎) to change the setting, and then press the Setting button (⊛).** The External flash func. setting screen appears.

> **TIP** If you have the 580EX II or 430EX II Speedlite, you can use Custom Function 00 to change the flash distance indicator on the rear LCD screen from meters to feet.

It's important to note that the options on the screen change as you make various adjustments, so be sure to continue exploring the options. Just turn the Quick Control dial (◎) to select additional options as they appear, and then press the Setting button (⊛) to view more settings.

The main Flash control screen also offers the option to set External flash Custom Functions. Having control of the Custom Functions from the camera is convenient.

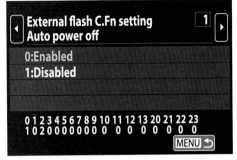

9.10 You can change the Custom Function settings for the Speedlite by choosing the External flash C.Fn setting option on the Flash control menu in Shooting menu 2. This is one of the Custom Functions for the 600EX-RT Speedlite.

TIP In low-light indoor or night outdoor scenes, the flash often illuminates the subject properly, but the background is too dark. In these scenes, switch to Aperture-priority AE (**Av**) or Shutter-priority AE (**Tv**) mode, and use a wide aperture, slow shutter speed (respectively), or both to allow more of the existing light to contribute to the exposure. Just ask your subject to remain still if the shutter speed is slow.

Setting Up Wireless Flashes

While it's beyond the scope of this book to provide detailed instructions for wireless flash techniques, the following sections help get you started with flash setups, ranging from one to multiple Speedlites. However, if you have only one Speedlite, then you can still get lovely images with it. Even if the built-in flash is all you have, you can experiment using some of the new attachments that diffuse the light to create pleasing illumination and combine it with existing light and reflectors to get very nice images.

Using a one-light setup

Any lighting system begins with a single light. With some creativity, you can use one Speedlite effectively for portraits, still-life subjects, and some food and product shots. Be sure to have reflectors on hand to increase your options for directing the light.

To get the best images, it's important to get the Speedlite off the camera. Speedlites come with small stands so you can place them where you want them. If you are using one or more optical Speedlites (models introduced before the 600EX-RT in 2012), then be sure that the flash has a clear line of sight to the camera's built-in flash so they can communicate. Then you can use the built-in flash to trigger the Speedlite(s). Alternately, you can use the Speedlite Transmitter ST-E3-RT or the ST-E2 with Speedlites older than the 600EX-RT. For Figure 9.11, I had the 600EX-RT Speedlite on a stand shooting into an umbrella. I positioned the flash above and slightly to the right of the camera. A large silver reflector filled shadows on the right side of the face.

9.11 A black background helps you avoid dark shadows behind the subject. Exposure: ISO 160, f/16, 1/125 second, 600EX-RT Speedlite, -2 stops Flash Exposure Compensation.

TIP If you're shooting in low light with a flash and you want to balance the ambient light with the subject that is being lit by the Speedlite, try using Aperture-priority AE mode (**Av**). Set a wide aperture, such as f/2.8 to f/4.0, and then use the ISO setting to control the shutter speed so it's between 1/4 and 1/30 second. Use a tripod, and ask the subject to remain still.

Setting up multiple Speedlites

It follows that if one light or flash is good, two or more flash units are better. While that logic doesn't hold true for everything, in the case of flash units it does. Multiple Speedlites enable you to set up lighting patterns and ratios just as you can with a studio lighting setup. In addition, you can use flash units to re-sculpt existing light, while still providing natural-looking illumination.

With multiple Speedlites, you can use lighting ratios to create classic lighting patterns for portraits and for other still-life subjects.

When I shoot portraits on location, I take three Speedlites with stands, silver umbrellas, a softbox, and multiple reflectors. This setup is a lightweight mobile studio that can either provide

9.12 A Stofen cap over a flash head can help create soft lighting. Exposure: ISO 100, f/20, 1/125 second, -2 Flash Exposure Compensation.

the primary lighting for subjects or supplement existing light. And with the 70D, I bring the Speedlite Transmitter ST-E3-RT if I'm using the Speedlite 600EX-RT.

In any lighting setup, the key light provides the primary light. Then you add another light, and it determines the depth of the shadows. From there, you can add a background light or two, and a hair light. Then, just set the lighting ratio to get the effect you want. It also helps to have a complement of reflectors, softboxes, stands, and umbrellas on hand to soften and direct the light. Even a simple Stofen cap (www. stofen.com) on the flash heads will provide softer light. For image 9.12, I put a Speedlite behind the orchid and one in front of it with a Stofen cap over it. I also dialed the output down with -2 Flash Exposure Compensation.

> **NOTE** You can set multiple Speedlites to fire as a single group when you need to fill an area with light. To do so, set the Firing group to ALL.

Choosing Lenses and Accessories

Just as the human eye is the artistic lens for the photographer, the camera lens interprets a scene for the camera, and ultimately, for your images. Your choice of lens is like the choice of a brush is to an artist. The more you know about lenses, the better your chances of selecting the right lens for the subject. Not surprisingly, Canon refers to its stable of more than 60 lenses as *The Eyes of EOS*.

As you evaluate lenses that you may want to buy, know that the higher the lens quality, the better the image you'll get with the 70D. High-quality lenses capture and retain excellent image detail even as you enlarge images for printing. As you buy new lenses, remember that you are building a system that will last for years — much longer than the camera body.

The EF 180 f/3.5L Macro USM lens provided the reach I needed to photograph this butterfly without disturbing it. Exposure: ISO 200, f/5.62, 1/800 second, -2/3 exposure compensation.

Lens Choices for the 70D

With more than 60 lenses available from Canon and many more available from third-party manufacturers, you can find a lens for virtually any shooting situation. While there are lenses aplenty, many of the best lenses carry high price tags. If you're new to photography or shooting with a Canon camera, I recommend planning lens purchases with the goal of gradually building a system that meets your shooting needs, while maximizing the money you have to spend on lenses.

For new photographers who have not settled on a specialty area yet, a good rule of thumb is to begin by buying two lenses that cover the focal range from wide angle to telephoto. With those two lenses as the foundation of your system, you can shoot 90 percent of the scenes and subjects that you'll encounter.

Because it's likely you'll use these lenses most often, they should be high quality. High-quality lenses produce images with snappy contrast and excellent sharpness, have low color fringing and distortion, provide even illumination across the frame, and are fast enough to allow shooting in low-light scenes.

> **NOTE** A *fast lens* is generally one with a maximum aperture of f/2.8 or wider. If the lens has Image Stabilization, you gain even more low-light shooting flexibility.

When I switched to Canon almost 10 years ago, my first Canon lenses were the EF 24-70mm f/2.8L USM and EF 70-200mm f/2.8L IS USM. These high-quality lenses covered the focal range of 24mm to 200mm on a full-frame camera. Today, I still use these lenses most often for everyday shooting. Because I shoot with a variety of Canon EOS cameras, I also know that I can use these lenses on any EOS camera body and get beautiful images.

For a videographer, EF lenses open doors to creative techniques that are impossible with traditional video cameras and lenses. EF lenses offer a shallow depth of field with a large aperture that often cannot be achieved with video lenses. And with fisheye lenses that have a 180-degree field of view, videos can provide views wider than can be seen by the viewer's eye. Likewise, high-magnification filming with a macro lens offers a view into tiny worlds. EF lenses enable videographers to record with a controlled perspective not offered by traditional video cameras.

Image courtesy of Canon

10.1 The EF 70-200mm f/2.8L IS II USM is a good starting point for building a lens system.

If you bought the 70D as a kit with either the EF-S 18-55mm f/3.5-5.6 IS STM or the EF-S 18-135mm f/3.5-5.6 IS STM lens, you already know that both lenses provide a good focal range for everyday shooting of still images and video. Of course, the 18-135mm lens provides a greater focal length range, and that makes it more versatile than the 18-55mm lens, but both are quite capable lenses. These lenses have the STM designation for Canon's stepping motor that provides fast, quiet focusing.

If you have the 18-55mm lens, then your next purchase might be a telephoto lens or a macro telephoto lens that not only enables wonderful macro shots, but also serves as a great lens for portraits and still-life subjects.

Types of Lenses

Canon uses the designation EF (electro-focus) for lenses, and it simply identifies the type of mount the lens has. The EF lens mount provides quick mounting and removal of the lens, as well as providing communication between the lens and the camera body. The EF mount is fully electronic and resists abrasion, shock, and play. When you

10

mount a lens, it does an automatic self-check and alerts you to any malfunction. And if you use lens accessories such as lens extenders, the exposure compensation is automatically calculated.

Many lenses also carry the USM designation, which stands for ultrasonic motor. USM lenses include a built-in motor powered by the camera, and the motor provides exceptionally fast focus. USM lenses also use electronic vibrations created by piezoelectric ceramic elements to provide quick and quiet focusing action with almost instantaneous starts and stops. Lenses with a ring-type ultrasonic motor offer full-time manual focusing without needing to switch the lens to Manual focus (**MF**). This is offered on large-aperture and super-telephoto lenses.

Lenses are categorized by whether they zoom to different focal lengths or have fixed focal lengths (known as *prime lenses*). There are three main categories: Wide-angle, normal, and telephoto. Macro lenses are either normal or telephoto, with the added advantage of their close focusing capability.

Another important lens distinction for the 70D is that it's compatible with both EF- and EF-S-mount lenses. The EF lens mount is compatible across all Canon EOS cameras, regardless of image sensor size and camera type, whether digital or film. However, EF-S lenses are specially designed to project a smaller image circle to the image sensor. EF-S lenses can be used only on cameras with cropped sensors, such as the 70D, T5i, and 7D. Because the rear element on EF-S lenses protrudes back into the camera body, they can't be used on full-frame cameras.

This also factors into how you build your lens system. As you buy lenses, think about whether you want those that are compatible with all Canon digital SLR cameras, or only those with the cropped sensor. As your photography career progresses, you'll most likely buy a second, backup camera body or move from the 70D to another EOS camera body. If your next EOS camera body has a full 35mm frame sensor, you'll want the lenses you've already acquired to be compatible with it, which means buying the EF-mount lenses. If you have EF-S lenses on hand in this situation, you can sell them, of course.

Understanding the focal-length multiplier

An important lens consideration for the 70D is that the camera has an APS-C-size image sensor. *APS-C* is simply a designation that indicates that the image sensor is 60 percent of the size of a traditional full 35mm frame. Because the image sensor is

smaller than the 35mm frame, when you use an EF lens on the 70D, the smaller image sensor takes in less of the scene than a full-frame size image sensor would.

This means the effective angle of view for Canon EF lenses that you use on the 70D is reduced by a factor of 1.6X at any given focal length. For example, a 100mm lens is equivalent to a 160mm lens on the 70D. Likewise, a 50mm lens is the equivalent of using an 80mm — a short telephoto lens on the 70D.

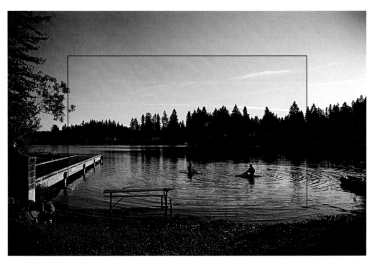

10.2 The difference in image size between a full-frame sensor and the smaller 70D (in color).

10

NOTE With the cropped sensor on the 70D, an EF lens's focal length must be multiplied by 1.6 to determine its actual focal length on the 70D. However, in everyday conversation, photographers refer to EF lenses by their focal length on a non-cropped (full 35mm frame) camera.

Just from the previous examples, you can see that you get extra reach from your lenses thanks to the focal-length multiplication factor. With telephoto lenses, it effectively increases the lens's focal length (although technically the focal length doesn't change). Given that telephoto lenses are more expensive than other lenses, you can buy a shorter and less expensive telephoto lens and get 1.6X more magnification at no extra cost. Also, because the smaller sensor uses the center (or sweet spot) of the lens, you get high sharpness and less chromatic aberration.

Where there is an upside, there is surely a downside. The downside of the focal-length multiplication factor is that wide-angle lenses include less of the scene than they do on full-frame cameras. This is because the focal length is magnified by 1.6. However, you can get a EF-S 10-22mm f/3.5-4.5 USM for an affordable price and get a true wide-angle view.

As you think about the focal-length multiplier effect on telephoto lenses, it seems reasonable to assume that the focal-length multiplier would produce the same depth of field that a longer lens — the equivalent focal length — does. That isn't the case, however. Although an 85mm lens on a full 35mm-frame camera is equivalent to a 136mm lens on the 70D, the depth of field on the 70D matches the 85mm lens, not a 136mm lens. This depth of field principle also holds true for enlargements. The depth of field in the print is shallower for the longer lens on a full-frame camera than it is for the 70D.

Zooms

Zoom lenses offer variable focal lengths in a single lens so that when you adjust the zoom ring, you bring the subject closer to you or move it farther away. Without question, zoom lenses are practical and convenient. For example, if you need lenses to cover a wide focal range, then the EF 16-35mm f/2.8L II USM and EF 70-200mm f/2.8L IS II USM (or a similar combination of two zoom lenses) would meet your goal. With a non-zoom or prime, you would need five to seven or more lenses to get the same focal range.

Besides being convenient, zoom lenses are able to maintain focus during zooming. Thus, you can work on composition even after establishing focus at another focal length. To keep the lens size compact and to compensate for aberrations with fewer lens elements, most zoom lenses use a multigroup zoom with three or more movable lens groups.

10.3 Wide-angle zoom lenses, like the Canon EF 16-35mm f/2.8L USM, provide a wide view of the scene.

Most mid-priced and more expensive zoom lenses offer high-quality optics that produce sharp images with excellent contrast. As with many Canon lenses, full-time manual focusing is available by switching the button on the side of the lens to Manual focus (**MF**). Getting a fast zoom lens means paying a higher price. Also, while zoom lenses allow you to carry around fewer lenses, they tend to be heavier than single focal-length lenses.

Some zoom lenses have a variable aperture. For example, the EF-S 18-135 f/3.5-5.6 IS STM is a variable-aperture lens. That means that at the widest focal length, the maximum aperture is f/3.5, and at the longer end of the focal range, the maximum aperture is f/5.6. In practical terms, this limits the versatility of the lens at the longest focal length for shooting in all but bright light or at a high ISO setting. And unless you use a tripod or your subject is stone still, your ability to get a crisp picture in lower light at f/5.6 will be questionable.

More expensive zoom lenses offer a fixed and fast maximum aperture. With a zoom lens that has an f/2.8 maximum aperture, you get faster shutter speeds that enhance your ability to get sharp images when handholding the camera. However, the faster the lens, the higher the price.

Primes

While you hear much less about *prime*, or *single-focal-length*, lenses than you hear about zoom lenses, prime lenses are worth careful consideration. With a prime lens, the focal length is fixed. This means you must physically move closer to (or farther from) your subject, or change lenses to change image composition. Canon has a nice selection of prime lenses, including the venerable EF 50mm f/1.4 USM and EF 100mm f/2.8L Macro IS USM.

Unlike zoom lenses, prime lenses tend to be fast, with maximum apertures of f/2.8 or faster. Wide apertures allow fast shutter speeds that enable you to handhold the camera in lower light and still get a sharp image. Compared to

10

10.4 **A single focal-length lens is ideal for macro shots like this. Exposure: ISO 200, f/10, 1 second.**

zoom lenses, single focal-length lenses are lighter and smaller. In addition, single focal-length lenses tend to be sharper than some zoom lenses.

Working with Different Types of Lenses

Within the categories of zooms and primes, lenses are grouped by their angle of view. The *angle of view* is the area of the scene that can be reproduced by the lens as a sharp image. The image sensor is rectangular, but the image captured by the lens is circular, and it's called the *image circle.* The image that's captured is taken from the center of the image circle.

For a 15mm fisheye lens, the angle of view is 180 degrees on a full-frame 35mm camera. For a 50mm lens, it's 46 degrees; and for a 200mm lens, the angle of view is 12 degrees. Simply stated, the shorter the focal length, the wider the scene coverage, and the longer the focal length, the narrower the coverage. The EF 8-15mm f/4L Fisheye USM lens was the world's first fisheye zoom lens. At the 8mm setting, the lens delivers a 180-degree angle of view for full-frame cameras that results in a circular image.

The lens's aperture range also affects the depth of field. The depth of field is affected by several factors including the lens's focal length, aperture (f-stop), focus position, camera-to-subject distance, and subject-to-background distance.

Finally, the lens you choose affects the perspective of images. *Perspective* is the visual effect that determines how close or far away the background appears to be from the main subject. The shorter (wider) the lens, the more distant the background elements appear to be. The longer (more telephoto) the lens, the closer the elements appear.

Wide-angle lenses

Wide-angle lenses are aptly named because they offer a wide view of a scene. The wide-angle lens category provides angles of view ranging from 114 to 63 degrees. Generally, lenses shorter than 50mm are considered wide angle on full-frame 35mm

image sensors. Excluding the 8mm and 15mm fisheye lenses, wide-angle lenses range from 17mm to 40mm on a full-frame camera. With the focal-length multiplication factor, you need lenses from 10mm to 22mm to get truly wide-angle shots.

Wide-angle lenses are ideal for capturing scenes ranging from sweeping landscapes to large groups of people, and for taking pictures in places where space is cramped. For Figure 10.5, I used the EF 24-70mm f/2.8L USM lens set to 24mm. The 24mm focal length gave an expansive view of the sunset, and heightened the dark clouds as they moved toward the horizon. Because I didn't have a tripod with me, I shot wide open to get a fast enough handholding shutter speed.

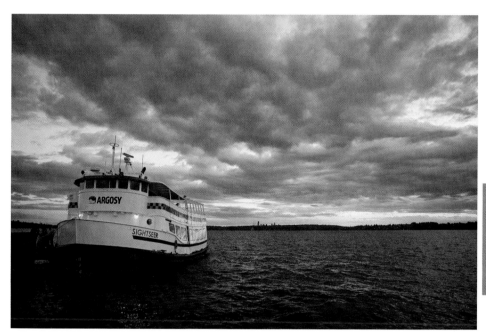

10

10.5 A moderately wide 24mm lens gives an expansive view of the scene. Exposure: ISO 200, f/2.8, 1/50 second.

When you shoot with a wide-angle lens, keep these lens characteristics in mind:

▶ **Extensive depth of field.** Particularly at small apertures from f/11 to f/32, the entire scene, front to back, will be in acceptably sharp focus. This characteristic gives you slightly more latitude for less-than-perfectly focused pictures.

▶ **Distortion.** Wide-angle lenses distort lines and objects in a scene, especially if you tilt the camera up or down when shooting. For example, if you tilt the camera up to photograph a group of skyscrapers, the lines of the buildings tend to converge toward the center of the frame, and the buildings appear to fall backward (also called *keystoning*).

▶ **Perspective.** Wide-angle lenses make background objects appear far away from the subject, but these lenses also cause objects close to the camera to appear disproportionately large. You can use this characteristic to move the closest object farther forward in the image, or you can move back from the closest object to reduce the effect. Wide-angle lenses are popular for portraits, but if you use a wide-angle lens for close-up portraiture, keep in mind that the lens exaggerates the size of facial features closest to the lens, which is unflattering.

Telephoto lenses

Telephoto lenses offer a narrow angle of view, enabling close-ups of distant scenes. On full 35mm-frame cameras, lenses with focal lengths longer than 50mm are considered telephoto lenses, and the focal lengths range from 70mm to 800mm. On the 70D, with the APS-C-size sensor, 50mm lenses (equivalent to 80mm on the 70D) and longer provide a telephoto focal length.

Telephoto lenses offer an inherently shallow depth of field that is heightened when you shoot at wide apertures. On the 70D, 50mm, 85mm, and 100mm lenses are ideal for portraits, while longer, 200mm to 800mm lenses allow you to photograph distant birds, wildlife, and athletes. When you're photographing wildlife, these lenses also allow you to keep a safe distance.

When you shoot with a telephoto lens, keep these lens characteristics in mind:

▶ **Shallow depth of field.** Telephoto lenses magnify subjects and provide a limited range of sharp focus. At wide apertures, you can reduce the background to a soft blur. Because of the extremely shallow depth of field, it's important to get

tack-sharp focus. Many Canon lenses include full-time manual focusing that you can use to fine-tune the camera's autofocus.

▶ **Narrow coverage of a scene.** Because the angle of view is narrow with a tele-photo lens, much less of the scene is included in the image. You can use this characteristic to exclude distracting scene elements from the image.

▶ **Slow speed.** Midpriced and even some expensive telephoto lenses tend to be slow; the widest aperture is often f/4.5 or f/5.6, which limits your ability to get sharp images without a tripod in all but the brightest light unless they also feature Image Stabilization. Due to the magnification, even the slightest movement is exaggerated. Regardless of the lens speed, using a tripod with telephoto lenses is always the best practice.

▶ **Perspective.** Telephoto lenses tend to compress perspective, making background objects in the scene appear close to the subject.

10.6 For this image, I used the EF 100-400mm f/4.5-5.6L IS USM lens, set to 250mm (equivalent to 400mm). Exposure: ISO 200, f/8.0, 1.3 seconds.

Normal lenses

Normal lenses offer an angle of view and perspective comparable to how your eyes see the scene. On full 35mm-frame cameras, 50mm to 60mm lenses are considered normal lenses. On the 70D, taking into consideration the focal-length multiplier, 50mm translates to 80mm. To get a 50mm view on the 70D, you must use a 31mm to 32mm lens zoom setting. The 50mm lens used to be the kit lens that came on new film cameras, and it was also the lens of choice for many photography greats, including Henri Cartier-Bresson. The 50mm was the first lens I used, and it is still one of my favorites due to its documentary look and feel, and fast aperture.

When you shoot with a normal lens, keep these lens characteristics in mind:

10.7 The EF 50mm f/1.4 USM lens is one of the oldest in Canon's lineup, but it offers excellent contrast, as shown in this pet portrait. Exposure: ISO 400, f/2.8, 1/90 second.

▶ **Natural angle of view.** On the 70D, a 50mm lens closely replicates the sense of distance and perspective of the human eye. This means the final image will look much as you remember seeing it when you made the picture.

▶ **Little distortion.** Given the natural angle of view, the 50mm lens retains a normal sense of distance, especially when you balance the subject distance, perspective, and aperture.

Macro lenses

Macro lenses are designed to provide higher magnification by enabling you to move in very close to the subject. Depending on the lens, the magnification ranges from half life-size (0.5X) to 5X magnification. Thus, objects as small as a penny or a postage stamp can fill the frame, while nature macro shots can reveal breathtaking details that

are commonly overlooked. Using extension tubes can further reduce the closest focusing distance. Macro lenses do double duty — in addition to macro shooting, they can also be used for standard types of photography, such as portraits.

If you're buying a macro lens, you can choose lenses by focal length or by magnification. For example, if you're shooting insects or other living creatures, a telephoto macro lens such as the EF 135 f/3.5L Macro USM enables you to maintain a distance from the subject and avoid disturbing the subject. However, due to the very shallow depth of field, it can be hard to render the entire subject in sharp focus. Thus, a standard macro lens such as the EF 100mm f/2.8L Macro IS USM may be a better choice.

Choosing a macro lens by magnification means choosing how much larger the subject appears in the image than in real life. The EF 50mm f/2.5 Compact Macro has a magnification of 0.5X. The EF 100mm f/2.8L Macro IS USM has a life-size magnification, and the MP-E 65mm f/2.8 1-5X Macro Photo has a 5X magnification.

10.8 The EF 100mm f/2.8L Macro USM lens allows focusing so close, I could almost fill the frame with this tiny, succulent blossom. Exposure: ISO 400, f/4.0, 1/50 second.

10

TIP It is important to keep in mind that at 1:1 magnification and at maximum aperture, the depth of field with the EF 180mm Macro lens is less than 1mm. To maximize the depth of field, use a narrow aperture and keep the camera parallel to the camera's focal plane.

With the shallow depth of field common in macro photography, be sure that the focus is tack sharp. You can tweak the camera's focus by using full-time manual focus on some macro lenses such as the EF 100mm f/2.8L Macro IS USM. Also, the higher the magnification, the higher the risk of camera shake causing blur, so be sure to use a tripod and a Self-timer drive mode (☉) or a remote release to fire the shutter.

Tilt-and-shift lenses

Tilt-and-shift lenses, referred to as *TS-E lenses,* alter the angle of the plane of focus between the lens and sensor plane to provide a broad depth of field even at wide apertures, and to correct or alter perspective at almost any angle. This enables you to correct perspective distortion and control focusing range.

Using tilt movements, you can bring an entire scene into focus, even at maximum apertures. By tilting the lens barrel, you can adjust the lens so that the plane of focus is uniform on the focal plane, thus changing the normally perpendicular relationship between the lens's optical axis and the camera's focal plane. Alternatively, reversing the tilt has the opposite effect of greatly reducing the range of focusing.

Shift movements avoid the trapezoidal effect that results from using wide-angle lenses pointed up (to take a picture of a building, for example). Keeping the camera so that the focal plane is parallel to the surface of a wall and then shifting to raise the lens results in an image where the perpendicular lines of the structure are rendered perpendicular and the structure is rendered as a rectangle.

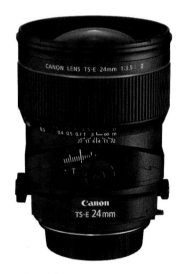

Image courtesy of Canon

10.9 The TS-E 24mm f/3.5L II is one of the new tilt-and-shift lenses. It minimizes chromatic aberrations, provides an 80-degree view on a full-frame camera, and has a specially coated, aspherical element that reduces glare.

TS-E lenses have a range of plus/minus 90 degrees, making horizontal shift possible, which is useful when you are shooting a series of panoramic images. You can also use shifting to prevent reflections of the camera or yourself from appearing in images that include reflective surfaces, such as windows, car surfaces, and other similar surfaces.

All of Canon's TS-E lenses are manual focus only. These lenses, depending on the focal length, are excellent for architectural, interior, merchandise, nature, and food photography.

Image Stabilized (IS) lenses

For anyone who has thrown away images blurred from handholding the camera at slow shutter speeds, the idea of Image Stabilization is a welcome one. Image Stabilization (IS) counteracts some or all of the motion blur from handholding the camera and lens, enabling you to shoot at slower shutter speeds than are generally considered acceptable. An IS lens shifts the optical system perpendicular to the optical axis to stabilize incoming light rays.

If you've shopped for lenses lately, you know that Image Stabilization comes at a premium price. IS lenses are pricey because they give you from 1 to 4 (or more) f-stops of additional stability over non-Image Stabilized lenses.

With an IS lens, miniature sensors and a high-speed microcomputer built in to the lens analyze vibrations and apply correction via a stabilizing lens group that shifts the image parallel to the focal plane to cancel camera shake. The lens detects camera motion via two gyro sensors — one for yaw and one for pitch. The sensors detect the angle and speed of shake. Then, the lens shifts the IS lens group to suit the degree of shake to steady the light rays reaching the focal plane. I handheld the camera and relied on Image Stabilization to get the image shown in Figure 10.10. I then converted the image to sepia using Nik Silver Efex Pro.

Stabilization is particularly important with long lenses, where the effect of shake increases as the focal length increases. As a result, the correction needed to cancel camera shake increases proportionately.

10.10 Image Stabilization allowed me to capture this image handholding the camera. Exposure: ISO 400, f/2.8, 1/25 second.

To see how the increased stability pays off, consider the rule of thumb for handholding the camera with a non-IS lens. The handholding rule says that the slowest shutter speed at which you can handhold the camera and avoid camera-shake blur is the reciprocal of the focal length, expressed as 1/[focal length]. For example, the slowest shutter speed at which you can handhold a 200mm lens and not get blur from hand shake is 1/200 second. If the handholding limit is pushed, then shake from handholding results in a blurry image.

Thus, if you're shooting in low light, the chances of getting sharp images at 200mm are low because the light is too low to allow a 1/200 second shutter speed, even at the maximum aperture of the lens. You can, of course, increase the ISO sensitivity setting and risk introducing digital noise into the images. However, if you're using an IS lens, the extra stops can mean that you don't have to increase the ISO as much as you would with a non-IS lens.

If you want to pan or move the camera with the motion of a subject, then Image Stabilization detects panning as camera shake and interferes with framing the subject. To correct this, Canon offers two modes on IS lenses. Mode 1 is designed for stationary subjects. Mode 2 shuts off Image Stabilization in the direction of movement when the lens detects large movements for a preset amount of time. So, when you pan horizontally, horizontal Image Stabilization stops but vertical Image Stabilization continues to correct any vertical shake during the panning movement.

While super-telephoto lenses may be out of your price range, it's a good idea to remain current with lens technology because it usually filters down to other, more affordable lenses. One such technology with super-telephoto lenses is a third Image Stabilization mode. This mode is designed for shooting action, where you need to quickly move the camera from one subject to another. With previous lenses, the view in the viewfinder sometimes did not keep up as the camera moved because the Image Stabilizer perceived the motion as camera shake.

To resolve this, Canon added Mode 3, in which the Image Stabilization motor begins working only when you make the picture. When you press the shutter button halfway, the lens calculates the amount of Image Stabilization needed, but the correction isn't applied until you fully press the shutter button. Thus, you have a clear view of the subject to compose the image, and stabilization is applied at the moment the image is made. Mode 3 detects panning motion and only applies Image Stabilization at right angles to the direction of movement.

At this writing, the EF 300mm f/2.8L IS II USM, EF 400mm f/2.8L IS II USM, EF 500mm f/4L IS II USM, and EF 60mm f/4L IS II USM lenses all feature Mode 3 Image Stabilization.

STM Lens Advantages

Another lens designation is STM, which stands for the stepping motor. First introduced in the 40mm f/2.8 STM pancake lens in 2012, the goal of STM lenses is to provide a focus motor that is quiet, smooth, and steady, particularly when using servo autofocus mode for making videos. STM lenses provide quick, smooth steps during focus changes — much smoother than non-STM lenses.

STM lenses also offer electronic manual focusing — that is when you turn the focus ring on the lens, the STM motor drives the lens's focus elements. The downside is that with electronics driving the lens motor, an extended zoom lens can't be manually retracted when it is off the camera because it needs power from the camera to retract.

Hybrid Image Stabilization for macro shooting

The EF 100mm f/2.8L II Macro USM lens features another iteration of Image Stabilization, dubbed *Hybrid Image Stabilization (IS)*. This technology improves on standard Image Stabilization to compensate for both angle and shift camera shake that can occur in macro shooting. *Angle shake* is rotation around a point, as if the lens is roughly rotating in a circle, and normal Image Stabilization can correct it. While the camera may also shift in a plane parallel to the subject, this type of shift shake is hidden by the focal distance in nonmacro shooting.

However, in macro photography, for which the focusing distance is shorter and the magnification is higher, shift shake is more visible. The classic rule of thumb says you need a shutter speed that is equal to or faster than the reciprocal of the lens focal length. Therefore, if you're shooting at a 180mm focal length, the minimum shutter speed for handholding the camera would be 1 over 180, or 1/180 second. However, for macro shooting, the stabilization needed is 1 to 2 stops greater than what's needed for nonmacro shooting.

To compensate, Hybrid IS uses the traditional vibration gyro to detect angular motion and adds an acceleration sensor to detect parallel shift shake. Thus, the camera can detect and compensate for camera movement in three directions. With the 100mm macro lens, this means that you can use shutter speeds roughly 3 stops slower at 0.5X magnification, and approximately 2 stops slower at 1X.

10

CROSS REF You can calibrate lenses that you use on the 70D. Aligning the focus of lenses is detailed in Chapter 6, and setting peripheral illumination and chromatic aberration correction is detailed in Chapter 2.

What Is Considered a Good Lens?

Photographers often talk about good lenses, and you may be wondering exactly what that is. Here are some characteristics:

▶ **High resolution/sharpness.** Lens resolution includes the lens's ability to clearly record very fine detail, such as lines per millimeter of the smallest black-and-white line pattern that can be recorded on the sensor. Resolution also involves the lens's clarity and contrast. High resolution is particularly important when you enlarge an image for printing so that the sharp detail is maintained in prints at 11 × 14 inches and larger.

▶ **High contrast.** Contrast is the distinction among brightness levels in a picture, such as the difference in brightness between dark and light areas. High contrast means that the reproduction ratio between white and black is clear. A good lens should deliver high, visually pleasing contrast.

▶ **Minimal aberrations.** The list of potential lens aberrations is a long one that ranges from color aberrations to spherical aberrations and various distortions. A common problem is *chromatic aberration*, color fringing around high-contrast edges in an image. Color fringing is typically seen as colors such as red/cyan or blue/yellow, or green/magenta, which is a combination of the previous two types. Check lens reviews to evaluate the aberrations and distortions for the lens you're considering. You can correct chromatic aberrations with the 70D.

▶ **Falloff.** Falloff describes how the lens's illumination decreases, or falls off gradually at the edges of the frame. It also describes illumination through the entire frame. The less falloff, the better the lens.

To see if the lens you're buying has these characteristics, you can read reviews in magazines and online (at www.dpreview.com, for example), or ask other photographers who have the lens for their opinions.

Lens Accessories

Lens accessories can be as simple as a lens hood to avoid flare, a tripod mount to change between vertical and horizontal positions quickly without changing the optical axis or the geometrical center of the lens, or a drop-in or adapter-type gelatin filter holder. Other options include using extension tubes, extenders, and close-up lenses that increase the focal range, but decrease the focusing distance to provide flexibility for the lenses you already own. These accessories are not only fairly economical, but they extend the range and creative options of existing and new lenses.

Extenders

For relatively little cost, you can increase the focal length of any lens by using an extender. An *extender* is a lens set in a small ring mounted between the camera body and a regular lens. Canon offers two extenders, the EF 1.4X III and EF 2X III, that are compatible only with L-series lenses. Extenders can also be combined for even greater magnification.

For example, using the Canon EF 2X III extender with a 600mm lens doubles the lens's focal length to 1200mm before applying 1.6X. Using the Canon EF 1.4X III extender increases a 600mm lens to 840mm.

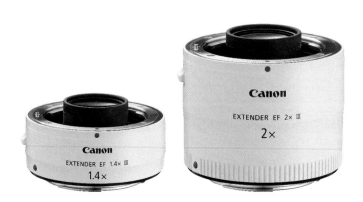

Image courtesy of Canon

10.11 The Extender EF 1.4X III and EF 2X III are excellent accessories that increase a lens's focal range by 1.4X or 2X, respectively.

A disadvantage to using extenders is that they reduce the light reaching the sensor. The EF 1.4X III extender decreases the light by 1 f-stop, and the EF 2X III decreases it by 2. However, an obvious advantage is that, in addition to being fairly lightweight, extenders can reduce the number of telephoto lenses you carry.

The latest EF extenders offer a new optical design that produces sharper images with less chromatic aberration along high-contrast edges. The fluorine coating is designed to repel oil and water, and make cleaning the lens easier.

Further, the new EF extenders have integrated processors that gather and transfer information from the lens to the camera, including the focal length, focus distance, and Image Stabilization. Also, if you set AF Microadjustment, you can include the extender with the lens during the process of adjusting the lens.

If you're using an extender, be sure to first attach the lens to the extender, and then attach both to the camera so that the camera can detect both the extender and the lens attached to it. If you first attach the extender without the lens to the camera, the camera will recognize the extender but not the lens you attach to it.

Extension tubes and close-up lenses

Extension tubes are close-up accessories that provide magnification increases from approximately 0.3 to 0.7, and they can be used on many EF lenses, though there are exceptions. Extension tubes are placed between the camera body and lens and connect to the camera via eight electronic contact points. Extension tubes can be combined for greater magnification.

Canon offers two extension tubes, the EF12 II and the EF25 II. Magnification differs by lens, but with the EF12 II and standard zoom lenses, it is approximately 0.3 to 0.5. With the EF25 II, magnification is 0.7. When combining tubes, you may need to focus manually. Extension tubes are compatible with specific lenses. Be sure to check the Canon website for lenses that are compatible with extension tubes.

Additionally, you can use screw-in close-up lenses. Canon offers two lens series that provide enhanced close-up photography — the 500D and 250D series that you can buy by filter size.

10.12 The 100mm f/2.8L Macro IS USM lens combined with a 20mm Kenko extension tube enabled a very close shooting distance so I could isolate focus on a thin line in this daisy petal. Exposure: ISO 800, f/4.0, 1/100 second, -2/3 exposure compensation.

10

Shooting Checklist

One of the most common comments that I get from readers and people who take my photography courses is that there is so much to remember when shooting. Inevitably, they forget to set the AF point or white balance, to set or remove exposure compensation, or adjust the ISO setting when they're shooting. Over time, checking these things becomes second nature, but remembering everything can be a challenge at first.

To help you remember what to think about and what to set on the camera, I've provided a general shooting checklist. Each subject and scene is different, so you'll need to modify the list to suit your shooting situation. This list assumes that you are using a semiautomatic exposure mode, such as Program AE (**P**), Shutter-priority AE (**Tv**), Aperture-priority AE (**Av**), or Manual mode (**M**). Of course, in the automatic modes, you can set fewer options.

Before you begin shooting, do the following:

▶ **Choose an interesting subject.** Make sure that what you're shooting is interesting and intriguing. Even if you choose everyday subjects, you can use your creativity to make them more interesting to the viewer.

▶ **Choose the best light.** There is light, and then there is stunning light. You want the latter — it makes all the difference. The most stunning outdoor light happens just after sunrise, just before and during sunset, and at dusk. Indoors, diffuse window light is excellent, and light from a north-facing window is superb.

▶ **Make interesting compositions.** Do your research and learn the principles of good composition. Use tight framing, the Rule of Thirds, strong diagonals, color, symmetry, repetition, vanishing points, and so on.

AA.1. The challenge here was to make a very common subject interesting. This image was lit by a north-facing window at camera left, an east-facing window behind the subject, and a large silver reflector at camera right. Exposure: ISO 200, f/5.6, 1/10 second, +2/3 exposure compensation.

► **Choose your exposure, focus, drive, and metering modes based on the subject.** If you're shooting a still subject, such as a portrait, nature subjects, or landscapes, then use Aperture-priority AE mode (**Av**) with One-shot AF mode (**ONE SHOT**) and Single-shooting drive mode (☐). If you're shooting sports, the classic settings are Shutter-priority AE mode (**Tv**), AI Servo AF mode (**AI SERVO**), and High-speed continuous shooting (⊒H). If you're shooting snapshots at a child's birthday party or a family get-together, Program AE mode (**P**) is great because you can quickly shift the aperture and shutter speed to suit the changing scene. Set the focus to AI Focus AF (**AI FOCUS**) and set the drive mode to Continuous shooting (⊒). Nine times out of ten, you will get good exposures using Evaluative metering (⊡), so don't be afraid to leave the camera set to Evaluative (⊡). Finally, keep the ISO as low as possible. Instead of cranking up the ISO, try using a tripod.

► **Focus, focus, focus.** Pictures with blurry subjects and pictures with the sharp focus in the wrong place go into the trash. Master the focusing systems on the 70D, and always be in control of where the sharp focus is placed in the image.

AA.2. I was damp, cold, and exhausted by the time this balloon glow finally started, but I was glad that I waited for it because it's an interesting subject. Exposure: ISO 800, f/2.8, 1/15 second, -2/3 exposure compensation.

▶ **Set the white balance to match the light in the scene and the Picture Style to suit the subject.** Setting the correct white balance saves you tons of time on the computer color-correcting images. Choosing the appropriate Picture Style can add a professional touch to your images.

▶ **Verify everything.** Be sure that you check the histogram while you are shooting so that if there are blown highlights or blocked shadows, you can use exposure adjustments and reshoot immediately. Magnify the image and verify that the sharp focus is, indeed, sharp and in the right place. For example, in a portrait, the sharp focus should be on the eye that is closest to the camera. Check the color. If you used the wrong white balance, reset it, and then reshoot.

▶ **Does the picture move you?** Finally, evaluate the picture to see if it moves you. Do you love it, or does it leave you feeling ho-hum? If the latter, rethink your approach and shoot until you love what you see.

How to Use the Color Checker Gray Scale Card

Have you ever wondered how photographers are able to consistently produce photos with accurate color and exposure? It's often because they use a color checker gray scale card. Knowing how to use this tool helps take some of the guesswork out of capturing photos with great color and correct exposures every time.

The color of light varies by light source, so what you might decide is neutral in your photograph isn't neutral at all. This is where a color checker gray scale card comes in. It is designed to reflect the color spectrum neutrally in all sorts of lighting conditions and provide a point from which you can measure shadows and highlights. It creates a measuring standard for later color corrections or to set a custom white balance on the spot.

> **TIP** When taking a photo of the card, unfocus the lens a bit; this ensures that you capture more even color.

You can use the card to:

▶ **Correct color later.** Compose your shot, setting the card in the scene, which ensures you have a neutral item to adjust colors against later. Make sure that the card is placed in the same light as the subject, and then remove the card and continue shooting. Because many common photo processing software programs enable you to address color correction issues, having the color checker gray card in the first of a series of photos allows you to adjust colors with reference values for neutral, black, and white. Depending on the capabilities of your software, you might be able to save the adjustment you make and apply it to all other photos shot in the same series.

> **TIP** If you plan to color correct your images later in photo editing software, it is best to shoot in RAW.

▶ **Correct color now.** If lighting conditions will remain mostly consistent while you shoot, you can use the color checker gray card to set a custom white balance in your camera. Compose your shot, place the card in the scene, and then check the exposure on the histogram. Ideally, you want both the black and the white points hitting the opposite edges of the histogram. If they do not, adjust your exposure until you achieve this. You can now set this as your custom white balance and continue shooting. Alternatively, you can zoom in on the gray portion of the card, balance on the mid-tone gray value, and set a custom white balance. This method might not be quite as precise, but if you are in a hurry or only taking a few shots at a time in changing lighting conditions, consider this option.

NOTE If you are shooting in mixed light, there are situations in which neutral color balance may not be achievable.

Glossary

720p/1080i/1080p High-definition video recording standards that refer to the vertical resolution, or the number of horizontal lines on the screen — either 720 or 1080 lines. Seven-hundred twenty horizontal lines translate to a width of 1280 pixels, and 1080 lines translate to 1920 pixels of horizontal resolution. The *p* stands for progressive scan, which displays the video frame all at once. The *i* stands for interlaced, an analog compression scheme that allows 60 frames per second (fps) to be transmitted in the same bandwidth as 30 fps by displaying 50 percent of the video frame at a time.

Adobe RGB A color space that encompasses most of the gamut of colors achievable on commercial printers, or approximately 50 percent of the visible colors specified by the International Commission on Illumination (CIE).

AE See *automatic exposure (AE)*.

AE Lock (Automatic Exposure Lock) A camera control that enables the photographer to lock the exposure at a point in the scene and focus at a different point in the scene.

angle of view The amount or area seen by a lens or viewfinder, measured in degrees. Shorter or wide-angle lenses and zoom settings have a wider angle of view. Longer or telephoto lenses and zoom settings have a narrower angle of view.

aperture The lens opening through which light passes. The mechanism is an iris diaphragm of several blades that can be continuously adjusted to vary the diameter of the opening. Aperture is expressed in f-numbers such as f/8 and f/5.6. See also *f-number*.

artifact An unintentional or unwanted element in an image caused by an imaging device, or resulting as a byproduct of image processing, such as compression.

artificial light The light from an electric light or flash unit.

autofocus A function in which the camera focuses on the subject using the selected autofocus point or points. Pressing the shutter button halfway sets the focus using the selected autofocus point.

automatic exposure (AE) A function in which the camera sets all or some of the exposure elements automatically. In automatic shooting modes, the camera sets all exposure settings. In semiautomatic modes, the photographer sets the ISO and either the Aperture-priority AE (Av) mode or the Shutter-priority AE (Tv) mode, and the camera automatically sets the shutter speed or aperture, respectively.

available light The natural or artificial light within a scene. This is also called existing light.

axial chromatic aberration A lens phenomenon that bends different-colored light rays at different angles, thereby focusing them on different planes, which results in color blur or flare. See also *chromatic aberration* and *chromatic difference of magnification*.

barrel distortion A lens aberration resulting in a bowing of straight lines outward from the center.

bit depth The number of bits used to represent each pixel in an image. Higher bit depths translate to more accurate color representation and more colors available for displaying or printing images. In monochrome images, it defines the number of unique shades of gray that are available.

blocked up A description of shadow areas that lack detail.

blooming Bright edges or halos in digital images around light sources, and bright reflections caused by an oversaturation of image sensor photosites.

bokeh The shape, illumination characteristics, and quality of the out-of-focus area in an image.

bounce light Light that is directed toward an object, such as a wall or ceiling, so that it reflects (or bounces) light back onto the subject.

brightness The perception of the light reflected or emitted by a source; the lightness of an object or image. See also *lightness* and *luminance*.

buffer Temporary storage for data in a camera or computer.

Bulb A shutter speed setting that keeps the shutter open as long as the shutter button is fully depressed.

cable release An accessory that connects to the camera and allows you to trip the shutter by using the cable instead of pressing the shutter button.

chroma noise Extraneous, unwanted color artifacts in an image.

chromatic aberration A lens phenomenon that bends different-colored light rays at different angles, thereby focusing them on different planes. Two types of chromatic aberration exist: axial and chromatic difference of magnification. The effect of chromatic aberration increases at longer focal lengths. See also *axial chromatic aberration* and *chromatic difference of magnification*.

chromatic difference of magnification A lens phenomenon that bends different-colored light rays at different angles, thereby focusing them on different planes; this appears as color fringing where high-contrast edges show a line of color along their borders. See also *chromatic aberration* and *axial chromatic aberration*.

CMOS (complementary metal-oxide semiconductor) The type of imaging sensor used in the camera to record images. CMOS sensors are chips that use power more efficiently than other types of recording media.

color balance The color reproduction fidelity of a digital camera's image sensor and of the lens. In a digital camera, color balance is achieved by setting the white balance to match the scene's primary light source or by setting a Custom white balance. You can adjust color balance in RAW conversion programs and in image-editing programs for JPEG images.

color/light temperature A numerical description of the color of light measured in Kelvin. Warm, late-day light has a lower color temperature. Cool, early-day light has a higher temperature. Midday light is often considered to be white light (5500K). Flash units are often calibrated to 5000K.

color space A subset of colors encompassed by a particular space within the visual spectrum of colors. Different color spaces include more or fewer colors. See also *RGB* and *sRGB*.

G

compression A means of reducing file size. Lossy compression permanently discards information from the original file. Lossless compression does not discard information from the original file and allows you to re-create an exact copy of the original file without any data loss. See also *lossless* and *lossy*.

contrast The range of tones from light to dark in an image or scene. Also, the degree of distinction between different brightness areas in an image, such as dark and light.

contrasty A term used to describe a scene or image with great differences in brightness between light and dark areas.

crop To trim or discard one or more edges of an image. You can crop when taking a picture by moving closer to the subject to exclude parts of a scene, by zooming in with a zoom lens, or by using an image-editing program.

daylight balance A general term used to describe the color of light at approximately 5500K, such as midday sunlight or an electronic flash. A white balance setting on the camera calibrated to give accurate colors in daylight.

depth of field The zone of acceptable sharpness in a photo that extends in front of and behind the plane of sharp focus.

diaphragm Adjustable blades inside the lens that open and close to determine the lens aperture.

diffuser Material, such as fabric or paper, that is placed over the light source to soften the light.

dpi (dots per inch) A measure of printing resolution.

dynamic range The difference between the lightest and darkest values in a scene as measured by f-stops. A camera that can hold detail in both highlight and shadow areas over a broad range of f-stops is said to have a high dynamic range.

exposure The amount of light reaching the image sensor. At a given ISO, exposure is the result of the intensity of light multiplied by the length of time the light strikes the image sensor.

G

exposure meter A general term referring to the built-in light meter that measures the light reflected from the subject back to the camera. EOS cameras use reflective meters.

extender An attachment that fits between the camera body and the lens to increase (or extend) the focal length of the lens.

extension tube A hollow ring attached between the camera lens mount and the lens that increases distance between the optical center of the lens and the sensor, and decreases minimum focusing distance.

fast A term that refers to film, ISO settings, and photographic paper that have high sensitivity to light. This also refers to lenses that offer a wide aperture, such as f/2.8 or f/1.4, and to a short shutter speed. See also *slow* and *speed*.

filter A piece of glass or plastic that is usually attached to the front of the lens to alter the color, intensity, or quality of the light. Filters are also used to alter the rendition of tones, reduce haze and glare, and create special effects such as soft focus and star effects.

flare Unwanted light reflecting and scattering inside the lens, causing a loss of contrast, saturation, sharpness, and/or artifacts in the image.

flat A term that describes a scene, light, or photograph that displays little difference between dark and light tones. This is the opposite of contrasty.

f-number A number representing the maximum light-gathering ability of a lens, or the aperture setting at which a photo is taken. It is calculated by dividing the focal length (f) of the lens by its diameter (D), or f/D. Wide apertures are designated with small numbers, such as f/2.8. Narrow apertures are designated with large numbers, such as f/22. See also *aperture*.

fps (frames per second) In still shooting, the number of frames the camera can capture in 1 second in either the One-shot or Continuous drive modes. In video film recording, the digital standard is 30 fps.

focal length The distance from the optical center of the lens to the focal plane when the lens is focused on infinity. The longer the focal length is, the greater the magnification.

focal point The point in an image at which rays of light intersect after reflecting from a single point on a subject.

focus The point at which light rays from the lens converge to form a sharp image. This is also the sharpest point in an image.

frame A term used to indicate a single exposure or image. This also refers to the edges around the image.

f-stop See *f-number* and *aperture.*

ghosting A type of flare that causes a clearly defined reflection to appear in the image symmetrically opposite to the light source, creating a ghostlike appearance. Ghosting is caused when the sun or a strong light source is included in the scene, and a complex series of reflections occur among the lens surfaces.

gigabyte The usual measure of the capacity of digital mass storage devices; 1 gigabyte is slightly more than 1 billion bytes.

grain See *noise.*

gray-balanced The property of a color model or color profile where equal values of red, green, and blue correspond to a neutral gray value.

gray card A card that reflects a known percentage of the light that falls on it. Typical gray cards reflect 18 percent of the light. Gray cards are standard for taking accurate exposure-meter readings and for providing a consistent target for color balancing during the color-correction process using an image-editing program.

grayscale A scale that shows the progression from black to white using tones of gray. This also refers to rendering a digital image in black, white, and tones of gray.

HDV and AVCHD High Definition Video and Advanced Video Codec High Definition refer to video compression and decompression standards.

highlight A term describing a light or bright area in a scene, or the lightest area in a scene.

histogram A graph that shows the distribution of tones or colors in an image.

hue The color of a pixel defined by the measure of degrees on the color wheel, starting at 0 for red, depending on the color system and controls.

infinity The distance marked on the lens between the imaging sensor or film and the optical center of the lens when the lens is focused on the farthest position on the distance scale of a lens (approximately 50 feet and beyond).

IP address (Internet Protocol address) A method used by computers connected to the Internet to exchange information. An IP address is the number assigned to every device connected to a computer network that uses Internet Protocol to communicate. IP addresses are binary numbers, but they appear in this format: 192.167.5.101. You may need to enter the IP address when connecting the camera to a LAN or to a web service.

ISO (International Organization for Standardization) A rating that describes the sensitivity of film or an image sensor to light. ISO in digital cameras refers to the amplification of the signal at the photosites. ISO is expressed in numbers such as ISO 100. The ISO rating doubles as the sensitivity to light doubles. For example, ISO 200 is twice as sensitive to light as ISO 100.

JPEG (Joint Photographic Experts Group) A file format that compresses data by discarding information from the original file to create small image file sizes. See also *lossy.*

Kelvin A scale for measuring temperature based around absolute zero. The scale is used in photography to quantify the color temperature of light.

LAN (Local Area Network) A small computer network, often based in a home, studio, or small business, that connects computers and other devices so that they can exchange data.

LCD (liquid crystal display) The image screen on digital cameras that displays menus and images during playback and Live View shooting.

LCD panel A panel located on the top of the camera; the LCD panel displays exposure information and changes made to exposure, white balance, drive mode, and other camera functions.

lightness A measure of the amount of light reflected or emitted. See also *brightness* and *luminance.*

linear A relationship in which doubling the intensity of light produces double the response, such as in digital images. The human eye does not respond to light in a linear fashion. See also *nonlinear.*

lossless A term that refers to file compression that discards no image data. TIFF is a lossless file format. See also *compression, lossy,* and *TIFF.*

lossy A term that refers to compression algorithms that discard image data when compressing image files to a smaller size. The higher the compression rate, the more data that is discarded and the lower the image quality. JPEG is a lossy file format. See also *compression, JPEG,* and *lossless.*

luminance The light reflected or produced by an area of the subject in a specific direction and measurable by a reflective light meter. See also *brightness* and *lightness.*

megabyte Slightly more than 1 million bytes.

megapixel One million pixels. It is used as a measurement of the capacity of a digital image sensor.

memory card Removable media, such as a CompactFlash or SecureDigital card, that stores digital images.

metadata Data about data or, more specifically, information about a file. This information, which is embedded in image files by the camera, includes aperture, shutter speed, ISO, focal length, date of capture, and other technical information. Photographers can add additional metadata in image-editing programs, including name, address, copyright, and so on.

middle gray A shade of gray that has 18 percent reflectance.

midtone An area of average brightness; a medium-gray tone in a photographic print. A midtone is neither a dark shadow nor a bright highlight.

neutral density filter A filter attached to the lens or light source to reduce the required exposure.

noise Extraneous visible artifacts that degrade digital image quality. In digital images, noise appears as unwanted multicolored flecks and as grain that is similar to grain seen in film. Noise is most prevalent in digital images captured at high ISO settings and/or with long exposure times.

G

nonlinear A relationship where a change in stimulus does not always produce a corresponding change in response. For example, if the light in a room is doubled, the human eye does not perceive the room as being twice as bright. See also *linear*.

normal lens or zoom setting A lens or zoom setting with a focal length that is approximately the same as the diagonal measurement of the film or image sensor used. In full-frame 35mm format, a 50-60mm lens is considered to be a normal lens. A normal lens more closely represents the perspective of normal human vision.

open up To switch to a larger f-stop, which increases the size of the diaphragm opening.

overexposure Giving an image sensor more light than is required to make an acceptable exposure. The resulting picture is too light.

panning A technique of moving the camera horizontally to follow a moving subject, which keeps the subject sharp but blurs and/or streaks background details.

photosite The place on the image sensor that captures and stores the brightness value for 1 pixel in the image.

pincushion distortion A lens aberration causing straight lines to bow inward toward the center of the image.

pixel The smallest unit of information in a digital image. Pixels contain tone and color that can be modified. The human eye merges very small pixels so that they appear as continuous tones.

plane of critical focus The most sharply focused part of a scene. This is also referred to as the point or plane of sharp focus.

polarizing filter A filter that reduces glare from reflective surfaces, such as glass or water, at certain angles.

ppi (pixels per inch) The number of pixels per linear inch on a monitor or in an image file. They are used to describe overall display/image quality or resolution. See also *resolution*.

RAW A proprietary image file in which the image has little or no in-camera processing. Because image data has not been processed, you can change key camera settings, including brightness and white balance, in a conversion program (such as Canon Digital Photo Professional, Adobe Camera Raw, or Adobe Lightroom) after the picture is taken.

reflective light meter A device — usually a built-in camera meter — that measures light emitted by a photographic subject back to the camera.

reflector A silver, white, or gold surface used to redirect light into shadow areas of a scene or subject.

resolution The number of pixels in a linear inch. Resolution is the amount of data used to represent detail in a digital image. Also, the resolution of a lens indicates its capacity of reproduction of a subject point. Lens resolution is expressed as a numerical value such as 50 or 100 lines, which indicates the number of lines per millimeter of the smallest black-and-white line pattern that can be clearly recorded. The resolution of a printed photograph depends on the resolution of the lens, the image sensor, and the printer. See also *ppi (pixels per inch)*.

RGB (Red, Green, Blue) A color model based on additive primary colors of red, green, and blue. This model is used to represent colors based on how much of red, green, and blue is required to produce a given color. See also *color space* and *sRGB*.

saturation As it pertains to color, a strong, pure hue undiluted by the presence of white, black, or other colors. The higher the color purity is, the more vibrant the color.

sharp The point in an image at which fine detail is clear and well defined.

shutter A mechanism that regulates the amount of time during which light is allowed into the camera to make an exposure. Shutter time or shutter speed is expressed in seconds and fractions of seconds, such as 1/30 second.

slave A flash unit that is synchronized to and/or controlled by another flash unit.

slow A reference to film, digital camera settings, and photographic paper that have low sensitivity to light, requiring relatively more light to achieve accurate exposure. This also refers to lenses that have a relatively wide aperture, such as f/3.5 or f/5.6, and to a long shutter speed. See also *fast* and *speed*.

G

speed The relative sensitivity to light of photographic materials such as film, digital camera sensors, and photographic paper. This also refers to the ISO setting, and the ability of a lens to let in more light by opening to a wider aperture. See also *fast* and *slow*.

spot meter A device that measures reflected light or brightness from a small portion of a subject.

sRGB A color space that approximates the gamut of colors of the most common computer displays. sRGB encompasses approximately 35 percent of the visible colors specified by the International Commission on Illumination (CIE). See also *color space* and *RGB*.

SSID (service set identifier) This is a unique 32-character string of characters and/or numbers that identifies a specific wireless network or router. Other devices look for the network's SSID number and the data packets the network provides.

stop See *aperture*.

stop down To switch to a smaller f-stop, thereby reducing the size of the diaphragm opening.

telephoto A lens or zoom setting with a focal length longer than 50-60mm in full-frame 35mm format.

TIFF (Tagged Image File Format) A universal file format that most operating systems and image-editing applications can read. Commonly used for images, TIFF supports 16.8 million colors and offers lossless compression to preserve all the original file information. See also *lossless*.

tonal range The range from the lightest to the darkest tones in an image.

TTL (Through the Lens) A system that reads the light passing through a lens that strikes an image sensor.

tungsten lighting Common household lighting that uses tungsten filaments. Without filtering or adjusting the correct white balance settings, pictures taken under tungsten light display a yellow-orange colorcast.

underexposure The effect of exposing an image sensor to less light than is required to make an accurate exposure. The resulting picture is too dark.

viewfinder A viewing system that allows the photographer to see all or part of the scene that will be included in the final picture.

vignetting Darkening of edges on an image that can be caused by lens distortion, or using a filter or lens hood. This is also used creatively in image editing to draw the viewer's eye toward the center of the image.

WEP (Wired Equivalent Privacy) A wireless standard used for network security. A WEP key or passcode is a code that enables devices on the same network to share messages while keeping the messages from being seen by outside networks.

white balance The relative intensity of red, green, and blue in a light source. On a digital camera, white balance compensates for light that is different from daylight to create correct color balance.

wide angle A lens with a focal length shorter than 50-60mm in full-frame, 35mm format.

WPS (Wi-Fi protected setup) A secure wireless connection setup mode that uses buttons instead of manually entering a network name (SSID) and security key to connect a device to a network. It offers a pushbutton connection (PBC) mode in which a connection is made by pressing the WPS button on the access point.

Index

Index

Flexible, fast, and fun, DigitalClassroom.com lets you choose when, where, and how to learn new skills. This subscription-based online learning environment is accessible anytime from your desktop, laptop, tablet, or smartphone. It's easy, efficient learning — on *your* schedule.

- Learn web design and development, Office applications, and new technologies from more than 2,500 video tutorials, e-books, and lesson files
- Master software from Adobe, Apple, and Microsoft
- Interact with other students in forums and groups led by industry pros

Learn more!
Sample DigitalClassroom.com for free, now!

We're social. Connect with us!

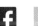 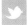

acebook.com/digitalclassroom
@digitalclassrm

Guides to go

Digital Field Guides are packed with essential information about your camera, plus great techniques for everyday shooting. Colorful and easily portable, they go where you go.

978-1-118-43822-0

978-1-118-16914-8

978-1-118-02223-8

978-1-118-16913-1

978-1-118-11289-2

978-1-118-16911-7

Available in print and e-book formats.

WILEY